WITH **300** dazzling color photographs

NATURE PHOTOGRAPHY

LEARNING FROM A MASTER

Photographs by Gilles Martin | Text by Denis Boyard

Translated from the French by Jack Hawkes

HARRY N. ABRAMS, INC., PUBLISHERS

CONTENTS

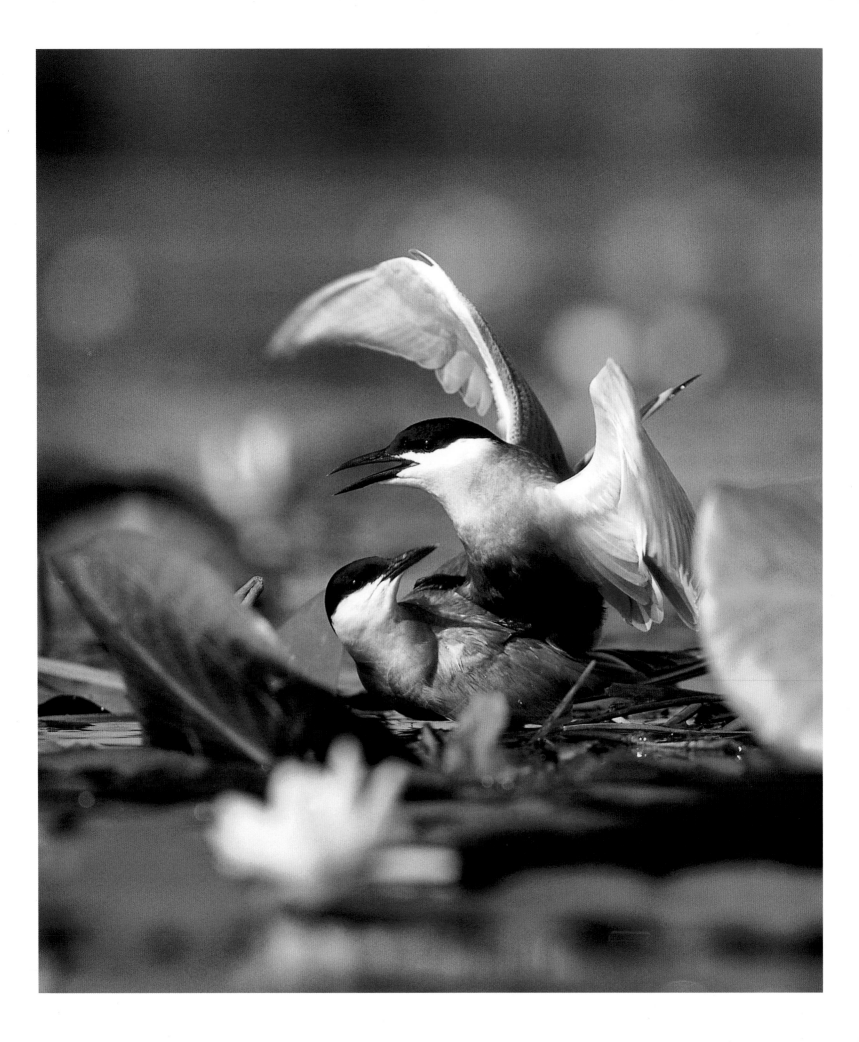

FOREWORD

We're proud of *Nature Photography* because it encourages the reader to explore the earth's diverse habitats in search of photographic emotions. Emotion is what it's all about, since before it becomes a tiny slide (no matter how magnificent), the image is an intense moment, in which an intimate encounter with an animal, plant, or landscape evokes a feeling of happiness. This word may seem too strong when you're miles away from the event, but when this encounter is the culmination of a day filled with wonder, when you've awoken at dawn, hiked over mountain paths, stopped for a meal by a waterfall, and painstakingly searched for your subject through binoculars, your mind is more sensitive to nature's simple beauties.

To be sure, the camera is a product of technology. Adept photographers will be better able to express themselves than neophytes. But technique is not an end in and of itself. It's important to learn quickly, so you can concentrate on the essential aesthetic elements and the message to be communicated. Nature photography is simultaneously a chronicle of wonder and a radical act to preserve the world's beauties. For this reason, our book devotes a lot of space to descriptions of the world's ecosystems and to the practical problems you'll encounter there. The nature photographer must be able to work efficiently in the globe's least hospitable places, which are often the most beautiful and wild.

Don't worry; we haven't left out practical advice relevant to our own part of the world. A complete description of techniques relating to stalking and blinds, how to find even the wariest species, tips to keep you from getting lost, and a wide variety of photographic techniques are explained in detail. What's more, we let you in on all the tricks of the trade you'll need to find fascinating wildlife in the suburbs or even in the centers of big cities.

Our task wouldn't be complete without the information you'll need to practice the craft presented in *Nature Photography*. The chapter on processing and distributing images will answer your questions about the life of the professional photographer. It provides a starting point for presenting your work, which will contribute to the appreciation and protection of nature, the only worthwhile motivations for wildlife photography.

Whiskered Terns
(*Chlidonias hybridus*) mating
300mm lens
1/200 sec. at f/4 - AF.

A BRIEF HISTORY OF WILDLIFE IMAGERY

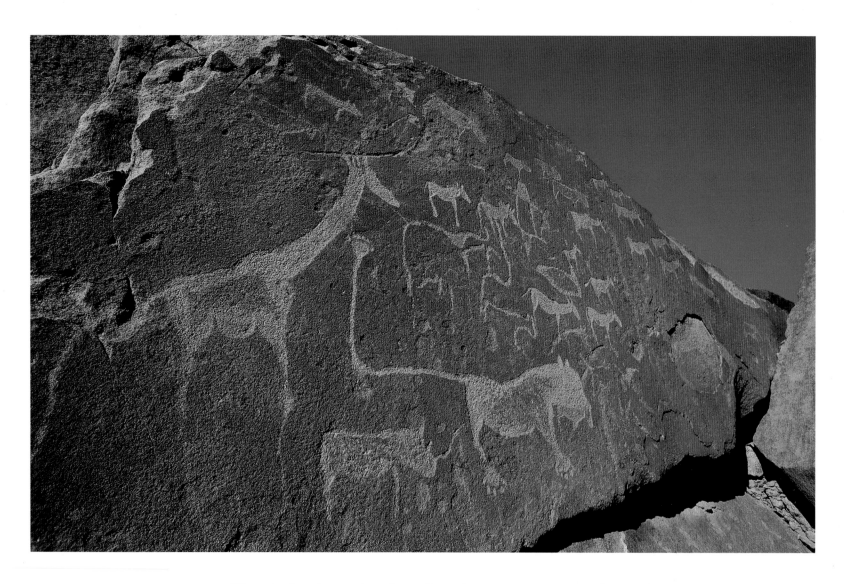

These giraffe, elephant, rhinoceros, and lion engravings in red sandstone are six thousand years old. In all countries where humans hunted in prehistoric times, drawings reveal man's need to appropriate animal imagery.

Petroglyphs from Twyfelfontein (Namibia).

When the first shaman drew the outlines of a bison or horse on a cave's rock wall thirty-five thousand years ago, he probably did so in order to lay claim to the image and give the clan's hunters a better chance for success. This idea may be completely unfounded in reality, but it is undeniable that there has always been an instinct of possession behind human representations of animals. Whether they were magical figures or just decoration, people have always surrounded themselves with depictions of animals, whether sculpted, drawn, or carved into rock walls, in order to evoke their positive qualities. Hunting is also a way of projecting the animal's qualities

onto ourselves, to demonstrate our superiority, as the hunter's preoccupation with trophies proves. This behavior may be seen wherever a tribe clothes itself in the skin, claws, and teeth of their victims. The earliest photographs of animals had difficulties overcoming this primitive hunter's mind-set and were limited to simple representations. The first artists who were enthusiastic wildlife photographers contributed elements borrowed from painters such as sensitivity to the quality of light, the aesthetics of composition, and graphic design.

In the earliest days of photography, cameras were enormous, lenses were slow, and film emul-

sions were appallingly insensitive. Poses had to be held for several minutes, or even several hours, to obtain a good image. The first photographers, eager to immortalize the world, were drawn toward the animal world, but long exposures led to composed "trophy shots" rather than photographs of animals living in their natural habitats.

Things began to evolve around the beginning of the twentieth century, especially with the marked improvement of film, and the subsequent decrease in shutter speeds to as little as a thousandth of a second. The English, who had long been avid birdwatchers, were the first to photograph them. Americans quickly followed suit, especially explorers of the National Geographic Society, who produced many spectacular photographs to illustrate the pages of the Society's monthly publication, which has now become the standard for nature magazines throughout the world.

Up until the sixties, photo safaris—as they were then called—were only within the reach of specialists who could afford telephoto lenses.

Photographs were black and white, and the results limited by the poor definition of the lenses then available, often two- or three-element achromatics that looked like bazookas. Only Leica produced lenses like the costly Telyt, whose performance was excellent in the center of the field but not very good at the edges.

Fortunately, the Japanese began to produce high-quality telephoto lenses in the seventies such as the Konica 300mm ED, the Nikon 300 and 400mm, quickly followed by Canon, Pentax, Minolta, Olympus, and other brands that have since disappeared. Once stigmatized by the little "donuts" of catadioptric telephoto lenses (which were miniature telescopes), the amateur nature photographer today is on an even footing with the professional, thanks to many lenses with intermediate apertures and special optical glass. Today's amateur wildlife photography equipment is more than adequate for publication in magazines or supplying a photographic library. The beginner with professional aspirations has only to master the medium and gain experience in the field.

This terrestrial bird was painted on the rocks of Quinkan 14,000 years ago. God or totem animal, this depiction probably had a magical function.

Cape York Peninsula (Australia).

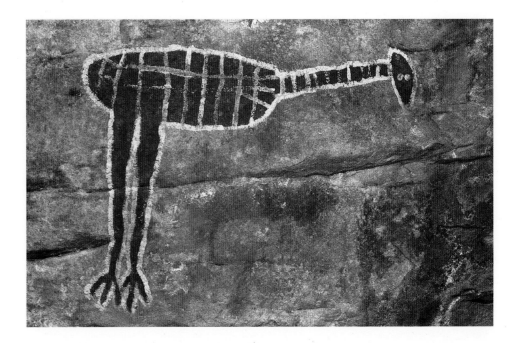

THE WILDLIFE PHOTOGRAPHER'S PROFESSIONAL CODE OF ETHICS

The practice of wildlife photography entails respecting definite rules to protect species and ecosystems. Outrages against nature—the work of overzealous or careless wildlife photographers —are common. Film boxes and wrappers are strewn over the landscape, vegetation that shielded the young from predators is cut down, adult birds are disturbed and abandon their clutch, fragile vegetation is trampled, dens disturbed, and wild animals chased with vehicles. A photograph that involves harming an animal or a plant should never be taken. Such an act undermines our reasons for taking photographs. We all have occasional lapses of attention, but the real nature photographer always catches himself in time to keep from harming what he loves best.

The extreme behavior of some photographers (destroying sites to ensure exclusivity, capturing protected species) has made nature photographers unwelcome in the eyes of wildlife associations in some places. For this reason, you shouldn't be surprised if you feel unwelcome; it takes years for memories to fade. Don't expect such associations to find subjects for you. The photographer who doesn't have anything to shoot shouldn't just head off into the bush. On the other hand, helping out by providing photographs of your observations is the best way to enhance the image of our profession.

Those of us who have the good fortune of understanding how natural ecosystems work— even in the most rudimentary fashion—are fully responsible for our actions. We must set a good example for the general public by communicating our love and respect for wildlife whenever we have the chance. A simple photography exhibition in a small townhall may increase people's awareness of how fragile nature is. After seeing the fox cub's innocent look and the heron's elegance, a child may be more sensitive to his environment. He or she will have assimilated the fundamental message that we are part of nature and owe it to ourselves to appreciate its true worth.

Gilles Martin in one of his floating blinds on a pond in the Brenne Regional Nature Park in France: "Nature photography is an activity that brings a great deal of pleasure. But respect for the animal and its habitat is essential, if only to perpetuate and protect the marvelous sites where we love to share our passionate pursuit of nature photography." Photograph: Eric Male-Malherbe.

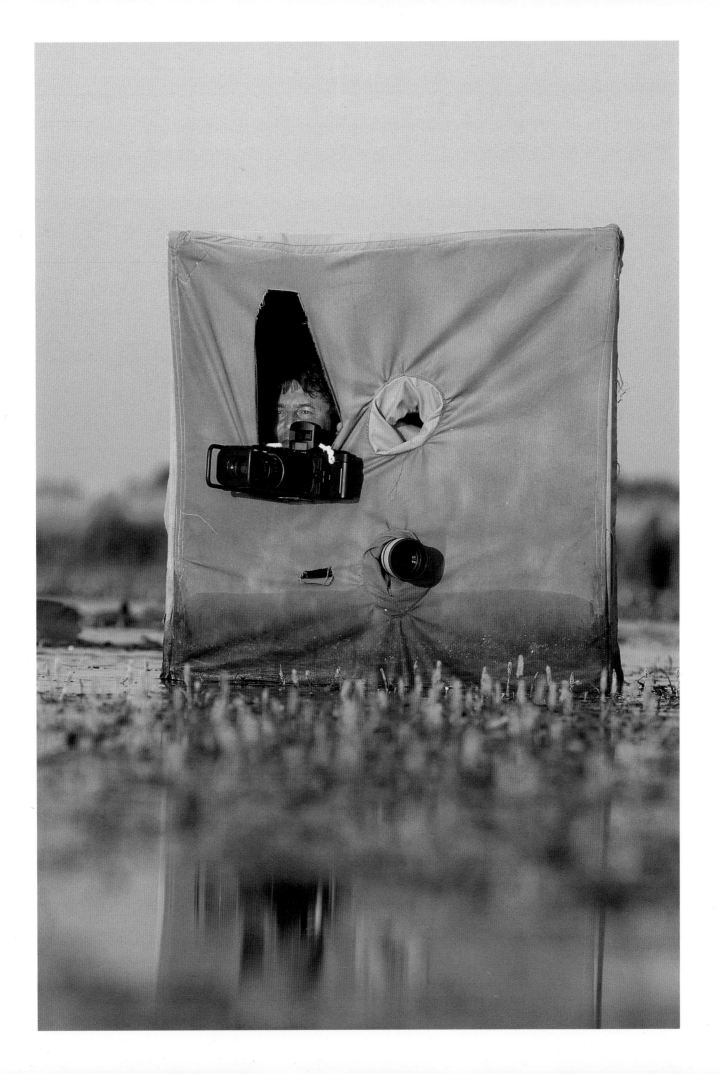

Every amateur photographer dreams of buying a great camera. Memorizing specification sheets, devouring articles in camera magazines, and trying out your friends' equipment will give you a good idea of what you're looking for, but the camera intended for wildlife photography must also meet your personal needs. Does it feel comfortable in your hands? Are its controls easily accessible? How heavy will it feel after a three-hour hike? Are the lenses you need available? The answers to all these questions depend on your habits and your personal preferences. Think about your needs carefully before selecting a brand.

A reflex camera intended for nature photography must have the following features:

○ Satisfactory resistance to moisture and shocks

○ Viewfinder covering between 95 and 100 percent of the image taken

○ Autofocus system with multiple independently selectable sensors

○ Multi-segment and spot metering

○ Exposure compensation

○ Bracketing

○ Shutter with high-speed flash synchronization (1/250 sec.) or FP synchronization

○ TTL flash metering with remote control

○ Silent motor drive or winder

○ "Aperture priority," "shutter priority," and "manual" modes

○ A wide range of long lenses available

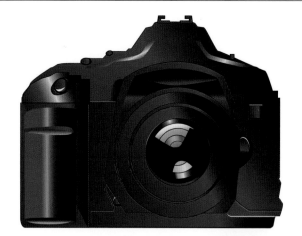

The Camera Body

A good camera should have automatic focus and exposure control, and the ability to switch to manual whenever you want. Autofocus is a real advantage, especially in the field, where the perfect shot may only be there for a fraction of a second. You need a lot of experience to be able to track a running animal with manual focus! When the subject is moving quickly over open ground, a wide-area sensor will make it easier for the autofocus system to keep up. In undergrowth, the opposite is true. Focusing through vegetation calls for a very selective sensor, or the foliage will be sharp and the subject blurred. Therefore, the ability to switch quickly from the wide autofocus range to spot analysis is indispensable.

There are analogous contradictory requirements for light reading. Most photographs are perfectly exposed, thanks to the SLR's multi-segment metering. The metering system divides the image into different areas and compares their light pattern with examples stored in the microprocessor's memory (up to 30,000, depending on the model). However, subjects with an unusual amount of contrast, like human figures against a snowy background, or photographs taken under hazy skies can sometimes fool the system. In cases like these, you should turn off the multi-segment metering and control the camera yourself. You can decide upon spot or selective metering, exposure compensation, taking additional over- and underexposed shots (bracketing), switching to manual mode, etc. Modern SLRs give the photographer many different ways to control exposure.

At the heart of the camera is the focal plane shutter. It usually consists of two leaf curtains (made of plastic, metal, or carbon fiber), one of which uncovers the film to be exposed, and the other covers it again. Varying the length of time

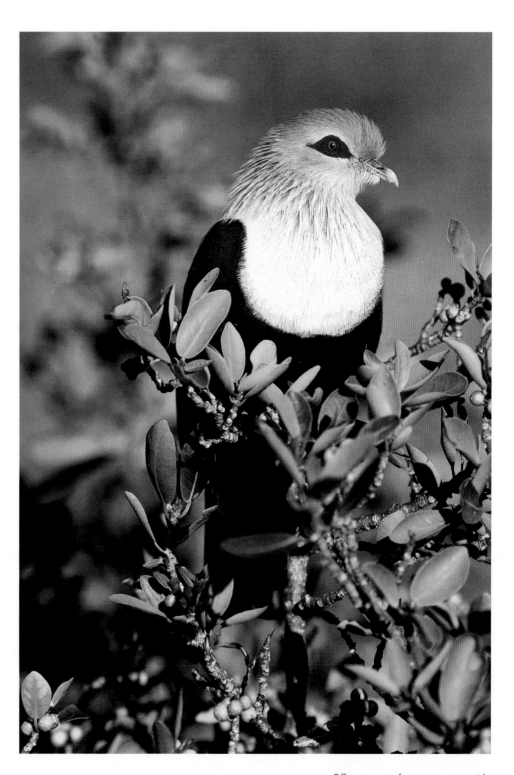

Off-center autofocus sensors provide more interesting framing possibilities than those of the first autofocus SLRs.

Comoro Blue Pigeon
(*Alectroenas sganzini minor*)
200mm lens
1/250 sec. at f/2.8 - AF.

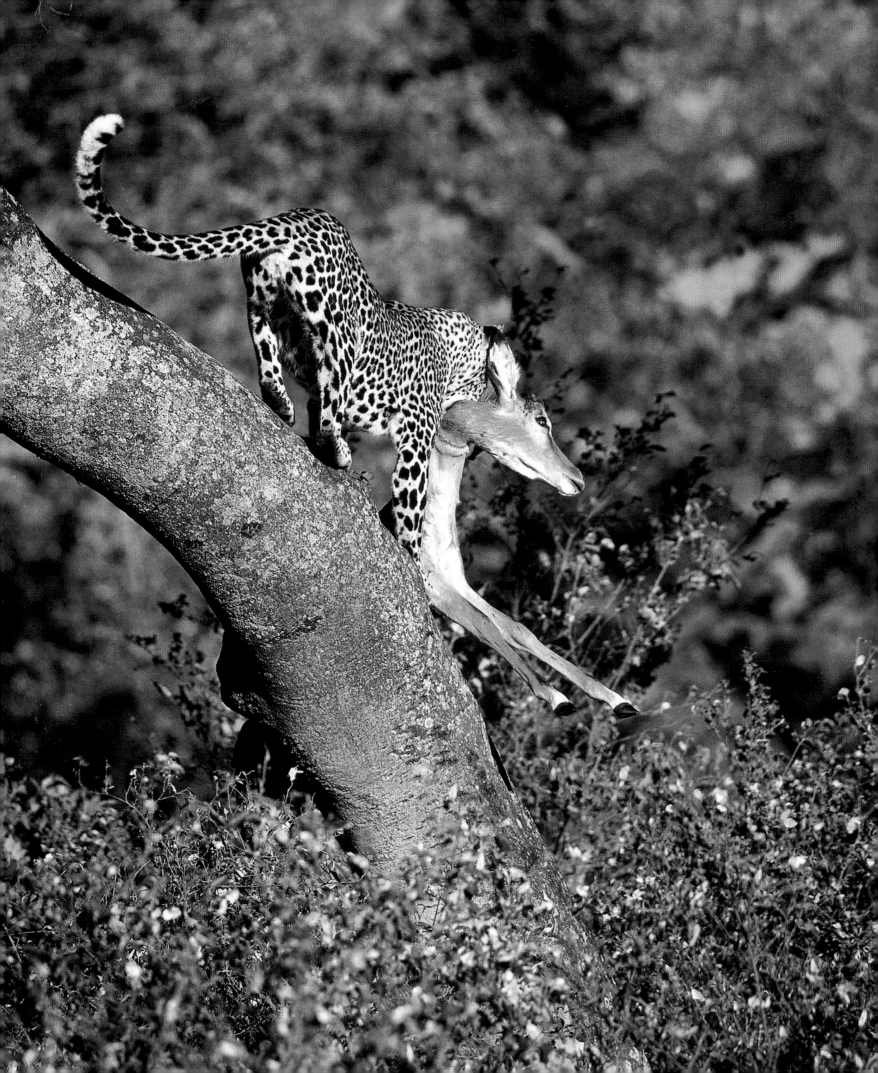

between opening the first shutter and closing the second gives a wide variety of exposures. With shorter exposures the second leaf begins to move before the first has completely uncovered the frame. The film is exposed by a travelling window of varying width. The time when the exposure window is completely open allows the electronic flash to be used. The whole frame is exposed simultaneously by the flash. The shorter the maximum synchronization speed of the flash, the easier it is to use the flash in daylight, e.g., to photograph a strongly backlit animal.

A built-in motor advances the film and cocks the shutter between each exposure. Two speeds are available in consumer-grade cameras: single frame and burst mode, depending on the model. Top-quality SLRs will take up to ten images every second. While such high-speed photography is rarely necessary (a 36-exposure roll will last only 3.6 seconds), the rapid advance of the motor between each shot guarantees an extremely fast reaction time.

Wildlife photography puts photographic equipment to the test; moisture, shocks, and scratched lenses are the main risks. This is why amateur wildlife photographers prefer professional or semiprofessional SLRs, which are better pro-tected against accidents. Still, you can protect a mid-range camera with tape and a plastic bag, especially for quick shots in inhospitable places (salt spray at the seaside, mountain downpours, etc.). It's imperative to clean your equipment carefully after every session in the field.

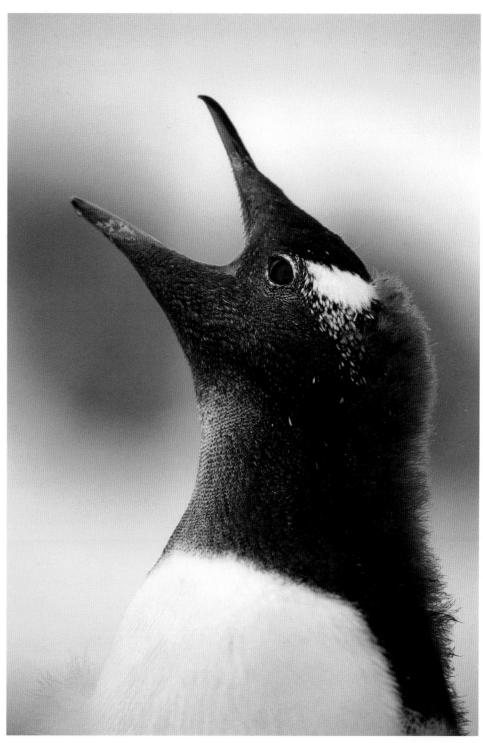

OPPOSITE

A camera that responds quickly allows you to capture extremely fleeting scenes, like the passage of this leopard, which is about to hide its prey in the high branches.

Leopard (*Panthera pardus*)
100–400mm zoom lens
1/60 sec. at f/5.6 - AF.

ABOVE

This young Gentoo Penguin is beginning to wear his adult plumage. It will soon be independent, and free to live its life in the Arctic peninsula.

Gentoo Penguin (*Pygoscelis papua*)
100–400mm zoom lens
1/160 sec. at f/5.6 - AF.

Lenses

There are five criteria when selecting a lens: mounting system, focal length, speed, quality, and price. From the inexpensive 80–200mm zoom f/4.5–5.6 to the pricey 600mm f/4, there's a plethora of choices in every quality and price range. Good lenses are still rather expensive, since the optical glass and rare-earth oxides used in their manufacture are costly and difficult to work with. Nevertheless, it's easy to find long lenses at moderate prices, as long as you're satisfied with limited aperture and performance that is not quite so spectacular. What's more, the used market abounds with telephoto and zoom lenses appropriate for nature photography.

Of course, every brand of camera has its own mounting system: you can't mount a Canon lens on a Minolta body, or vice versa. Especially since the electrical contacts that communicate between camera and lens are today real information highways that require great precision. Even independent lens manufacturers sometimes have compatibility problems between cameras by the leading makers and their lenses, even though they've been developed according to the technical specifications of the camera's designer.

A general-purpose lens lets the beginner gain experience and identify his or her future needs. The zoom telephoto lenses (80–200mm or 75–300mm) that come with inexpensive kits will

This fish-eye lens gives a distorted view, 180° wide. Its particular rendering gives a new perspective to nature photography, especially when the subjects fly fairly close to the photographer, as here on Cosmoledo Atoll (Indian Ocean).

Sooty Tern (*Sterna fuscata*)
16mm fish-eye lens
1/60 sec. at f/22 - MF.

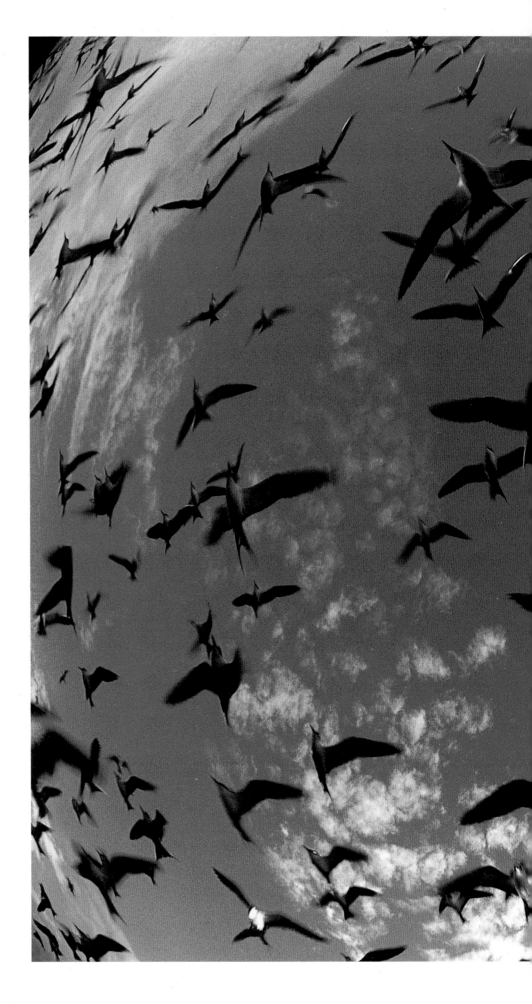

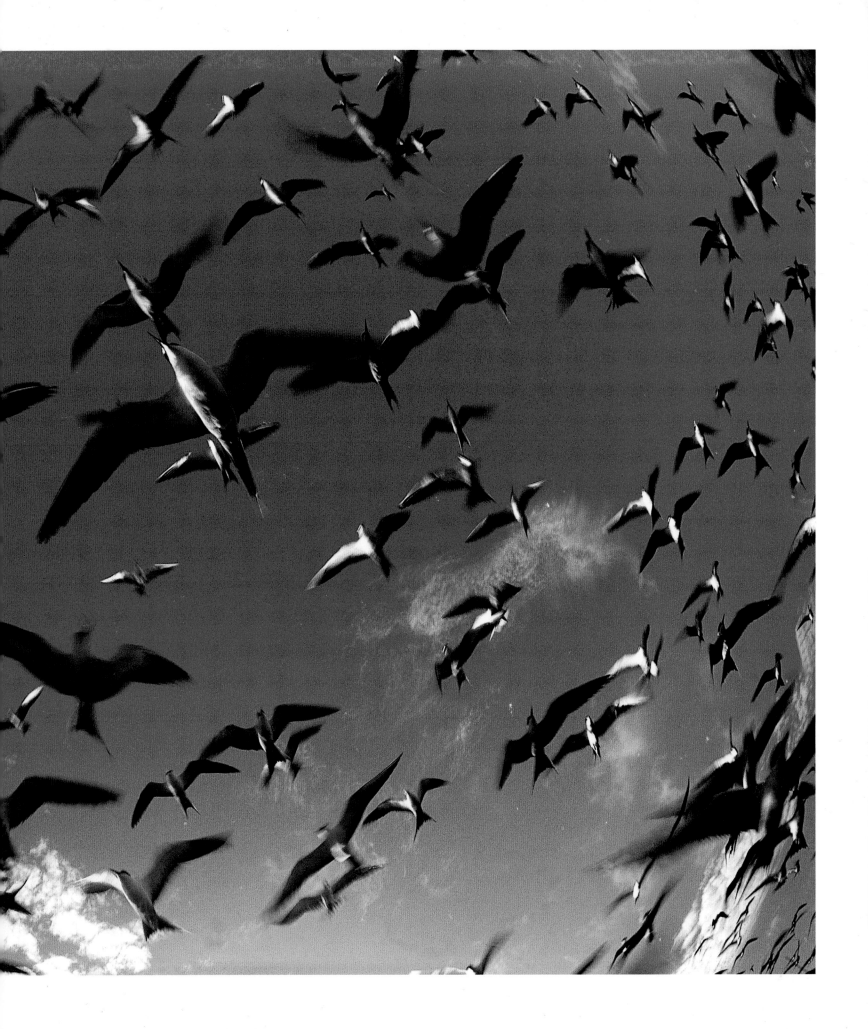

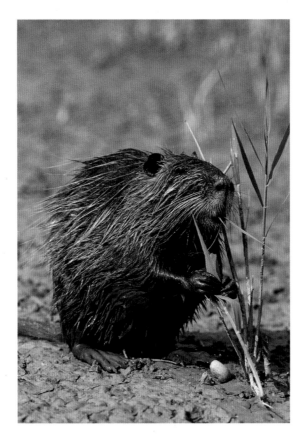

let you photograph animals that aren't too wary. The zoom's variable focal length makes it easy to frame subjects from the blind, but the moderate aperture of these lenses limits their use in low light. Fortunately, sensitive film helps compensate for modest lens speed, especially color negative film that has excellent emulsion quality.

For more demanding photographers, wide-aperture zoom telephoto lenses (70–200mm f/2.8 or 80–200mm f/2.8) combine the flexibility of variable focal length with the speed (i.e., light-gathering ability) of wide apertures and professional optical quality. Their high cost is proportional to the benefits they provide. These lenses may be fitted with a teleconverter, which is mounted between lens and camera body to increase the basic focal length. With a 1.4x teleconverter a 70–200mm f/2.8 becomes a 98–280mm f/4, or a 140–400mm f/5.6 with a 2x doubler. As you will have noticed, the 1.4x multiplier absorbs one f-stop, and the doubler two stops. Teleconverters are certainly practical, but the loss of aperture and optical quality makes them useful only occa-

sionally. Those who use very long focal lengths regularly are well advised to acquire better-quality zooms and large telephoto lenses.

A few years ago it was unusual for a beginner to use a 400mm lens since movement blur was guaranteed below 1/500 sec. With image-stabilized lens technology, very long focal lengths can be used by everyone. The mechanism instantly compensates for the photographer's movements. Hence the success of image-stabilized 100–400mm and 80–400mm zooms, which are incomparably versatile lenses. What's more, these lenses also offer new possibilities to experts, who can use a very wide aperture without risk of camera shake at the slowest shutter speeds. Control of depth of field becomes child's play. Fixed-focus lenses also benefit from image stabilization, especially those made by Canon, whose professional lenses almost always include this feature. Among the other brands, only Nikon has now mastered this technique enough to extend it to some of its lenses. Long lenses without image stabilization should not be ignored. On a tripod or monopod, the meticulous photographer can take pictures at relatively low shutter speeds without worrying about camera shake. Wide apertures are an advantage with fixed focal length lenses (300mm or 400mm). The wider the aperture, the faster the shutter speeds that can be used. The used market, particularly rich in traditional large telephoto lenses, is ideal for amateurs who want fast lenses without spending a fortune. Be careful because telephoto or zoom lenses without image stabilization require a shutter speed at least equivalent to their focal length, i.e., 1/500 sec. for the 500mm, 1/250 sec. for the 300mm. A slower shutter speed considerably increases the risk of image blur with handheld cameras.

What Are Lenses, Focal Lengths, Apertures, and Diaphragms?

A lens is an optical system designed to focus the rays reflected by the subject onto the light-sensitive photographic emulsion. It may be formed of a single lens (in inexpensive cameras) or an optical group of several lenses, which optimizes image transmission. The focal length is the distance between the optical center of the lens (which is very often not the physical center of the lens) and the focal point (film plane), where the light passing through the lens converges.

The focal length, indicated in millimeters (mm) is related to the magnifying power of the lens. The focal length closest to the human field of vision is 43mm (the diagonal of the standard 35mm image, which measures 24 x 36mm), but manufacturers established the 50mm lens as the standard in order to avoid an excessively complicated formula. With the standard at 50mm, the 100mm lens enlarges the image two times, the 200mm four times, and so on. A lens with a focal length of less than 43mm is called a wide-angle, and, below 24mm, a super wide-angle. Above 60mm is a telephoto and a super telephoto is over 300mm.

The speed of a lens depends on its focal length and approximately on the diameter of its front lens. Thus a 300mm focal length lens whose front lens is 75mm in diameter has a maximum aperture of f/4 (focal length divided by 4). The same aperture for a 600mm lens requires the manufacturer to use a front lens of 150mm. This explains the high price of fast telephoto lenses, especially since the makers use very expensive special glass to increase performance.

Since lenses are not always used at full aperture, they're furnished with a mechanical system called the diaphragm to reduce the amount of light they transmit. This system is based on the iris, controlled by a rotating ring, which may be external (manual), internal (electro-mechanically operated), or external (mixed operating mode). Among other things, it enables you to vary the aperture of the lens based on available light. To indicate the aperture in the same way from one focal length to another, they are standardized according to a geometrical progression based on the $\sqrt{2}$ (1.414): 1 - 1.4 - 2.8 - 4 - 5.6 - 8 - 11 - 16 - 22 - 32 - 45 - 64 - 90 - 128. These rounded values correspond to the relationship between the focal length and aperture diameter. The area of the aperture doubles with each stop. For additional control over exposure, the apertures of photographic lenses may be set to a half- or third-stop depending on the camera make.

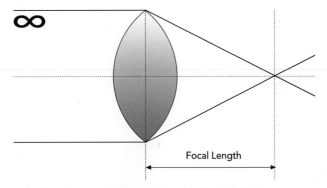

The focal length is the distance between the optical center of the lens and the focal point (film plane), where the light passing through the lens converges.

Accessories to Minimize Camera Shake

A monopod lets you hold the camera steady and is less cumbersome than a real tripod. It is possible to shoot one or two shutter speeds slower than you can using a hand-held camera without the image blurring due to camera shake. For additional stability, use the monopod handle with telephoto lenses ≤ 400mm, and hold the front of longer lenses. Photographs: Houria Arhab.

When you don't have an image-stabilized lens—or when your shutter speed is below the capabilities of the stabilizer (1/15 to 1/30 sec.)—you have to support the camera and lens on a stable surface to avoid troublesome vibrations. The ideal is to use a sack of heavy canvas filled with rice or plastic beads as a support. This trick, effective and very practical in the field, also works for taking shots from a vehicle on a photo safari. To avoid carrying five or six pounds of rice along on an

airplane, just bring the cloth bag and buy the rice when you reach your destination. Finding a support when you are hiking is sometimes difficult. The simplest solution is to carry a monopod with you. This is a rigid telescoping tube, equipped with a standard mount, which is screwed to the tripod mount on your lens. The monopod's height is adjustable and it gives you a stand you can use almost everywhere and makes it easier to carry large telephoto lenses on

your shoulder. With a little practice, the mono-pod allows you to shoot two shutter speeds slower than you can with a handheld camera (e.g., 1/125 sec. with a 500mm).

When you're in a blind, the last word in stability is a tripod. Choose a high-end model, where the high stability-to-weight ratio makes it easy to carry on hikes. It should also be adapted to the lens you use most often. A 500mm f/4 weighing eight or nine pounds is harder to

steady than a 200mm f/2.8, which weighs just over a pound. The tripod-mounted lens should be very stable, both in a low position and with the legs extended. An extra support, attaching the camera body to one of the tripod legs, is a very good idea if you use a large telephoto lens. It minimizes the oscillation of lenses with long focal lengths. The whole assembly (tripod, extra support, camera body, and lens) is cumbersome, but very useful in a blind.

Mounting the camera on a tripod eliminates camera shake.

Hoopoe (*Upupa epops*)
400mm lens
1/125 sec. at f/4 - MF.

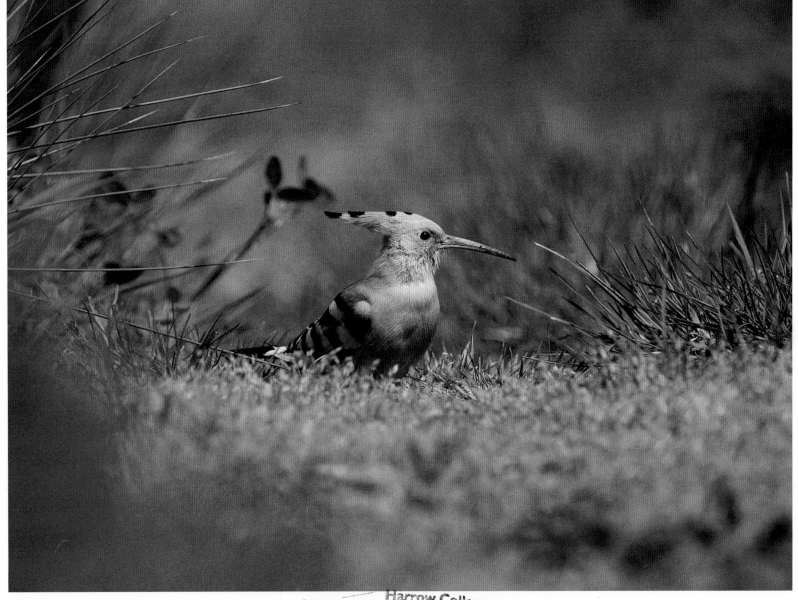

The Flash Unit

Like lenses, modern flashes are made for brand-name and generic cameras. When buying a flash unit, the beginner has two options. Either buy the flash designed for your camera, or investigate compatible products made by independent manufacturers. Be careful with the independents. The compatibility of their flashes with some brands—not necessarily the least expensive—are sometimes chancy and frequently incomplete. For this reason, it is essential before you buy to read the specifications, as well as reviews in camera magazines, which give honest information about the real performance and potential deficiencies of the products they review. The information furnished by the tests they conduct is particularly useful, since manufacturers have a tendency to overestimate the capacity of their flashes enormously (power, speed, color temperature, light quality, etc.). For example, flash speeds given in the specifications as 1/30,000 sec. hardly ever exceed 1/15,000 sec. under the best circumstances, which isn't fast enough to freeze rapid movements (hummingbird wings, striking snake).

On the other hand, controls on modern flashes are remarkably precise. Whether we want to use the flash to balance daylight exposure (fill-in flash), or control several flashes automatically without any connection between them, flashes by the top manufacturers are unbeatable. The constantly evolving technology offers totally new possibilities such as information exchanges between flashes by coded pulses of light, intelligent remote controls, TTL (through-the-lens) metering, multi-segment exposure control, and high-speed synchro flash (FP synchronization) up to 1/8,000 second. It's too bad that despite all this progress, the reflectors on more compact flip-up flash units have lost a great deal in light

Light from the flash will be reflected by water and moisture. Pay careful attention when placing the flash.

Common Toad (*Bufo bufo*)
50mm macro lens
1/60 sec. at f/8 - MF.
2 electronic flashes.

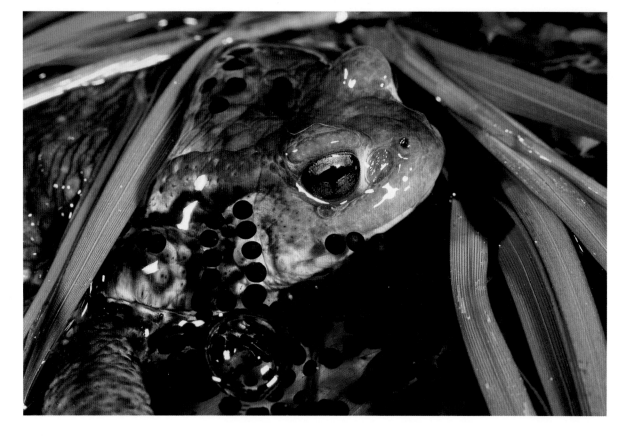

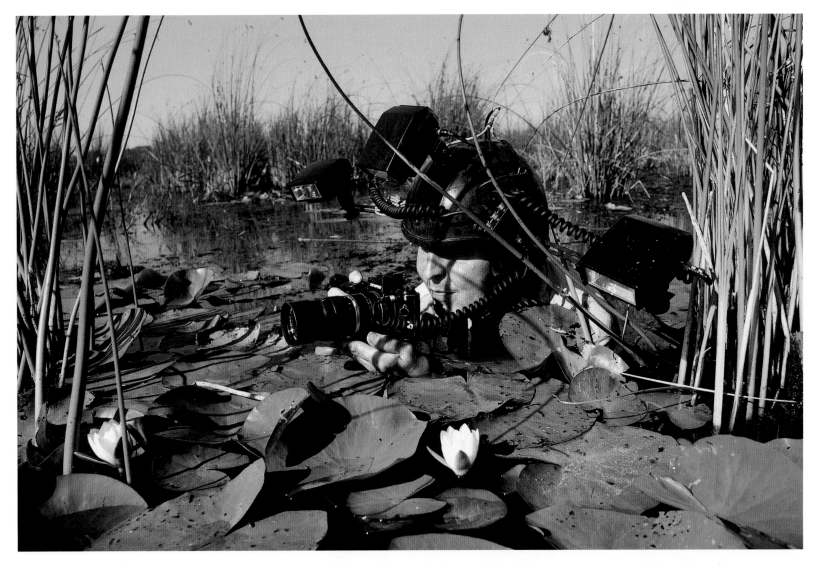

quality, especially in flash coverage. Getting even light that is not blue-tinged requires additional accessories (diffuser, reflector, warm filters). Of course, these all absorb light, which is a good reason to pick the most powerful flash you can find. In a flash with a high number guide, which is a rough indication of the power of the flash, batteries are put to the test. It's a good idea to stock up before every photographic session. If you use a lot of batteries think about buying a high-end recharger to keep expenses down. Modern batteries (NiMH, for example) have the additional advantage of a very short recycle time between

flashes. They're also less sensitive to low temperatures than alkaline batteries. For overseas travel, it's imperative to get a charger and plug that will work in the country of destination since voltage, alternating-current frequency, and plug size and shape vary quite a bit from one country to another.

If you don't have an adapter, regular AA batteries are easy to find in most large cities, but these are frequently non-alkaline batteries with very low power, especially in underdeveloped countries.

When your hands are busy with the camera and you're up to your neck in water, the only solution is to mount the flash on your head. This "special wetlands" helmet has two lateral flashes, which illuminate the subject, and a central flash to eliminate background shadows. Photograph: Houria Arhab.

Protecting Your Equipment

Protecting your equipment is essential in nature photography. Dust, sand, hard knocks, scratches, moisture, and accidental immersion can quickly make camera and lenses useless. Top-of-the-line cameras are meticulously manufactured and have dust-proof seals, which are also likely to keep out a few drops of rain.

Fortunately, there are some very practical tricks for protecting your consumer-grade equipment. The most common is to reinforce fragile areas with good adhesive tape, which will prevent harmful leaks without leaving traces of adhesive. Cloth-backed tape will help protect against wear and tear better than plastic tape. Cameras, lenses, the monopod's topmost section, and tripod legs covered with tape are also more pleasant to handle when it's cold. In very wet areas, always keep a plastic bag with you. It provides excellent protection against rain and salt spray. A higher-tech solution is the completely watertight bag, which, if less handy, gives complete protection in case of immersion.

In arid regions, dust is the enemy. A good zippered camera bag provides fundamental protection when you're not working. While you're shooting, a kaffiyeh such as those worn by desert nomads will prove very practical; you can wrap it around lens and camera, especially when you drive on dirt roads in an open vehicle. It's good for a quick dusting of your equipment, will protect the photographer against the sun, and, of course, makes a good scarf when it gets chilly.

The most fragile and expensive part of photographic equipment is the lens's front element. To protect it, mount a UV filter on the lens. Don't confuse this with a skylight filter, which salespeople are often eager to sell. The salmon-pink color of these filters tints photographs irreparably. To avoid any mistake when buying a filter, put the filters the salesperson shows you on a piece of white paper. The prevailing color will be immediately apparent.

The photo backpack is the best way to carry your equipment in the field. It also provides better protection against damage. This one is a compact container for all the equipment necessary for most styles of nature photography:
- 2 SLR 35mm bodies
- 20mm f/2.8
- 28–105mm f/3.5–4.5
- 100mm f/2.8 macro
- 100–400mm f/4.5–5.6 L IS
- Set of extension tubes
- 1.4x focal length multiplier
- Flash
- Binoculars
- Headlamp.

Filters and Their Functions

There are two kinds of filters: utilitarian and creative. The following are the most common utilitarian filters:

○ UV Filters: UV filters only serve to protect the front element of the lens, since glass lenses absorb UV on their own.

○ Neutral Density Filters: These filters are useful if you want long exposures in daylight. The neutral density filter is usually used to add an attractive sense of movement to pictures of water (waterfall, river, beach). The original exposure is multiplied by 2, 4, or 8, depending on the filter's density. A variation is the graduated neutral-density filter, which is used to achieve a balanced exposure when the sky is very bright and the ground dark.

○ Polarizing Filters: Indispensable and irreplaceable! They eliminate nonmetallic reflections, enhance contrast between blue sky and clouds, and also serve as a 4x neutral density filter. For cameras with a semitransparent mirror (all modern SLRs), only circular polarizing filters are useful, since the linear type will render some exposure meters inoperable.

○ Conversion Filters: A color-correcting filter (yellowish brown or bluish) provides balance when light and film are used in an unconventional way. The blue (80 A) lets you shoot daylight film by artificial lighting, the brown (85 B) makes tungsten-balanced film work in daylight. Widely used in the movie industry, these filters don't concern nature photographers very much.

Creative filters act directly on the way the image is rendered. They color, hide, distort, or diffuse light to produce special effects. In the field, tinted filters are useful in overcast weather; blue, orange, and mauve are among the most widely used.

As long as the filters are used discreetly, the addition of color doesn't change the natural look of a photograph too much. Other models designed for special effects don't add much to images: a good photograph should be able to stand on its own.

Mirror effects, iridescence, and fog rarely give the expected results. Only the highest quality soft filters (e.g., Zeiss) can add to the artistry of flower photography.

ABOVE LEFT

The polarizing filter reduces reflections on nonmetallic surfaces. It also emphasizes the blue of the sky and increases contrast with clouds when the angle is favorable.

ABOVE RIGHT

Without the polarizing filter, irritating reflections make it hard to see details and the sky lacks density.

Binoculars for Spotting and Identification

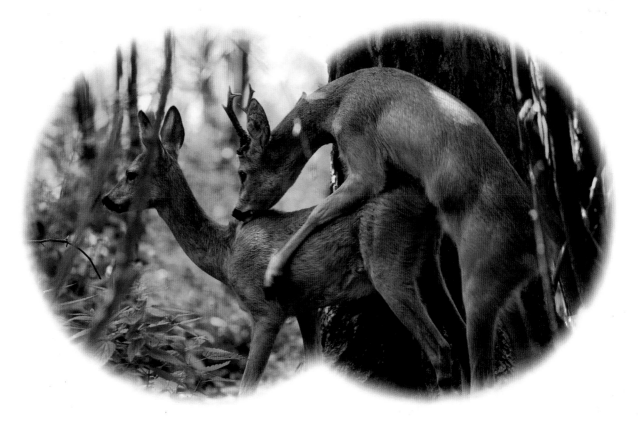

The nature photographer should always have a pair of binoculars in his or her camera bag. Otherwise, how will you see the flock of bighorn sheep hidden in the shadows, or identify an Arctic tern diving one hundred yards or meters away?

You don't need to go all out and buy a powerful pair of night glasses. An 8 x 32 pair (8x magnification and 32mm diameter) will be quite adequate for spotting. Moreover, the photographer who halts while stalking an animal will experience the effects of an accelerated heartbeat and heavy breathing. At such times, binoculars with 8x magnification are easier to hold without shaking.

Birdwatchers usually like higher magnifications, around 10 x 42. This ratio lets subjects be observed with enough magnification to help with identification, even in low light levels, thanks to the ample lens diameter (4.2mm exit pupil). For higher magnifications, you'll have to rest the binoculars on a support to control shake. For this reason, many models are fitted with a tripod mount. Canon equips its high-magnification binoculars with an image-stabilization system: IS models have this feature, which makes them incomparably easier to use.

The most powerful are also designed with UD optical glass, with extremely low dispersion that is essential for perfectly-defined images. These two added advantages make them irreplaceable tools for naturalists. Their only defect is that the image stabilization won't work without batteries, so be sure to stock up before leaving on your trip.

To calculate the light-gathering ability of binoculars, divide their diameter by their magnification: 32/8 gives a 4mm exit pupil for 8 x 32 binoculars. Those who like photography at dusk and dawn, on the other hand, should buy binoculars with more light-gathering ability (they are, of course, heavier), like 8 x 40 (5mm exit pupil), or even 8 x 56 (7mm exit pupil), whose light-gathering ability is appropriate for observing mammals at night. You should be aware that binoculars equipped with zoom lenses are of appalling quality.

Spotting Scopes: High-End Optics

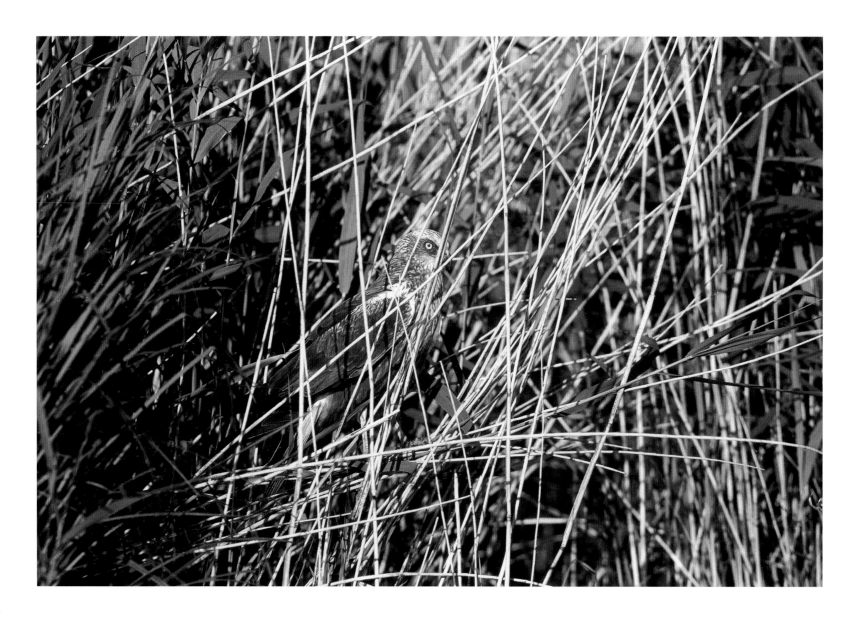

When an animal is this well hidden in the vegetation, only systematic observation of the terrain will find it.

Marsh Harrier (*Circus aeruginosus*)
300mm lens
1/200 sec. at f/5.6 - MF.

Spotting scopes have longer focal lengths than binoculars. Thanks to their interchangeable objectives, it's easy to change their magnification, including those with high-end zoom eyepieces. Quality is particularly important for spotting scopes and their eyepieces. Due to their long focal lengths and high magnification, sharpness will not be satisfactory if the scope does not have at least achromatic optics.

The best instruments are fitted with fluorite lenses and/or extremely low-dispersion glass, which has earned the label "apochromatic." This means that white light, which is broken into colors by normal lenses (prism effect) is kept together as a whole. The blurring caused by light's varying wavelengths is avoided (see diagram).

The best compromise between scope diameter and magnification depends on the quality of the instrument. With a diameter of 60 mm, a fixed-eyepiece with a magnification between 20x and 30x is reasonable. With larger diameters (from 70 to 80mm), try a high-quality zoom objective

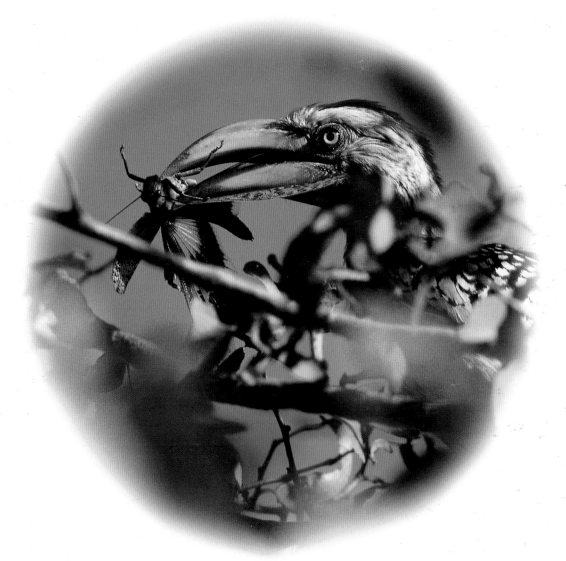

(20–80x) or the highest-quality fixed eyepiece.
In any case, the spotting scope is mounted on a
tripod so the image can be seen clearly.

Some of the top manufacturers sell acces-
sories that can turn spotting scopes into long
lenses. While the optical quality of these instru-
ments makes them attractive at first glance, these
accessories never give satisfactory results. A
400mm telephoto lens and a doubler give much
higher-quality images than even a very high-end
spotting scope.

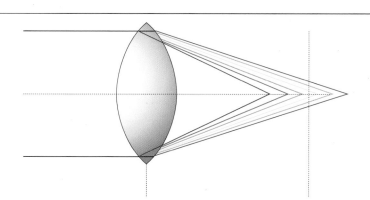

A lens acts like a prism. The white light, which
goes through it, is broken down into the
spectrum: the different wavelengths disperse
the image on either side of the focal point.
Only glass with an ultralow dispersion index
eliminates this breakdown of light rays.

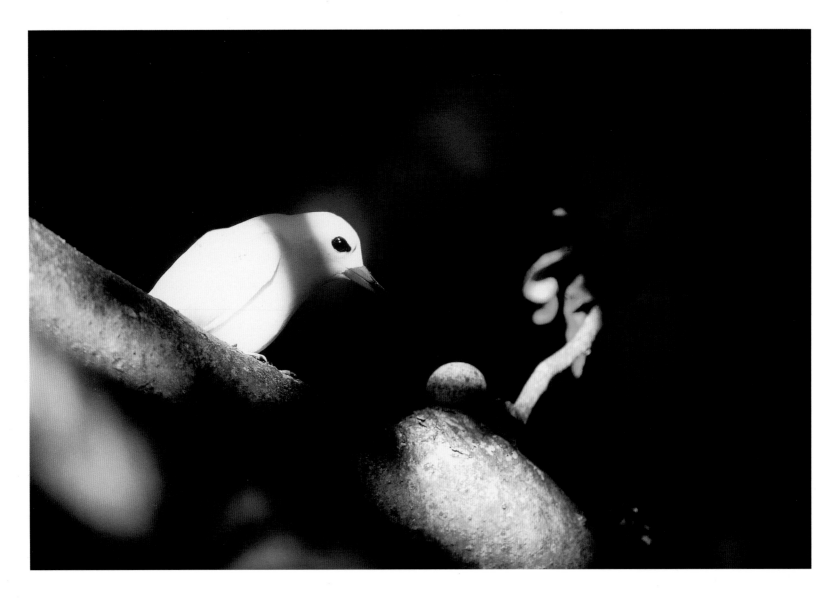

The immaculate white of this bird would have been overexposed without spot metering on the plumage.

Fairy Tern (*Gygis alba*)
400mm lens
1/125 sec. at f/4 - MF.

Light is the key to good photographs. Without the warm light of morning or the deeper reds of late afternoon, your camera will only produce harsh images, without real character. The skillful alchemy of natural light is sometimes unpredictable, but it is a great pleasure when the magical ambience transcends the subject and the photographer captures the image he or she dreams of. Professional photographers are highly aware of this fact, and they are constantly seeking the perfect light when they scout for sites, even if it means going back to the same place several times. This is why their pictures are better than those taken by beginners.

In general, the best summer light is found before ten o'clock in the morning and after five o'clock in the afternoon. But this depends on the sun's angle. In summer, when the rays of the midday sun are vertical, shadows are harsh and the thinner atmospheric layer has a minimal influence on light quality. Avoid this time, since it's unsuitable for photography. In winter, the inclination of the earth on its axis reduces the sun's angle. The light traverses a thicker atmospheric layer and

Light

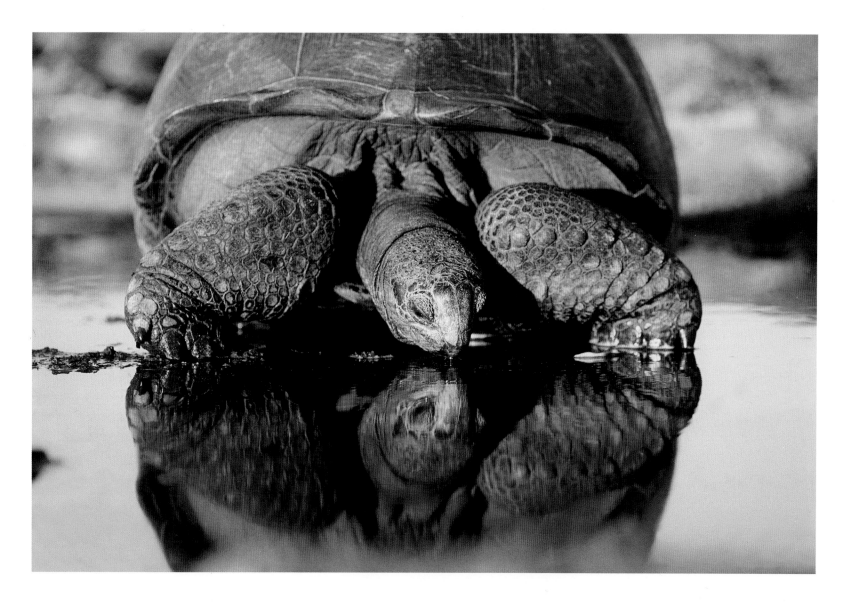

looks warmer. Even at midday, photographs taken in winter sunlight often have an orange tone. The intermediate seasons of spring and autumn bathe nature in a warm and powerful light that has a special charm. These seasons are very favorable for wildlife photography and coincide with a time of great natural activity: mating, migration, birth of the young, and the growth of vegetation.

Good lighting must also be adapted to your subject. Rocky landscapes look best in a warm light, which emphasizes the density of the bright rocks while harsh shadows bring out the stone's coarseness. On the other hand, a partially backlit mammal is much prettier when the whole sky is bright enough to reduce shadow density. It's all a matter of harmony between the subject and the light. Of course, the animal doesn't care about the quality of the light when it comes out of the forest looking for food, but the demanding photographer has a choice between taking a picture or waiting for a more favorable moment. Stalking wild game with your camera is first and foremost a creative act. You also need a certain light level to avoid the camera shake that characterizes photographs taken at low shutter speeds.

The warm low-angled light of evening highlights the coarse skin of this giant tortoise.

Aldabra Giant Tortoise (*Geochelone gigantea*)
300mm lens
1/125 sec. at f/5.6 - AF.

Shutter Speed

The long exposure and slight movement of the animal causes the blurring typical of camera shake.

Wolf (*Canis lupus*)
200mm lens
1/15 sec. at f/5.6 - AF.
Photograph taken at a game farm in Poland.

Shutter speed is the period during which the film is exposed to light when a photograph is taken. In SLR cameras, focal plane shutters with curtain leaves of plastic, metal, or carbon fiber have replaced shutters with rubberized cloth curtains, which are now obsolete. The curtains' movement is vertical; the leading curtain opens a passage for the light, and the second closes it. Depending on the exposure time, the whole surface of the film may be exposed when the shutter opens, or the second curtain may begin to move even before the first is completely open, so that a slit sweeps across the film to expose it. For cameras with the fastest shutter speeds, the maximum exposure, for which the first curtain has totally opened before the second curtain begins to move, is as high as 1/300 sec. This speed is called X-synchronization. It is the maximum shutter speed with which an electronic flash can be synchronized.

All higher shutter speeds are obtained by a moving slit, producing exposures as short as 1/12,000 sec. for the best cameras. With consumer-grade cameras, the X-synchronization speed varies between 1/90 and 1/250 sec., while the fastest slit exposures range between 1/2,000 and 1/8,000 sec.

Ultrashort exposures are used to freeze very rapid movement. An abundant source of light or sensitive film is essential to provide correct exposure in this case. In nature photography, these shutter speeds are valuable when you want to reduce the risk of camera shake as much as possible. The longer the lens's focal lengths, the more you need high shutter speed to prevent a blurred image. It is usually a good idea to set the shutter speed to at least the inverse of the lens's focal lengths: 1/500 sec. for 500mm, 1/250 sec. for 300mm, etc.

Slower shutter speeds are still necessary, however, especially to achieve correct exposure

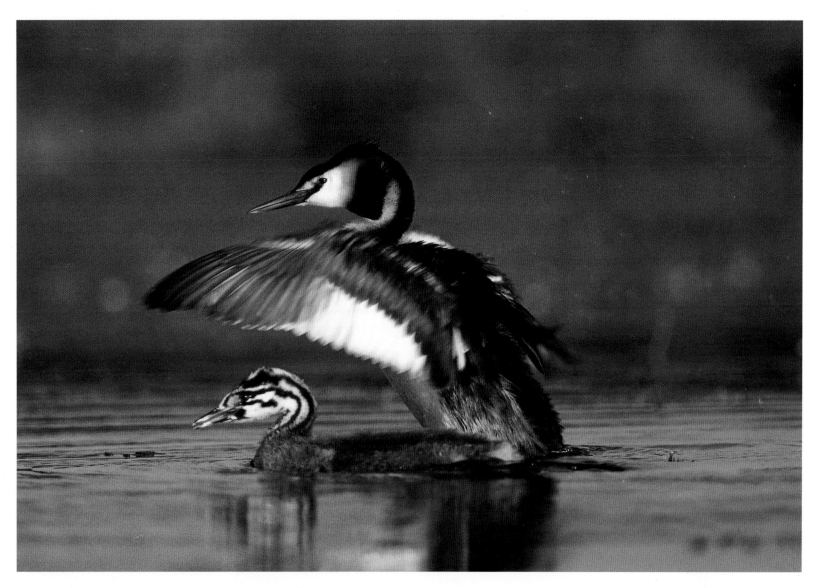

in low light. In these circumstances, it's a good idea to mount the camera and lens on a tripod, monopod, or bag of rice. Otherwise you'll certainly have a blurred image due to camera shake, especially with long lenses. Some telephoto lenses are equipped with a tripod mount, so you don't have to mount a heavy lens from the camera's tripod mount. Aside from making the whole more stable, this lets you increase rigidity with a supplemental brace connecting the camera body and one of the tripod's legs. When you're fighting vibration, two attachments are better than one.

Aperture

Aperture has numerous functions: it regulates the light entering the camera, alters depth of field, affects the optical performance of the lens, and corrects some distortion. The lower the aperture number, the more light enters the camera.

f/2 f/8 f/32

Full aperture lets the first lioness be isolated from the second to give her the leading role in the picture. Since she is also at the key point of the frame, her expression takes on particular importance: you can imagine the prey she's following outside the frame.

Lion (*Panthera leo*)
300mm lens
1/250 sec. at f/4 - AF.

The aperture, like the shutter, precisely controls the amount of light reaching the film. But, unlike the shutter, the aperture is an integral part of the optical system. It also affects the performance of the lens, depth of field, and the look of material outside of the field of focus. This is why it is so important to think about aperture for a moment when we take a photograph. The aperture is often compared with a faucet. The wider it is, the more light it lets through. Wide apertures correspond to the smallest numbers (1.4–2–2.8), and the smallest apertures to the largest numbers (11–16–22). Logic would dictate opening the diaphragm as wide as possible when light levels are low, and closing it when there's enough light. But things aren't so simple, because the diameter of the aperture influences the depth of field, i.e., the zone of sharp focus extending in front of and behind the focus plane. It is very important that you understand this concept so you can eliminate a distracting background or photograph a landscape that is in focus from the foreground to infinity.

In fact, the concept of depth of field doesn't have any meaning from the purely optical point of view. When you focus on a point, the only sharp area is the point you focus on. Everything in front or behind becomes increasingly out of focus the farther away you get. Depth of field arises from the imperfection of the human eye, which can't differentiate details below a certain size (around 1/10 mm).

When viewing an 8 x 10-inch print made from 35mm-format film, the distance on the film below which the eye can't distinguish two adjacent points on the print is about 0.03mm. For the same size print from 6 x 6cm film, the distance between adjacent points on the film is 0.06mm, and for 4 x 5-inch film it's 0.1mm. This distance is called the "circle of confusion," since the eye will see the two points as one.

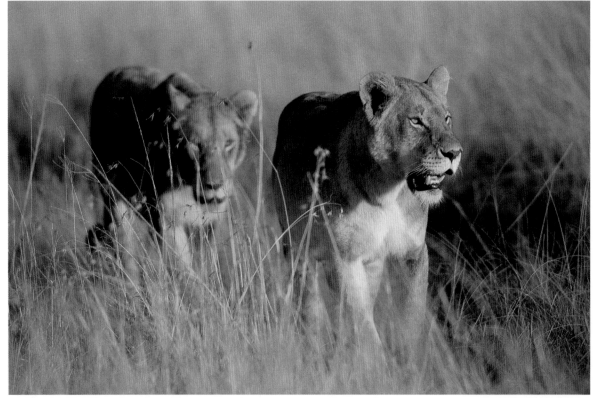

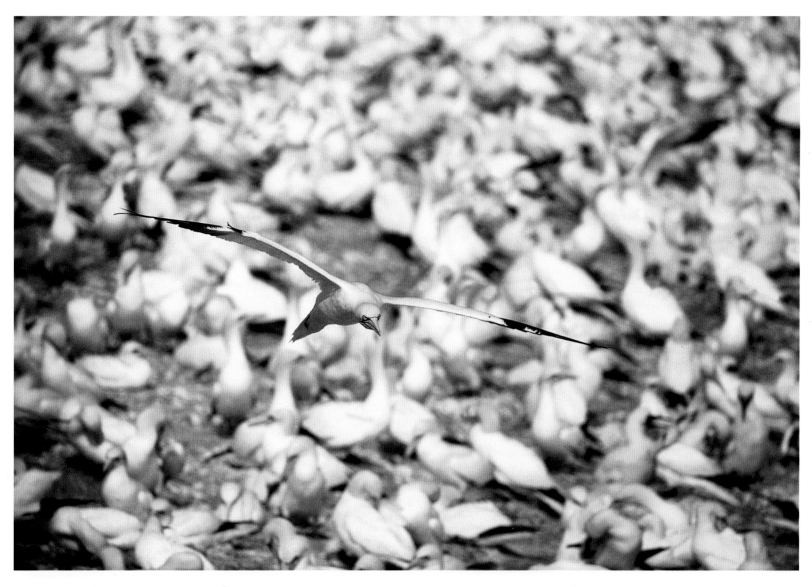

The size of the points, which form the image outside of the focal plane, are proportional to the diameter of the lens. The faster the lens, the larger the points. Details located in front of and behind the focal plane rapidly reach the size of the circle of confusion when a lens has a large diameter: the zone of sharp focus seems shallow.

When the diaphragm reduces the lens's diameter mechanically, the size of the points outside the focal plane also decrease. Therefore, the number of points whose diameter is at or below the size of the circle of confusion increases on either side of the focal plane. The impression of depth of field increases.

It is important to point out that depth of field increases more (about twice as much) behind the focal plane; additionally, fewer details can be seen far from the subject. Therefore, to have a sharp photograph from front to back, focus on the first third of its depth, even if there isn't anything notable there. Just pressing the depth-of-field preview button—if your camera has one—will let you choose the aperture that will make the picture sharp throughout. If you don't have a depth-of-field preview button, use the depth of field scale engraved by the manufacturer on the lens, or calculate it yourself (see the box on page 37, "Depth of Field in Numbers").

"From the watchtower I was using as a lookout, the only way of separating this Northern Gannet from the colony was a wide aperture. Without a fast lens, the subject would have been visually overwhelmed by its fellow creatures."

Bonaventure Island (Quebec). Northern Gannet (*Sula bassana*) 400mm lens 1/350 sec. at f/4 - MF.

Hyperfocal Distance and Depth of Field Chart

Thanks to a small aperture, there is great depth of field in this photograph, perfectly integrating the gecko into its natural habitat.

Namib Desert (Namibia).
Giant Ground Gecko
(*Chondrodactylus angulifer*)
20mm lens
1/125 sec. at f/11 - AF.

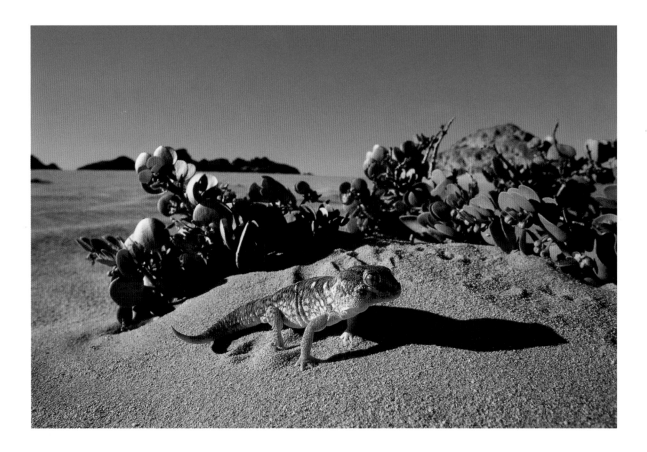

Calculating depth of field charts introduces the idea of hyperfocal distance, i.e., the focus distance that gives maximum depth of field for a given aperture. A knowledge of hyperfocal distance is essential for the demanding landscape photographer. In practice, there's no need to do any calculation if the lens has a depth of field scale engraved on it. Set the infinity sign "∞" on the focal ring with the marking of the corresponding aperture on one side of the scale, and read the focal distance directly from the point across from the marking for the same aperture, on the other side of the scale. In this position everything between the focal distance shown and infinity will be sharp (see diagram page 40). On autofocus lenses, which often don't have a depth of field scale, you'll have to do the calculations by hand; it's a little daunting at first, but you only have to calculate once for every hyperfocal distance and aperture used and remember to bring your notes along in the field.

From these calculations, you can see that the depth of field decreases as the focal plane approaches the camera. Depth of field varies with the lens's magnification; the greater the magnification, the smaller the zone of sharp focus. This quickly becomes apparent in macrophotography. This explains the apparent shallow depth of field of long lenses, which are often used at high magnifications, and the greater depth of field—still only apparent—of short lenses, used at low magnifications. In reality, depth of field varies only slightly as a function of focal length, but considerably as a function of magnification. The impression that depth of field varies with focal length is mostly a result of the various uses of different types of lenses.

Depth of Field in Numbers

Depth of field is the region of apparent sharpness located in front of and behind the focal plane. It is caused by the limited resolution of the human eye, which cannot distinguish details smaller than about 1/10 mm in diameter. When 35mm-format film is enlarged to an 8 by 10-inch print, two points on the film within 0.033 mm will look like a single point on the print; this value is called the "accepted circle of confusion." If the spot formed by focusing an image point is smaller than 0.033 mm, it is perceived to be in focus. When this diameter is exceeded, it seems more blurred the larger it is. We shouldn't forget that depth of field is a subjective value. The blurring starts imperceptibly, and may be perceived differently by different eyes. Should this happen, the value of the accepted circle of confusion used for these calculations may be decreased (e.g., 0.015 mm), especially when the image must be greatly enlarged and observed at a distance less than the diagonal of the original format. But this is an extreme case, and one not very suitable to the aesthetic appreciation of a photograph.

THE FORMULAS

To calculate depth of field, you need to determine its near and far limits for every focal distance and aperture. This information is contained in a depth of field chart. To calculate it, we must first determine the hyperfocal distance of the lens's different apertures, i.e., the focal distance, which gives the maximum depth of field for a given aperture.

Calculating the hyperfocal distance:

$$\text{Hyperfocal Distance} = \frac{\text{Focal Length}^2}{\text{Circle of Confusion} \times \text{Aperture}}$$

For a 200mm telephoto lens used at f/5.6, the formula becomes

$$\frac{40,000}{0.033 \times 5.6} = 7,459.2 \text{ or a hyperfocal distance of 216 meters}$$

When the focusing ring of a 200mm lens at f/5.6 is set at infinity, the depth of field will extend from 216 meters to infinity. But the minimum distance may be reduced if we set the focusing ring on about 216 meters (remember, the markings

may not be perfectly accurate). In that case, the minimum focal point will extend from half the hyperfocal distance (108 meters) to infinity. On lenses with a depth of field scale, you'll notice that at f/5.6, when the focus is set at 216 meters, the infinity sign "∞" is just to the left of the f/5.6 mark. The minimum distance at about 108 meters is on the opposite side of the f/5.6 mark.

CALCULATING DEPTH OF FIELD CHARTS

Once the hyperfocal distance has been determined for all the lens's apertures, the calculations for the depth of field charts should be carried out for common focal distances. It's sufficient to establish the front and far limits for the zone of sharp focus by taking the hyperfocal distance as a starting point, which itself takes into account the circle of confusion at 0.033 mm.

Here are the two formulas:

$$\text{Near Limit} = \frac{\text{Focal Distance} \times \text{Hyperfocal Distance}}{\text{Hyperfocal Distance} + \text{Focal Distance}}$$

$$\text{Far Limit} = \frac{\text{Focal Distance} \times \text{Hyperfocal Distance}}{\text{Hyperfocal Distance} - \text{Focal Distance}}$$

Since we know that our 200mm lens at f/5.6, set on a hyperfocal distance at 216 meters, has a zone of sharpness between 108 meters and infinity, it is easy to determine these limits for another focal distance.

Depth of field for a focal distance of 12 meters (200mm at f/5.6):

$$\frac{12 \times 7.46}{216 + 12} = \text{near limit at 11.4 meters}$$

$$\frac{12 \times 7.46}{216 - 12} = \text{far limit at 12.7 meters}$$

* When the result of subtracting the focal distance from the hyperfocal distance is less than zero, we assume that the far limit is infinity.

The 200mm lens at f/5.6 focused at 12 meters gives a depth of field between 11.4 and 12.7 meters. Now just redo the calculations for all the focal distances engraved on the lens at every aperture to draw up a customized depth of field chart.

The Aesthetic Effects of Blur

Aperture affects the size and shape of the points that form the image. For this reason, points larger than the circle of confusion will appear as blurry spots. It is these blurry spots—which get bigger the farther away they are from the focal plane—that determine the degree of blurring outside of the zone of sharpness. A lens with an aperture that is perfectly round and therefore composed of many blades, will make spots that are quite round, creating a soft and gradual blurring effect. With a hexagonal aperture the blurry spots, also shaped like hexagons, have a choppier look that is much less pleasing to the eye. The position of the aperture within the lens also affects the aesthetic effects of blur, but it is difficult to judge without some experimentation. These factors, although they are subtle, can still have an appreciable impact on photographs taken at short distances. The photograph of an animal or flower gains in aesthetic interest if the subject stands out against a uniform haze.

The "bubbles" formed by the mirrors of catadioptric lenses give objects outside of the field of focus a particular aesthetic blurring effect.

La Digue Island (Indian Ocean). Green-backed Heron (*Butorides striatus*)
500mm catadioptric lens
1/60 sec. at f/8 - MF.

The Diaphragm and the Judicious Use of Aperture

At full aperture, the bird is easily distinguished from the background. Therefore, the colors and graphic quality of its plumage stand out and the interference of a busy background is avoided.

Green-winged Macaw
(*Ara chloroptera*).
Central America
300mm lens
1/200 sec. at f/4 - AF.

The diaphragm performs more than one function. Not only does it control light and depth of field, it also influences optical rendering. You should know that a lens, even if it is corrected for optical aberrations, always has some small defects, especially at the edges of the image. When the diaphragm is at full aperture, almost the entire lens surface is used.

The light rays, which pass through the thinnest parts of the lens, those at the edges, increase spherical aberration (the difference in refraction between the center of the lens and its edges) and cause a noticeable decrease in sharpness at the edges. You have only to reduce the aperture by one or two f-stops to minimize spherical aberration, coma (distortion caused by oblique light rays), and vignetting (optical or mechanical darkening of the image's edge) simultaneously. Only professional-quality lenses—which use aspherical lenses and/or special glass—give a satisfactory rendering at full aperture.

But the aperture itself can also affect image sharpness. Like a stream of water, which widens when the orifice through which it passes is reduced, the aperture diffracts light when it is stopped down.

Don't worry, these problems only arise at very small apertures. In a 35mm format, diffraction appears at around f/8, and only really begins to affect sharpness at f/16.

In general, it is not a good idea to take photographs between f/16 and f/22, certainly not f/32, with standard lenses. In short, avoid extremely small apertures if you want impeccable optical quality.

This said, the vagaries of depth of field—deep or shallow—can lead a photographer to accentuate the aesthetic rendering to the detriment of pure and simple technical perfection. A beautiful landscape with a very near foreground, which is more or less in focus throughout the whole image, is preferable to a blurred foreground and a razor-sharp background.

The depth of field scale, here set between the other two scales, allows a visual estimation of the depth of field. It begins in this example at 0.5 meters and ends at infinity with the aperture f/22.

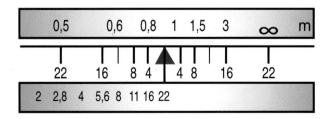

Exposure

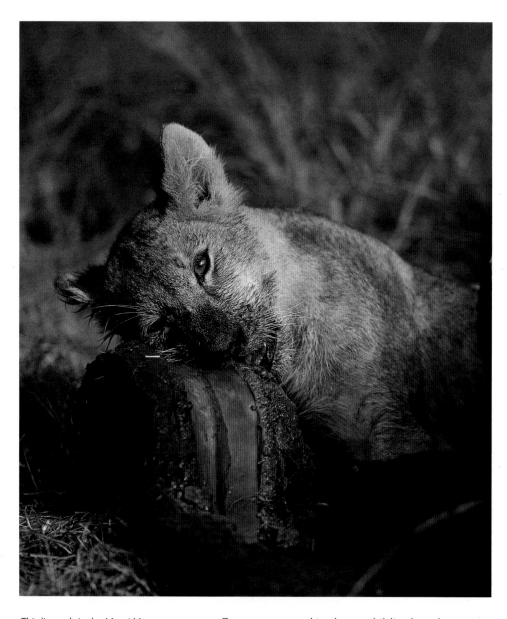

This lion cub in the Masai Mara Game Park (Kenya) is devouring the trunk of a dead elephant.

Lion (*Panthera leo*)
600mm lens
1/200 sec. at f/4 - AF.

Exposure control is almost child's play when you understand the meaning of shutter speed and aperture. Correct exposure simply consists of determining the right shutter speed and aperture combination, which will admit the exact amount of light energy necessary to expose the film. Too much light and the photograph's overexposed. Not enough and it's underexposed. Every type of film has its own sensitivity to light, which is called the film speed, marked on the box and cartridge by the ISO (International Standards Organization)

number. ISO 100 film is considered normal with reversal (slide) film, while advances in color negatives have today established ISO 400 as the standard for color print film.

Light is regulated by the aperture and shutter. To understand how they work, we can once again use the analogy between the aperture and a faucet, while comparing the shutter to a bucket. When a faucet is just barely open, a bucket is filled slowly. If the faucet is opened wide, the bucket fills quickly. Aperture and shutter work in the same way: a diaphragm at full aperture requires a high shutter speed, and a small aperture requires long exposures. Each is related to the other, and can give an identical exposure value (Exposure Value or EV) at various apertures and shutter speeds.

For example: 1/250 sec. at f/5.6 gives the same EV (13 in the case of ISO 100 film) as 1/125 sec. at f/8, 1/60 sec. at f/11, or 1/500 sec. at f/4.

An f-stop is more or less the same as doubling or halving the shutter speed.

Some professional cameras (Contax 35mm and 4.5 x 6, Hasselblad 6 x 6) can link shutter speed and aperture for any EV (selected in the viewfinder), and let you vary the depth of field while keeping the same exposure. Stop down the aperture, the shutter speed increases, and vice versa if you want to reduce depth of field.

To measure the exposure of a scene to be photographed, you can use the camera's built-in light meter or a handheld meter. The SLR's built-in light meter measures the light reflected by the subject through the lens, using sensors inside the body, near the viewfinder. The difficulty in obtaining a reliable measure of reflected light lies in the variation in a subject's ability to reflect light—there's a world of difference between snow and dark ground.

This is why many photographers prefer to analyze incident light ("falling" light) with a hand-held light meter fitted with a white diffuser dome. With it you can measure the light reaching the subject without having to take into account its reflection coefficient. You still have to bear in mind that the light meter gives an average reading, calculated for an exposure based on a middle gray (Kodak 18% gray card).

With film that has infinite exposure latitude, whites will always be white and blacks will always be black. Unfortunately, every film's exposure latitude is limited. Consequently, the image may be washed out in very bright light and muddy in low light. A detailed understanding of film properties is a prerequisite to working effectively with a handheld meter.

To keep beginners from making mistakes, SLR makers have greatly improved the metering systems built into their cameras. First of all, center-weighted metering, whose sensors emphasize the lower part of the viewfinder, minimizes the influence of an overly bright sky. However, in order to function correctly, this system must also be set for an ideal exposure at 18% middle gray. Hence, the irritating tendency to overexpose dark tones (bright background and totally washed-out subject) and underexpose whites (dirty-looking snow and dark people). The beginner will have to correct the exposure of difficult subjects to take good photo-graphs by setting at −2 EV at a stage performance and +1.5 EV in snowy landscapes. Next, manufacturers added narrower sensors to their cameras using selective or spot metering. They allow you to examine a precise area of the subject. Nonetheless, you must still find a subject whose reflection coefficient, though not necessarily color, is close to 18% middle gray.

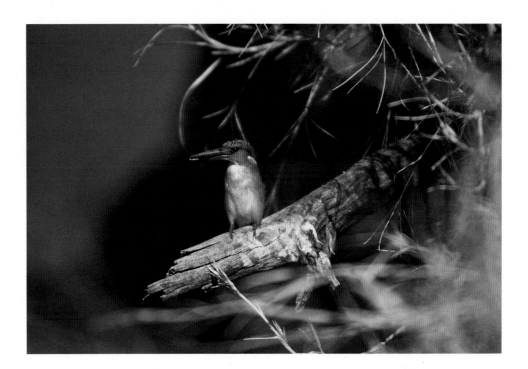

If there's any doubt about the validity of multi-segment metering, selective metering lets you read the light level precisely on the subject.

Malachite Kingfisher (*Alcedo cristata*), photographed in Zambia. 400mm lens 1/250 sec. at f/5.6 - MF.

EV	SPEED/APERTURE PAIRS										
	f/1	f/1.4	f/2	f/2.8	f/4	f/5.6	f/8	f/11	f/16	f/22	f/32
−2	4 s	8 s	15 s	30 s	1 min	2 min	4 min	8 min	16 min	32 min	1 h
−1	2 s	4 s	8 s	15 s	30 s	1 min	2 min	4 min	8 min	16 min	32 min
0	1s	2 s	4 s	8 s	15 s	30 s	1 min	2 min	4 min	8 min	16 min
1	1/2 s	1 s	2 s	4 s	8 s	15 s	30 s	1 min	2 min	4 min	8 min
2	1/4 s	1/2 s	1 s	2 s	4 s	8 s	15 s	30 s	1 min	2 min	4 min
3	1/8 s	1/4 s	1/2 s	1 s	2 s	4 s	8 s	15 s	30 s	1 min	2 min
4	1/15 s	1/8 s	1/4 s	1/2 s	1 s	2 s	4 s	8 s	15 s	30 s	1 min
5	1/30 s	1/15 s	1/8 s	1/4 s	1/2 s	1 s	2 s	4 s	8 s	15 s	30 s
6	1/60 s	1/30 s	1/15 s	1/8 s	1/4 s	1/2 s	1 s	2 s	4 s	8 s	15 s
7	1/125 s	1/60 s	1/30 s	1/15 s	1/8 s	1/4 s	1/2 s	1 s	2 s	4 s	8 s
8	1/250 s	1/125 s	1/60 s	1/30 s	1/15 s	1/8 s	1/4 s	1/2 s	1 s	2 s	4 s
9	1/500 s	1/250 s	1/125 s	1/60 s	1/30 s	1/15 s	1/8 s	1/4 s	1/2 s	1 s	2 s
10	1/1000 s	1/500 s	1/250 s	1/125 s	1/60 s	1/30 s	1/15 s	1/8 s	1/4 s	1/2 s	1 s
11	1/2000 s	1/1000 s	1/500 s	1/250 s	1/125 s	1/60 s	1/30 s	1/15 s	1/8 s	1/4 s	1/2 s
12	1/4000 s	1/2000 s	1/1000 s	1/500 s	1/250 s	1/125 s	1/60 s	1/30 s	1/15 s	1/8 s	1/4 s
13	1/8000 s	1/4000 s	1/2000 s	1/1000 s	1/500 s	1/250 s	1/125 s	1/60 s	1/30 s	1/15 s	1/8 s
14	—	1/8000 s	1/4000 s	1/2000 s	1/1000 s	1/500 s	1/250 s	1/125 s	1/60 s	1/30 s	1/15 s
15	—	—	1/8000 s	1/4000 s	1/2000 s	1/1000 s	1/500 s	1/250 s	1/125 s	1/60 s	1/30 s
16	—	—	—	1/8000 s	1/4000 s	1/2000 s	1/1000 s	1/500 s	1/250 s	1/125 s	1/60 s
17	—	—	—	—	1/8000 s	1/4000 s	1/2000 s	1/1000 s	1/500 s	1/250 s	1/125 s
18	—	—	—	—	—	1/8000 s	1/4000 s	1/2000 s	1/1000 s	1/500 s	1/250 s
19	—	—	—	—	—	—	1/8000 s	1/4000 s	1/2000 s	1/1000 s	1/500 s
20	—	—	—	—	—	—	—	1/8000 s	1/4000 s	1/2000 s	1/1000 s
21	—	—	—	—	—	—	—	—	1/8000 s	1/4000 s	1/2000 s

Correspondence between exposure values (EV) and speed/aperture pairs for ISO 100 film.

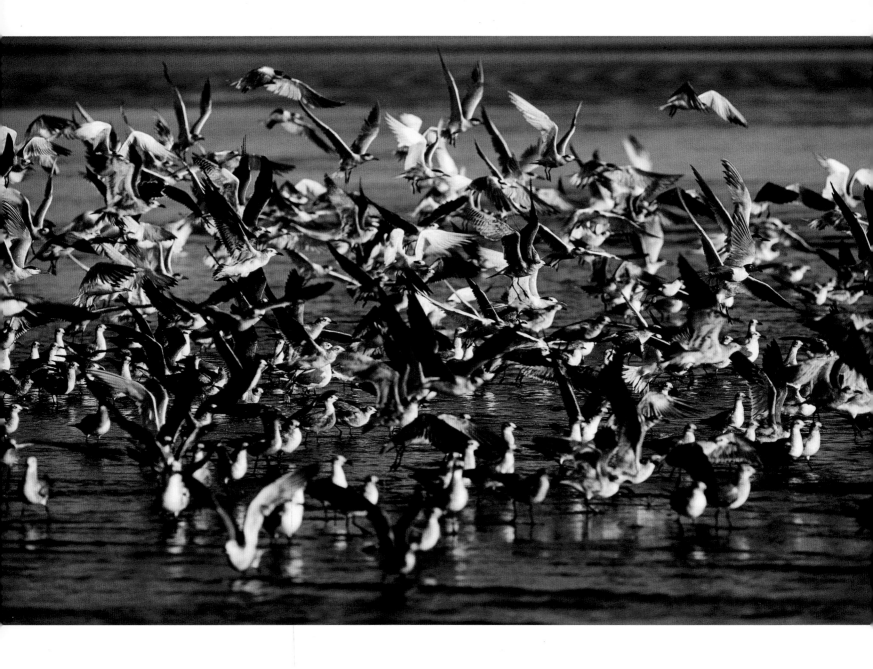

Multi-segment metering is particularly effective on most subjects. This "wide screen" flight is a good example of a scene in which you can fully trust a modern exposure control system.

Chacahua Lagoon (Mexico)
200mm lens
1/250 sec. at f/8 - MF.

Nikon found the solution to all these problems with matrix or multi-segment metering, which divides the viewfinder into areas. A built-in computer reads the different values in each area and compares the result to examples stored in its memory. When it sees a very bright area at the top of the image, for example, the camera ignores it. The meter gives priority to the other areas, where the main subject has more chance of being found.

When the bottom of the image is bright, the darker areas are emphasized, in order to give good exposures of people against a snowy background.

Today all SLRs have multi-segment metering of varying quality, with a huge number of examples in their memory to compare to the subject being analyzed.

This system will let you avoid most of the difficulties raised by backlighting, snow scenes, and sunsets. Problems only arise with low contrast (bright fog, beaches under a gloomy sky), which provide the light meter with the same conditions as center-weighted metering—all the

areas give identical readings. If you don't know how to correct this, it's best to use automatic bracketing. Take three photographs with predetermined EVs (e.g., 0 EV, +1 EV, –1 EV)—a very useful function when you're in doubt. Of course, you can reduce the bracketing spread by using ½ EVs, or increase it using the exposure control.

With a correction of +1 EV, the bracketing given above becomes: +1 EV, +2 EV, 0 EV, a good range when taking pictures at dusk or against a snowy background.

The exposure control isn't just for repairing images; it's also a way of influencing exposures creatively, including with multi-segment metering. For example, the warm light of late afternoon is accentuated when the picture is underexposed by ½ to 1 EV.

As far as landscapes are concerned, when underexposing by ½ to 1 EV, rocks look denser and warm tones are more saturated—ideal lighting in places like the Grand Canyon or Monument Valley.

The same underexposure of ± 1 EV will also help you photograph brightly lit vegetation against a dark background. The background turns black and the fine lines of the vegetation are exposed correctly; without a slight correction most of the plants would be overexposed.

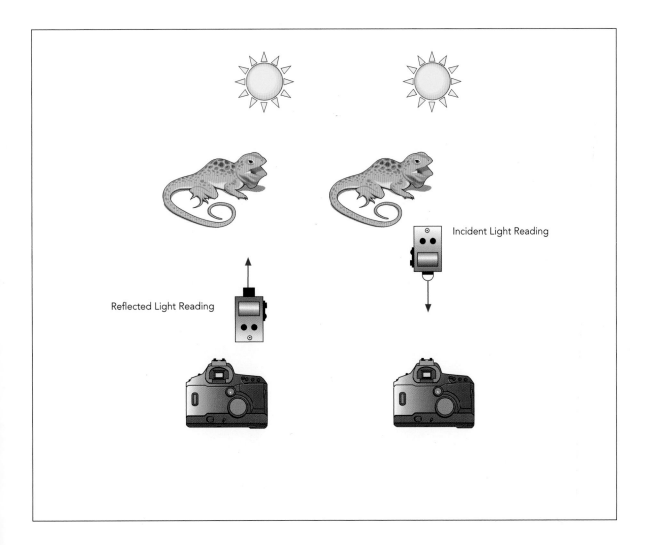

Reflected Light Reading

Incident Light Reading

Reflected light reading taken in the direction of the subject is based on its reflection coefficient: if it is too bright or too dark, the meter is fooled. With incident light, we only read the ambient light, through the white integrating sphere turned toward the camera; the sensor doesn't take into account the variations in reflection by the subject.

When a Flash Is the Main Source of Light

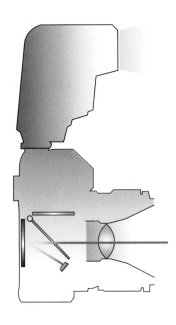

The power of a flash unit is given by its guide number (GN) for ISO 100. It is determined by measuring the flash from a distance of one meter. GN values given by manufacturers are often optimistic. They're not completely false, but are often given in telephoto position, where the reflector's Fresnel lens really affects the flash. Read the instructions carefully (power is usually given there for each focal length) if you want to use it manually, following the classic formula: GN ÷ distance from flash to subject = working aperture.

Today most flashes are automatic. Exposure is controlled by light-sensitive elements in the camera's reflex chamber (TTL or through-the-lens metering). The meter automatically compensates for the lens speed or light loss caused by optical accessories. The metering procedure is simple. The camera controls the flash. Its cell analyzes the duration of the flash and cuts it off as soon as it calculates the optimum exposure for the film used. Manufacturers have helped this technology evolve toward multi-segment metering, as well as available-light metering. Some even use the same metering system to measure a pre-flash. The system also keeps track of a subject's different reflection coefficients. It also allows you to keep a record of the flash on a similar subject at the same distance, especially to avoid a distracting background (a water bird on a reflective surface, a mammal against a dark background).

The sensor in the floor of the reflex chamber measures the duration of the flash reflected by the film, and cuts off the flash as soon as it is sufficient for a good exposure.

Flashes placed to the side eliminate undesirable facial reflections. The scene gains in depth and looks more natural.

Parsley Frog (*Pelodytes punctatus*)
50mm lens
1/60 sec. at f/11 - MF.
2 extension flashes.

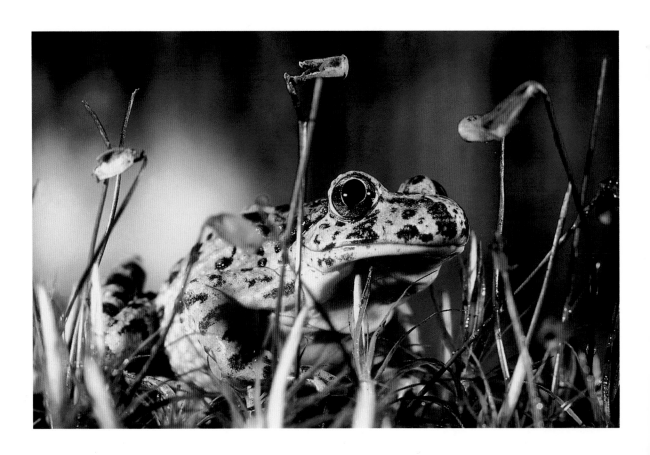

The Flash: Advantages and Disadvantages

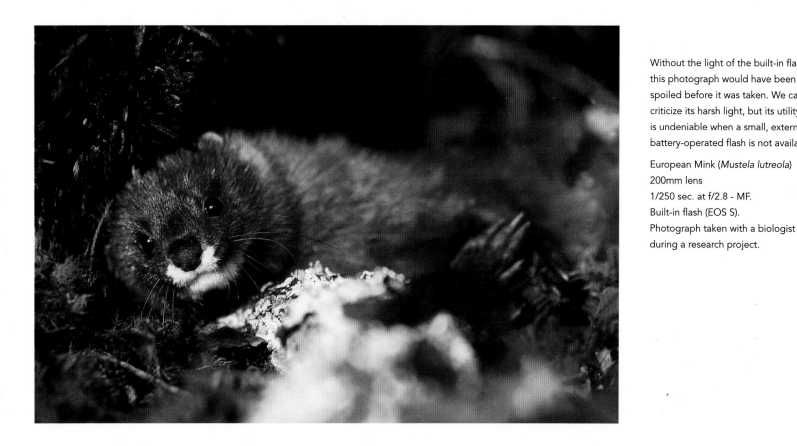

Without the light of the built-in flash, this photograph would have been spoiled before it was taken. We can criticize its harsh light, but its utility is undeniable when a small, external battery-operated flash is not available.

European Mink (*Mustela lutreola*)
200mm lens
1/250 sec. at f/2.8 - MF.
Built-in flash (EOS S).
Photograph taken with a biologist during a research project.

Using a flash as the main source of light ruins the scene's natural look. A flash mounted on the camera's hot shoe gives a cold and harsh light, which casts distracting shadows behind the subject. This is why we advocate using the flash only as an adjunct to daylight, using a low-density warm brownish-yellow filter, to harmonize the flash with the tones of the naturally lit background.

For nighttime photography, it's a good idea to use several flashes to light the scene while generating a minimum number of shadows. Modern automatic flashes live up to their full potential in this situation, especially when it's possible to regulate the slave units' power with the master flash. In this way you avoid technical problems, since all the flashes are controlled by the camera's internal meter. The highest-performance pairings of camera and flash even use multi-segment metering. The high price of these accessories should encourage you to protect them as much as possible from bad weather—showers are common while you're lying in wait. Provide solid mounts, protect the flash body with adhesive tape, and cover everything with a plastic bag. A special watertight bag with a neutral window to avoid coloring the light is ideal.

Older-model manual flashes, less costly in case of accident (theft, breakage, damage by animals), can be used in an installation that has been set up for several days in the field. In this case, use an external battery system and protect the flashes as described above. Exposure is measured with a hand-held flash meter, as in a portrait session. Try some preliminary experiments on slide film to verify the effectiveness of the system. Such a setup can work completely autonomously as a photographic trap—practical with various nocturnal species (badger, fox, etc.).

BUILDING IMAGES

This photograph is based entirely on oppositions: life and death, dark and light, sand and sky.

Aldabra Giant Tortoise
(*Dipsochelys elephantina*)
200mm lens
1/1000 sec. at f/8 - AF.

FRAMING

Framing is the simplest way to turn a photograph into a personal statement by eliminating a detail of the landscape or choosing a vertical rather than horizontal composition, which are creative decisions in and of themselves. Framing makes a photograph more easily readable and masks superfluous elements but, like other instinctual actions, framing often arises from a much deeper level—our personal culture unconsciously directs our eye. To frame a picture is to shape reality and extract the element that provokes an emotional response to beauty. We also repeat the aesthetic ideals we've seen in magazines, on television, or at the movies. Whether we like it or not, personalizing our photography sometimes means making it conform to the aesthetic canons of society— but it doesn't matter. The main thing is to feel the pleasure that comes from discovering the image we want to share and facilitating an exchange

through a logical presentation. Photography is also a social act. We discover what is beautiful and share it with others. This is an excellent reason to take your time when you're framing a shot, especially in the beginning, since improper framing often results from a lack of concentration. The most common mistake is centering the image with the subject stuck right in the middle; this keeps the eye from moving around the image. The only reason to center the image is to help identify the subject by making it as large as possible, but that's not creative photography.

COMPOSITION

If some people have an innate sense of visual harmony, others have to learn the classic rules to develop their sense of composition. We read images instinctively; a photograph has only a fraction of a second to attract the viewer. You should try to help the eye as it circulates by making it easy to read the image from left to right, the way we are all trained to do as children. For this reason, we quickly look away from the image when the subject is on the left side, and the right side is less interesting. On the other hand, when the left-hand side of the image is empty, it causes the eye to linger on the subject on the right, just at the key point of the frame.

The point of interest is not a modern invention. Artists in ancient Greece used the golden ratio to help design harmonious temples. In photography, as in painting, you simply divide a rectangle into thirds vertically and horizontally. Every intersection is a key point.

According to the way we read images, the key points to the upper and lower right are in the best position to hold our interest. However, through perspective lines and vanishing points, it's easy to guide the eye toward secondary points of interest. The more the eye is guided within the image, the better it understands the image and the more easily it circulates.

If geometrical lines can guide the eyes, the best way of increasing circulation is to add a third dimension to the composition. A simple vanishing point on the horizon gives depth to the image. If you include a leading line from the bottom corner of the image the results will be impressive.

Of course, natural leading lines can guide the eye to the right or the left and, in this way, lead the eye from one key point to another. These leading lines don't need to be more than suggested. The edge of a lake, a mountain peak or a few clouds will make adequate lines. It's a matter of holding the eye long enough to convey the emotion, and this sometimes happens very quickly.

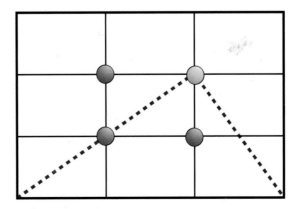

When you divide the length and width of a 24 x 36 frame into thirds, the key visual points are located at the line intersections. The top right-hand point, where the perspective lines converge, is the most aesthetic.

CONTRASTS FOR EMPHASIS

Contrasts help the main subject stand out in the composition. Put two rocks of very different sizes at the composition's key point, and the larger will attract the eye more. This is contrast of scale. Paint the large rock red and the little one green, and the contrast will be increased. Reverse the colors, and the small rock will quickly become the center of interest. Color contrasts are more complicated than those of size, since each color has a different evocative power in our minds. Red means food (berries), risk (poisonous plants and animals), and danger (blood), which makes it visually very powerful.

The evocative power of the subject evolves according to a hierarchy dictated by the emotions. Rock formations are spectacular if they're large enough, but a single tree on a mountain will hold the eye. Put an animal next to it, and the tree will fade into the background, but if a person shows up, that's all we look at.

It's very interesting to contrast extremes (mountain and person, large objects and animals). The most evocative subjects (humans, animals) will benefit from the contrast. When we frame a mountain in its entirety, a tiny human set at its foot draws the eye, as if he will be crushed at any moment by the massive rock. Unfortunately, the human figure will not have enough detail to keep it from being anonymous. If the image is framed more closely, including only a small area of the mountain, which must be easily identified in the background, it will make the subject's details more visible and strengthen the impression. We will then have to imagine the real dimensions of the mass in the background (implied contrast).

This kind of contrast is very useful for nature photography with a message. For example, imagine a human hand in the foreground reaching for an animal in a trap. The wounded animal will have enormous evocative power. The man, represented by his hand alone, will leave us in no doubt about his destructive intentions. On the other hand, if just a part of his sleeve shows him wearing an Indian vest, the act becomes acceptable, since the man is integrated into nature and is killing to survive. Always be careful when you use contrasts since they are filled with contradictions.

The framing of the tortoise in the foreground and the coral rock just behind gives a pleasant dynamism and graphic sense to this photograph. The natural perspective line fills the image space and holds the eye in the frame.

Hawksbill Tortoise
(*Eretmochelys imbricata*)
24mm lens
1/60 sec. at f/16 - AF.

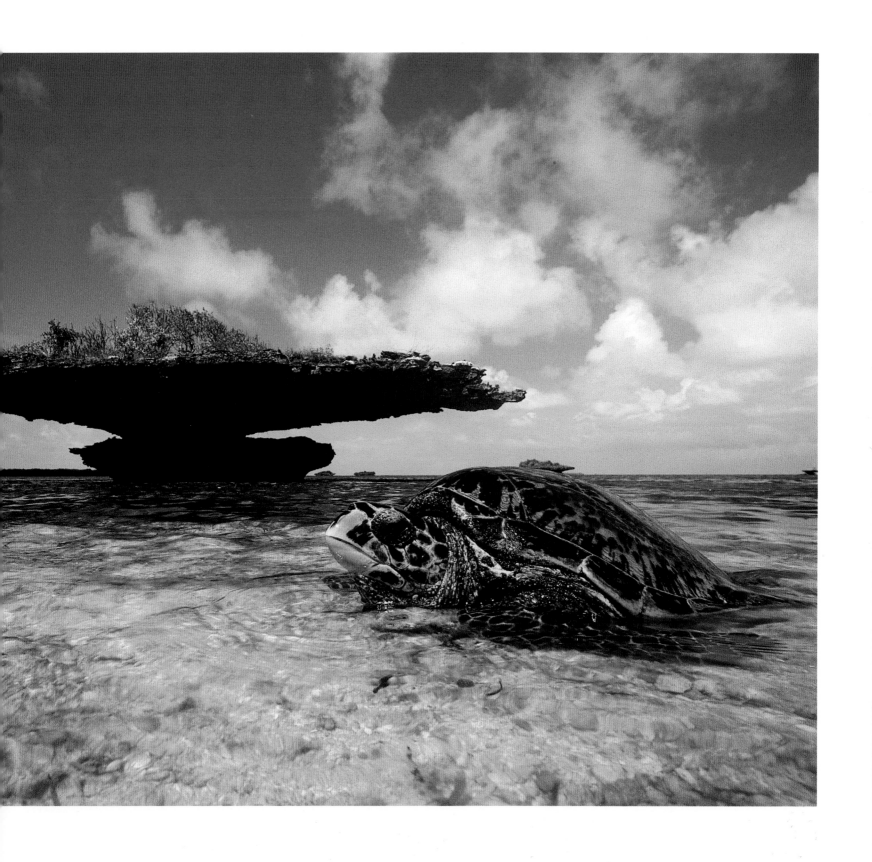

FILM

Fine-grained emulsions are essential to render subtle details, like the plumage of these pelicans from Lake Eyre (Australia). This species is endemic to Australia and New Guinea.

Australian Pelican
(*Pelicanus conspicillatus*)
400mm lens
1/125 sec at f/5.6 - MF.

Whether to use black-and-white or color film is a fundamental decision you have to make before beginning to take photographs. Black-and-white film is seldom used for nature photography, except for landscapes (a carefully printed image is always beautiful). Color film is much more common, either negative film—which, in a constant process of evolution, gives unequaled flexibility for exposure—or slides, with which you can produce spectacular projected images as well as color or black-and-white prints, especially using digital equipment. The most advanced black-

and-white film technology is available from Kodak and Ilford, whose tabular grain emulsions have very fine grain even at high sensitivities (from ISO 100 to 3200). This is a major advantage when you don't have much light. These films are universal, easy to process, and with rich grayscale. Agfa uses standard technologies, but also has excellent low-sensitivity film. Color negative film is unquestionably the most flexible as far as exposure is concerned. It's available in a wide range of sensitivities from all the leading manufacturers (Fuji, Kodak, Konica, Agfa...) and has

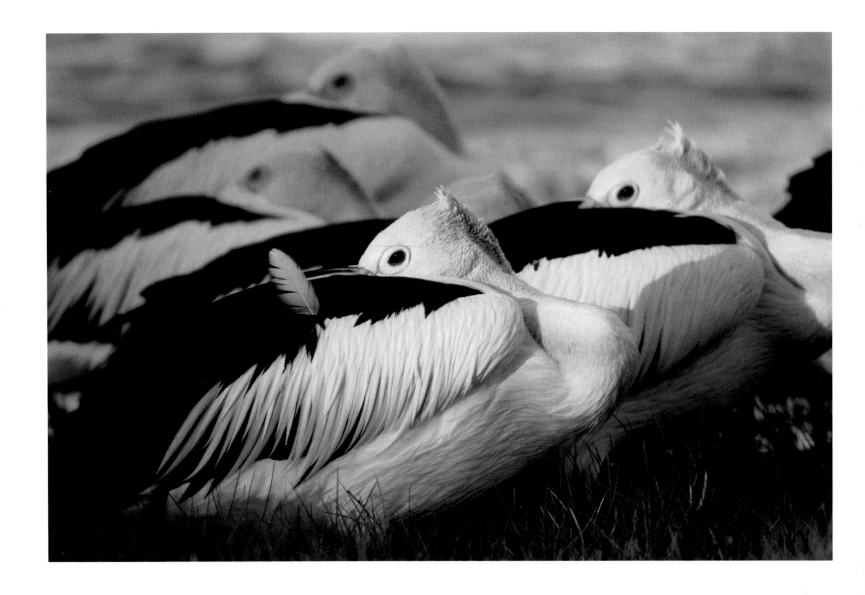

very fine grain up to ISO 800. Color negative film is the film of choice for difficult light, e.g., lying in wait at daybreak when the sun is just about to illuminate a herd of bighorn sheep. Its wide latitude (correct exposure at −1 to +3 EV) will even tolerate some errors in metering. Negative emulsions are generally neutral and fairly saturated, i.e., the colors sparkle, as the viewers expect.

Color slide (reversal) film is most popular for nature photography. Every image is an original, which doesn't have to be subjected to the rigors of printing as do color negatives. A slide is richer in density, sharper, and better adapted to being stored in large quantities. The standard sensitivity is ISO 100. Reversal films require precise exposure, since their latitude is relatively low. This having been said, cameras with multi-segment metering usually make correct exposures. Slides can be projected, of course, but it is better not to do this too much when you hope to publish them one day. The projector's heat and bright light will damage the emulsion, warping ("popping") and discoloring it. It's better to store your slides in metal drawers and in chemically neutral plastic sleeves, to sort through them on a light table with the aid of a magnifying glass, and only project duplicates, which are commonly made in nature photography. Fortunately, slides are cheaper than quality prints from color negatives.

Rare is the photographer who can turn in film to be developed without a pang of anxiety. Loss, wear, scratches, and careless handling are the common fate of rolls of film left at commercial film developers. With color negative film, the prints often leave something to be desired.

Digital Photography

The growing capabilities of digital photography today attract many amateurs. Are we ready to abandon film and take purely digital pictures? The best equipment today allows us to do so, especially since the introduction of high-resolution CCD (charged-couple devices) sensors. Digital photography lets the photographer check image quality in the field and delete bad photographs on the spot. At home, the amateur digital photographer can easily touch up image defects, print out copies on an ink-jet printer with a quality equal to that of film-based photography, and store them on CD-ROMs, DVDs, or other inexpensive and reliable media.

However, digital photography has its drawbacks. For example, it is much easier to sort through fifty sheets of twenty slides in a few minutes than to boot up the computer, open your cataloging software and look at thumbnails, which aren't very sharp and take relatively long to load. Moreover, digital files are easily lost or corrupted, especially when the images aren't catalogued properly. To this we add the imponderables such as crashed hard drives, computer viruses, and power outages while saving a shot. The media also have a limited life. How long will we be using CD-ROMs and DVDs? The box of black-and-white glass plates you find in an attic can still be printed after fifty years, while there may not be any CD players working thirty years from now.

For these reasons, it's best to take advantage of digital photography for images that will have a limited life. Or get the best of both worlds: take slides and scan them as necessary. A slide scanner produces higher-quality images than any digital camera, and the original is always available for future digitizing. What's more, a slide can resolve 6 to 80 million pixels—depending on the scanner—for less than a dollar, while you still can't store digital images at such high resolution

They're made by machines that produce thousands of prints an hour, without any possibility of individual processing.

In fact, these standard prints should be considered as a trial run, to select which to have enlarged later on.

For slides, the most critical moment is when they are put into mounts. This is when your precious originals are sometimes irreparably scratched. Worse, it sometimes happens that the film shifts when they're mounted and all are cut in the middle of the image. Imagine how you'd feel to see a set of half-slides with a black line down the middle of each. It's better to entrust your precious images to high-end laboratories. With their standard service, you may be sure that the films go off to Fuji or Kodak. Everything isn't always perfect there, but the leading brands have stricter standards than independent laboratories. The best solution of all is to leave your films at a laboratory that caters to professionals.

A professional lab doesn't usually do amateur work but, if you're careful to leave several rolls at once, you'll be welcome. The services of professional labs are much more expensive than those who target the general public but the processing is top-notch with a wider range of available services:
◦ development of a test strip (a short segment of film—two images—to calibrate the development process
◦ pushing or pulling by a third of a stop (overdeveloping film which has been intentionally underexposed to compensate for low light level or compensating for an overexposed roll)
◦ strip development to avoid scratches
◦ personalized slide mounts (for large outputs)
◦ production of Photo CDs and digital processing.

IF YOUR FILM IS DAMAGED

In amateur laboratories, compensation is usually limited to replacement of the spoiled film. A friendly resolution may be reached by mutual agreement, but this takes place on a case-by-case basis. Usually the order envelope warns you against leaving photographs of commercial value without notifying the clerk. Legal action is unlikely to succeed, unless the film has been intentionally damaged.

In professional labs, it's also a good idea to work things out informally. Nonetheless, there are greater possibilities for recourse, since professional photographers' work is assumed to have commercial value. To be safe, talk with the lab's manager before leaving your film (you can also insure your photographs).

SLIDE DUPLICATION

Duplicating your slides lets you project them without risk of damage to the originals. Non-professional labs provide this service more or less competently, depending on the subcontractor. Alas, many of the "dupes" produced by these labs are out of focus and have too much contrast. If this happens, ask the lab to do them over. In professional labs, dupes can be made in several formats (from 24 x 36mm to 4 x 5 inches), and using various processes. Most dupes are photographs of your slides taken on a special film. The quality is generally good, but the best duplicates are produced by contact printing.

With digital processing, the slide is scanned and duplicated by flashing the image on standard slide film using a machine with a CRT display.

Once again, professional labs are expensive, but the quality of their service is generally beyond reproach.

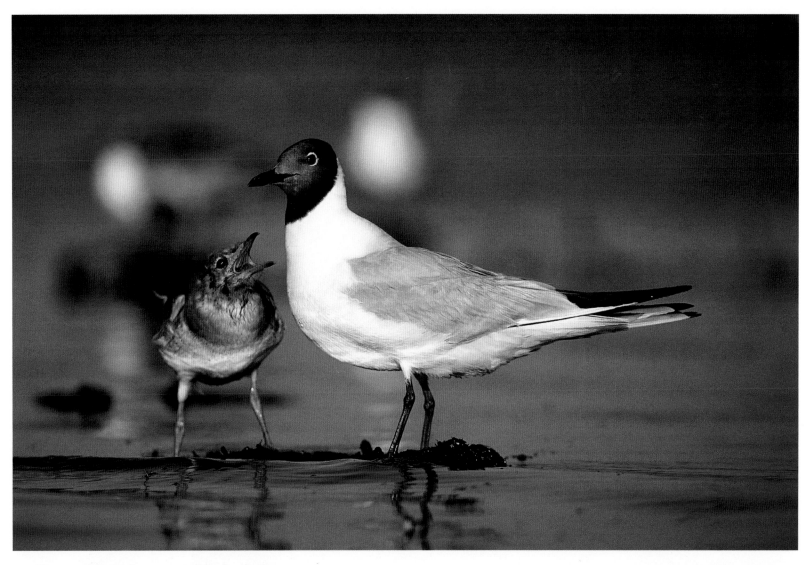

You can also duplicate your slides by digitizing them and saving them on a digital media such as a CD-ROM. Fuji and Kodak provide this service in amateur labs, at rather low resolutions, with the exception of the Kodak Photo CD. Professional labs offer the service in higher resolutions, along with digital image retouching.

Photographers who own a quality slide scanner and a CD or DVD burner, can make their own collections of images. Be careful to name your files clearly, and catalogue the images with software made for the purpose, or a lot of your CDs will quickly become useless.

Developing your slides at a professional laboratory is a guarantee of quality: ultrafine grain, development to the nearest 1/3 stop, test strips, careful insertion of slides into mounts.

Black-headed Gull (*Larus ridibundus*)
300mm lens
1/350 sec. at f/4 - AF.

NATURE PHOTOGRAPHY IN PRACTICE

Wildlife photography often requires stalking your subject in dense brush, where you can hide among the branches or in the bushes. Your photography equipment must be easy to operate and capable of photographing the animal from a distance. Getting too close makes noise, which will frighten away wary species.

The ideal lens in this situation is a 300mm stopped down to f/4. Its very satisfactory speed and relatively small size are appropriate for taking pictures in uneven terrain. Because it is lightweight, this lens can be used without a monopod, although a support reduces the risk of camera shake, and lets you make better use of the optical quality. Image-stabilized models may be handheld down to 1/30 sec. These are very practical, but be aware of the animal's movements, because the image stabilizer will compensate for the photographer's movements but not for those of the animal during long exposures. Optically, the 300mm f/4 stands up to professional lenses, thanks to its components of ultralow dispersion glass. For that matter, many pros prefer the 300mm f/4 to the 300mm f/2.8, which is too heavy for long hikes.

Those who like photographing forest animals will still be drawn to the 300mm f/2.8, in spite of its size, since there's never enough light in the

forest. This ultrafast lens is certainly heavy (around 6½ lbs. or 3 kg), but its large diameter lets you take photographs in low light with films of standard sensitivity. A monopod is essential as a lens support and makes carrying the equipment over your shoulder much easier. In the past, many amateurs mounted their long lenses on stocks, like those on rifles. This custom fell into disuse with the introduction of multiple-element telephoto lenses, which are much less tiring to hold. Moreover, the stock only gives you limited additional stability. A monopod is much more practical and useful.

Before the introduction of image-stabilized lenses, gunstock mounts were used for stalking animals in the open. The camera was operated directly by a cable release mounted in the place of a trigger.

The Photographer's Gear

The photographer's clothing should be practical, water-resistant, and protect against dirt and thorns. Military surplus stores are overflowing with used clothing of sturdy fabrics, whose green color blends in with the natural environment. If you're allergic to olive drab, any slightly faded clothing in natural tones (tan, brown, khaki, etc.) will do fine. The pockets should have zipper closures, and it is essential to avoid any buckles or straps that can catch on the vegetation.

The rest of your gear depends on the season. In summer, avoid cotton underwear, which absorbs perspiration and takes hours to dry. Synthetic fabrics made for hiking dry more quickly, especially on your back, under your pack. In the winter, do your shopping in the ski section. Warm, light underwear and high-quality polar fleece will serve you well in the early hours.

There are differing opinions about footwear. Some photographers like rubber boots, while others prefer hiking boots. Rubber boots will protect you from water and mud, but they are heavy and not very comfortable. Hiking boots are usually comfortable and especially practical if they are lightweight and waterproof. Those lined with GORE-TEX® or similar materials are waterproof without causing excessive perspiration. Choose boots with VIBRAM® soles that stick to any surface and minimize the risk of falls. As for socks, nothing beats wool, which can keep you warm even when it's wet.

Finish off your outfit with a camouflage net from military surplus. You can use it as a scarf when it's cold, and it will help hide you in the field. In case you encounter an animal unexpectedly, lie down on the ground under the netting, and you have a chance of escaping unnoticed. On the other hand, avoid stuff like camouflage makeup and deer-attracting perfume. The discreet photographer who knows in what direction the wind is blowing doesn't need to dress up like Rambo.

Stalking in the Underbrush

When you stalk an animal in the underbrush, you can take cover behind trees and bushes. These are a big help, but you still have to move noiselessly over the dried leaves and through the bushes. Before approaching your subject, pick out the most hidden path, and the one least obstructed by plants that can snag your clothes. Make sure which way the wind is blowing before you begin. Mammals can smell odors several hundred yards or meters away. It's no good trying to hide behind a bush if your scent is acting like the flashing lights on a fire truck.

In the underbrush, a discreet approach will let you focus in on wary animals.

Greater Flamingo
(*Phoenicopterus ruber*)
200mm lens
1/100 sec. at f/8 - AF.

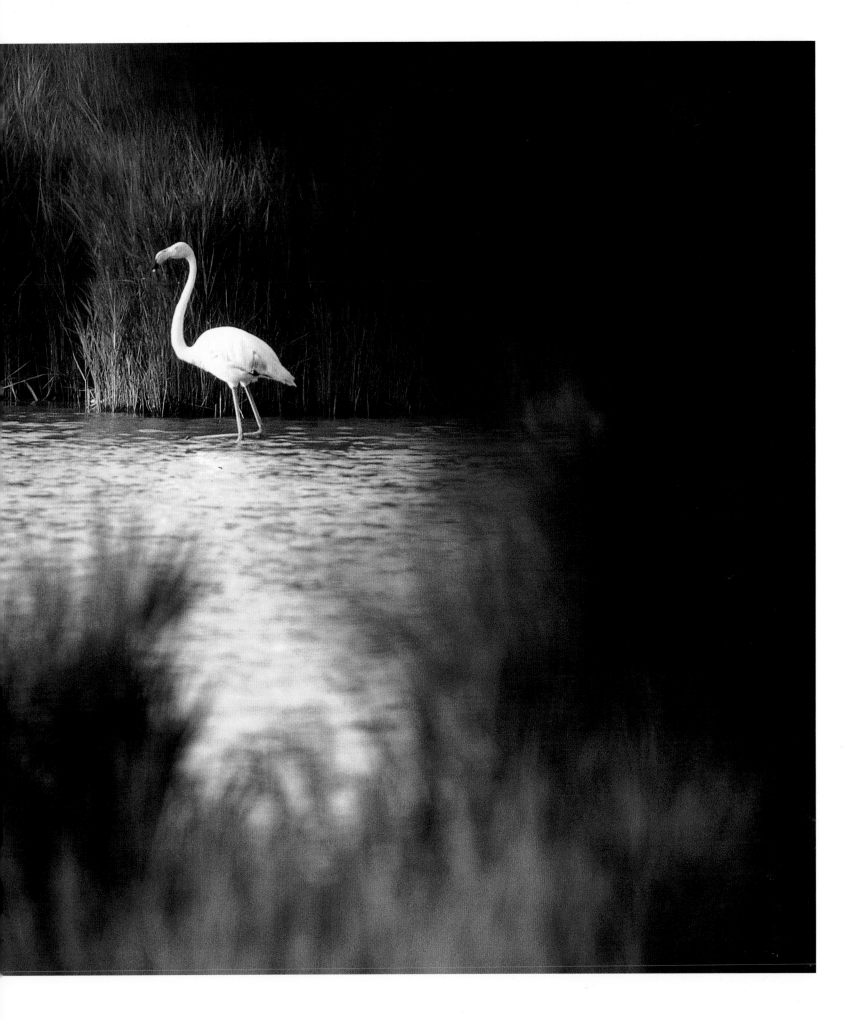

Stalking over Open Ground

Gilles Martin approaches a young elephant seal in the rookery at Punta Delgada (Patagonia). Photograph: Philippe Huet.

When you stalk over open ground, your subject sees you coming but doesn't identify you as a threat. You have to crawl over the ground carefully, without betraying the least interest in the animal. Wear clothing that blends with the landscape and spread a camouflage net over yourself. This becomes a game of patience between the animal as it goes about its business and the strange mound, which seems to move from time to time. About ninety percent of the time, your approach will end with the animal running away. Each species has its own safety zone, which can vary from one individual to another. But one magical day, the animal tolerates your presence more than usual. Your shutter clicks, it raises its head, waits a moment, and goes back to browsing. This little game may last long enough for you to take several photographs. Sometimes the animal won't leave. Once you've taken your photographs, you have to crawl backwards without frightening it, which isn't always easy to do. To keep up your morale, remind yourself that the same animal may be there tomorrow, when the light will be better.

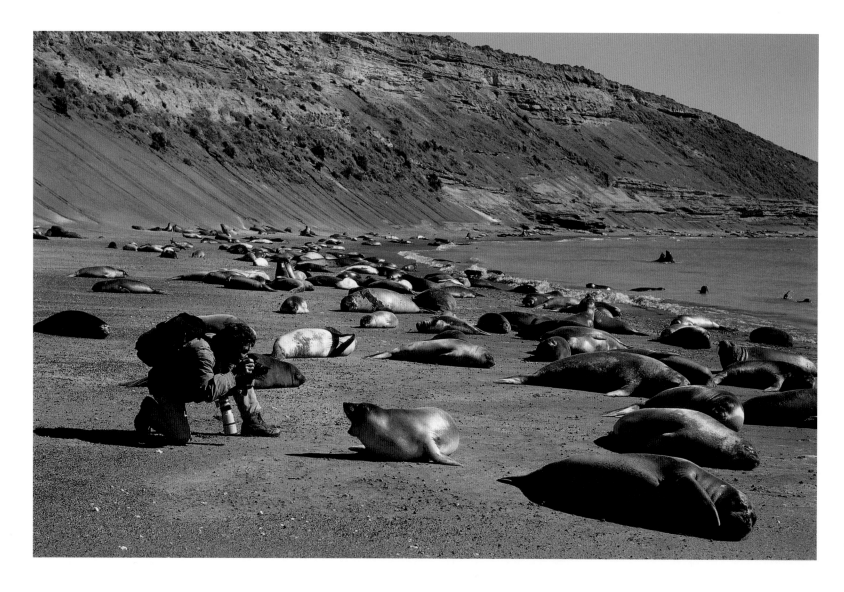

One of the pictures of a young elephant seal taken during this approach. The animal barks a challenge but is still relaxed enough to remain lying down.

Southern Elephant Seal
(*Mirounga leonina*)
300mm lens
1/320 sec. at f/5.6 - AF.

Flight Distance According to Species

Sea lions fleeing from the photographer: "Never get between marine mammals and the ocean, since they may feel trapped and can attack."

South American Sea Lion
(*Otaria flavescens* or *Otaria byronia*)
300mm lens
1/250 sec at f/5.6 - AF.

An animal's flight distance depends on available cover, the escape routes provided by the environment, and on many other factors linked to the season, the weather, and the individual's "personality." Generally speaking, birds are more easily approached than mammals, since birds rely most on their highly-developed vision. Ducks, egrets, and spoonbills are fairly easy to photograph while they are feeding. Herons are more troublesome. Cranes are among the species that are quickest to fly away, with a flight distance of as much as 2,600 feet (800 meters). With songbirds in wintertime, a little food will let you get almost close enough to a robin to touch it. The same bird may seem like an ungrateful animal when it takes flight at almost 100 feet (30 meters) once the weather is good.

The quick intelligence of the corvids (crows, magpies, jays) makes these birds difficult to photograph. They'll investigate food if there's no one around, but will fly away without further ado at the least alert.

The sense of smell is enormously important to mammals. Your scent, whatever it may be (perspiration, perfume, cigarettes), is instantly perceived. From a distance, the animal watches what you do and how you act and prepares to flee in case you come too close. From a short distance, it will bolt before even identifying the scent carried by the breeze. As soon as you spot an animal, check the wind's direction. If it's blowing into your face, continue your approach without making any noise; if the breeze is carrying your scent toward the animal, you might as well give up because it already knows you're there. It's better to pretend to leave, while resigning yourself to a very big detour to come back by another route altogether.

Research and Documentation

Wildlife photography requires careful preparatory research on the regions to be visited. It is almost impossible to find an animal or plant if you don't understand its habitat. Take the season, weather, and the time of day into account when you look for your subject. Natural history guides will give you precise information about the area you visit, from its geology to the animals you're likely to encounter there. Bring field guides to help identify the species you encounter, essential for being sure what you're photographing, as well as for informing you about the animal's behavior. In protected areas, park rangers can be of help, as long as you know your subject and can demonstrate that you're a responsible photographer who won't harm the reserve in order to take a photograph.

Locals are a good source of information. They know the region intimately and can inform you about areas rich in animals, superb landscapes, streams, lakes. Some can even open the doors to previously inaccessible places. Contacts like these are indispensable in many areas, where the interesting places are almost all on private property. Making such contacts easily is a great advantage to the photographer.

Stationary Blinds

Setting up a stationary blind requires that you do your homework to confirm the common presence of the species you want to photograph. Trails made by the animal, signs (feces, droppings), and sightings at different times of the day will give you the information you need to choose a good location for the blind. Before you install it, set up a decoy the same size as the blind, made of some branches and old tarp. Leave this temporary installation in place for a certain amount of time to get the animals used to this new element in the landscape. Come back later to set up the real blind at a time when the species is not active. Build a solid blind, covered with light waterproof canvas (be careful about synthetic cloth, which is noisy and prevents moisture produced by respiration from evaporating). Once you're certain that the animals will accept the blind, you can move in as soon as the area is deserted. It's best to arrive at the blind with a second person and have the other person leave immediately. An animal observing the scene will think that the blind is empty once calm is reestablished at the site. The first thing to do in the blind is to prepare everything you need to take photographs. Mount the lens, load film and new batteries, place your "ammo" nearby, and remove noisy wrappings in advance (except for the plastic canister that protects the roll). A second camera body, equipped with a shorter lens, is handy if the animal stops right in front of the blind. This always happens when you're not ready. Blinds have to be comfortable since spending eight or ten hours in a badly set up blind is torture! Locate the blind in the shadows, and make sure that you have enough space to stretch your legs. Include nourishing food, water, a blanket, and an empty bottle so you can relieve yourself (if you mark your territory, the animals will stay away). A field guide and a pair of binoculars will let you pass the time by reviewing standard procedures. The wait will sometimes seem long, but what excitement when the animal finally comes into view! Furthermore, an inopportune exit can spoil your chances of using the area you've put so much work into. Patience is your photographs' strongest ally.

Using natural elements, it is easy to blend the stationary blind into the landscape.

Mobile Blinds

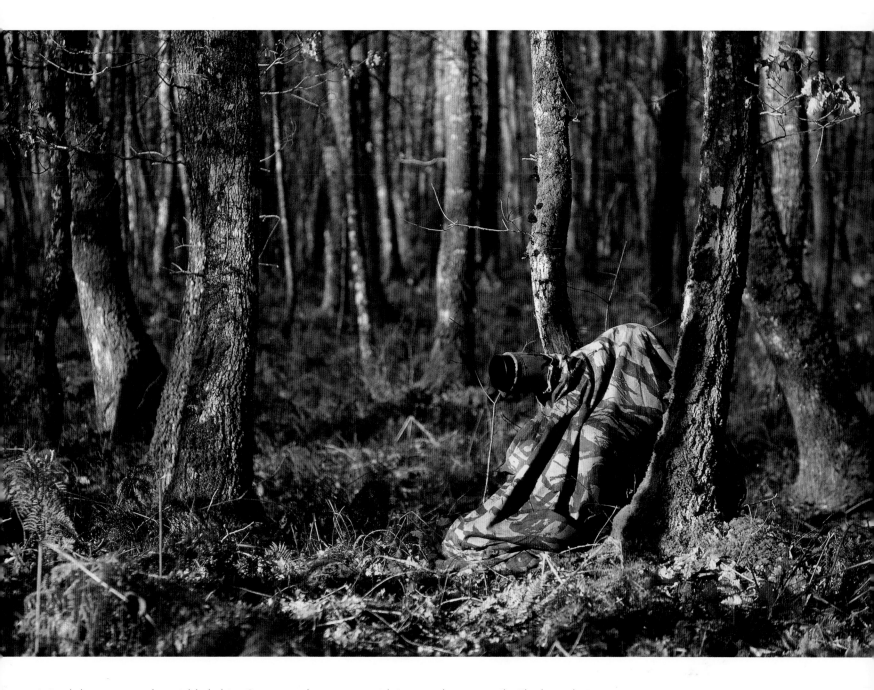

Animals have extremely variable habits. Some travel the same route every day, while others wander through their territory by circuitous paths. Light also changes through the course of the day, and it may be a good idea to change location to maximize your chances of taking a good photograph.

A mobile blind is the solution to all these problems. It lets you move about as necessary, e.g.,a bottomless blind equipped with straps lets you pick it up and move easily. The best design has a rigid tubular structure upon which the camera can remain mounted as you change your vantage point. Similarly, all your accessories have to move with the structure (adhesive tape, snap hooks), so you won't lose anything en route. Take advantage of the time when the animals are away to turn the blind or reposition it—without making any noise, of course.

Halfway between stalking and blind, a simple camouflage cloth lets you hide in a few seconds. This method, less restrictive than setting up a stationary blind, lets you cover large areas with better results than stalking.

Buried and Elevated Blinds

The wariest species, which live on the plains, can be photographed from a buried blind. Dig a hole big enough for you to lie down in stretched out full length, and cover it with a waterproof tarp secured with camping stakes. In wet weather, put two poles in the middle of the tarp to drain the water off to the sides like a tent. When the soil is sandy, and if the blind is going to be there for a long time, dig deeper so that you can sit down in the hole. When you're not there, stretch construction warning tape from four stakes to warn any hikers of the presence of the hole. When it's dry, protect your photographic equipment with a cloth or plastic bag sealed with adhesive tape, since the wind kicks up more dust at ground level.

Although photographing birds in their nest is strongly discouraged, you may want to set up an elevated blind, especially as part of a scientific study in collaboration with a researcher. A blind set up in a tree must not be flimsy. The tree has to be solid, in good health, and formed so that your installation will do no harm—a tree is a living organism.

Actually, for short-term use, it's enough to mount a tarp blind on a tubular structure, with snaps and straps, making sure that the structure is sufficiently rigid. As with any stationary blind, give the animals enough time to get used to the blind before using it. It's imperative to attach each accessory to the blind's framework or to solid branches. Finally, wear a climbing harness and attach yourself at two different points to prevent any catastrophic fall.

Lacking a convenient tree, a collapsible tower is the only answer. Such materials may be rented from concert, film, or construction equipment suppliers. Be careful; towers used in construction are heavier. We won't go into how to set them up safely, which depends on the model, but be sure to get as much information as you can from the renter and from regulatory agencies. Setting up building scaffolding requires careful planning.

Setting up a blind is easier in a collapsible tower than in a tree, since the tubing that forms the structure provides attachment points for equipment and structure. You should use a very long lens (from 500 to 600mm), since the distance between your structure and the subject you're photographing must be great enough not to disturb the animal.

A buried blind gives a very interesting worm's-eye view. It shows the animals' environment as they see it and eliminates foreshortening. As with any stationary installation, this blind requires authorization from the property owner.

Montagu's Harrier (*Circus pygargus*)
Tripod-mounted 300mm lens
1/200 sec. at f/8 - AF.

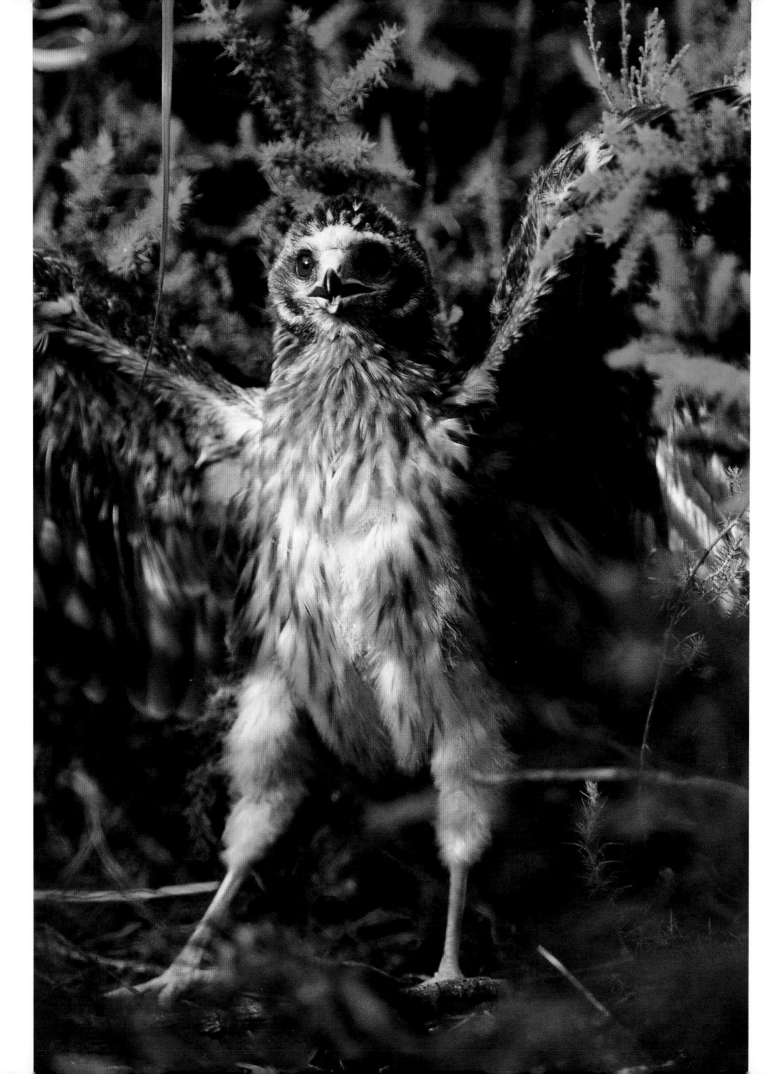

Floating Blinds

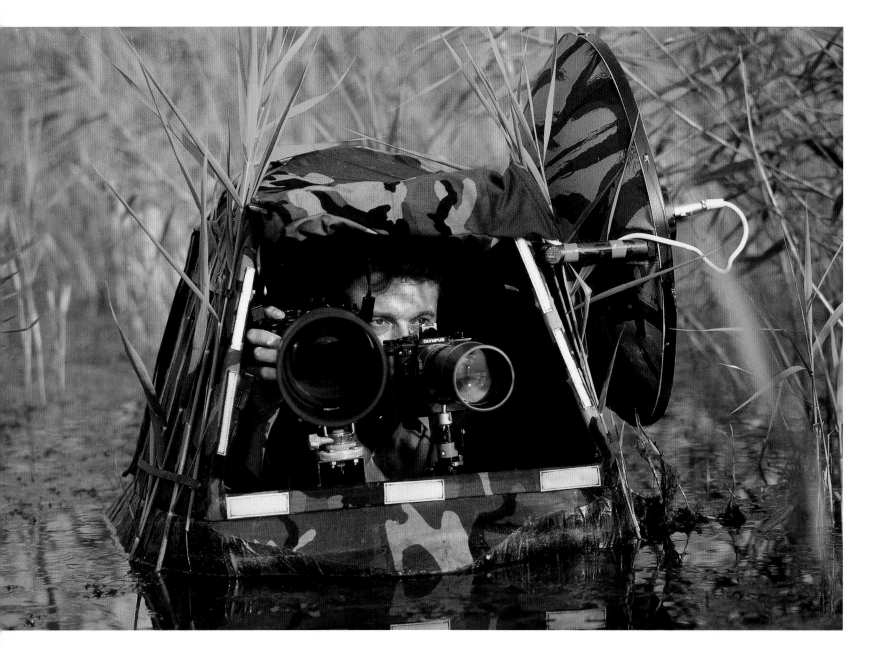

This floating blind is equipped with two cameras focused on the same subject. This makes it easier to select the magnification you need. On the side, a parabolic microphone records the sounds of the lake. Photograph: Houria Arhab.

Taking photographs of waterfowl is often complicated by the large distances between the shore and the animals' habitat. As long as you're not afraid of getting wet, a floating blind will let you get very close to such birds. These blinds are nothing but camouflage cloth stretched over a fiberglass or aluminum framework, which covers the head and shoulders of the photographer, who stands in the water.

The blind is constructed over a floating structure (here, an oak hull filled with expanded polystyrene), with one or more openings for lenses (e.g., a 500mm f/4 and a 300mm f/4). The camera and lens are mounted on the blind's floating structure, which must be stable when the equipment is attached to it. Camouflage netting placed on the blind hides the end of the lens where it protrudes.

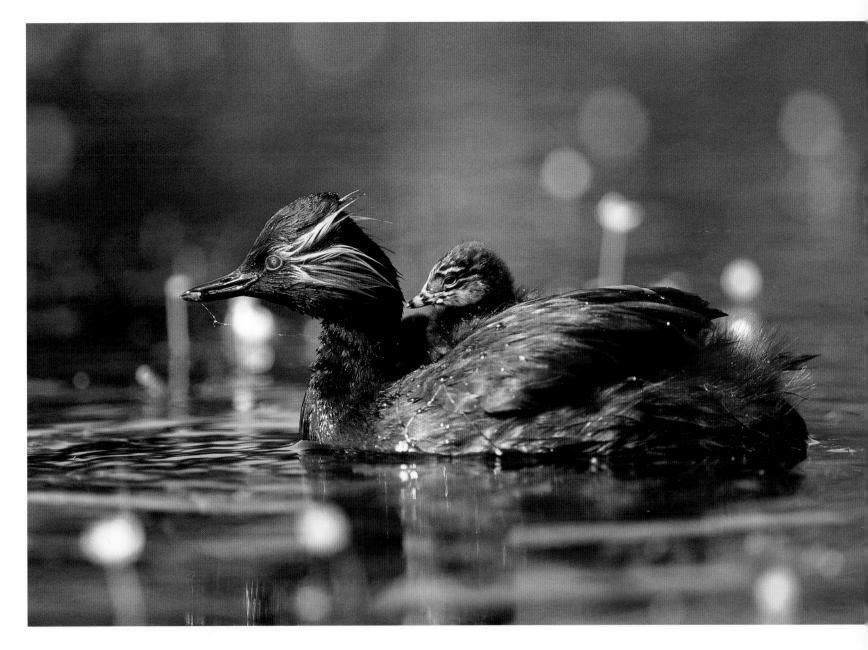

Three things are essential: the blind must be large enough to be stable, the water body must have an even bottom, and you must protect yourself against hypothermia by wearing a wetsuit when it is cold. The blind may be used from March to July for photographing courtship and nest-building.

The more comfortable boat blind will keep the photographer dry. This is a tarp-covered hull with a small electric motor, which lets you move about on the water without disturbing the animals, especially if the resident birds are used to fishermen.

As in any other vehicle, the telephoto lens is supported on the structure using a cloth bag filled with plastic beads or rice.

A monopod may be used in a boat, but it's less effective than a beanbag, which is very good for absorbing vibration.

Symbiosis between the wildlife photographer and his subject: this Black-necked Grebe is attracted by the insects stirred up in the mud by the cameraman's feet.

Black-necked Grebe
(*Podiceps nigricollis*)
300mm lens
1/250 sec. at f/5.6 - AF.

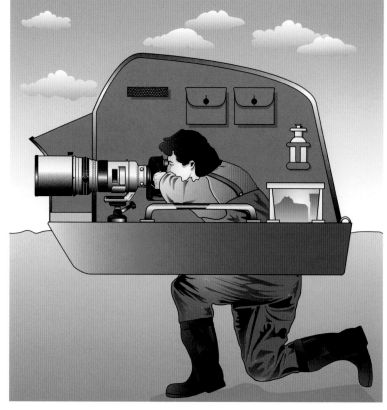

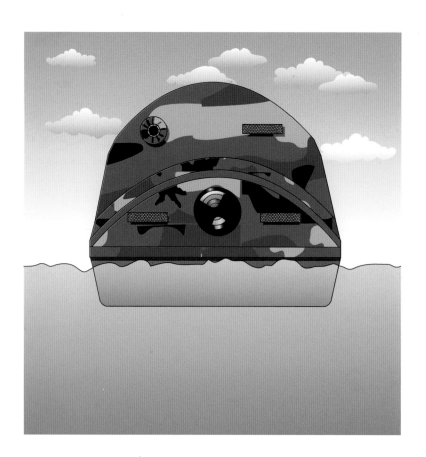

The floating blind contains everything the photographer needs: mount for camera and lens, side handles for relocation and to serve as arm rests, watertight compartment for extra equipment and film, storage pouches, and a water bottle. This last item is very important when the photography session lasts several hours.

OPPOSITE

The floating blind allows the photographer to get very close to his or her subject without disturbing it. These Whiskered Terns, usually very shy, are here completely at ease.

Whiskered Tern (*Chlidonias hybridus*)
300mm lens
1/200 sec. at f/4 - AF.

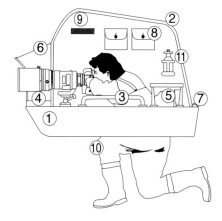

1) The horseshoe-shaped floating base is made of a wooden hull (¾ in. or 2 cm thick oak planking). The interior is filled with polystyrene foam.

2) Framework of light, corrosion-resistant aluminum tubing, ¾ in. (18 mm) in diameter.

3) Handle for moving the blind. It is also used as an armrest when shooting and to adjust the horizon line.

4) Rigid foam to cushion the lens if it should fall forward when the ball-and-socket joint is loosened.

5) Watertight container (one per side) for storing equipment and film. Also serves as a counterweight to stabilize the blind.

6) Sheet-aluminum shield. Protects the lens from rain.

7) Ring for anchoring the blind.

8) Storage pocket sewn into the cover.

9) Peephole.

10) Hip waders or watertight overalls.

11) Water bottle.

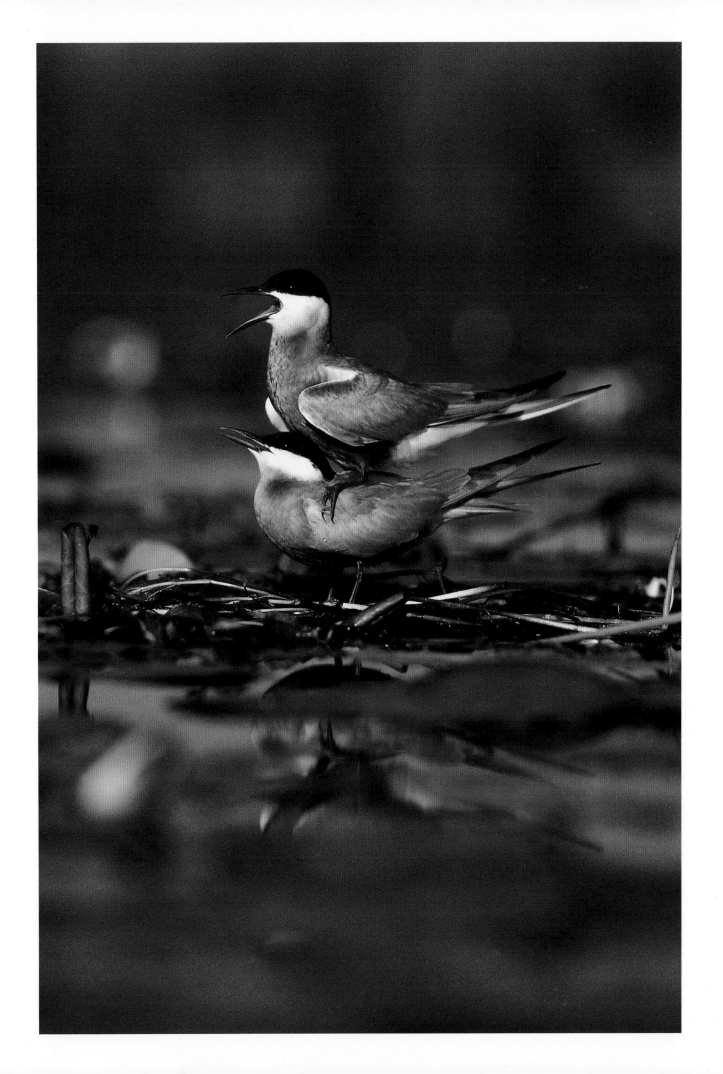

Attracting Animals to the Blind

A blind set up by a wildlife photographer who has done his homework will usually produce many opportunities for taking photographs. Depending on the terrain and species selected, there are areas where animals traverse regularly, and where they eat and drink. There are still times when the most experienced photographers are desperately inactive, without anything at all in front of their lens.

Others are working on such specific projects that they are only interested in a single species, even if it means passing up excellent opportunities. The solution to this problem is to attract the animals to the blind, but you have to know what you're doing.

The surrounding vegetation lets you make the blind totally invisible when necessary. Here, set near a wild-boar wallow, the blind is hidden in ferns. Photograph: Antony Mercier.

FOOD

Attracting wild animals with food is easy. Set out a few sunflower seeds, suet, or overripe fruit on the ground, and a wintertime garden quickly becomes the rendezvous for all the songbirds in the neighborhood. The same thing can be done in the forest. The single moral obligation is to continue helping your little friends during the coldest part of the year to thank them for their assistance. With mammals, things are more complicated. First of all, you have to know the feeding habits of the animal, i.e., what do deer, antelope, or bears eat?

Natural history guides can inform you on the eating habits of every species. Salt licks are an excellent lure for herbivores (which often lack mineral salts; deer and bighorn sheep often mix with flocks of domestic sheep to use the salt licks shepherds set out). To avoid disturbing the local ecosystem, always leave the minimum amount of food necessary. You only have to attract one or two individuals at a time to take pictures.

Feeding carnivores is more difficult. You can spend hours looking at a chicken carcass without a fox showing the tip of his muzzle. On the other hand, if you leave your blind for a few hours, the chicken will end up in the wily animal's stomach. You should understand that carnivores have a fixed territory, which they patrol regularly, in search of food.

The first thing to do is to look for droppings and strong-smelling markings. Begin by setting up a dummy blind and, from time to time, set out a piece of chicken that will be visible from your blind.

If the food disappears regularly, set up your real blind after several weeks. Next, move into the blind and wait for the animal, who has become used to finding a free meal near your blind. Depending on the wind and how wary the animal is, you will have a chance to take some very good pictures or run the risk of being spotted before you take even a single one; that's what makes wildlife photography so exciting.

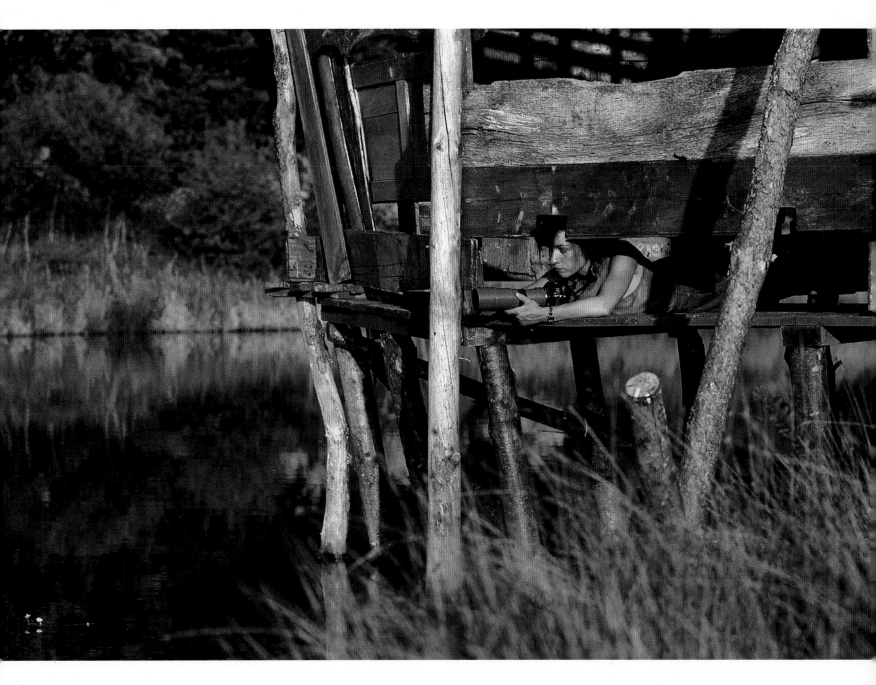

USING LURES

Lures are especially effective with birds during the breeding season. Generally speaking, you can imitate the bird's song in order to attract members of the species or set out decoys on a body of water to encourage those that fly by to land. Acoustic lures may have undesirable side effects on the local ecosystem. They disturb adult birds who are busy feeding their chicks, make males in the neighborhood aggressive, and may even attract predators, who are also drawn by these imitations. For these reasons, they should be used on a very limited basis, perhaps for just enough time to check for the presence of the species in a given area.

A hut or tourist blind, present in the area for years, is completely ignored by the animals. It provides a good opportunity to take some easy photographs.

Lenses for Use in Blinds

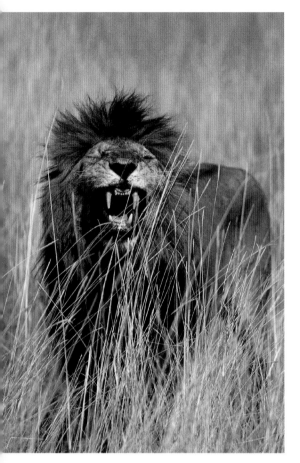

200mm

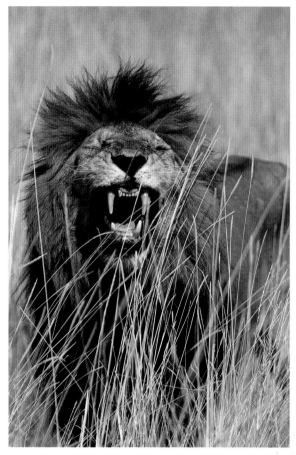

300mm

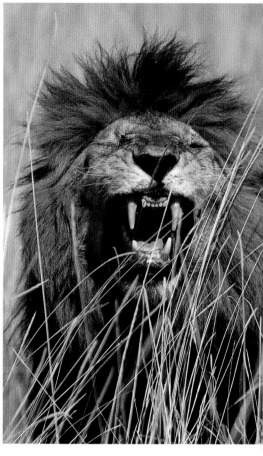

400mm

The photographer who is forced to remain in a blind needs at least two lenses. A medium telephoto lens (around 200mm) can be used for photographing subjects who come close to the blind and a longer focal length (400 to 600mm) for wary species and small animals. In both cases, fast lenses will give you greater flexibility in low light levels. The bulk of the longest lens isn't an issue when you're in a blind, since it has to be mounted on a tripod in order to be useful, anyway. Beyond 600mm, we enter the realm of extreme

focal lengths. From 800–2000mm, the magnification is such (from 16x to 20x) that the least vibration will affect the image's sharpness. It's not unusual to have to mount these lenses on *two* tripods. Another consequence of high magnification is that as soon as the sun warms the atmosphere, the resulting turbulence also degrades sharpness. Unless you absolutely must document a particularly rare and shy species, lenses with focal lengths longer than 600mm are rarely necessary. The 300mm f/4 used with a 1.4x

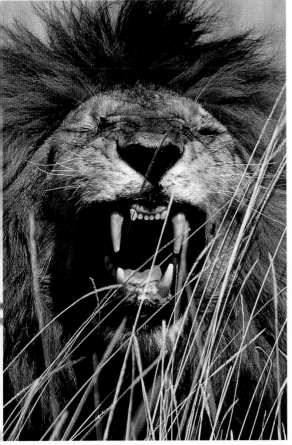

500mm

600mm

This big male in the Masai Mara Reserve has just smelled the territorial mark of another lion. Turning off the autofocus is essential here to avoid focusing on the blades of grass. Depending on the focal length selected, you can use a wide frame and emphasize the diagonal line of the grass or come in tight on the lion's head to follow his behavior closely.

Serengeti Plain (Tanzania).
Lion (*Panthera leo*)
500mm lens
1/500 sec. at f/8 - MF.

multiplier (resulting in a 420mm f/5.6) is a good compromise when you may or may not be shooting from a blind. You can use the lens either with the multiplier or alone depending on your needs. Keep in mind that the optical quality is much better without the multiplier, although if the lens aperture is closed down two or three stops, results can be quite good. This kind of lens is also easy to maneuver, and light enough to carry over difficult ground.

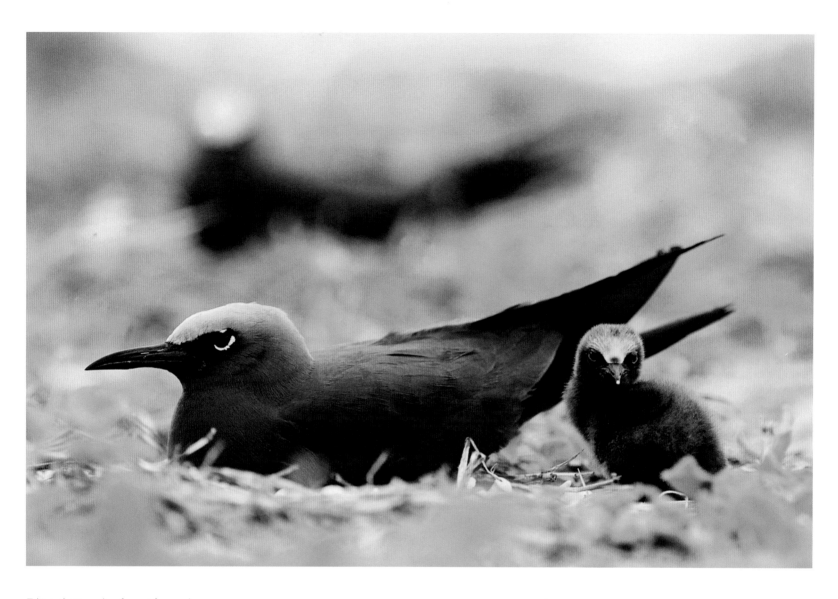

Taking photographs of a nest from a close distance requires a good understanding of the animal's habits. This Brown Noddy in the Amirante Islands is a very trusting bird.

Brown Noddy (*Anous stolidus*)
200mm lens
1/200 sec. at f/8 - AF.

OPPOSITE

Thanks to a flash balanced with the ambient light, this little Tasmanian marsupial is highly detailed and perfectly integrated into its habitat.

Tasmanian Pademelon
(*Thylogale billardierii*)
200mm lens
1/60 sec. at f/3.5 - MF.
Flip-up flash.

Observation in the field is the best way to learn how to find, track, and photograph wildlife. In the beginning, carry a light camera with a 300mm f/4 lens (in case of a chance encounter), and devote yourself to studying the site with binoculars. Take long hikes in different habitats to immerse yourself in the fauna present. Here, a woodpecker flits through the scrub oaks; there, a warbler perches on a stalk in a reed-bed; while far away a bighorn sheep hides in the shadow of a rock face near a cool snowbank.

Little by little, you'll find yourself able to predict what you'll find in different habitats. There are also pleasant surprises, like the marsh owl discovered on the ground in a big field probably infested with rodents. At such times, the camera that has been such a burden up until then suddenly becomes your best friend.

As you wander here and there, you'll discover traces left by animals, such as torn ground indicating the passage of a wild pig the night before, large tubular droppings full of berries revealing the presence of a grouse; while a beautiful track

in the mud can only belong to a great solitary stag. Like a Neolithic hunter, learn to keep your eyes open for subtle clues. Even odors may be helpful (the musky smell of a rutting stag, or the ammonia smell of a hoopoe's nest).

Your hearing will let you identify birds from a distance. The drumming of a woodpecker followed by its characteristic call, will leave no doubt as to the author. The Black Woodpecker, Green Woodpecker, and Great Spotted Woodpecker all have calls that are easy to tell apart. The identification of songbirds, on the other hand, takes both a lot of experience in the field and in listening to high-quality recordings. Listen closely, breathe the forest's odors, look around. Keeping all your senses on the alert will make you a better photographer.

Putting a species' name to the signs left by wildlife entails a lot of field experience. In the meantime, studying field guides is a great help. Bring along with you a guide that identifies tracks and droppings, and take photographs of the most typical of them to make your slide shows more

educational. Take advantage of family hikes to teach your children to identify animal signs. Help them make plaster casts and drawings, which will be very useful as captions for some of your photographs. Spotting animal signs will quickly become so automatic that you'll sometimes be surprised to see beginners passing them by without seeing anything.

Your chances of seeing one species rather than another varies enormously with the season. Migration, courtship displays, reproduction, nest-building, feeding the young, and fledging are all good times to take pictures. The arrival of the cuckoo, the first call of the oriole, the mating call of the stag, and the migration of the geese are all events that take place at precise dates. The amateur wildlife photographer must plan ahead to be at the right place at the right time for picture-taking. Some enthusiasts take two weeks' vacation at the end of September in order not to miss the rut, others take them in the beginning of July, for the rut of the roe deer; there are even some who leave in November to document the loves of the chamois in the Pyrenees.

The nature photographer who isn't too specialized will have a full date book, which could include among other things, the first nests of the short-eared owl at the end of January, mating of the Whiskered Bat in February, southward migration of the cranes in March, return of the cuckoo and the swallow in April, arrival of the oriole and birth of fawns in May, brooding and hatching of grebes in June, the rut of the roe deer in July, the second nesting in August, the mating call of the stag in September, the rut of the chamois at the end of October, northward migration of cranes in November, and finally the mating of wild boars in December. There's plenty to keep you busy, especially since this list is far from being exhaustive.

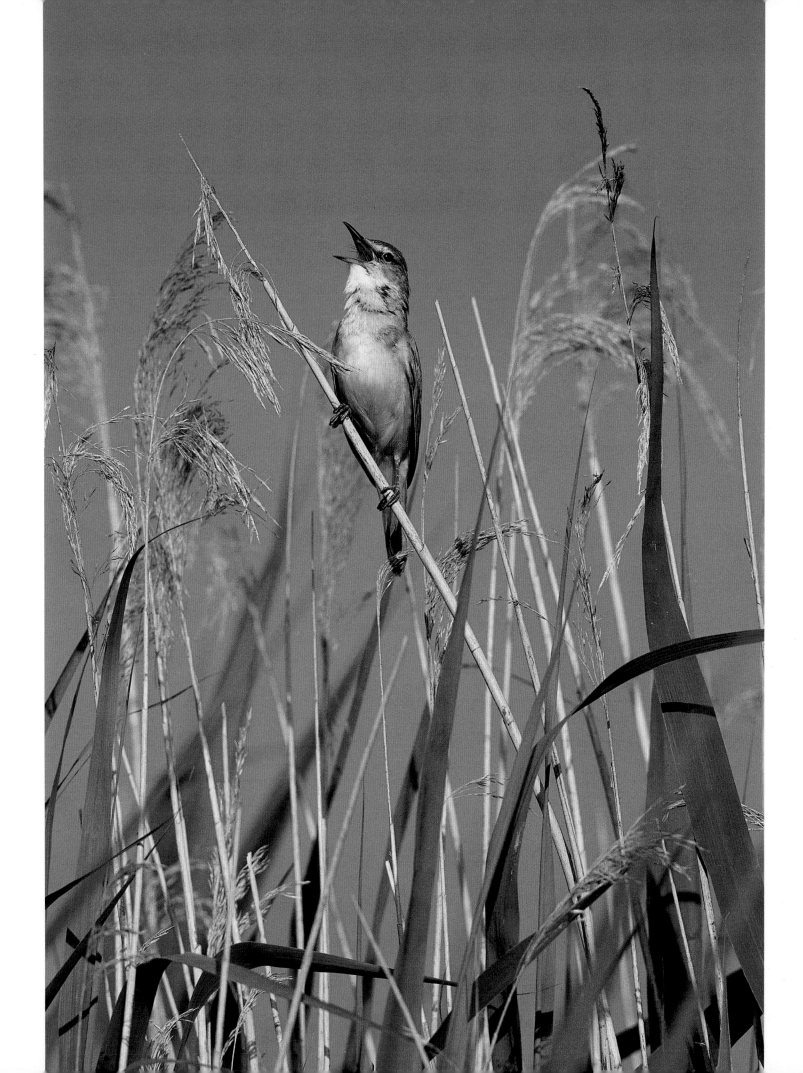

FINDING YOUR WAY

Knowing how to find your way is essential for your safety outdoors. Detailed maps (with a scale of 1/25,000, for example) are easy to find in camping stores or bookstores. For longer journeys, it's a good idea to buy a recent map before you leave, even if you find a better one once you arrive. When it comes to safety, you can't overdo it. Don't be satisfied with the old map a friend generously gives you. Trails and water holes change quickly, especially in countries where their location is most important.

For a map to be of any use, you have to know which way is north. It's easy with a compass, since you just have to look which way the needle is pointing. To travel in a given direction, pick out

a landmark in the distance (a big tree, a mountain) and walk toward it. Once you get there, find another landmark in the same direction, and so on. If you don't have a compass, you can rely on the North Star, which is easy to find at night in the northern hemisphere (see diagram). Remember where the sun rises (east) or sets (west) in order to deduce which way is north. Carry old-fashioned flat razor blades with you. Set one on the surface of water and the arrow engraved on the magnetized blade will always point north. Also a magnetized needle will point north when stuck into a bit of cork floating on the water.

The latest technology uses GPS (global positioning system). It applies triangulation and measurement of the Doppler effect to several of the twenty-four satellites making up the GPS network. This allows calculation of position, speed, and altitude of the receiver.

GPS provided two levels of service: a Standard Positioning Service (SPS) for general public use and an encoded Precise Positioning Service (PPS) primarily intended for use by the U.S. Department of Defense. SPS signal accuracy was intentionally degraded to protect U.S. national security interests. This process, called Selective Availability (SA), controlled the availability of the system's full capabilities. The most effective civil GPS would give measurements within 100 meters (approximately 300 feet). Even so, engineers found a way of correcting this lack of precision through DGPS (Differential Global Positioning System), which partially offset GPS corruption to achieve an accuracy of about 10 yards or meters.

On May 1, 2000, President Bill Clinton ordered Selective Availability (SA) turned off. Since then, civilian GPS users around the world no longer experience the up to 100 meter random errors that SA added to keep GPS a more powerful tool for the military. Today, GPS units are accurate to within 20 meters (approximately 60 feet); although in good conditions, units should display an error of less than 10 meters. Now that SA (Select Availability) has been switched off, both the accuracy and dependability of DGPS has been enhanced. Without SA, the GPS signals are extremely stable, and a good correction every minute or so provides an extended coverage and excellent accuracy (due to noise tolerance being improved).

THE WEATHER FORECAST

It's good to have some idea what the weather is going to do before setting out to take photographs in a remote location. This is especially true in the mountains, where a simple shower can turn into an emergency if you don't have the proper equipment. The more a place is subject to violent changes in the weather, the more you need to know what to bring with you in order to be safe. Often a quick visit to the office of

OPPOSITE

The ideal vehicle for the savanna is a four-wheel-drive truck since tracks and grasslands turn into a mud-hole with the first drops of rain. The following safety equipment is essential:

- special off-road equipment (reinforced undercarriage, heavy-duty shocks, tow straps, winch)
- 53-gallon (100-liter) water can
- food to last a month
- double gasoline tank (autonomy for 620 mi. or 1,000 km)
- shortwave radio
- GPS receiver.

The last item tells you your position even if you've been driving aimlessly for hours.

Polaris—which points north—may be found along the axis of the far edge of the Big Dipper (Ursa Major). Just measure off five times the distance between the two stars to find Polaris, which is also the last star of the Little Dipper (Ursa Minor).

tourism will let you find out the forecast for the next twenty-four hours. Most industrialized countries have well-organized weather services, which publish exact information in the newspaper. In less-developed countries, get general information before you leave (in specialized magazines, on Internet sites, at the embassy). Once you're there, a portable radio will let you get the national and even the local weather, as long as there's a station in the area you're visiting. As long as it's recent, a local newspaper will have detailed information. Also ask local farmers, who are often very good at predicting the weather in the near future. Once you're there, direct observation will let you guess what the weather will do for the next few hours, although the margin of error could be significant. Your forecasting will be better if you have specialized instruments such as a barometer, hygrometer, anemometer, and thermometer. You can buy battery-operated miniature weather stations—including most of these instruments—which will give you more information about the upcoming weather.

In places as inhospitable as this mangrove swamp in Queensland (Australia), knowing how to avoid getting lost and having survival equipment is essential. Map, compass, GPS, freeze-dried food, water-purification tablets, mosquito repellant, emergency drugs, bandages, dressings, and clothing for any weather conditions are a minimum. Photograph: Houria Arhab.

TAKE CARE OF YOURSELF

Being alone in nature can be dangerous if you don't take the proper precautions. Before leaving to take photographs alone, it's essential to give a friend an itinerary and an arrival time, so they can sound the alarm in case of need for such problems as a pulled back, twisted ankle, or broken leg, which can cripple anyone, even close to home. In industrialized countries, a cell phone can take care of the problem in an instant, as long as you have reception. At night, a flashlight or flash unit will increase your chances of being spotted, but having someone waiting for you within a specified range of time is still the best solution. A well-stocked backpack (nourishing food, water, warm coat, waterproof poncho, matches or lighter, survival blanket, mini first-aid kit) will help you to wait a long time without suffering too much from your misfortune.

In a jungle on the other side of the world, the problems are more complicated. Several months before you leave, ask your doctor to prescribe and, if available, administer the vaccines and medications you'll need in the country you'll visit. In metropolitan areas, you can also get information and receive vaccines at hospitals offering treatment of tropical medicine and at travel medicine clinics. Kill two birds with one stone by asking for information about your destination.

Antimalarial treatment is rarely required, but it's imperative to protect yourself in high-risk areas. Ask your doctor, who will have a list of these areas as well as the type of treatment required for the local strain of malaria. If you neglect this protection, you can easily be bitten by a mosquito carrying a strain of this illness, which wreaks havoc in hot and wet areas throughout the world.

To be even more safe, use antimosquito creams, which are made for both your clothing and skin. Of course we don't need to say that it's best to use both. Finally, passive defense is recommended. Keep yourself well covered, especially in the evening and in hot, humid areas.

There are many other tropical illnesses transmitted by insects (sleeping sickness from the tsetse fly), the water you drink (dysentery), bathing water (schistosomiasis), badly washed clothing (subcutaneous parasites), etc. Do your homework and, above all else, pay attention to medical advice so as not to increase your risk needlessly.

A first-aid kit is also indispensable in countries without a developed medical system. A simple scratch can turn into an emergency. Rather than giving you a general list, I suggest you consult your doctor for precise recommendations. Once there, don't, under any circumstances, rely on the "natural" medicine provided by local witch doctors and shamans. It may make things worse, and will always waste precious time.

To get this close to a seabird colony you need to have a good understanding of their behavior. Some species will attack you with their razor-sharp beaks.

Bird Island (Seychelles)
16mm fish-eye lens
1/60 sec. at f/22 - MF.

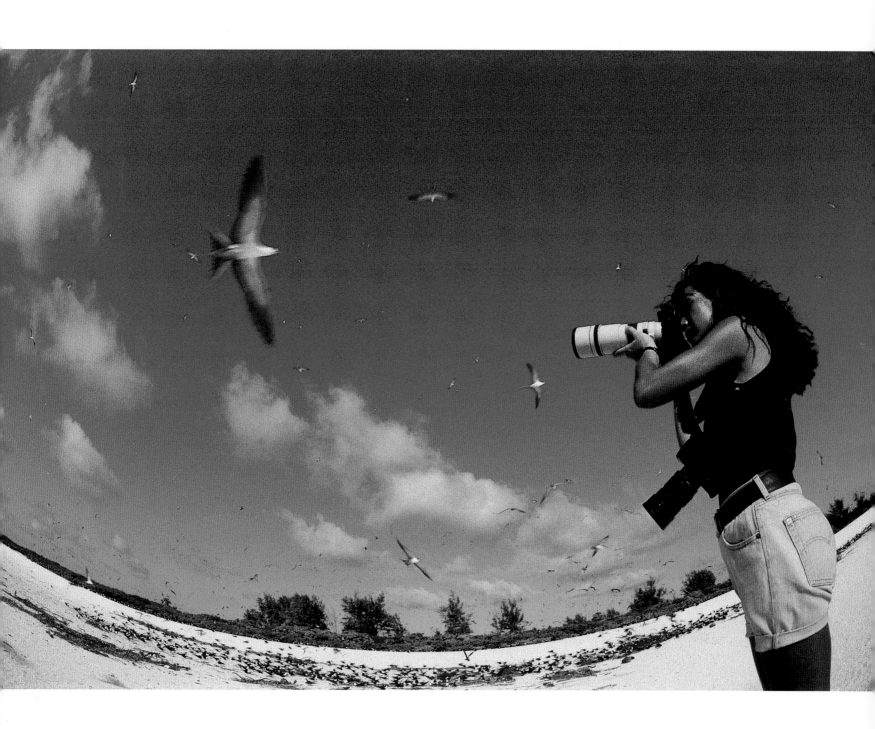

A long lens is essential when photographing deadly snakes.

African Puff-Adder
(*Bitis arietans arietans*),
Botswana
400mm lens with extension ring
1/125 sec. at f/8 - MF.

DANGEROUS ANIMALS

Traveling alone in isolated country will expose you to many risks, especially in the African savanna, where the grass sometimes hides predators in wait. This is common behavior for hyenas, which can disappear from view in 8 in. (20 cm) of grass, since their coat is perfectly camouflaged in their habitat. Felines also take advantage of their camouflage coats to hide themselves, either in the trees (leopards), or in the high grass (lions). You should never leave the safari vehicle out on the savanna, not even for an instant. The local guide leading the safari is the only person who is

competent to evaluate the risks and give you permission to do so. Danger is not always greatest where you would expect, as some who get too close to "peaceful" herbivores on the savanna discover. Buffalo and hippopotamus are among the most dangerous animals and hold the sad record for injuring humans. Even within the enclosure of the lodge (bush hotel), it is never safe to get closer than 1,600 feet (500 meters) to a buffalo. Resist any impulse to get closer, and wait until you're in a vehicle to take photographs. In some game parks in East Africa (Manyara—Tanzania—especially), you can get quite close to hippopota-

mus pools. Local guides sometimes tell you that the rows of stones set around the viewing points are enough to protect tourists. We'd like to think so, but we prefer not to rely on them. As far as we're concerned, we're more comfortable photographing the hippos from a four-wheel-drive vehicle. When you're taking photographs near water, don't forget that there may be crocodiles. They look just like floating logs and can move very quickly. Also be careful with rhinoceros. They have poor vision but a keen sense of smell, and their charge is incredibly powerful. People say that all you have to do is jump aside, and the

animal will rush by without seeing you, but we would rather not put this rumor to the test.

Other kinds of animals, like snakes, insects, and parasites, require constant vigilance, especially when you're photographing venomous animals in places without good medical services. It's less dangerous to use accessories for photographing from a distance than to attempt to approach a large viper or any other venomous snake. Another solution is to use a long lens to keep out of the danger zone. These tricks also work with arachnids (spiders, scorpions), which can be quick to crawl into clothing and sting.

"To get near dangerous or very shy animals, I designed this little wheeled dolly at the end of a long pole. It lets me get photographs of animals in their environment with a super-wide-angle lens."

Using a flash in daylight helps to "clean up" shadows in a backlit shot or add brilliance to the eye of a bird with matte black plumage. You need to use enough light to balance the ambient light. Most modern SLRs will automatically control fill-in flash, using the background measurement of the multi-segment metering as a point of departure. Some are quite accurate, while others have a tendency to overexpose the foreground. Take some trial shots to figure out the exposure correction applicable to the flash (–1/3 to –1 EV, depending on the camera).

Using a flash in daylight requires a high X-synchronization shutter speed. If the shutter speed isn't fast enough, the ambient light level may dictate an aperture incompatible with the distance between flash and subject. On high-end cameras, X-synchronization speeds of 1/250 sec. give ample flexibility for daylight flash. A few cameras without such high-quality shutters make up for this lack with a high-speed synchro system called FP synchronization, which lets you use shorter exposure times.

Instead of exposing the whole image with a quick flash as with X-synchronization, the camera calls for a long flash (around 1/60 sec.), which illuminates the subject for the whole time the shutter opening sweeps the image. Using this technique, there are mid-range cameras that will synchronize up to 1/8,000 sec., while their shutter's X-synchronization speed is only 1/125 sec. This technological trick has a drawback since the power of the flash decreases as the shutter speed increases.

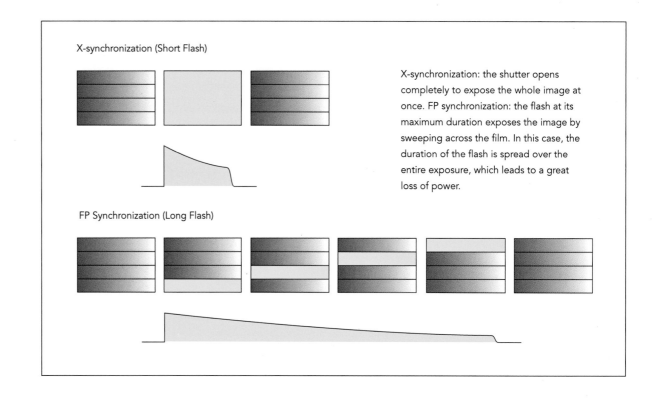

X-synchronization (Short Flash)

X-synchronization: the shutter opens completely to expose the whole image at once. FP synchronization: the flash at its maximum duration exposes the image by sweeping across the film. In this case, the duration of the flash is spread over the entire exposure, which leads to a great loss of power.

FP Synchronization (Long Flash)

Fill-In Flash

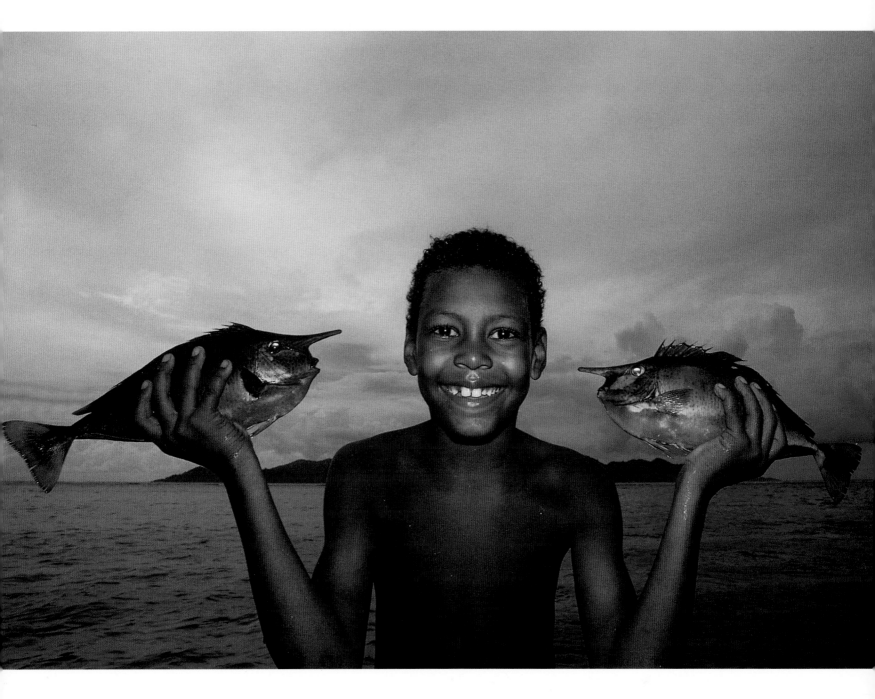

With older cameras, which lack both rapid shutters and FP synchronization, the low X-synchronization speed (from 1/50 to 1/125 sec.) means that you must stop down a lot if the ambient light level is high. This requires a very powerful flash, since the aperture controls the range of the flash. The procedure for taking pictures is simple. Measure the ambient light without exceeding the X-synchronization speed, and calculate the distance between flash and subject compatible with the given aperture (GN ÷ aperture = distance). To give less importance to the light coming from the flash, move back slightly (40% increase in distance equals −1 EV).

Fill-in flash (or daylight flash) allows balancing a foreground lit with the flash and a background lit by natural light. Young fisherman in the Indian Ocean.

24mm lens
1/60 sec. at f/11 - MF.
Flip-up flash.

Backlighting

Beginners often think that backlighting poses an insurmountable problem—a leftover from the days when film boxes included directions to "put the sun at your back before taking your photograph." Today, lens coatings will let you take a photograph with the sun almost in front of your lens without causing flare (parasitic reflections between the lenses), which often spoiled photographs in the past. In fact, backlighting can be one of the photographer's best friends since it creates extraordinary lighting, adds relief to landscapes at the end of the day, and creates a halo of light around an animal's fur.

There are many kinds of backlighting. The bold backlighting of full daylight is the most difficult, since it only leaves you with two possibilities. You can set the exposure for the highlights and block the shadows or set the exposure for the shadows and overexpose the highlights. SLRs with multi-segment metering will handle backlighting pretty well when the subject fills a large portion of the viewfinder. The camera automatically meters the low light levels to make the details visible in the shadows. But as soon as the bright background occupies a larger area than the animal, the metering will ignore it and concentrate on the highlights. In this case, it's better to set the camera on selective or spot metering to meter the light from the important part of the subject. Another solution is to leave the camera set on multi-segment metering and correct the exposure by +1 to +1.5 EV so as to overexpose the bright area and emphasize the backlit subject.

Backlighting earlier in the day is easier to control, since the atmosphere diffuses the light more. This causes partial backlighting, which lets you expose brighter and darker areas judiciously without enduring great variations in light. When the sun is directly behind the animal, there are two solutions. Either set the exposure for the brightest areas (multi-segment metering with exposure correction set at −1 EV) and photograph the animal silhouetted against the background or —if you're willing to take a risk—use the flash as fill-in to balance the light between foreground and background, assuming you're close enough to your subject.

Late in the day, backlighting is softened by the low contrast between the setting sun and the sky, which is still luminous. You can shoot without correcting the exposure with multi-segment metering. The photograph will have readable details in the shadows, and the highlights will be perfectly defined. Of course these are not ironclad rules, since place, season, and weather cause wide variation in conditions. Selective or spot metering, exposure correction, and bracketing will reduce risk in doubtful cases.

Most SLRs will automatically adjust for this kind of high-contrast backlighting. If you're not sure, take a second shot at −1 EV.

Pochard (*Aythya ferina*)
Image-stabilized 300mm lens
1/30 sec. at f/4 - MF.

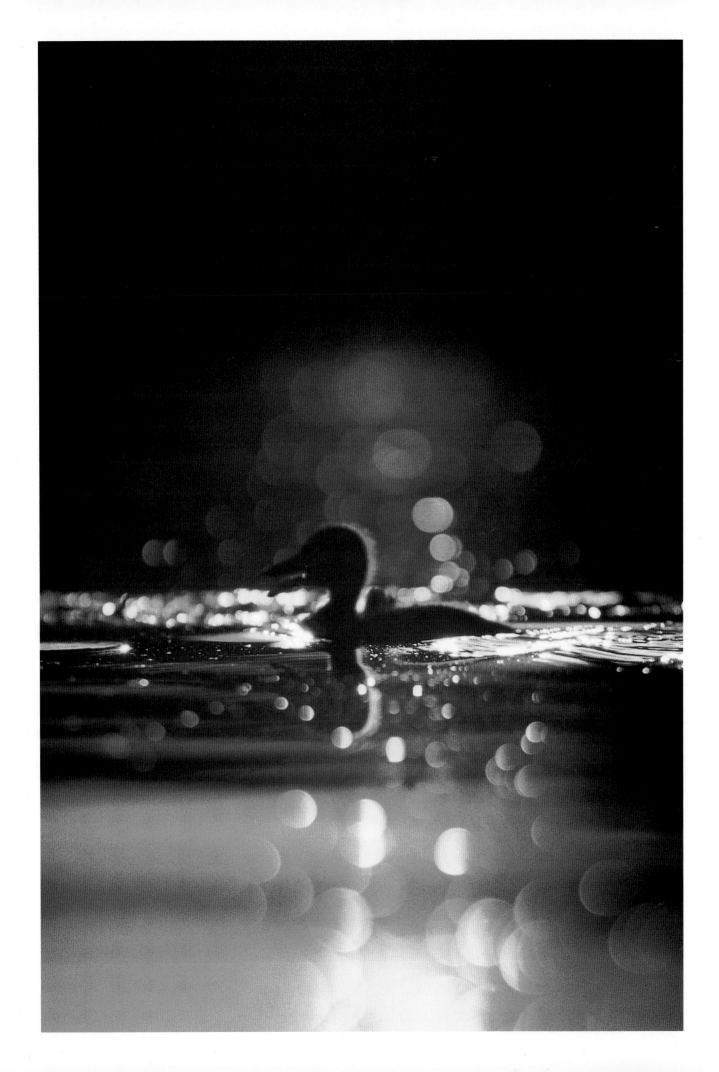

Zoom Exposure

At low shutter speeds it's easy to zoom in during the exposure. This stretches the subject away from the center of the image.

Etosha National Park (Namibia). Image-stabilized 100–400mm lens 1/15 sec. at f/5.6 - AF.

Zoom exposure creates a spectacular sense of movement from the center of the image outward in every direction. This effect is created when you zoom a lens throughout its range during a fairly long exposure (around 1/15 sec.). The subject in the middle of the frame is relatively sharp because it is not much affected by the spin-out caused by the variation in focal length. It's best to start zooming, then trip the shutter immediately afterward and finish zooming just after the shutter closes. In practice, this sequence is often only approximated, which makes the effect vary in sometimes unexpected and creative ways. On the other hand, it is possible to control the effect to some extent by varying the exposure time, or by changing the zoom range. Sweeping through a wide range of focal lengths gives a more spectacular spin-out effect.

Bracketing

Bracketing is taking about three photographs with different exposures in order to obtain at least one good picture. With modern SLRs, bracketing is automatic and most have a standard bracketing range of 1 EV (–1, 0, +1).

The order of exposures varies from one model to another but can sometimes be set using customizable features.

The bracketing step size may also be controllable, from ⅓ to 3 EV, depending on the camera. This lets you fine-tune the exposure if the light metering has already been done carefully, especially to ensure a good shot when it is impossible to retake it later. Some cases require bracketing in only one direction; overexposed or underexposed. Using exposure compensation and bracketing at the same time lets you take sequences like 0, –1, –2 or 0, +0.5, +1 EV.

When the exposure bracketing step is small, more than one shot will be usable. Therefore, the photographer will have two or three different shots of the same subject. This technique is very useful for recording the nuances of a sunset or to guarantee the success of a backlit shot taken without a flash.

With bracketing, the exposure indicated by the meter is sandwiched between two other shots: one theoretically underexposed, the other overexposed. This technique is useful when the subject has high contrast, especially when you're unsure exactly how the meter will read the scene. Here the step between shots is 1 EV, but this may be adjusted from 0.3 to 3 EV with top-quality cameras.

King Penguin
(*Aptenodytes patagonica*).

Overexposed

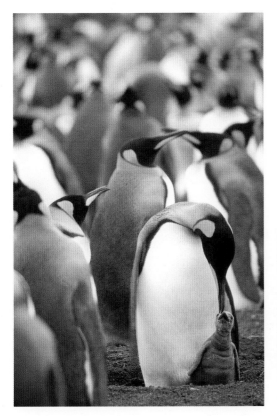

Correctly Exposed

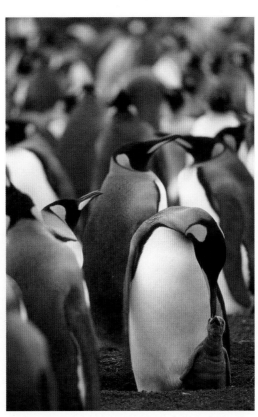

Underexposed

Multiple Exposures

Double exposure: portrait of a lioness and savanna landscape. The two shots are purposely under-exposed by 1 EV so that the superimposition is correctly exposed.

African lion (*Panthera leo*)
200mm lens (lioness)
20mm lens (savanna).

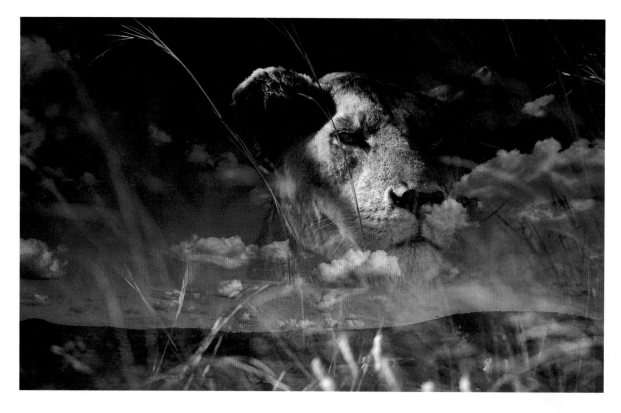

The easiest way to take multiple exposures is to take two shots one after the other without advancing the film. Some SLRs have the capability to superimpose from two to nine shots. Be careful because the camera prevents the film from advancing between shots but pays absolutely no attention to the critical matter of exposure control. You must correct the exposure by –1 EV when superimposing two shots, –2 EV for four shots, –3 EV for eight shots, etc. Go down 1 EV each time the number of exposures doubles. In order to avoid any problem with film advancement, always shoot a blank frame (lens cap on the lens and camera set on manual at 1/1,000 sec.) after the last shot is superimposed. This habit dates from the days when you had to push the film release, block the rewinding knob with your finger, and rewind manually between shots, without forgetting to burn a shot so that the subsequent shot would not overlap the precious multiple exposure.

Multiple exposures create a "third" image by superimposing the first two shots. When both shots are fairly bright, the resulting photograph is not very readable, since parts of both images are mixed up—the visual equivalent of cacophony. A good double exposure is worth a little bit of preparation. Choose two subjects that fit together, i.e., photographs where the dark area of one corresponds to the bright area of the other, and vice versa. Take both pictures at the same time of day

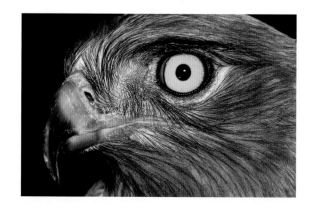

to achieve a uniform light quality. Also try to avoid subjects in motion, which can cause confusion in the second shot when they're absent from the first. If you respect these directions, your multiple exposures will be much more realistic, and their elements will harmonize.

Multiple exposures can also play a practical role in the image. This is true for multiple exposures taken with a flash by tripping it several times in the dark. At short distances when the flash is fixed, an increase in the number of flashes will make up for the modest power of a flash unit. A flash of GN 140, in feet (42 in meters) for ISO 100 used at a distance of 50 feet (15 meters) requires an aperture of f/2.8. If the subject is stationary, use a double flash to "stop down" to f/4, quadruple it for f/5.6, and so on. By the same logic, a single flash can light the inside a large cave. Since the exposure rule for manual flash (GN ÷ aperture = flash-to-subject distance) doesn't depend on camera placement, all you have to do is hold the flash, set the camera to the aperture corresponding to the chosen distance, and direct the flashes—at the desired distance from the subject—to different places, giving as many light sources as there are flashes. Of course, the camera's shutter is opened on "T" (press once, the shutter opens; once more, it closes) using a cable release. Many cameras do not have "T" settings but do have "B," in this case use a locking cable release. It's easier to take pictures like this with two people. One person can cover the lens while the other moves around from one place to another using a flashlight. Be careful not to stand between the camera and the flash when you set it off, or your silhouette will be visible in the picture.

Multiple exposures are sometimes made long after the pictures are taken, for example by placing two slides in the same mount. Though it's better to take shots expressly for this purpose, you may find that two overexposed slides, by chance, give good results when they're sandwiched together. In order to try this technique, use the same basic rule as for normal multiple exposure. Choose compatible subjects both for aesthetic compatibility and exposure. Unlike images super-imposed on the same film, the dark parts of one image will hide the bright parts of the other—so experiment. The most flexible system involves creating multiple exposures and montages on the computer after digitizing the slides. Density and dominant coloration are very easy to adjust, and you have total freedom to put together very different images. Take the precaution of choosing photographs taken at more or less the same time of day to harmonize the components of the future image.

Sandwiching consists of super-imposing two slides in a single mount. Choose slides that are rather overexposed to retain as much information as possible from the originals.

Red Kite (*Milvus migrans*).

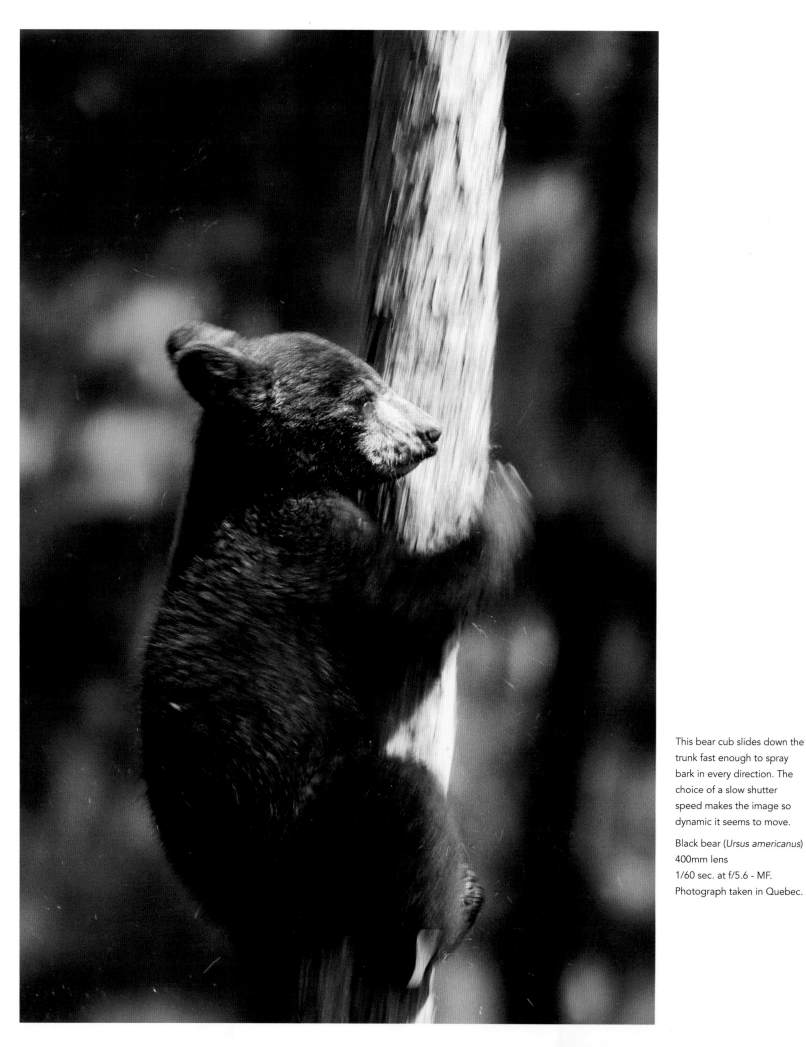

This bear cub slides down the trunk fast enough to spray bark in every direction. The choice of a slow shutter speed makes the image so dynamic it seems to move.

Black bear (*Ursus americanus*)
400mm lens
1/60 sec. at f/5.6 - MF.
Photograph taken in Quebec.

The Sense of Movement

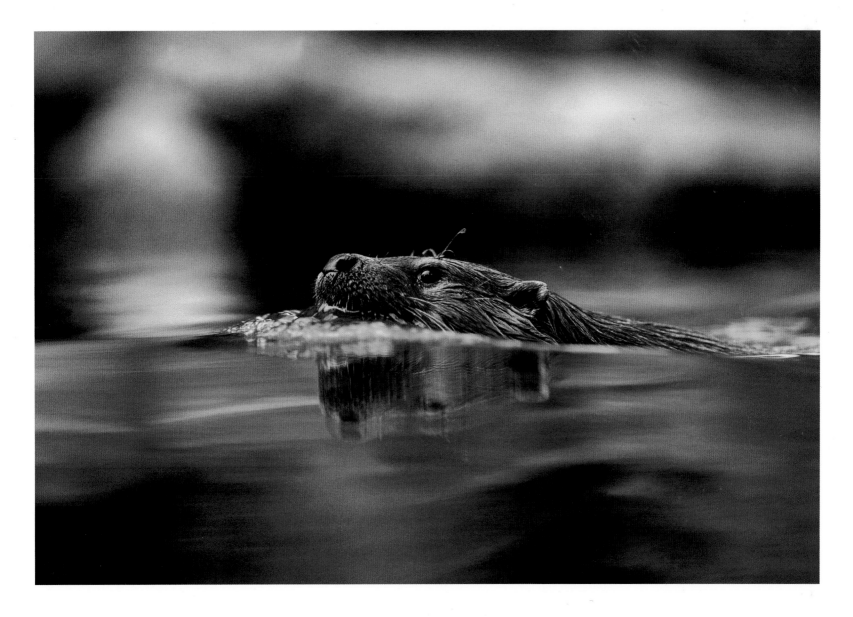

Here's an elegant way to make a moving subject stand out against a blurred background. When an animal is moving laterally fairly quickly, it's easy to track it in the viewfinder. If you select a relatively slow shutter speed (around 1/30 sec.), track the animal carefully, press the shutter release when he comes closest, and continue to follow him after the shutter closes, to avoid any jerks. Depending on the shutter speed, the background will range from very blurry (1/30 sec.) to slightly blurry (1/125 sec.). The blurring of moving legs works in the same way. It's easiest to take tracking shots at high shutter speeds, but good shots taken at low speeds (not all of the ones you take will come out) are the most spectacular.

It's easy to vary the quality of the background. With a wide aperture, the streaks of movement are blurred together. On the other hand, when there's good depth of field, the details in movement are much choppier. Depending on the desired effect, it may be interesting to play with these variations. For example, using a neutral-density filter will let you reduce the shutter speed without stopping down the aperture.

The slow shutter speed coupled with a 400mm lens requires tracking the animal very carefully. Only the water should be blurred to suggest the otter's movement.

European otter (*Lutra lutra*)
400mm lens
1/30 sec. at f/5.6 - MF.
Photograph taken at the French Reproduction Center for the European Otter (*Centre français de reproduction de la loutre européenne*).

Strobe

The goal of using a strobe is to break down movement, using a series of manually or electronically controlled flashes of light. The flashes should come one after the other, at regular intervals, in order to transform the movement into a series of fixed images. Depending on the number of flashes and their frequency, you can break down the image into a few images or an artistic stream of images.

In nature photography the strobe is useful for obtaining images of the movements that make up flying or leaping. Stroboscopy takes place in the studio, so the animal can be constrained to take the correct path perpendicular to the camera. The equipment you use will depend on your requirements. A flip-up flash that has a strobe function will work at very short distances, while a wide shot of a larger animal will require the use of several flash units.

The main disadvantage of the flip-up flash used as a strobe is its low power. The system divides up the condenser's charge into many small flashes. Stroboscopic frequency may be up to 100 Hz (100 flashes a second). A frequency this high is too much for creative effects, since it only lasts a very short time and tends to overexpose the more stationary parts of the subject. It's better to use lower frequencies (5 Hz) to fully break down the movement. This way you avoid the danger of differences in exposure between the parts of the subject that have been illuminated once and those that have been lit many times within a short period of time.

To freeze longer movements or to work with larger animals, you have to use a multiflash system. Several flash units—even low-quality ones—are connected to an electronic command console that regulates flash order and frequency. Each flash is only used once in a sequence, in order to get maximum flash intensity if need be. Positioning the flash units along the animal's path and the frequency at which they fire should be decided by experimentation (with a person, for example), which will ensure the success of the shoot, with correct frequency and optimal exposure.

Multiflash stroboscopy is easier in the studio. The camera is connected to a remote-control console that trips one flash after the other at an interval that depends on how much the movement is to be broken down. The photographs are taken in the dark, so the shutter can remain open throughout the sequence.

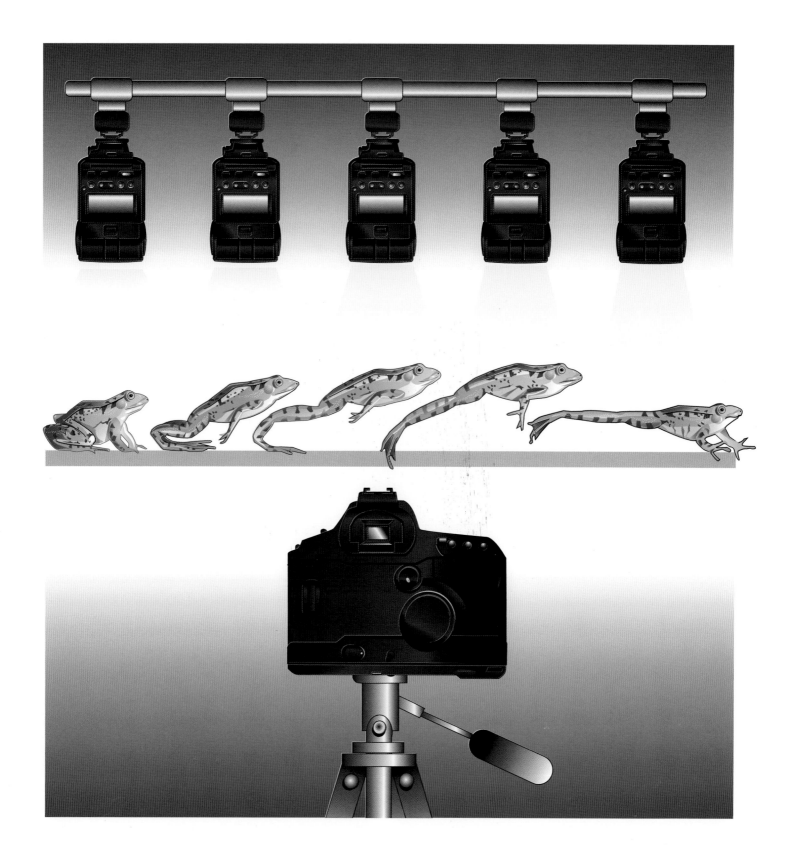

Animal Portraits

This big male photographed on the Valdés Peninsula (Argentina) shows his powerful teeth to warn the visitor. He is so sure of himself that he remains casually stretched out in the water.

Southern Elephant Seal
(*Mirounga leonina*)
300mm lens
1/350 sec. at f/5.6 - AF.

Taking portraits of animals uses many of the same techniques as with people, the difference being that the animal is rarely a voluntary participant. In the field, portraits are taken with long lenses (from 300 to 600mm).

Use an appropriate frame as you would for a person. Vertical for a close shot of the face, horizontal if you want to emphasize the profile against a background of the animal's habitat.

Given the high magnification and short distances used, depth of field is very shallow with tight shots. Animals with long muzzles require stopping down the aperture (between f/11 and

f/16) so that nose and ears will be equally sharp. Profiles are less demanding, since most wild animals have relatively narrow heads with an eye on either side. Photographed frontally or in profile, the eye must always be very sharp since that's what we look at first. The viewer will accept a frontal shot of an animal with very shallow depth of field if the eyes are perfectly sharp. All the other parts of the head will be blurred, which will add to the graphic quality of the shot if the eyes are sharp. The lighting—a fundamental element of the portrait—is hard to control in wildlife photography. You don't have the luxury of setting up

flash units with reflectors and diffusers around wild animals. You have to make do with the ambient light, and only take wildlife portraits when conditions are perfect. Ideal conditions include a slight backlighting with warm light, and bright surfaces (bright leaves, sand, snow) which will reflect the sun's rays onto the animal, and shots taken a few yards or meters from the subject. When you're certain of getting a good photograph on the first shot, try using a fill-in flash. Some animals will run away, while others will seem to ignore it and will just move off peacefully.

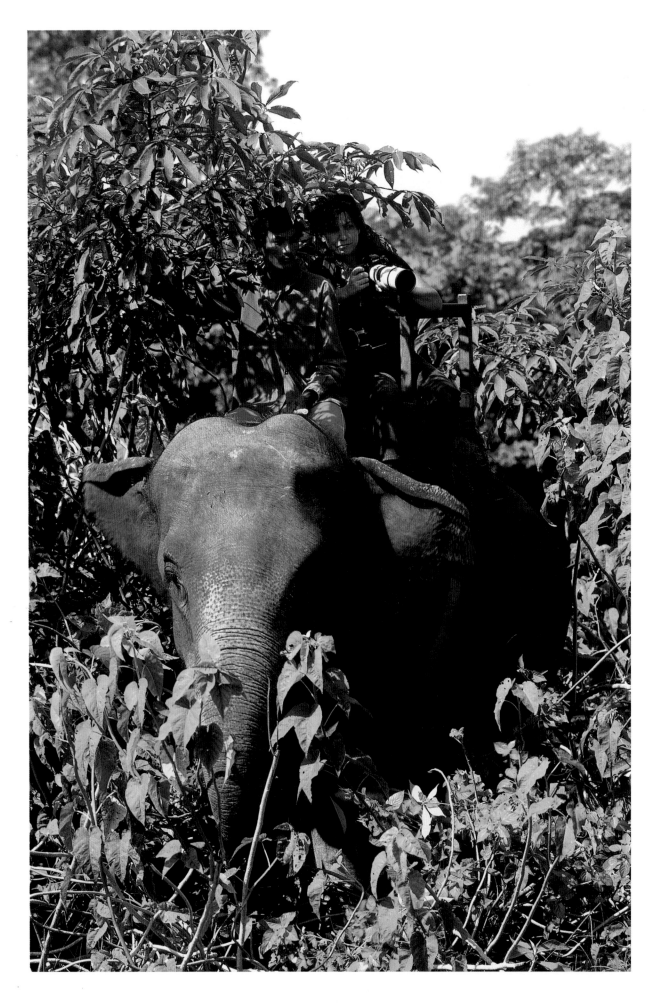

LEFT

In the Chitwan National Park (Nepal), the best means of transportation for approaching animals is the elephant. It is essential to wait until the animal settles down before attempting to take photographs with a telephoto lens.

Indian Elephant
(*Elephas indicus*)

OPPOSITE LEFT

When shooting from a four-wheel-drive vehicle, resting the lens on a beanbag is the best way to stabilize the camera. Here the beanbag is attached to the vehicle so you won't have to get out to pick it up if it falls (predators hide in the grass).

OPPOSITE RIGHT

Indian rhinoceros photographed from an elephant's back (Chitwan National Park, Nepal). For a lower-angle shot, the mahout has the elephant lie flat in the grass.

Greater Indian Rhinoceros
(*Rhinoceros unicornis*)
Image-stabilized 300mm lens
1/60 sec at f/8 - AF.

Shooting from a Vehicle

As surprising as it may seem, motor vehicles are excellent temporary blinds. Many animals are used to seeing them in their habitat and will ignore them totally. A stationary vehicle will still make them suspicious, but if the animal arrives after the vehicle, it will pay no attention. The vehicle's color makes no difference; the only things that may alarm the animal are your scent (often masked by that of the vehicle), and your movements inside the vehicle. A tarp or some camouflage netting stretched over the windows will be enough to hide you. Camouflage netting is preferable, since it provides ventilation in the summer. Attach the ends of the camouflage net with gaffer's tape (a special photography tape) to keep it from flapping in the wind like a flag.

You can buy accessories to attach the camera to the vehicle's window or door. We don't recommend them because they amplify vibration, making the cure worse than the disease. On the other hand, a cloth bag filled with plastic beads or rice makes a very stable support that is very good for absorbing vibration. This beanbag prevents scratching the finish. It can be carried empty and filled once you reach your destination when you fly off on a photo safari. Two pieces of heavy cloth and some Velcro will make a beanbag of any size you want.

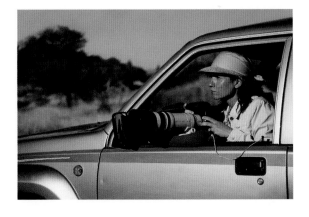

Photographing Birds in the Nest

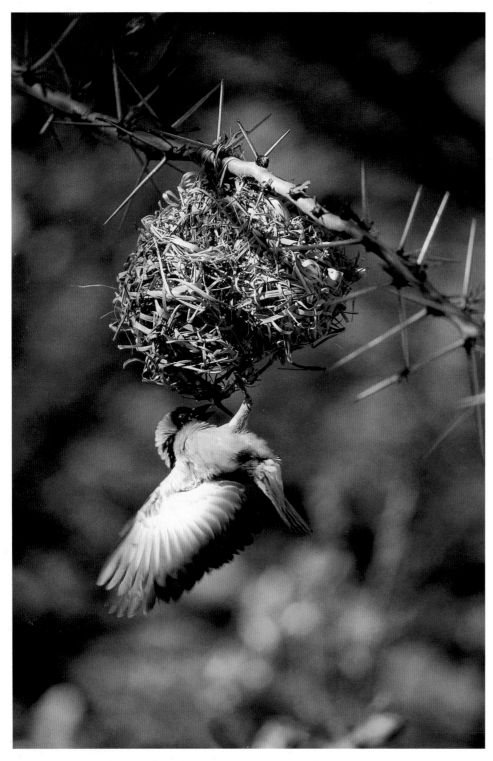

The male weaver builds his nest in the shape of a ball. The best-built nest will attract a female.

Black-headed Weaver
(*Ploceus cucullatus*)
100–400mm zoom lens
1/200 sec. at f/5.6 - AF.

We strongly advise beginners against photographing birds in their nests, and even experienced nature photographers must do so with great care. Losing a clutch "naturally" is sad enough, but to see one ruined by a clumsy photographer is unacceptable. You should always begin observation of the nest with binoculars, as discreetly as possible. If the parents are sitting on the nest without flying back and forth to bring food, it's too early. Birds whose eggs have not yet hatched will abandon the nest at the slightest disturbance. When they're feeding their young, pay careful attention to the frequency of their trips. Any decrease means that you have been noticed and are disturbing the life of the nest. Setting up a remote-controlled camera is a good way to take photographs without disturbing the birds.

Open nests pose no particular technical problem, except that they are hidden in the vegetation. You have to find an angle from which to photograph the chicks being fed without any branches in your field of vision. No matter how tempting it may be, do not cut branches that get in the way, since they are the life insurance of the nest against predators who are also lying in wait.

Closed nests (hollow trees, clumps of grass, daubed mud, holes in the earth, etc.) are trickier.

You have to begin your observation before the chicks hatch to be ready to see the young sticking their heads out of the hole to be the first fed.

Some amateurs cobble together a piece of glass and a false bottom and install it in a nest, but this kind of concoction is unreliable and dangerous to the clutch. Moreover, the resulting photographs are conventional and not very attractive. Finding beautiful lighting and unusual compositions from outside is much more satisfying for the creative wildlife photographer.

Feeding a young spoonbill in the Keikadei National Park (India). Long hours spent watching the nest are essential to capture these intimate moments.

Eurasian Spoonbill
(*Platalea leucorodia*)
400mm lens
1/200 sec. at f/8 - MF.

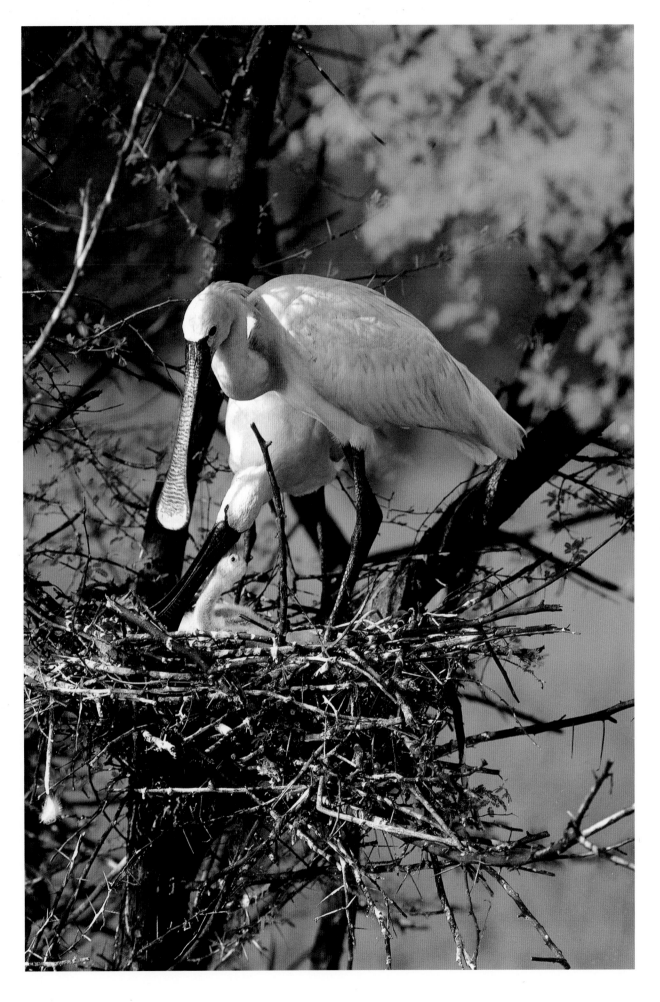

Night Photography

Nighttime wildlife photography without supplementary light may be practiced at nightfall or daybreak, or when you track a nocturnal animal at its first or last moments of activity. You need the right equipment such as ultrafast film (from ISO 800 to 1600), a very fast lens (200mm f/1.8, 300mm f/2.8), a stable tripod, and a cable release. To minimize the slightest vibration, set up the tripod on ground that is not too hard (rock will transmit the shock of the shutter tripping), use the mirror lock, and—when possible—a cable release. The beauty of the light at dawn and dusk more than compensates for the technical difficulties.

Even when it's completely dark, some shots may be taken by the light of the full moon using an exposure of several seconds for stationary subjects only. Landscapes are bathed in an astonishing cold light, completely unlike the warm light of day. Metering this light is beyond the capability of most built-in light meters, which are usually coupled up to 0 or –1 EV (see table of exposure values). Some handheld light meters go down to –2 EV, but this slight increase does not justify their cost. What is more, film has a tendency to lose sensitivity when it is exposed by a small amount of light over a long time. This is the famous "Schwarzschild effect," named for the mathematician whose experiments showed that film absorbing 1 lux for 1,000 seconds is less exposed than 1 absorbing 1,000 lux for one second. This rule is also called "reciprocity failure." An analogous phenomenon takes place when exposure times are ultrashort (less than 1/40,000 sec.).

You can still photograph an animal by the light of the full moon, as long as you make up for low light levels with a flash. Set the camera (or the flash) to synchronize with the shutter's second curtain, begin your long exposure discreetly, and the animal in the foreground will be photographed by the flash at the end of the exposure. The subject must be within 33 to 39 feet (10 or 12 meters) to be exposed by a flash of GN 110 in feet (GN 40 in meters). The danger of provoking panic in the animal is real—only try this on open ground, far from any danger. Fortunately, some species are less disturbed by the flash than by your scent, borne by the wind.

The flash is very practical in a blind at night, when an animal is photographed near its den. Multiple flash units are used, so as to avoid the disadvantages of conventional frontal illumination (green or red reflections from the dilated pupils, unattractive shadows in the background, artificial brilliance of the fur). Set up your flashes during the day so as not to disturb the animal. Protect your equipment with plastic bags, but make sure there is some circulation of air from the bottom in case there is any discharge of gas by the batteries. A system designed to be used for several nights running should be powered by external batteries. You can run wires to the flash units directly from your blind. Limit your comings and goings through the animal's territory, since some species with a sharp sense of smell (especially badgers) may pick up your scent long after you've set up your light sources.

A dying bird discovered in the rocks just after sunset. The fill-in flash dramatizes the image while preserving the details of the sky in the background.

Lesser Noddy
(*Anous tenuirostris*)
24mm lens
1/60 sec. at f/11 - MF.
Flip-up flash.

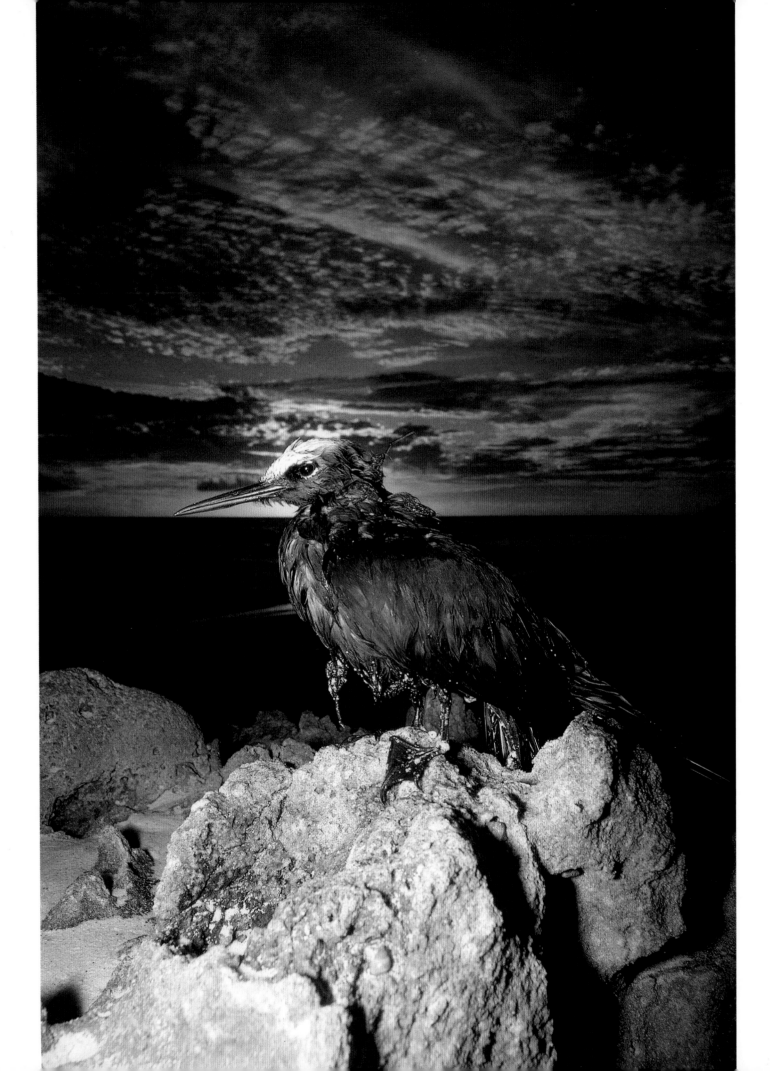

Action Photography

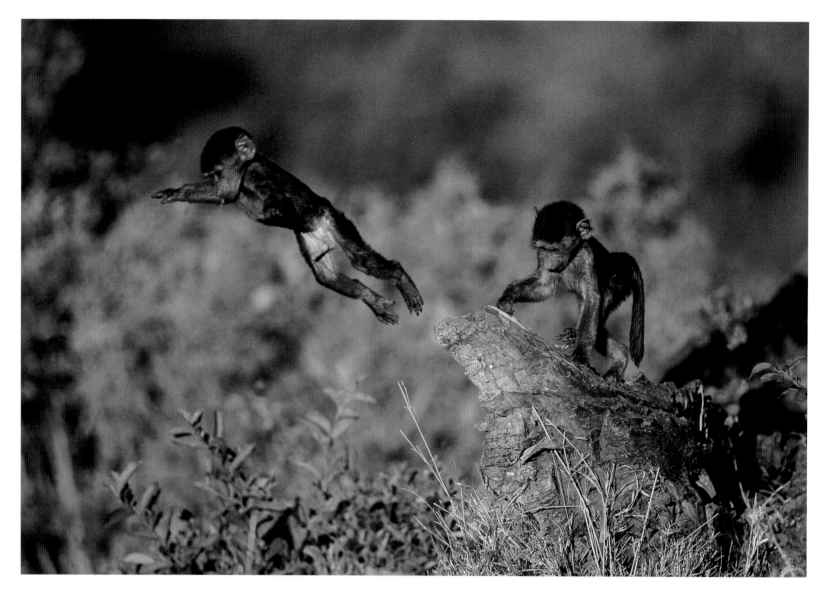

The best animal action shots to photograph are essentially related to hunting, flight, and play behaviors. As long as there is enough light to use a high shutter speed (around 1/250 sec.), play is relatively easy to photograph, since young animals usually stay within a safe area near an adult and their den. Young animals tend to follow predictable paths as they run around, so you can choose a point where they'll pass in order to preset your focus manually. Then all you have to do is to wait for the perfect moment, the most typical expression, or the best lighting. Press the shutter release once the subject is in focus. High-performance autofocus SLRs also let you track the animal continuously without losing focus. But there is a risk that the camera will focus on a blade of grass or some other object in the foreground—only try this over completely open ground.

On the other hand with hunting and flight, the animal's movements are completely unpredictable. Tracking a hunt with manual focus is within the realm of possibility, but autofocus is a definite advantage if you want to increase your chances of taking good photographs. The camera

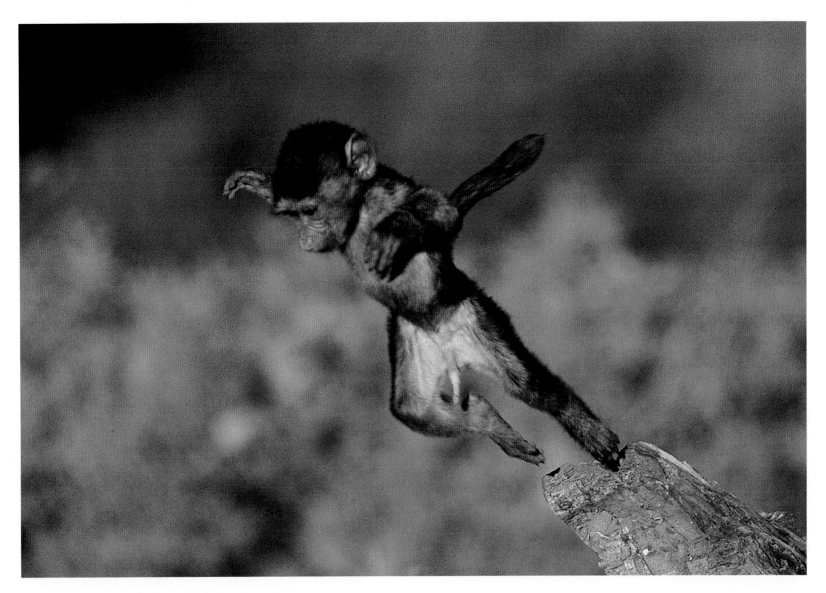

must be set on continuous autofocus, preferably locked on a cross-shaped autofocus sensor. The processor, which needs to carry out fewer calculations, is more efficient, and the sensitivity of these sensors to variations in contrast is greater. To take advantage of the possibilities of multiple-sensor cameras, there are customizable features that let you isolate the sensors by small groups. The processor bases its calculations on fewer sensors, thereby gaining speed and doing away with the limitations imposed by the cross-shaped sensor array.

Thanks to a very long lens, the play of these young baboons in the Masai Mara National Park (Kenya) is undisturbed. The photographer has only to watch them, choose the right moment, and take several shots in order to capture the perfect pose.

Yellow Baboon
(*Papio cynocephalus cynocephalus*)
600mm lens
1/250 sec. at f/4 - AF.

A gull harasses a heron that
has come too close to its nest.

Black-headed Gull
(*Larus ridibundus*),
Grey Heron
(*Ardea cinerea*)
300mm lens
1/400 sec. at f/4.5 - AF.

The direction the animal is moving in determines your chances of taking sharply focused photographs. Lateral movement is very easy to follow, even with manual focus. When it is oblique and coming toward the photographer, things are more complicated—in this case having an SLR with a wide autofocus zone is a great advantage. When the animal is moving directly toward you, autofocus systems show their overwhelming superiority.

A high-end camera, taking photographs in bursts of eight images per second, will follow a car moving at 62 mph (100 kph) up to 26 feet (8 meters) away. With manual focus, you have to prefocus the camera to the chosen distance, wait for the subject, and press the shutter release just before it reaches that point. At best, the result is a single well-focused photograph with manual focus compared to ten to twelve impeccable shots using the autofocus system.

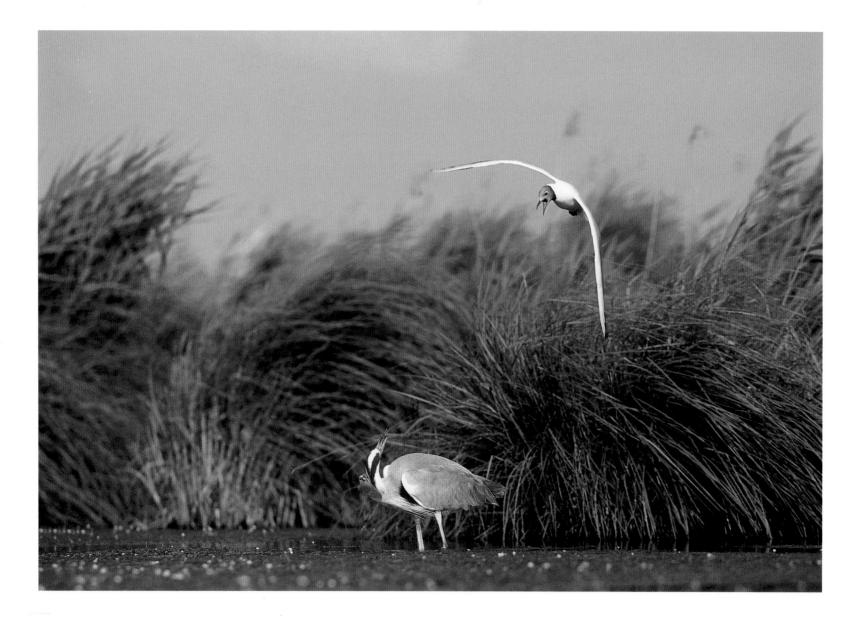

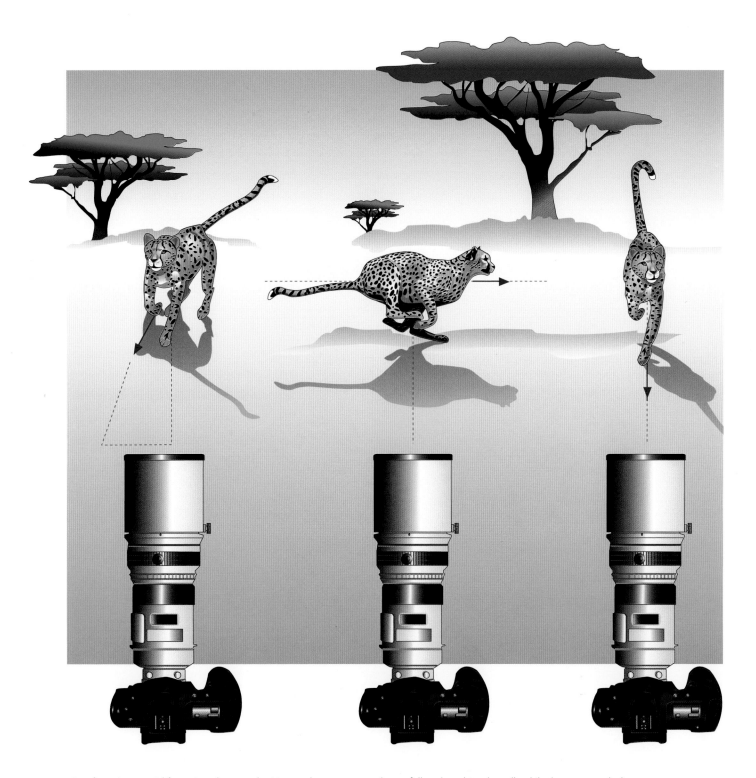

Autofocus is essential for action photography. Not used very often for lateral tracking shots, autofocus is more useful when the camera is still and the subject moves from one sensor to another without stopping.

The most challenging situation for predictive autofocus control is diagonal movement toward the camera. The autofocus has to follow the subject laterally while the camera calculates how quickly it is approaching. True head-on movement is much easier since it uses only the central sensors. To increase speed, use only the central sensor: this way the built-in computer has less information to process.

Photographing Birds in Flight

The difficulty of following birds in flight is related to the variable size of the subject in the viewfinder and the backlighting produced by shooting toward the sky. Large birds obviously cause fewer problems than songbirds, which are often difficult for autofocus systems to detect.

You can console yourself by saying that a bird, which is too small to be detected, is also too small to make a good subject. This is why songbird photographers use long lenses, the only ones capable of producing sufficiently large images of these birds, which are often wary to boot.

As with mammals, autofocus reveals its superiority as soon as the animal's speed increases. Small birds are more difficult to follow, since their size lets them change direction with extreme rapidity. Wide autofocus using many sensors is a definite advantage when you're trying to follow a subject whose movements are so unpredictable.

Manual focus works fine with birds flying perpendicular to you.

The deep blue of the sky and the brilliance of the sand below bring out the details of this tern's plumage shot from below. The high shutter speed freezes movement.

Sooty Tern
(*Sterna fuscata*)
200mm lens
1/500 sec. at f/8 - MF.

If a bird is flying toward you, you have to have prefocus on a point, wait for the bird to come close, and trip the shutter just before it reaches the focus plane. The period when adults are feeding chicks in the nest is particularly suited to this kind of photography, since the birds often follow the same path.

For a larger zone of sharpness, stop down the aperture; the acceptable margin of error when the shutter is released will be increased.

A flying bird photographed from below is not very attractive. Unless you want to show the characteristic silhouette of the species (the elongated diamond-shaped tail of the Bearded Vulture, the gently curved neck of the Purple Heron, etc.) or to highlight the graphic quality of the flight (e.g., the W-shaped formation of Blue Herons), a backlit bird against the sky is not really worth the shot. Wait until it approaches and reveals its profile, or the next time it turns on its wing; choose a high vantage point—even if you correct for the exposure, a backlit photograph of a bird against a bright sky is often too strong. Only a dense blue sky lets you take photographs from below with reasonable contrast.

The Chacahua Lagoon (Mexico) harbors an amazingly rich avian fauna. This stork was photographed from a small boat with a hand-held camera, in order to pan the camera to follow its flight.

Wood Stork
(*Mycteria americana*)
400mm lens
1/500 sec. at f/11 - MF.

Taking Sequences

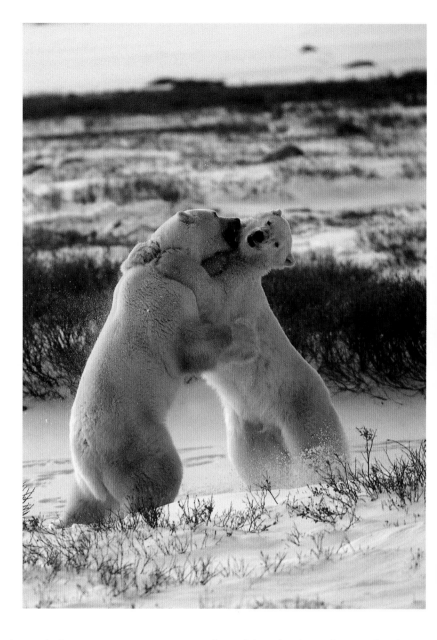

Polar bears dancing in a sequence shot at 6 frames per second. Such speeds can analyze very brief behaviors, but a 36-shot roll of film lasts only six seconds.

Polar Bear
(*Ursus maritimus*)
600mm lens
1/250 sec. at f/4 - AF.

Sequences are a simple and effective technique to describe an animal's behavior, to study in detail how it moves about from place to place, or to create amusing and educational sketches. There are two ways of taking series, based on the time between shots.

SHOT-BY-SHOT SEQUENCES

With shot-by-shot, the action is examined carefully through a series of the images taken at crucial moments. It takes a lot of self-control to keep from running out of film prematurely. For this reason, with unpredictable subjects you need enough film and two cameras, so as not to miss an important shot while reloading. If you're familiar with the animal's behavior, you can decide in advance what shots to take and even draw up a little story-board beforehand of the moments you don't want to miss. In the heat of the action this reminder is very useful, since a missing photograph can spoil a series if it comes at a key moment such as the male tern offering his gift to the female, or a mother whale helping her calf to take its first breath.

Shot-by-shot sequences also let you compress time artificially to record the opening of a flower, to show the sun's track across the sky, or the building of a nest. In this case, it is best to

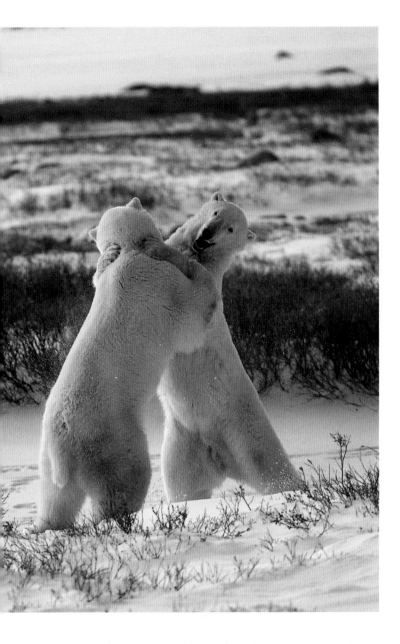

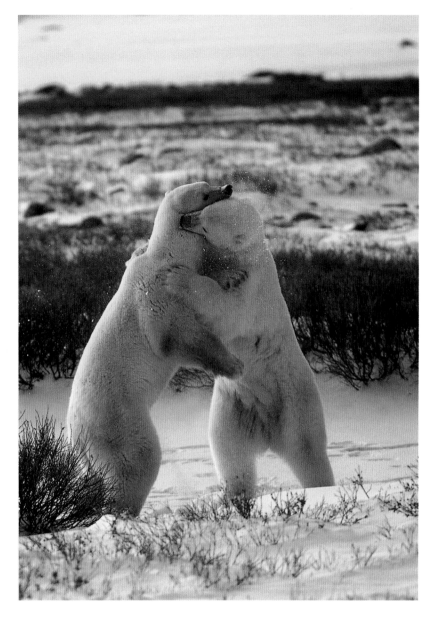

use an intervalometer, a mechanical or electronic accessory that controls the timing between the shots that may range from a few seconds to a few hours, if required.

Enough film should be loaded for the number of shots and timing programmed. As in the case of a long session in the blind, mount the camera solidly and protect it from the weather. As a variation, use a quick dismount to remove the camera from the tripod without losing your framing. This system is a good idea when the sequence will take several days in a place where there are a lot of people around. All you have to

do is come back at the right time and mount the camera for the time it takes for one shot.

To give the photographs making up a long sequence a uniform look, exposure and ambient light levels should be identical from one shot to another. Setting the camera on manual and securing the rings with adhesive tape will reduce the risk of mistakes. Measure light levels carefully with a hand-held meter to ensure consistency, and keep track of all the settings. If the ambient light level changes completely, it may be best to postpone the next shot, depending on the subject and practical considerations.

Sequence shot from a research boat at 3.5 frames per second off the coast of Labrador during a study of humpback whales.

Humpback Whale
(*Megaptera novaeangliae*)
135mm lens
1/350 sec. at f/8 - MF.

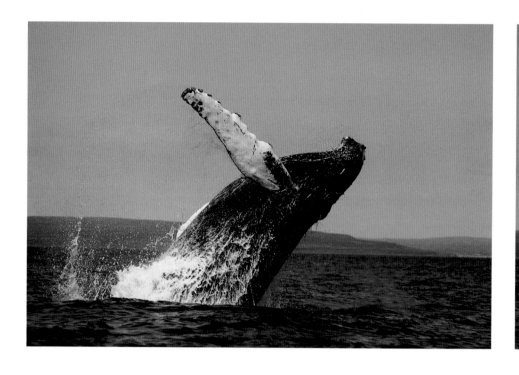

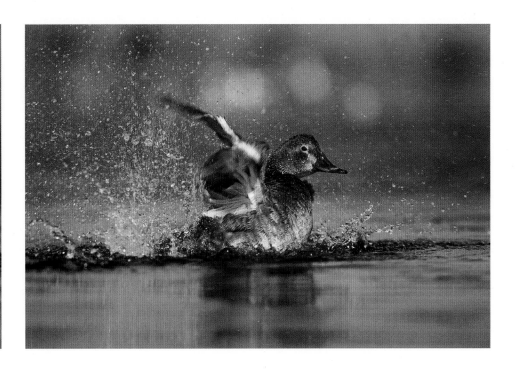

A high exposure rate (6 frames per second) breaks down the fastest actions. Here a pochard grooms itself as it is photographed from a floating blind.

Common Pochard
(*Aythya ferina*)
300mm lens
1/500 sec. at f/4 - AF.

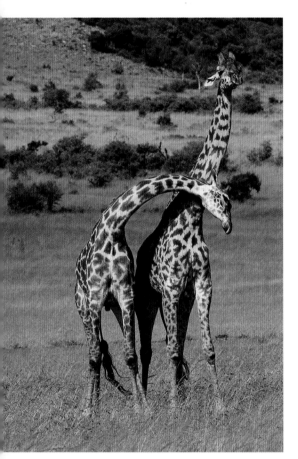
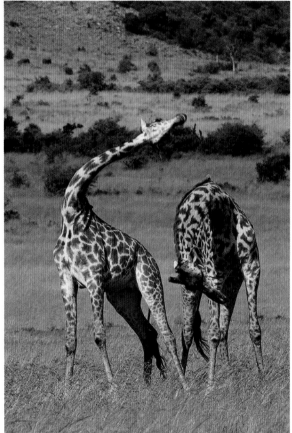
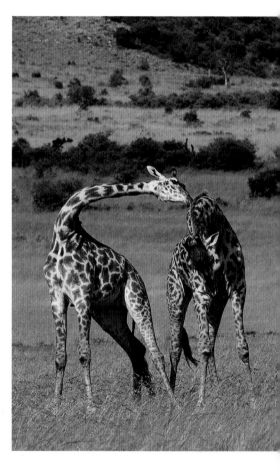

The amorous play of Masai giraffes immortalized at 4 frames per second in a sequence to analyze movement.

Rothschild's Giraffe
(*Giraffa camelopardalis rothschildi*)
100–400mm zoom lens
1/320 sec. at f/6.3 - AF.

BURSTS

Bursts taken in the heat of the moment are more problematical. When shooting in burst mode, you keep your finger on the shutter release the whole time. Be careful because a high-quality SLR will burn a 36-shot roll in 3.6 seconds. This means you have to be sure of yourself to avoid running out of film at the critical moment. The choice of the moment to begin shooting is the key to success.

If you're in doubt, you're better off choosing a slow speed (around three frames per second), which increases the "range" of a 36-shot roll to 12 seconds. This is really more than you need to photograph hunting animals or diving seabirds. Beyond this, the shot-by-shot sequences may become a better alternative.

The golden rule: the reason to take a burst sequence is not to take thirty-six shots to get one or two good ones (that only happens rarely), but to break down a movement to see how it evolves. For this reason, every image should be identical to the others, so keep the same exposure after the first photograph.

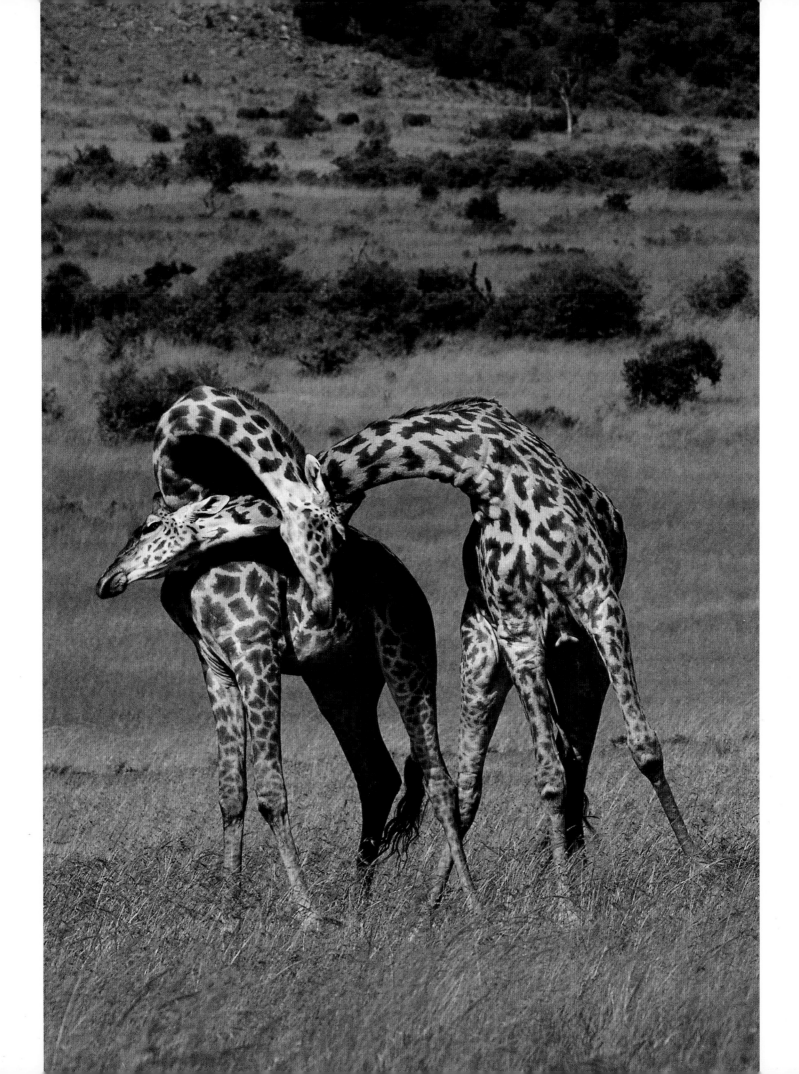

Remote-Controlled Cameras and Camera Traps

thing (a branch or blade of grass) interrupts the beam from the control unit.

Radio-control systems are much more flexible, with ranges of between 164 and 656 feet (50 and 200 meters), depending on the model. They let you photograph wary species by using binoculars or take pictures from another angle thanks to a second camera mounted on a tree branch or in another blind.

This equipment may be fitted with a black-and-white video viewfinder, which makes it possible to control framing from a distance, using a monitor connected by a cable or dedicated transmitter. The cost of such an installation is quite high.

Taking pictures by remote control is a good way to photograph wary species. You have only to set up your equipment when the animal isn't there, to keep track of its movements from a distance, and to trip the camera at the right moment. Remote control also gives you the ability to take photographs from two angles at once without leaving the blind.

REMOTE-CONTROLLED CAMERAS

The least expensive way of controlling your camera by remote is to use an electric shutter release. The main disadvantage is that you're limited to 33 to 49 feet (10 to 15 meters) of wire. It's a useful technique if you want step back a little bit from your subjects while remaining close by. Similarly, infrared shutter releases are also limited to short distances, with the additional problem that you could lose control of the shutter if some-

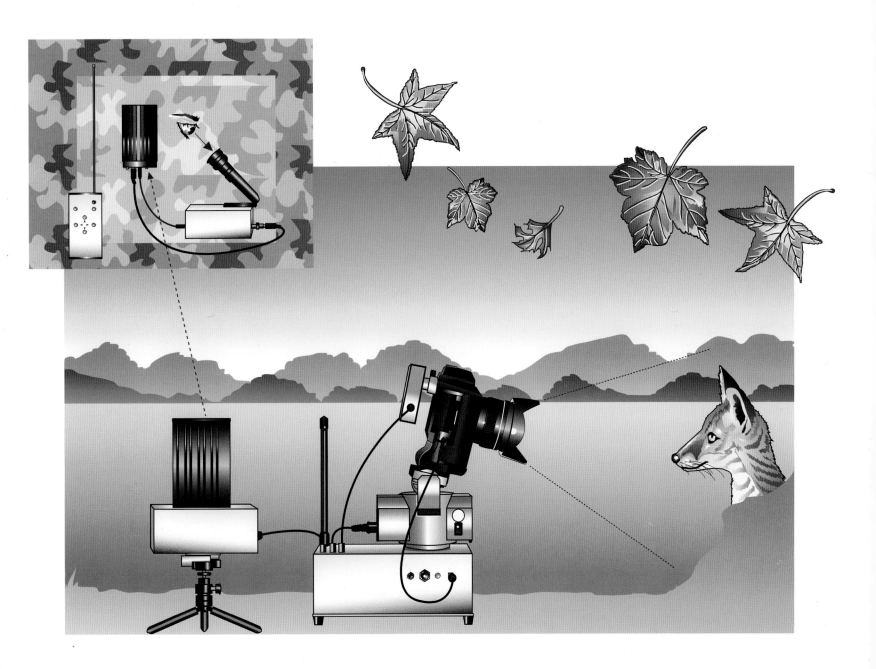

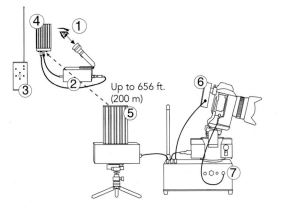

Up to 656 ft.
(200 m)

1) The photographer watches the fox's den from the blind

2) Video display for controlling the image

3) Camera remote control (electronic universal joint, autofocus, shutter release)

4) Receiver

5) Transmitter

6) Wireless video feed

7) Electronic universal joint

The "perching bird detector" is made of a photocell that releases the shutter when the subject blocks the ambient light. Its sensitivity is adjustable, so that a shot will not be taken when a cloud blocks the sun.

AUTOMATIC RELEASE SYSTEMS

Using an automatic release system to take photographs is not a very creative way to work. It comes more under the heading of documentation or scientific research for the identification or study of species that are known to be rare in an area. Research into movement patterns is another use for auto-release systems. Insects, bats, or songbirds in flight trip the camera involuntarily by interrupting beams of infrared light. But the photographer does not pick the moment when the shutter is trapped, and the pleasure of capturing the instant is almost entirely absent. You have to rely on luck to take good photographs in this way.

SIMPLE CAMERA TRAPS

Having the animal release the shutter is an attractive idea. To do so there are systems that will release the shutter when they detect sounds or vibrations (using a microphone), or when the ambient light is blocked (using a photocell). An animal attracted by bait—or moving along a well-trodden path—trips the shutter and flash units as it passes them. The problem is that the target species is not the only one that likes food (rats, corvids, and mustelids are all good eaters) and fine-tuning such systems often takes a great deal of patience. If you don't mind waiting until the film has been developed to find out what greedy animal has been tempted by your menu, these traps are for you. But be careful, it's easy to get tired of burning film on rats and crows when you really want to photograph a genet. And let's not forget that the animal has no reason to present its most photogenic parts to the lens.

Here the camera is tripped by the "perching bird detector." The photographer doesn't choose the shot, since it is the bird's arrival that trips the shutter.

Black-headed Gull
(*Larus ridibundus*)
200mm lens
1/250 sec. at f/6.3 - MF.

Soundproofing a remote-controlled SLR makes it less noticeable and increases its effectiveness. Depending on the level of soundproofing required, the camera can be simply wrapped in fleece cloth, or a more complicated box may be specially made.

The bat machine, designed and built by Gilles Martin, ensures that the bats will be correctly oriented for the photograph. It is a tunnel-like shooting box into which the animal is introduced by a one-way cloth sleeve. In order to escape it is forced to take flight (the shape of the machine directs its path) and leave by the front opening. Two infrared beams set off the flash units located on either side of the exit. In this way, the bat is photographed head-on, just before fading into the background for some well-earned rest. All the animals photographed with this apparatus have been captured by biologists, who study and release them.

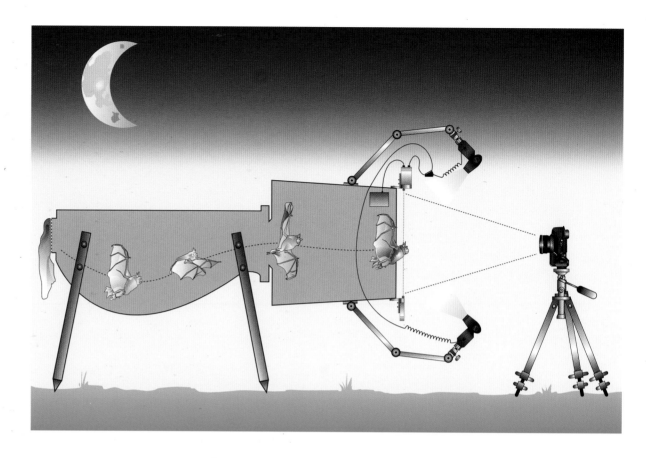

1) Body of the machine

2) Collapsible section supporting the electronics

3) Infrared transmitter

4) Infrared receiver

5 and 6) Flash units

7) Tunnel entrance furnished with a light-tight sleeve

8) Tripod-mounted camera

9) Legs with pointed ends for stability

10) External 9V battery for the infrared transmitter

11) Infrared beam (in reality invisible)

12) Funnel for centering the animal

13) Cable connecting flash units to infrared receiver

14) Path of the animal within the apparatus

COMPLEX CAMERA TRAPS

Camera traps using infrared beams (produced by diodes or lasers) are much more precise. It is possible to predict within a millimeter where the animal will be photographed. Two (or more) invisible beams intersect, and the shutter and flash units are only tripped when the subject blocks them both. This method lets you anticipate the animal's position and even choose a background when a shooting box is used. Animals that don't block the intersection of the beams are ignored by the system. The whole difficulty of using detection beams is to get the animal to pass through them without changing its behavior. The exit from a

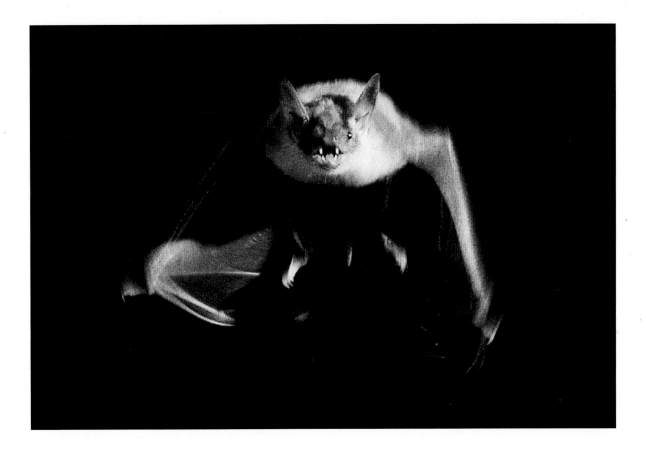

Greater Mouse-eared Bat photographed leaving the bat machine. The variable power of the flash units lets the image be adjusted depending on the desired effect. Several attempts are sometimes necessary when a particular wing position is desired. Working with researchers is essential when working with protected species.

Greater Mouse-eared Bat
(*Myotis myotis*)
50mm lens
1/60 sec. at f/11 - MF.

baited area is a good place, but you have to conceal the equipment in the vegetation so it doesn't disrupt the photograph's aesthetic quality. Another solution is to put out food on a branch where the beams cross to photograph birds just before they alight on this unexpected treat. Changing the beam's height in relationship to the food lets you choose the subject's position.

The most efficient system is to make a shooting box from wood. Release the animal in the shadows on one side, and it will take off, attracted by the lighted exit, which is narrower and furnished with infrared beams. The animal is of course disturbed and this technique should be used in conjunction with an ornithologist, e.g., by using a shooting box to free birds after they're banded. The speed with which they move and the beating of their wings require working with flash units,

preferably at their highest speed (1/64 to 1/128 power) to freeze the movement as much as possible. Since the nominal power of each flash unit is weak, you need several units to give the correct depth of field. Be careful—the flash speed reported by the manufacturer is usually false. Flash units whose highest speeds are reported as 1/30,000 sec. usually aren't really more than 1/15,000 sec. To freeze the wings of a flying bat, special flash tubes (capillary tubes designed for extremely rapid ionization) are absolutely necessary. Stephen Dalton, an expert on the subject, uses research flash units designed especially for him, whose pulses last 1/1,000,000 sec. Bird wings move much more slowly (except, of course, for hummingbirds) and may be frozen with commercial flash units at their highest speeds.

Remote-Control Vehicles

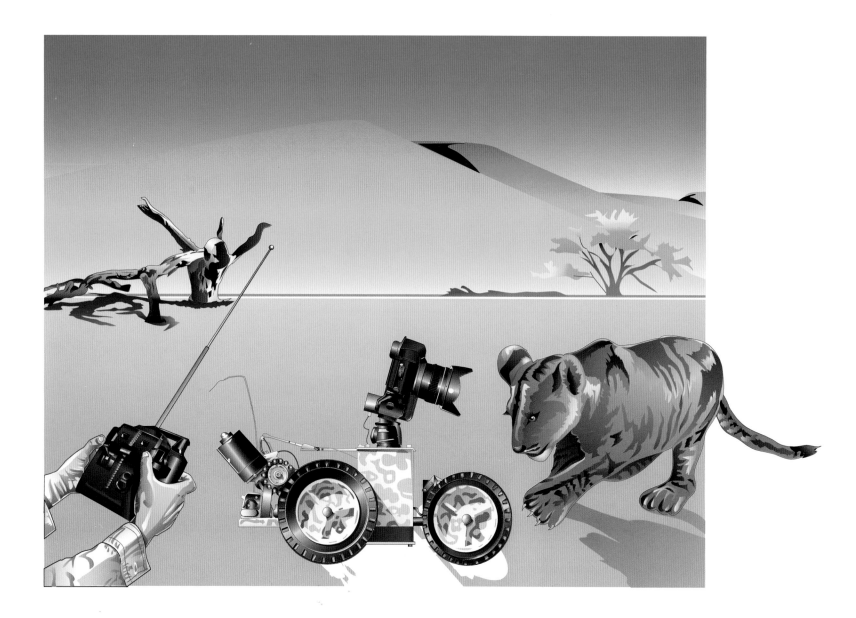

1) Lawnmower wheels (for propulsion)

2) 12V motorcycle battery

3) Golf cart windshield-wiper motor

4) Bicycle chain-and-gear drive

5) Model helicopter gyroscope

6) Camera and lens

7) Chassis made from ⅛ in. (2mm) sheet
 stainless steel

8) Receiver antenna

9) Receiver battery

10) Steering unit (weight 29 lbs. or 13.2 kg)

When the animal won't go to the camera, the camera has to go to it. To do this, remote-control vehicles are very useful. Avoid toys made for children (of any age), since models with enough stability to carry a camera and lens are rare.

Ask the advice of a model-builder who makes his own vehicles. He can help you design a two- or four-wheel-drive vehicle designed for your equipment. Be sure the wheelbase is long enough and wide enough to prevent the vehicle from turning over. Four to six driven wheels will keep you from seeing your precious machines get stuck two feet from a pride of sleeping lions. The camera can be suspended from a trapeze or mounted on a motorized universal joint; be sure there's enough play in every direction.

A gyroscope, originally designed for a model helicopter, can be used to control the camera's tilt. These gyroscopes theoretically handle tilt of up to 45 degrees.

Balancing the weight of the photography equipment is obviously essential; otherwise, the vehicle may fall on its nose in the dirt. Experiment with several kinds of lenses of varying lengths and weights before using your vehicle in the field. Equipment mounted on a remote-control vehicle must be protected from shock and humidity. Foam, plastic, and adhesive tape will all work well, since they're extremely light. Furthermore, this protection will muffle the noise of the motor drive to some extent.

The radio control unit should have at least four channels:

○ forward and backward motion
○ left and right turn
○ shutter release
○ channel for one additional function

The fourth channel can be used to charge a flash unit or to control a little headlight to help see in the dark. Four-channel systems are easy to find in hobby shops.

OPPOSITE

The remote-control vehicle used by Gilles Martin is specially designed for photography. Toys—even quality toys—won't work: they do not have enough traction and go too fast. This model is designed according to a specific set of criteria:

○ slow movement
○ silent operation
○ motor able to move 33 lbs. (15 kg)
○ inclusion of a gyroscope that can compensate for a slope of around 45 degrees.

BELOW

The remote-control vehicle operates in almost any terrain: left, in the Namib desert; right, on a forest trail. It is commonly used with lenses from 135mm to 15mm fish-eyes. These latter produce totally unexpected images in wildlife photography.

Remote-Control Boats

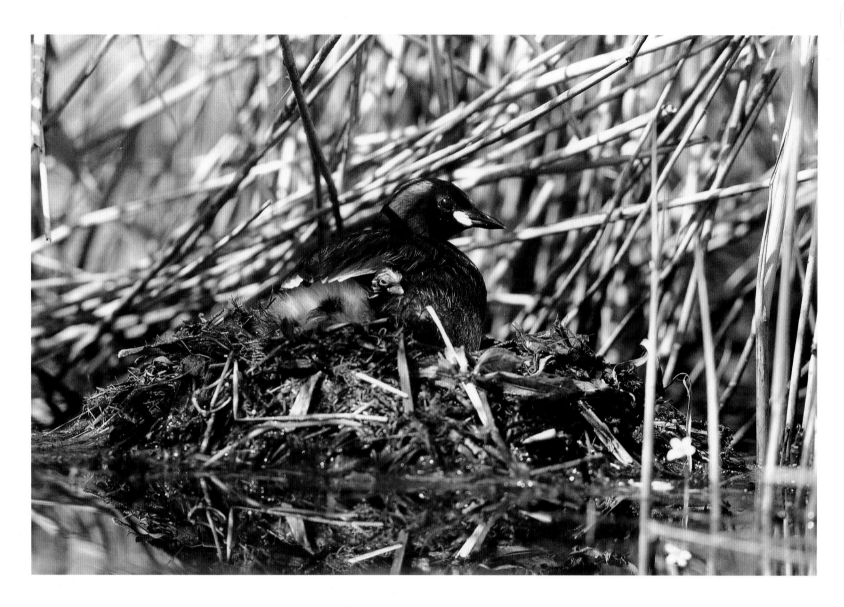

It was easy to photograph this grebe and her chick, without causing the slightest disturbance.

Little Grebe
(*Tachybaptus ruficollis*)
28–105mm zoom lens
1/125 sec. at f/5 - AF.

As with ground vehicles, design your remote-control boat based on your particular needs. Ready-made boats certainly work well, but they aren't designed to carry a camera above their normal center of gravity. It's better to begin with a stable hull, or even two joined hulls, and design a superstructure to carry your camera and its lens. Be sure to include a place for the remote-control equipment and the drive motor. It's best to put them below waterline, so the extra weight will help stabilize the boat.

The boat has to be stable enough so that it doesn't turn over with the first ripple after the camera is installed. First check for stability with a weight equal to that of the camera equipment. Make big waves to be sure that you have enough stability. If the boat is to be camouflaged with cloth or using a decoy, carry out further trials using the complete installation. The effort is better than dunking a costly camera and lens.

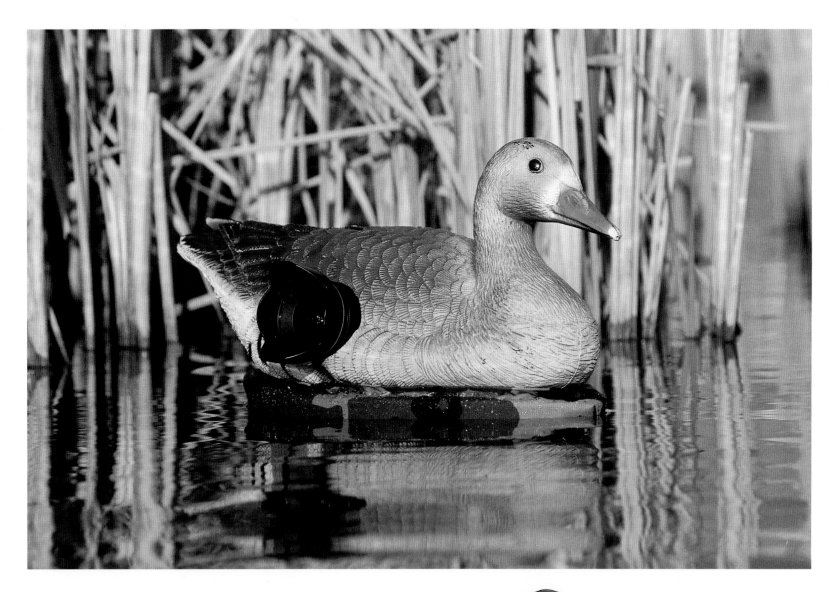

1) Camera

2) Decoy (White-fronted Goose)

3) Miniature boat model

4) Receiver with antenna

5) Steering servomotor

6) Electric motor

7) Battery

8) Acceleration servomotor

9) Speed control

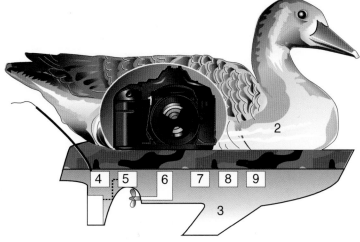

This friendly White-fronted Goose is a decoy normally used for less peaceful purposes. It is mounted on a remote-control model boat that has been extensively modified, especially in regard to the precision with which it can be guided and its resistance to small waves. An SLR fitted with a wide-angle lens is mounted inside the decoy, with the lens alone protruding by the wing. The entire device is controlled by a four-channel transmitter.

PEOPLE AND ANIMALS

Relationships between people and animals are always ambiguous, since people attribute feelings to animals that they don't have. The family dog is rarely understood by his own "owners." The dog's behavior, evolved for life in the pack, is interpreted by the humans as respecting the rules of society. The puppy caught peeing on the living-room rug sees being scolded as an expression of territorial rights and a reminder of the pack hier-archy—not as a lesson in hygiene. Similarly, anthropomorphism plays a crucial role in the images that unite humans and animals. It is up to the photographer whether or not to play up this aspect of the relationship, depending on the message the photograph is to convey. You can be the involuntary witness of a scene in which peo-ple and animals have a close relationship, or plan the encounter to take a particular photograph. In the first case, the ability to react quickly is tremen-dously important, especially during a quick exchange between the two subjects. The only solution is to rely on the camera's automatic set-tings and to trust in the instinctive framing and composition you have developed. Good framing becomes a reflex when you teach your eye how to read and compose a shot. An encounter that unfolds more slowly lets you refine the photo-graph, e.g., by waiting for the best moment to shoot, setting exposures on highlights to increase shadow density, or including a secondary subject in contrast with the key point. These techniques will highlight the main subject visually and strengthen the story told by the image. When the relationship between person and animal is close, expressions are the most important means of communication between species. The exchange may also be violent—if you want the photograph to expose mistreatment of animals—or tender to

Rat temple in Rajasthan (India). This companionship may shock our Western sensibilities, but there is no doubt as to the closeness of their relationship.

200mm lens
1/640 sec. at f/7.1 - AF.

emphasize the closeness between animal and the well-intentioned person. Here again framing, exposure, and selection of focal point can accentuate the dramatic aspect of the scene or, on the other hand, play down apparent contrasts in a touching picture. Once mastered, this technique is an essential tool for communication through images. When the encounter between person and animal is set up by the photographer, creative possibilities increase. Subject, setting, lighting, and mise-en-scène are chosen and directed with the sole goal of producing the desired image. This takes rigorous preparation, particularly when one of the subjects is a child.

Shots that mix children with necessarily tame animals require a preliminary interview. Explain to the child that the animal will be free, that it will only tolerate the child for a moment, and that trying to escape is a natural reaction. If he understands the rules of the game, the child will not be disappointed and will learn to appreciate the encounter, no matter how brief. It is up to the photographer to keep the shoot as brief as possible and maintain full control of the animal's reac-

tions. The least sign of anxiety in the subject should end the session. Site, camera equipment, and lighting should be ready before the subjects arrive. Make sure that cables and fragile objects are out of reach, protect the floor with a tarp if necessary, adjust the lighting, and set up the shot beforehand. A short practice session will help prepare for the unforeseen and ensure that everything goes smoothly. If you work with a flash, take several trial shots without the child to test the animal's reaction. Some will take fright and run away, while others will ignore it. Take advantage of these trial shots to make sure everything is set up right for the real thing (depth of field, focus, exposure).

Adults are much easier to photograph with animals. They're calmer than children and will pay more attention to your directions.

Anxiety can still be a problem, especially with people who aren't used to being around non-domesticated animals. An anxious person will give off pheromones to which animals are sensitive, creating tension that is sometimes hard to control. The best way to minimize this problem is to set up one or two encounters between the two subjects. Have the person feed the animal or groom it, just as you do before riding an unknown horse. Photography shoots are much easier once communication has been established between the two subjects. When the animal is large or presents any danger (biting, scratching, trampling), the photography session should take place under the control of a professional handler. Handling a dangerous animal is not a job for an amateur, even one with experience and seems sure of himself. You should also research any legal precautions relating to the transportation and possession (even temporary) of a non-domesticated animal.

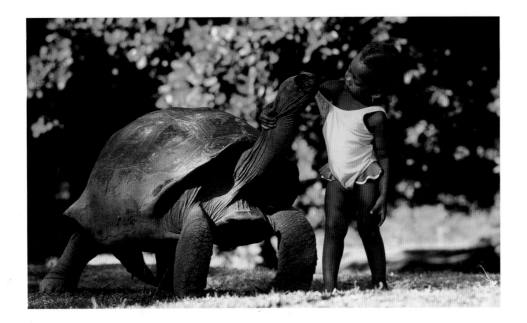

Photography with Researchers

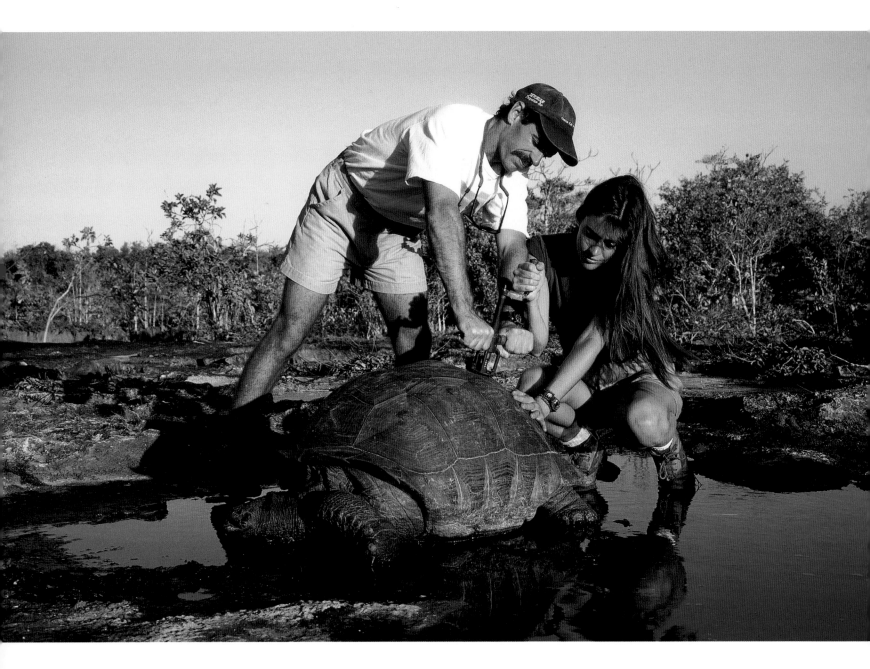

Biologists Susan Pierce and Dave
Augéri count, mark, and sex these
giant land tortoises in the Indian
Ocean for the Smithsonian Institute.

Researchers are a precious resource for the wildlife photographer who wants to complete an assignment on a particular species. A good mutual understanding is important, especially when the researcher gives you very technical information or wants to investigate a behavior that is hard to capture in images. Techniques of approach and blinds, mastery of very long lenses, use of photographic traps, experience in the field, and the ability to produce the best possible image of the subject are the photographer's most important attributes. The researcher must have the necessary information and facilitate the shoot by noting the best approach, pointing out the subject's most interesting behaviors, as well as the best times to get spectacular images and the best locations for shooting. When the researcher has to travel a long way with you, decide in advance what equipment and practical matters will be necessary. Authorship should be clearly defined when you leave for a long trip in search of hard-to-photograph subjects. Give some thought to what you will do in case you can't find the animal, don't have enough information to get the prized shot, or in case something happens that makes you interrupt the trip. Having a backup subject if you can't photograph your first choice may help make your trip worthwhile.

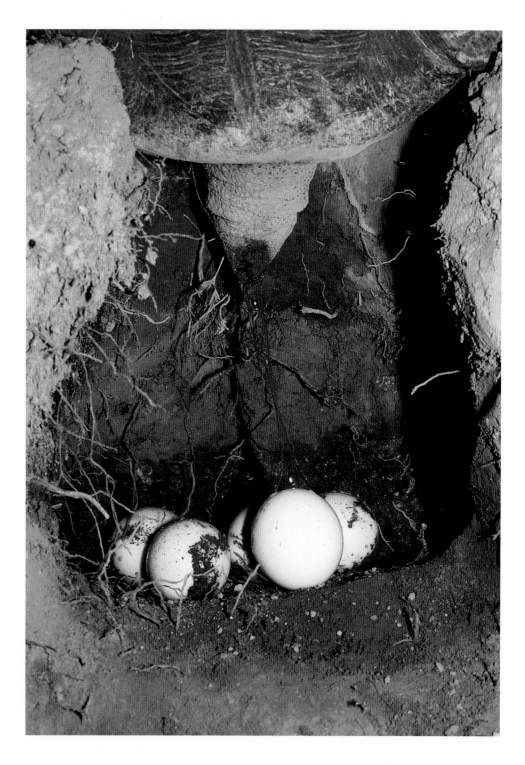

The fruit of a collaboration between photographer and researchers, this photograph of this species laying its eggs is a world first. In order to ensure that the animal is not disturbed, working with specialists is absolutely essential.

Indian Ocean Aldabra Tortoise (*Geochelone gigantea*) laying eggs.
50mm lens
1/60 sec. at f/11 - MF.
Two extension flashes.

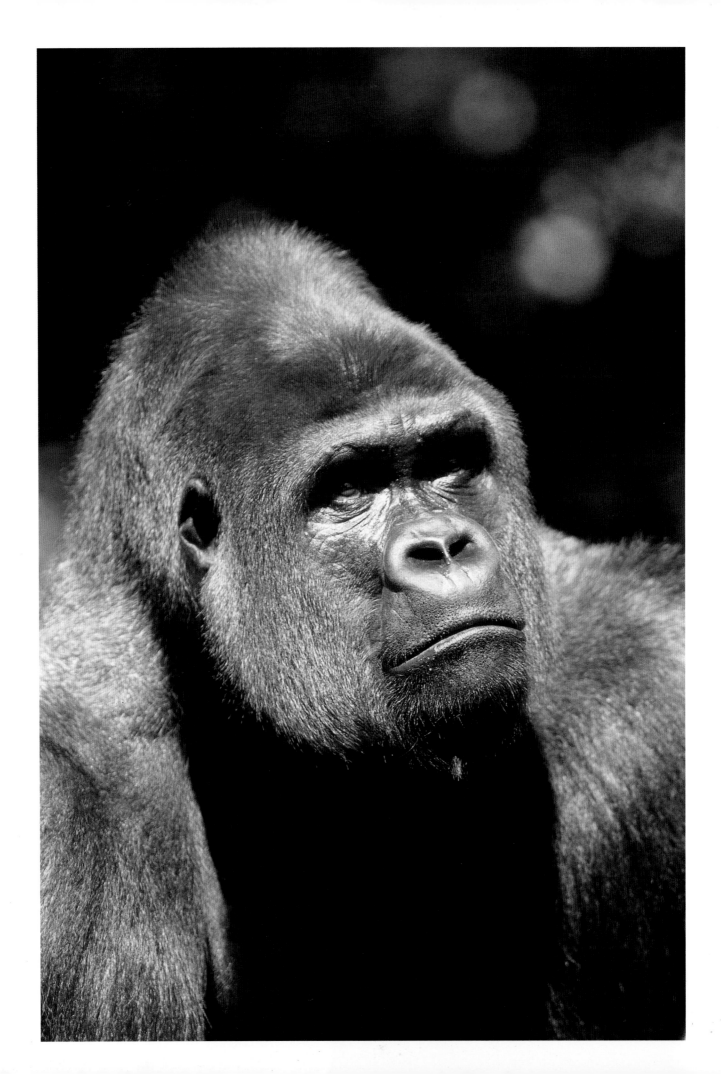

Photography in Zoos and Wildlife Parks

Photographs taken in zoos or wildlife parks rarely win favor with purists. Nonetheless, they are an excellent way to learn wildlife photography. You may criticize the chubby look of animals fed too many peanuts by the visitors, but what a thrill the first time you see a lion in your viewfinder. And then, captivity lets you record details that are almost impossible to photograph in the field, such as close-ups of the eye, details of the claws, the graphic quality of the skin, and the pattern of fur. Even pros sometimes bend the rules of professional conduct a little bit to photograph a behavior that is rare in nature or to photograph a scene by daylight that usually takes place at night. Photographs of captive animals also help the beginner to discover the most aesthetic framing and to learn what kind of coat will trick the camera's sensors or how to use a flash to highlight the eye of a bird with black plumage.

Captive-animal collections also help you learn the species. With big mammals it's not hard. But where birds are concerned, it takes quite a bit of experience to distinguish a little egret from a great white egret at first glance, a sandwich tern from the common tern, a common pochard from a European wigeon. In case of doubt, regular visits to an ornithological park will be helpful. There you will see caged birds and also some that can fly free in aviaries, separated from the public by screens that are perfectly integrated into the decor. This is a good transition

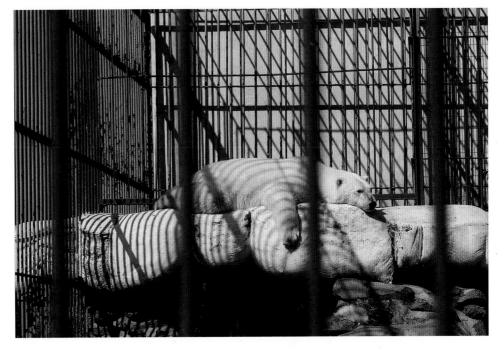

ABOVE

A prisoner behind bars and stressed by the innocent but constant onslaught of visitors, this zoo polar bear falls into a lethargy that no doubt allows him some interior escape. This image emphasizes the bars to focus on the sadness of the captive animal.

Polar bear (*Ursus maritimus*)
28–105mm zoom lens
1/60 sec. at f/11 - AF.

BELOW

This wild polar bear in Hudson's Bay (Canada) is full of life, and delights in rolling around on his ice floe. His thick coat emphasizes the health of an animal that is free and at ease—the photograph leaves no doubt.

Polar bear (*Ursus maritimus*)
Image-stabilized 600mm lens
1/200 sec. at f/7.1 - AF.

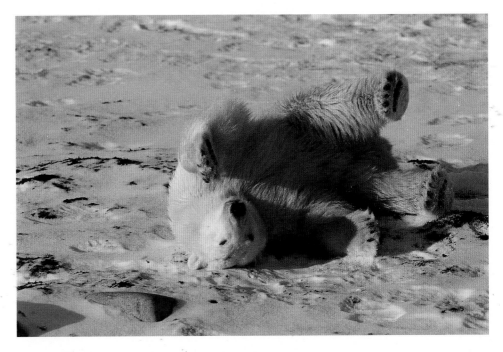

OPPOSITE

The choice of harsh early-afternoon light for this portrait reinforces the expression of boredom on this lowland gorilla's face.

Lowland gorilla
(*Gorilla gorilla*)
300mm lens with 1.4x focal length multiplier
1/60 sec. at f/8 - MF.

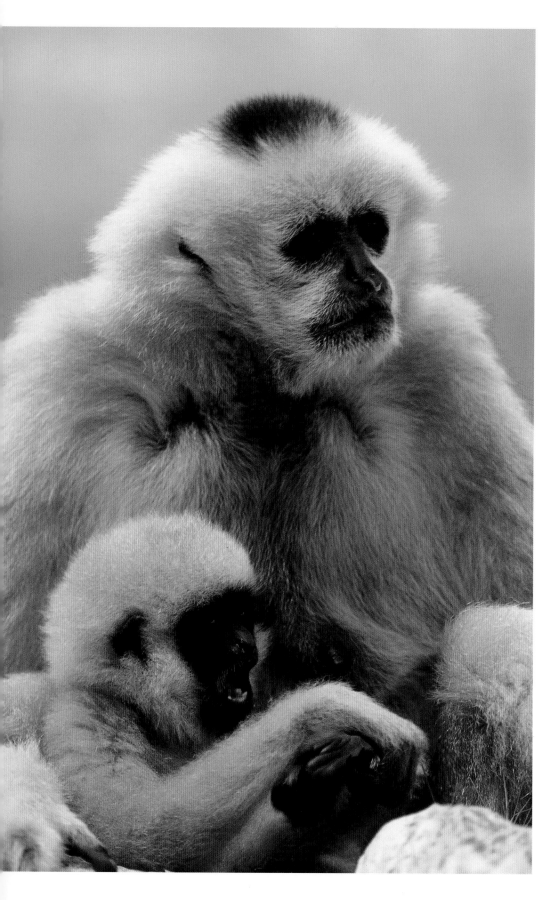

between photographing animals in the zoo and shooting truly wild animals.

Subjects in the zoo are close enough to encourage the use of medium lenses. An 80–200mm zoom will work in pretty much every situation, going from a tight close-up to a full-length portrait for most species. It's still best to use a lens opened to f/2.8 to blur out bars and other unpleasant backgrounds. If the fencing around the animal is too small for your lens to fit through, hold your zoom right up to the fence and open the diaphragm as wide as possible. A faint crosshatching will still be visible in the photograph, but this is not very obvious. If you come across safety glass instead of bars, hold the lens directly against it to avoid reflections. Note that the thickness of laminated glass and its less-than-perfect cleanliness will reduce sharpness—and be sure to clean the fingerprints from your side of the glass. Holding the lens (or the lens shade) against the glass lets you use a flash without unwanted reflections.

In wildlife parks, the environment is more natural and the distances greater. Depending on the park's design, the best focal length varies between 200mm and 500mm. Open ornithological parks are the most demanding as far as focal lengths are concerned. Many birds stay at the top of their enclosures, which are too noisy when

Zoos let you get to know exotic species and facilitate close-ups of rare animals. On the other hand these animals, often elderly and fed too much popcorn, may not look much like their wild counterparts.

White-cheeked Gibbon
(*Hylobates concolor leucogenys*)
300mm lens
1/250 sec. at f/5.6 - AF.

there are lots of visitors. These places are prized by wildlife photographers who like the absence of bars in the observation posts and the natural behavior of the birds. Parks featuring large mammals often have chain-link fences. Fortunately, the openings are rather large in the herbivore enclosures. Some parks have watchtowers which let you see directly into the enclosures. You'll always be shooting down, but this is better than shooting through bars. A 300mm lens is very good for taking photographs of large mammals. As in nature, some times are better than others for photography in wildlife parks. It's best to get there when the gates open first thing in the morning so you can see the animals when they're active, and be the first to go through the park.

Later in the day the animals are often knocked out by the heat or stressed by the presence of too many people. The other choice moment is the final hour before closing. The light is good and the animals are quieter once the crowds go away. In some parks it's possible to go through the park backwards to leave the last visitors, who are finishing their visit, behind you. Unless you're on good terms with the management, try not to be in the middle of the park when it's time to close.

Zoos are an excellent place to perfect your techniques for animal portraiture. You will learn to spot unusual expressions and postures.

Blue and Gold Macaw
(*Ara ararauna*)
135mm lens
1/250 sec. at f/2.8 - MF.

139

Public Aquariums

The low light levels at public aquariums require maximum stability and sensitive film. Avoid taking photographs after feeding time, when the water's cloudiness increases.

Touraine Aquarium (France)
28–105mm zoom lens
1/125 sec. at f/6.3 - MF.

Public aquariums are interesting places to photograph in because the animals are totally used to their environment and it has been designed to please the eye. The principal technical difficulty is photographing through thick glass that is necessary for safety in public places. Image quality is also affected when the glass is dirty (bring a cloth) or, worse, when the water isn't perfectly clean (algae, etc.). Avoid taking pictures for an hour after feeding when the water's turbidity (suspended particles) makes it impossible to take good photographs.

Once there, using a flash is rarely permitted, but this isn't much of a problem since a flash through the glass will emphasize the turbidity of the water and introduce distortion. Take photographs using ambient light, with sensitive color negative film (between ISO 400 and 800). Shutter speeds are low and the aperture open wide, but the potential optical quality is quite good,

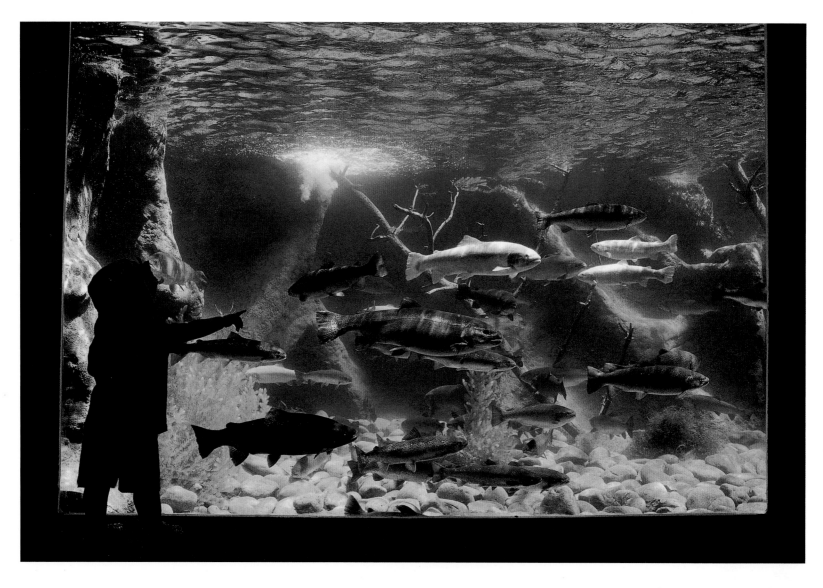

especially given the flattening caused by the aquarium glass. To avoid reflections, mount a rubber lens hood on your camera and hold it against the glass.

Magnification ratios close to those used in macrophotography and the low contrast in the water prohibit the use of autofocus. Focus manually as you track the subject at rest. If it's moving, wait until it comes into the sharp focus plane before releasing the shutter.

A pike snapped as he passes in front of the glass of the tank. Hold your lens against the glass to avoid troublesome reflections and use fast film (minimum ISO 400).

Northern Pike
(*Esox lucius*)
50mm lens
1/60 sec. at f/3.5 - MF.

The gulls that swarm around large coastal cities disturb the local ecosystem. Many birds, which nest on the shore, are subject to constant attack and a high level of predation by the gulls. Dubrovnik (Croatia).

300mm lens
1/350 sec. at f/4 - MF.

Nature in the City

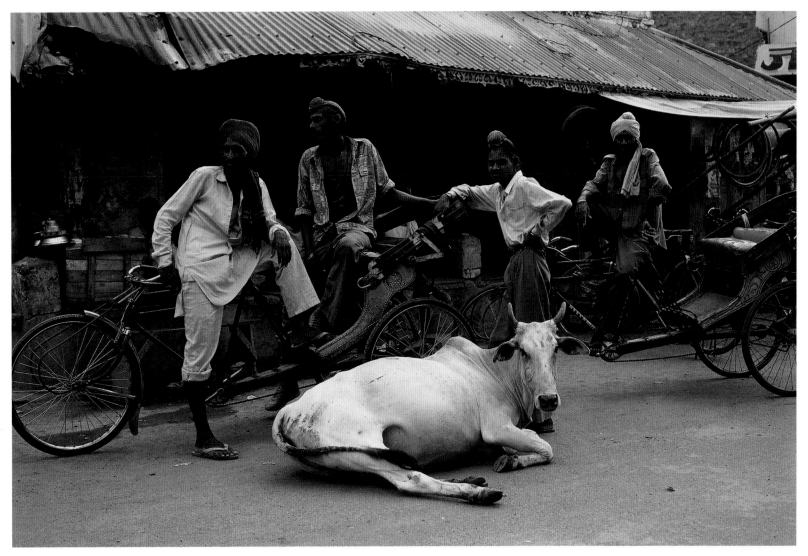

Busy city dwellers usually forget about the wildlife living in the city around them. In big cities, you can see quite unusual species such as falcons, ravens, sparrows, martens, bats, and rabbits living in parks, empty lots, and even cathedral towers. This little world, used to moving around quietly, comes out while the city sleeps. The suburban dweller who sees a fox rarely guesses at the identity of that odd animal when he meets it on his evening walk with Rover. Only birds remain active throughout the day, but in places that are inaccessible to the hordes of busy passers-by. You have to play the tourist in the towers of Notre Dame in Paris to see falcons chasing the sparrows, drunk on exhaust fumes.

To photograph these city imps, you can either lure them to your garden or wander around with a medium telephoto lens (between 200 and 300mm—and a flash for nighttime journeys). Birds are relatively easily to photograph, especially when they flock around a monument or a nesting site. With mammals things are trickier, since you can't predict when you're going to run into a mustelid (weasel family). The solution? Scout around while you're walking Rover, then come back with your car using it as a blind in the creature's territory. The animal usually makes it's rounds at the same time every night, but pay attention, it can disappear in the blink of an eye.

In India sacred cows are often guests in city streets. This story should be treated from the perspective of the relationship between them and the local inhabitants.

Bharatpur (India)
28–105mm zoom lens
1/100 sec. at f/9 - MF.

Domesticated Animals

Photographing family pets might seem like child's play to someone who specializes in working with wild animals, but don't be too sure! The pretty kitty, "well-behaved and not fussy," can become a real nightmare as soon as it sees the camera and gets its first taste of the flash. It won't stay still, scratches, hisses, and spits. A lion in the middle of the savanna is calmer. Before trying to photograph family pets, you have to woo them and get into their good graces. Ask the owners what the pet's favorite treat is, if the owners will stay during the shoot, and especially not to forget the pet's bedding or favorite toy when you're taking photographs in your studio. Finally, set off a few low-power flashes without looking at the cat. If you're patient, it will usually grow used to your stratagem. That said, I've known pussycats that were so uncooperative that I had to use a different subject.

For professional shoots, the photographer has the advantage of being able to do his own casting based on the animal's behavior. The "actor" you hire should be particularly calm when posing with people, and especially with children. In such a situation with an unknown animal, avoid using a flash and use long lenses (from 180 to 200mm), which will let you work at a generous distance without disturbing the animal. Don't count on being able to pose your subject for more than a few minutes. Only animals specially trained for film work can stand up to a photographer's demands for a relatively long time.

Since dogs are so often photographed, it's a good idea to choose an unusual background to give the image more impact.

300mm lens
1/500 sec. at f/7.1 - AF.

OPPOSITE

Predictive autofocus lets you track the horse without losing your focus.

300mm lens
1/500 sec. at f/7.1 - AF.

Here the cat's pose and the unusual setting make the image more dynamic. Conventional shots of kitties curled up comfortably have little artistic merit.

200mm lens
1/100 sec. at f/7.1 - AF.

OPPOSITE

In Nepal an elephant is a domesticated animal like any other. From a Western perspective, this photograph depicts a shackled wild animal: an easy-to-take shot that can still carry an important ecological message.

Asian Elephant
(*Elephas indicus*)
28–105mm zoom lens
1/200 sec. at f/8 - AF.
Photograph: Houria Arhab.

Dogs are much more easily won over. A treat, a few friendly pats on the back, and a couple of minutes spent scratching his belly, and Rover will be your friend for life. There's still one problem: dogs have a tendency to break their pose constantly to sniff the camera or make a slightly excessive declaration of their affections. Asserting your dominance is a possibility with dogs trained to respond to this treatment. With a spoiled little doggie, it's better to get a person—whether or not included in the composition—to keep him settled down.

Outside shoots can take place without the animal's knowledge. Have the owner control the animal while you take your photographs with a telephoto lens (200 or 300mm). Food is always a good way of controlling the animal, e.g., setting out dog biscuits at strategic points in the area. If your subject is a cat, get it used to looking for treats where you want it to go a few days before the session, and it should do what you want without any problems when it's time for the picture. Food is the only way to control other domesticated animals (birds, hamsters, guinea pigs, tortoises), since they are rarely trained. It's best to design a route along the ground with objects—visible in the photograph or not—to direct the hamster or guinea pig to the right place.

Birds are best photographed in an aviary, in an environment they're used to. Set up backdrops and flashes near their seed dish. If the bird panics a little bit with the first flash, it'll get used to it relatively quickly. Automatic flash units, which vary flash length, are less traumatic than manual flashes, which use the diaphragm to regulate a full-power flash.

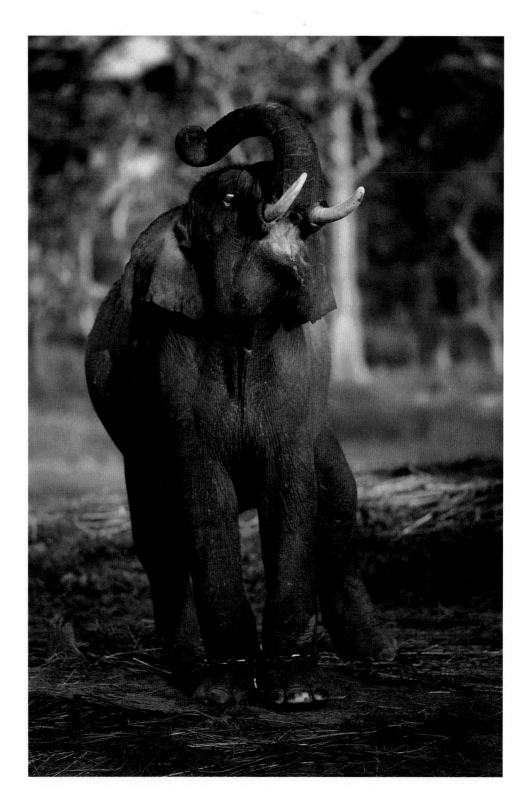

LANDSCAPE PHOTOGRAPHY

Landscapes are a subject unto themselves for the photographer who is interested in nature. They may be photographed for their intrinsic beauty, to show the details of a place, or simply to serve as a backdrop behind a primary subject. In any case, a beautiful landscape should be perfectly focused and rich in detail, especially plants and minerals. This means the photographer needs to use the best possible film and equipment.

The equipment used for landscape photography is dictated by the final use to be made of the images and the level of quality desired. A 35mm camera equipped with a high-performance lens will produce very sharp images. You certainly shouldn't expect the quality possible with a high-grade medium-format camera but, with moderate enlargement, 35mm film gives astonishing results, given its small emulsion area. The use of ultra-fine-grained film (color slide or black-and-white negative) is absolutely essential. The fine grain emphasizes the texture of materials and increases your chances of getting the very best performance from the lens.

Medium format includes equipment designed to expose 120 and 220 roll film, used in the following negative sizes (in centimeters): 4.5 x 6 – 6 x 6 – 6 x 7 – 6 x 8 – 6 x 9 – 6 x 17 panoramic. Some panoramic cameras use 35mm film to take photographs that are compatible with medium format. The exposures measure 1 x 2½ in. (24 x 65 mm), which corresponds to a cut-down 6 x 7 cm negative. The superior quality of medium format is simply a result of the film's surface area, which is much higher than 35mm. For example, 6 x 7 format—whose dimensions are in fact 2¼ x 2⅞ in. (56 x 72 mm)—gives a film surface area of 6¼ in.2 (4,032 mm^2), as opposed to 1⅓ in.2 (864 mm^2) with 35mm. As a result, there is 4.7 times as much surface area to capture details when you

The famous outlines of Digue Island (Seychelles), a paradise for the lover of images and landscapes. Control of depth of field is essential for a good rendering of the landscape.

20mm lens
1/80 sec. at f/14 - AF.

Film Formats

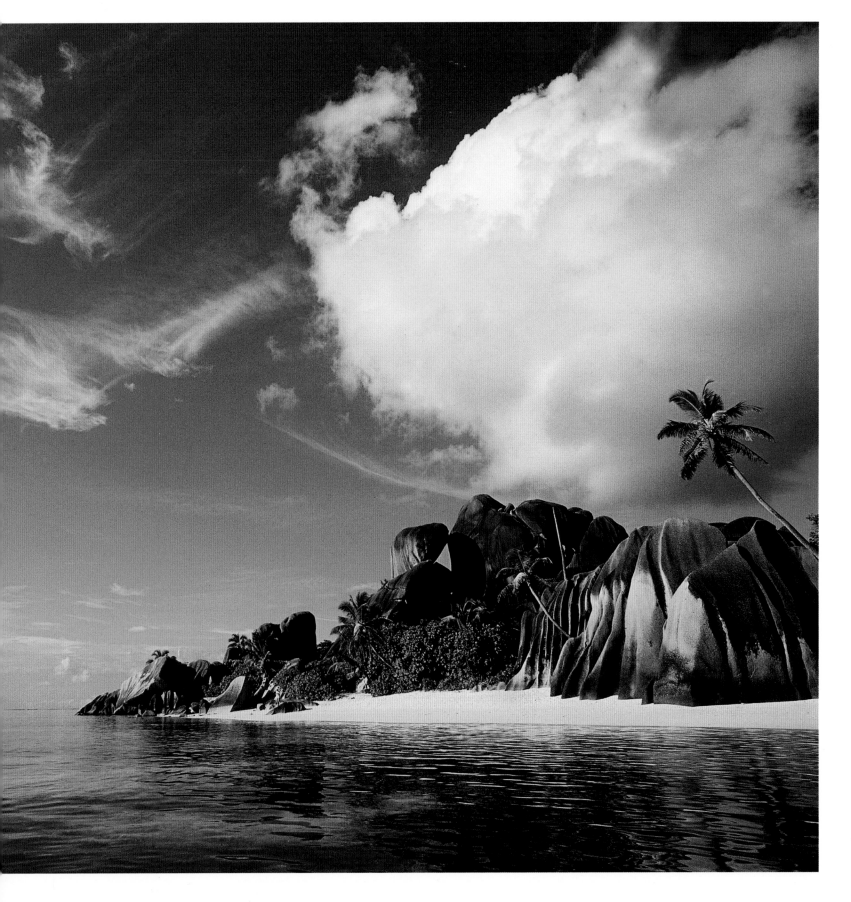

use 6 x 7 format instead of 35mm. Despite a widely-held belief, the lens has nothing to do with this superior quality. Lenses designed for the medium-format image circle have less definition than a lens designed to cover a 35mm surface. With an equal degree of enlargement, the 35mm exposure will be far better. You have to fill the viewfinder with your subject to reap the full benefits of medium format, which is also true for 35mm. With a few exceptions, medium-format cameras are crude compared to 35mm SLRs. On the other hand, they introduce a modularity unknown in the smaller format. Each camera is like a puzzle from which you may remove lens, viewfinder, film back, and motor drive. With several backs you can switch from one kind of film to another in the middle of a roll. A safety shutter protects the film from exposure. The same is true for viewfinders; you can switch from a folding viewfinder to a prism in a few seconds. This modular design—in conjunction with the detail offered by medium format—justifies the interest that pros and demanding amateurs take in these odd-looking cameras.

In the hierarchy of image quality, large format is king. These cameras are called view cameras. Roll film—not stiff enough for the film's large surface area—is replaced by sheet film. And don't even think of taking snapshots, since you have to change film between each shot. To use a view camera is to go back to the early days of photography. With the exception of a few small details, view cameras have changed very little in fifty years.

A large-format view camera is made up of a movable lens board and camera back connected by a light-tight bellows. The lens is mounted on the lens board and has its own internal shutter. The camera back is equipped with a ground glass screen used for focusing (the image is reversed and upside down), itself attached by a series of latches so it can be removed to mount the film back loaded with two sheets of film (one in front, the other in back). The process for taking a picture is long, but gives total control over the image:

○ open the shutter, set on "T" (press once, the shutter opens; a second time and it closes) to project the image on the ground glass screen

○ focus roughly by moving the lens board or the camera back

○ final focus using a 10x magnifying lens on the ground glass screen

○ lock the lens board and the camera back

○ close the shutter

○ insert the loaded film holder

○ cock the shutter

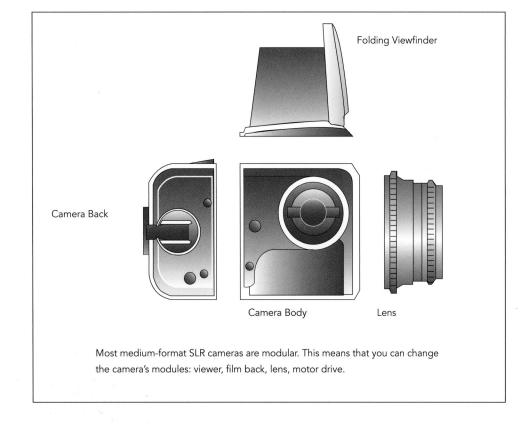

Folding Viewfinder

Camera Back

Camera Body

Lens

Most medium-format SLR cameras are modular. This means that you can change the camera's modules: viewer, film back, lens, motor drive.

- set the aperture and shutter speed indicated by the hand-held light meter
- remove the front slide from the holder (it prevents accidental exposure of the sheet film during handling)
- release the shutter
- reinsert the opaque slide into the film holder
- turn the film holder over to take a second shot identical to the first or start all over again with a new subject.

This doesn't include adjusting lens shift and tilt, which is a little more complicated, but nevertheless adds greatly to the beauty of landscapes photographed with a view camera. Image size is given in centimeters, except for 4 x 5-inch format. The most common formats are 4 x 5 in. (10.1 x 12.7 cm), 5 x 7 in. (13 x 18 cm), 7 x 9 in. (18 x 24 cm), and 8 x 10 in. (20 x 25 cm). There are view cameras that use 12 x 16 in. (30 x 40 cm)

These penguins involuntarily create a perspective line that gives this composition all its dynamism.

Royal Penguins (*Aptenodytes patagonica*)
20mm lens
1/250 sec. at f/11 - AF.

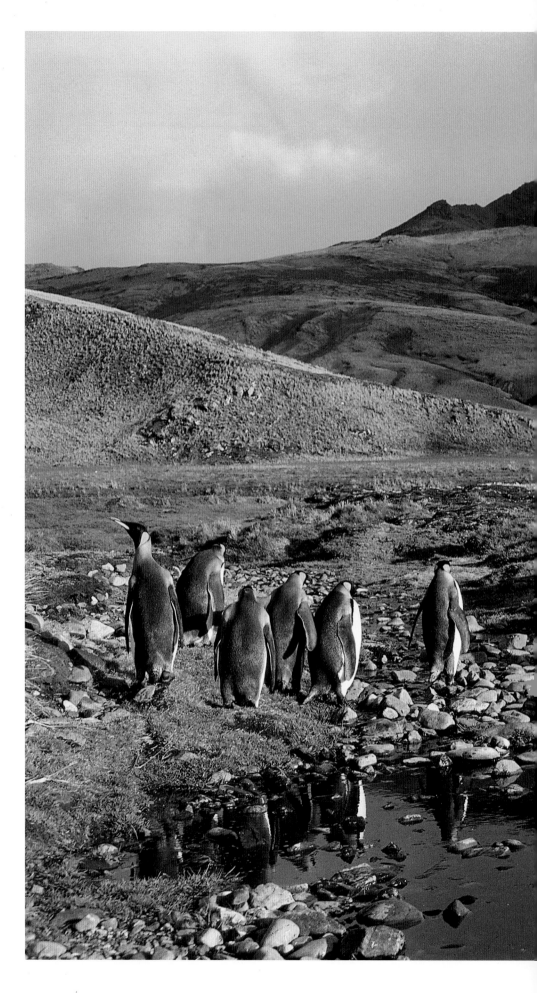

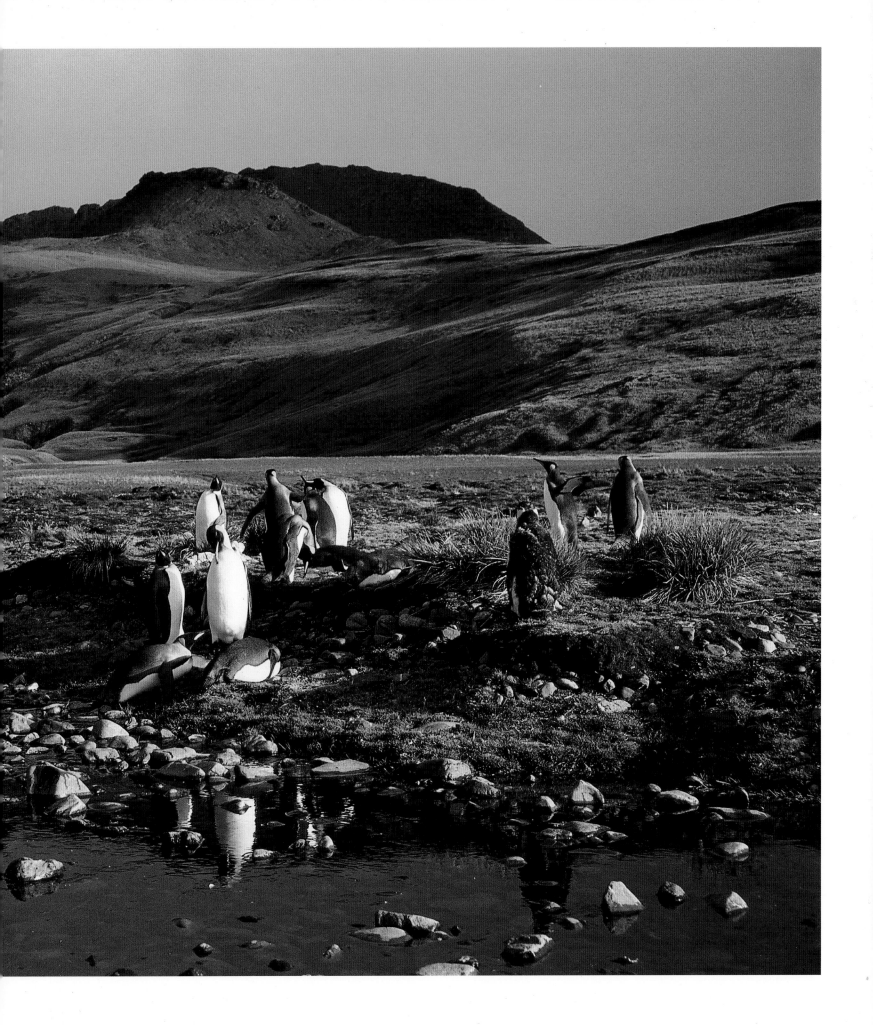

Six Full-Size Formats

35mm format

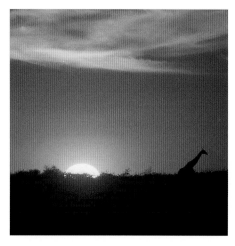

Medium format 6 x 6 cm

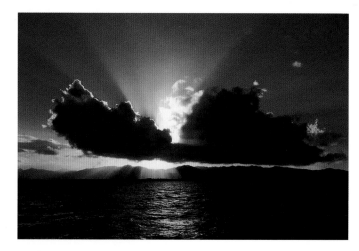

Medium format 6 x 9 cm

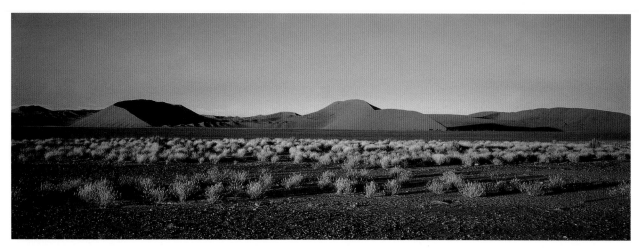

Panoramic format 6 x 17 cm

or even 20 x 24 in. (50 x 60 cm) sheet film, but these are highly specialized cameras.

Why do pros and landscape photographers use view cameras when medium-format cameras give such high-quality images? Because for landscape photography, view cameras are unbeatable for extraordinary image sharpness and detail. A view camera will capture details unavailable to any smaller format. The 10 x 13 ft. (4 x 3 m) posters used in advertising, giant photographs seen in exhibition halls, and full-page magazine shots swarming with detail are all taken with view cameras. Of course, it's not much fun spending twenty minutes setting up a shot, but you have to take your time to get the most you can from a landscape.

Medium format 6 x 7 cm

4 x 5-inch format (10.1 x 12.7 cm)

And when the sheet of film comes back from the lab, what a fantastic image! Then you understand why famous landscape photographers like Ansel Adams and David Muench all used—or still use—large-format cameras.

Don't Forget Your Tripod

Whatever format you choose, landscape photography requires a tripod. Of course you can always take nice photographs with a hand-held camera, but always to the detriment of quality. If your photograph is good without a tripod, it would've been perfect with one. The tripod doesn't just give stability, it also makes it easier to control framing to the millimeter. Thanks to it, the horizon is truly horizontal, irritating details are easily removed from a shot, depth of field can be controlled precisely, several shots of the same view are possible, the camera stays put when you move a troublesome branch a few feet away, all risk of imperceptible movements (which affect micro-contrasts) is eliminated, etc. The list goes on and on. If you don't yet own a tripod, get a rigid model that is heavy enough to support a large telephoto lens. Gitzo and Manfrotto (Bogen) are the best-known brands among specialists in nature photography.

When great depth of field is required, the tripod lets you use low shutter speeds. It also allows great precision in framing, with the possibility of taking several identical shots.

Mahé (Seychelles)
Tripod-mounted 24mm lens
1/60 sec. at f/22 - MF.

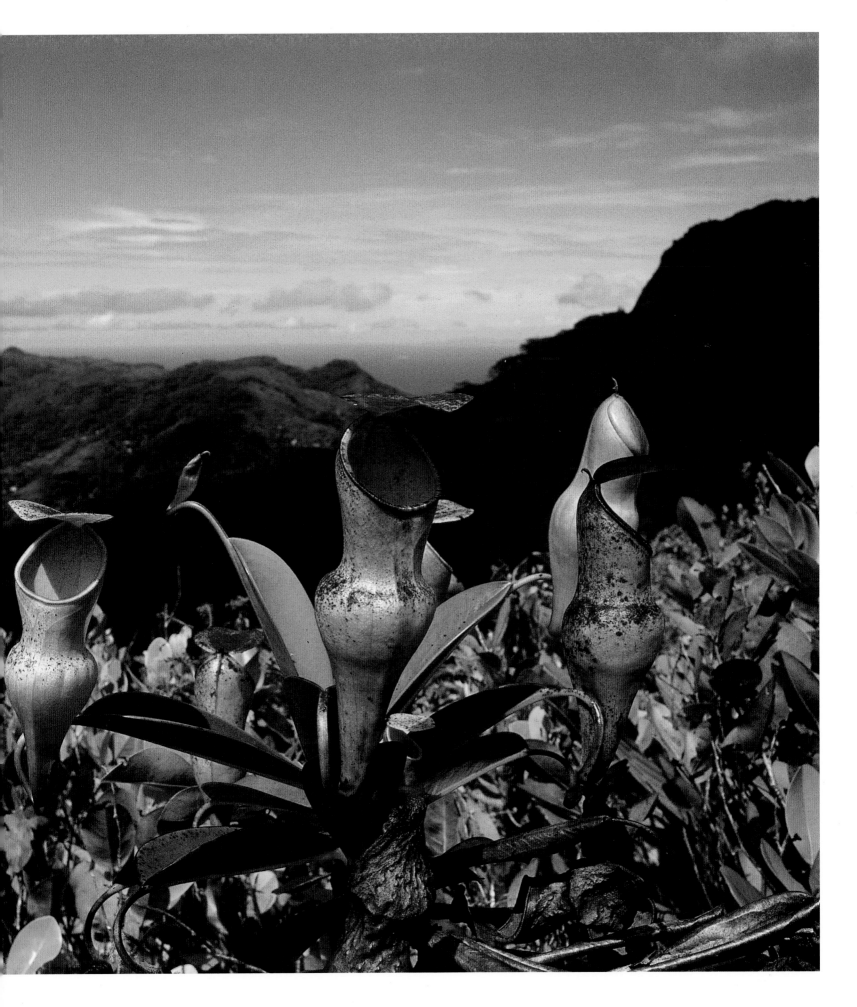

Choose the Right Lens for Landscape Photography

The fish-eye lens produces spectacular photographs thanks to its strong distortion and the amazing field of view it gives (180°). With a subject in the close foreground, fish-eye images are extremely dynamic and very useful for bringing out the relief in a rather flat landscape.

16mm fish-eye lens
1/60 sec. at f/22 - MF.

Lens quality is essential: a landscape is judged by how well details and textures are reproduced. Fixed focal-length lenses give the best results, thanks to their impeccable sharpness and their high level of distortion correction. The landscape photographer's lens must maintain its performance at minimum aperture to give maximal control of depth of field. Photographing at f/16 or f/22 without visible loss of detail is indispensable when you set up a shot with a subject in the foreground (flowers, animals).

The speed of the lens is usually secondary, since you will always be working with a tripod. In any case, fixed focal-length lenses of modest aperture are at least equal in speed to high-performance zooms (f/2.8 on average). Very good pictures can also be taken with high-end zooms, but distortion—impossible to correct completely

with a variable focal length—will always bend straight lines, especially the line of the horizon, which will curve up or down. On the other hand, the sharpness and performance at minimum aperture of pro zooms equals that of fixed focal-length lenses. The photographer who doesn't want to worry about his zoom lens can always carry a fixed focal-length lens (e.g., 24mm) for landscapes that have a completely straight horizon. When the horizon line is masked by the landscape, the zoom's distortion is lost in the details.

Among fixed focal-length lenses, those with shift and tilt deserve the attention of the landscape photographer. These use highly specialized optics, originally designed for architecture and the photography of spherical objects. They cover an image field much larger than 35mm and let you shift the lens by means of a micrometer built into the lens body. Greater or lesser degrees of shift correct the perspective of vertical lines. With conventional lenses, shooting upwards makes vertical subjects look like they're falling over backwards. Using a shift lens, the dynamics of a landscape composed of trees, mountains, or large rocks is maintained. The other great virtue of special lenses is the possibility to tilt the lens around its center to shift the sharp focus plane. This feature lets you align the sharp focus plane with the ground to obtain an infinite depth of field. This method is mostly used by landscape photographers who work with large-format cameras, where lenses may be shifted and tilted to an even greater degree. Most leading manufacturers produce shift lenses, but only Canon and Nikon also have tilt lenses.

With a couple of exceptions, there are no medium-format zoom lenses. The fixed focal-length lenses from most manufacturers are of very high quality. This said, be careful when making your choice since prices are much higher than for 35mm.

With large-format cameras, consider lens coverage when you choose a lens. The larger the area the lens covers, the more you can take advantage of moving the components. What's more, a wide-coverage lens will let you use a larger film back on modular view cameras.

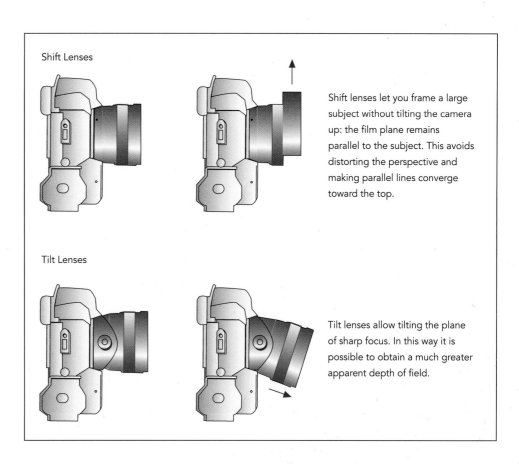

Shift Lenses

Shift lenses let you frame a large subject without tilting the camera up: the film plane remains parallel to the subject. This avoids distorting the perspective and making parallel lines converge toward the top.

Tilt Lenses

Tilt lenses allow tilting the plane of sharp focus. In this way it is possible to obtain a much greater apparent depth of field.

Light

The difference between success and failure in landscape photography almost always depends on light. This is why the photographer must determine which times of the day are most suitable for taking interesting pictures. When there's no fog, morning light is the purest. The sun's rays, still low on the horizon, pass through a thick atmospheric layer, emphasizing warm tones. These are certainly not the orange-reds of the end of the day, but shades of yellow that contrast with the cold shadows cast by the blue sky. At this time of day well-exposed slide film gives pleasant and detailed images.

When morning fog persists, the sun creates a fantastic spectacle of colors. From yellow to pink, and even purple, almost the whole spectrum is refracted by the drops of water vapor. In this case, standard slide film is at its best. Nevertheless, it is a good idea to take two or three shots at different exposures (± 1 EV) to have different versions of the same picture (bracketing).

In late morning, haze persists in the valleys. It is blue, almost opaque, and not very aesthetically pleasing. You could still turn this to your advantage in a composition in which the bluish horizon suggests the distance behind an attractive foreground. It is also possible to minimize it to some extent with a polarizing filter. With the approach of midday, the sun is at its zenith, and its direct rays make harsh shadows under the subject disappear, and highlights are washed out. This is the worst time for landscape photography.

Things pick up around four o'clock in the afternoon. The sun, beginning its long descent to the west, produces warm tones as shadows delicately lengthen. You should still be careful of large areas of shadow when the sky is totally clear. They're dense, with rather ugly blue halos (color temperature near 12,000 K). You will do better on days when white clouds diffuse and reflect the sun's light over the shadows, a little bit like reflectors set here and there in the sky. Under these circumstances, lighting is equalized between the bright areas and the shade. Standard films are quite suitable, but for slide films a slight underexposure (around 0.5 EV) helps expose the highlights correctly.

Beginning at about six or seven o'clock the sky is at its most beautiful. The atmosphere, through which the light passes almost horizontally, warms the sun's rays to a yellow-orange. Exposed rock is emphasized, especially if you meter on the highlights. This doesn't mean you take every photograph at −1 EV, but bracket a shot from time to time, e.g., with a landscape composed of bright rocks. Those who use very saturated slide film should limit themselves to −0.5 EV, since this film is often less sensitive than the numbers provided by the manufacturer would suggest.

These rocks, highlighted by the warm light, reveal the limestone strata that form them. Valdés Peninsula (Argentina).

28–105mm zoom lens
1/200 sec. at f/13 - AF.

Framing and Composition

Framing a landscape requires the choice of a point of view that gives the best perspective on the subject. Depending on the landscape, you may choose a high vantage point, which lays out each part of the composition, or, on the other hand, compress the composition by shooting almost at ground level. In the first case the horizon, placed in the upper part of the image, reduces the impact of the sky. The setting sun can restore its emphasis, and even become the dominant feature of the photograph. The second option emphasizes the sky, especially if there are pretty clouds against the blue background. Changing lenses without changing the point of view preserves the original perspective. Using a lens, which magnifies the image, is just like re-framing a portion of the photograph with the enlarger.

Framing a picture also involves selecting the most beautiful portion of the landscape, while hiding areas and details that are less pleasing. Having such a large area in the viewfinder requires the photographer to look carefully for telephone lines, signposts, or cars that spoil the picture's harmony. We're so used to reading all the information in the viewfinder and the auto-focus area that we have to force ourselves to search every part of the frame to avoid overlooking anything; a disturbing element in the middle of the frame may be easily hidden with a tree or a rock. With practice, the eye will almost automatically pick out the best composition and any flaws in the image. Judicious landscape composition uses two elementary criteria: how the eye reads the image, and the use of perspective lines. The eye reads a photograph from left to right. This is why the most basic composition has the photograph's main subject in the key point in the upper right-hand area of the frame. Simply divide the image's rectangular area into thirds vertically and horizontally; the key points are located where the lines intersect.

In more elaborate compositions, the strategic position at the upper-right-hand point may be held by a secondary subject, which leads the eye to the principal subject with a straight line. This line is often a perspective line, which adds an intriguing sense of depth and gives the photograph a three-dimensional look. The most obvious perspective lines connect the lower corners of the photograph with the upper-right-hand third. But using natural perspective lines (the shore of a lake, an arrangement of trees, a mountain peak) will result in much more aesthetically pleasing compositions. Depending on the height of the vantage point, vertical orientation increases the effect of perspective lines, while horizontal compositions emphasize lines dividing the image diagonally.

The zigzag lines, which stretch from the foreground to the focal point of the composition, lend majesty to this astonishing rock in precarious balance.

Devil's Marble (Australia)
24mm lens
1/500 sec. at f/8 - AF.

Depth of Field

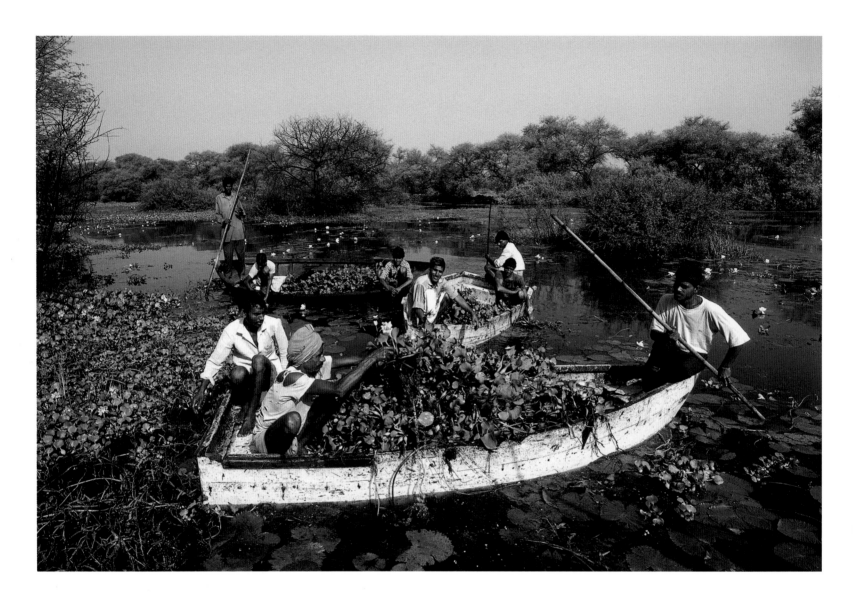

Trying to halt the spread of the water hyacinth in the Bharatpur Reserve (India). The choice of a small aperture lets the near foreground be included in the zone of sharp focus. Visual control using depth of field preview is essential.

24mm lens
1/30 sec. f/22 - AF.

Landscape photography demands absolute precision. Everything must be in focus, from the foreground to the background. To keep both foreground and horizon in focus, use a small aperture (from f/11 to f/22). Diffraction at these apertures does reduce image clarity, but this is preferable to any area of the image being out of focus. Diffraction effects increase the more the aperture is reduced, so use f/11 rather than f/16, and f/16 rather than f/22. Inspecting the zone of sharpness using the depth of field preview will allow you to select the aperture that gives the best compromise.

Maximum depth of field is obtained when you set the focus ring to the hyperfocal distance (see "Photographic Techniques"). Everything will be in focus, from half the hyperfocal distance to infinity. Only view cameras and tilt lenses can produce an apparent zone of sharp focus larger than that obtained using the hyperfocal distance. This is not a real increase in the depth of field, but an inclination of the plane of focus. When film plane, lens plane, and subject plane all intersect at one imaginary point, the zone of sharp focus is parallel with the subject plane (Scheimpflug's law).

Field of View

Optical Axis

When the film, lens, and subject plane intersect at a single point, sharpness along the subject plane is at its maximum (Scheimpflug's law).

Intersection of Three Axes

Shallow depth of field is better accepted in landscape photography with a telephoto lens. A blurry background behind the sharp focus of the subject reinforces its impact. The effect is stronger when the mass of the background is large and spectacular. A telephoto lens at wide aperture is preferable, since it produces softer focus. For a well-blended background, open the diaphragm: the round opening of maximum aperture produces a more even look than that produced by the six or eight blades of the standard iris. With a limited depth of field, photograph the subject from a good distance (at low magnification), so the background is not too blurry to be identified.

The Foreground

A landscape shot with a wide-angle lens recedes into the distance and loses detail. The introduction of a significant foreground at the edge of the image makes this distancing visually acceptable, creates a very dynamic sense of depth, and may also make details of the rocks and plants in the landscape more visible. Stones, flowers, and grasses make excellent starting points for perspective lines and also increase the apparent relief. In order for the information given by the foreground to be useful, it should be of the same nature as the rest of the landscape. If the desired effect is purely creative, its nature doesn't matter so long as it has sufficient aesthetic value. In this case, it's better to rely on contrasts of color or mass to give impact to the foreground. In nature photography, the ideal foreground contains an animal. It is perfectly integrated into its surroundings, and its impact is much greater than that of a rock or a clump of flowers. Depending on how much space is available, the composition may be shot with anything from a wide-angle lens to a telephoto. For example, you can take superb landscapes in the Serengeti with a 600mm lens, especially since the plains are swarming with animals. On the other hand, the super-wide-angle lens provides unusual perspectives in wildlife photography, but getting close enough to use it takes a lot of patience.

Graphic Elements

The graphic quality of a photograph derives from the harmony of geometric lines, colors, and forms. It is the emotion we feel when we see this magic created by incredibly subtle relationships fashioned only by chance. Nature's graphic quality is apparent everywhere you look: interlaced tree branches, blades of grass tracing circles in the sand, insect tracks in the mud, the structure of the leaf eaten by beetles, curved forms sculpted in the rock by water, a solitary tree in an empty field, or an ephemeral silhouette in the middle of a cloud.

The beauty of a line, which seems obvious to you, may go unnoticed by another person. Sensitivity to graphic elements must be learned. You have to have a trained eye to see the feminine quality of some curves, the originality of a contrast of colors, or to perceive the astonishing gradation of forms in a line of mountain peaks.

Just as some artists can create a portrait from a few pencil lines, the experienced graphic artist will see a host of symbols in utterly simple subjects. The investigation of graphic elements is also an excellent way to learn composition, especially when you're trying to fill the image space harmoniously with just a branch or a pebble.

Namib Naukluft Park (Namibia) provides a host of subjects for those who like strong graphic features. The crossing lines of the dunes and their monumental scale in contrast with the stunted desert trees create gripping contrasts.

100–400mm zoom lens
1/60 sec. at f/13 - AF.

Color

At sunset the color of the light changes very quickly: "barely five minutes and a single f-stop separate the two photographs. Nonetheless, the color rendering has shifted strongly toward the warm reddish tones."

Masai Mara (Kenya)
600mm lens
1/60 sec. at f/8, then f/5.6 – MF.

Landscape colors vary most with the seasons and the time of day. Vegetation is the main source of color in a landscape, but the angle by which the sun lights it also changes with the seasons. Almost vertical at midday in summer, the sun hangs low on the horizon in the middle of winter. Light passes through a variety of different moods throughout the day. Choosing the season or the time of day for a shot means choosing the colors that will enrich the photograph. A demanding photographer will not hesitate to wait for a particular season to start working. It's a good idea to take notes to help you to remember the best time to photograph your favorite landscapes.

Summer is cloaked in the dense greens of lush forests, and the dry yellow of grasses baked by the sun. Its light is harsh at midday and becomes magnificent in the evening. Take your landscape photographs at the beginning and end of the day to avoid the harsh light.

Autumn is among the high points of the year. Contrary to what you might think, turning foliage is at its best for only a short time, from two to three weeks at the most. A strong wind, a few showers, and that magnificent photograph of a golden beech or chestnut tree is put off for another year. As soon as the leaves begin to turn, begin your research (state of the foliage, movement of the sap, which trees contrast with their

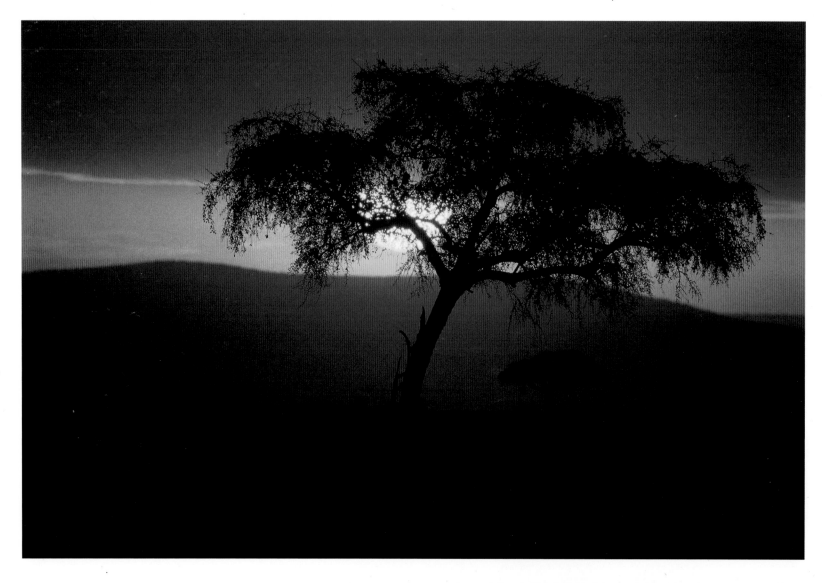

environment). As far as light goes, the autumn sun is lower in the sky, so the warm light persists in the morning and comes earlier in the afternoon. A real windfall for the landscape photographer!

In winter, ice and snow cover the withered vegetation. Once the branches are covered with frost, the landscape takes on a surreal aspect, bathed in a bluish light that contrasts with the warm tones of the winter sun.

It's not worthwhile photographing snow-scapes on overcast days. The result would be an unattractive monochromatic black-and-white. With no snow, winter landscapes are enlivened by the warm light of the sun, very low on the horizon. Without these tones, the lighting tends toward a brown-magenta, which is not very pho-togenic. On the other hand, winter is a good time for wildlife photography since birds and small mammals stand out sharply.

Springtime is eagerly awaited by photogra-phers. From the bright green grass to the carpets of flowers in the undergrowth, there's color every-where. This is especially true since the sun is still not very high in the sky.

All the same, be careful of the great predominance of green at the end of spring. It is not always attractive when it is too pervasive. Try contrasting it with a secondary subject to make it visually acceptable.

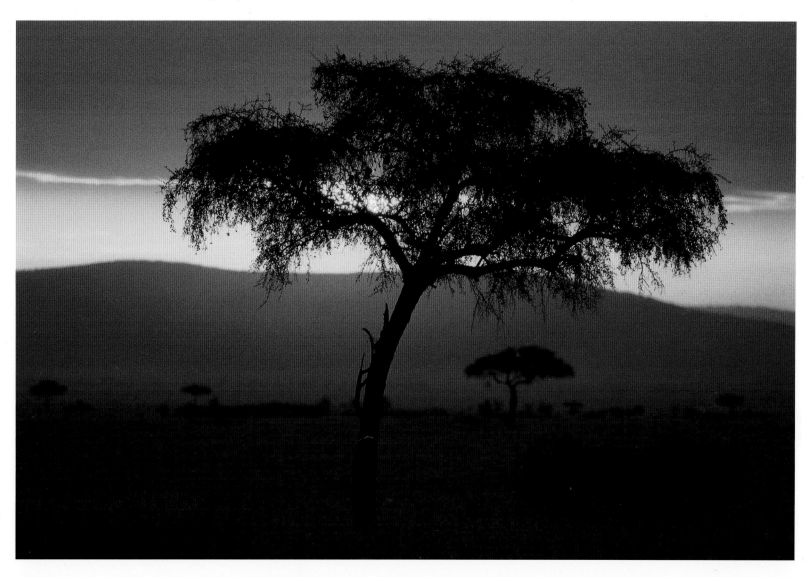

Filters for Landscape Photography

The loss of two f-stops due to the 4x neutral density filter allows slow shutter speeds in broad daylight. This is ideal for giving the waters of Russell Falls (Mount Field National Park in Tasmania, Australia) a gracious sense of movement.

Tripod-mounted 24mm lens with 4x neutral density filter
1/15 sec. at f/16 - MF.

The most useful filter for landscape photography is without a doubt the polarizer. It saturates colors and the blue of the sky, partially eliminates atmospheric haze, and minimizes reflections off water and nonmetallic subjects. Its only drawback is that it takes away 2 EVs in exposure. However, this could sometimes be an advantage, especially when long exposures give a sense of fluidity (movement of grass in the wind, running water, moving flowers). Use a circular polarizer, the only kind that works with autofocus SLRs.

Don't bother buying the most expensive brand, since most screw-mounted polarizing filters are of high quality. To get the most out of it, mount it on the lens and rotate the outer ring: reflections from leaves and water will change gradually as you rotate. Choose the most artistic effects, depending on the look you want.

Contrast between the blue sky and the white clouds is greatest in the naturally polarized region of the sky. You can find this by turning your back to the sun: the whole area located at ninety degrees from an imaginary line between the sun and your camera is polarized. To demonstrate this effect, turn the filter while you look at the sky, and this part will darken spectacularly.

Neutral density filters are undervalued by most photographers. They are very useful to give additional density to a sky that is too bright or to increase exposure time to give a sense of movement. Neutral density filters may be had in various densities: –1EV (x 2), –2EV (x 4), –3EV (x 8). You can even find one designed for very long shots in broad daylight. You lose almost 9 EVs with these filters. Neutral density filters are especially useful for increasing exposure times in broad daylight. Any moving water (rivers, waterfalls, waves) will be wreathed with a mist that is very attractive. The same is true for landscapes on windy days, when the movement of the plants takes on a graphic quality.

Variable neutral density filters are also available. With them, it is easy to reduce the contrast between a bright sky and dark ground. A cloudy sky looks stormy, and tones are much more even. A landscape photographer should always have a collection of neutral density filters in his or her camera bag.

Other filters, such as UV and skylight filters, are often recommended for landscape photography. The first is useless for UV (glass lenses will filter UV on their own), but they are very good protection against scratches and impact. Choose a neutral model whose mount is thin enough so that it doesn't shade the corner of your photographs (vignetting). You should avoid Skylight filters. Their salmon-pink color is supposed to add a warm look, but they give the photograph an exaggerated quality, and even turn the clouds pink.

Since they're often mixed in with UV filters, check the filter's color when you buy one by placing it on a sheet of white paper to see exactly what you're getting.

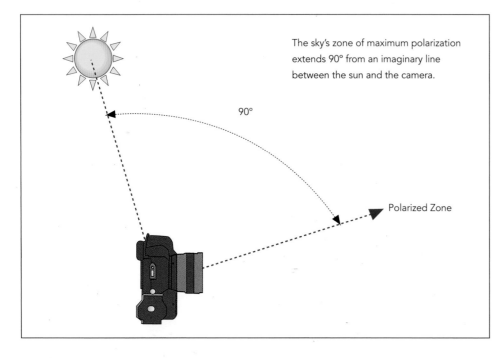

The sky's zone of maximum polarization extends 90° from an imaginary line between the sun and the camera.

90°

Polarized Zone

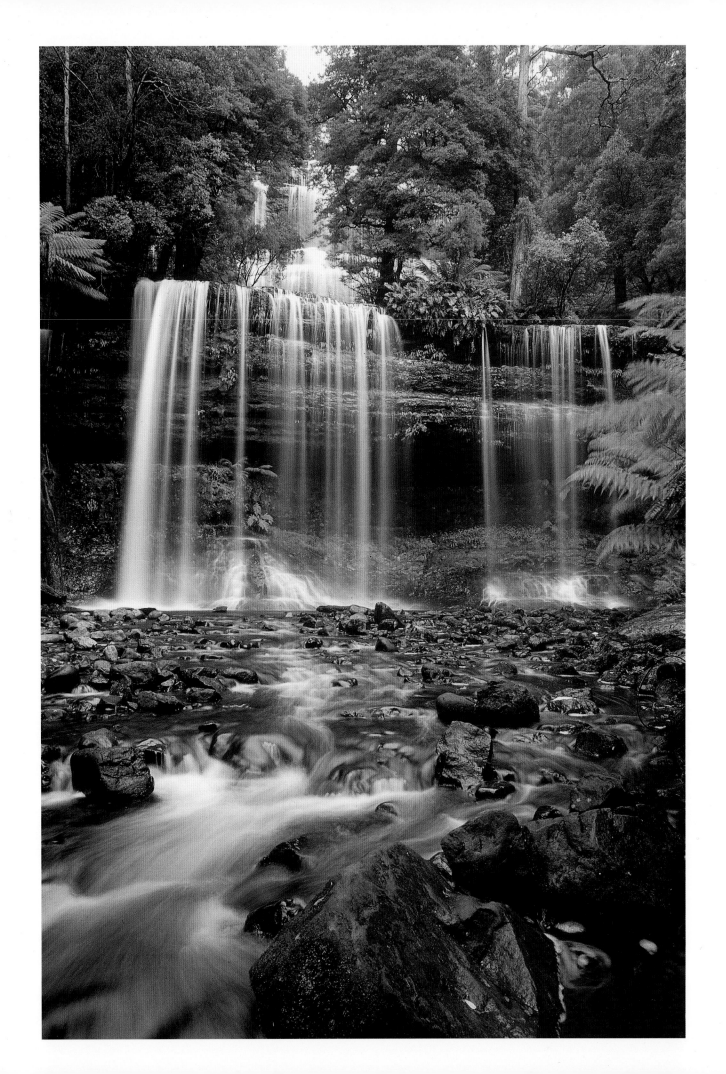

Landscapes and Panoramic Photography

Panoramic photography adds great possibilities to landscapes that can be difficult to frame elegantly with regular formats. Of course, any landscape photograph may easily be presented in panoramic format using a pair of scissors or a razor knife. But a photograph originally conceived as a panorama offers more creative possibilities, especially in terms of composition, since the position of the foreground is always more off-center with large formats. Reframed 35mm shots make good panoramic photographs, but the lack of framing marks in the viewfinder is often a problem. It's best to use a viewfinder with grid lines, whose upper and lower lines work fairly well to indicate the panoramic format. If cut-down 35mm film seems a little skimpy to you, you can buy a real panoramic camera, which uses increased film surface to capture more detail. Some cameras use 35mm film lengthwise for photographs that are 1 x 2½ in. (24 x 65 mm); others use medium-format roll film up to 6 x 17 cm. As in any photography, image quality is proportional to the film surface available—an essential concept to keep in mind when you intend to enlarge photographs. Pitfalls to avoid have to do with the camera's alignment when you're shooting: if the film plane is not perfectly vertical, the horizon line becomes an exaggerated curve.

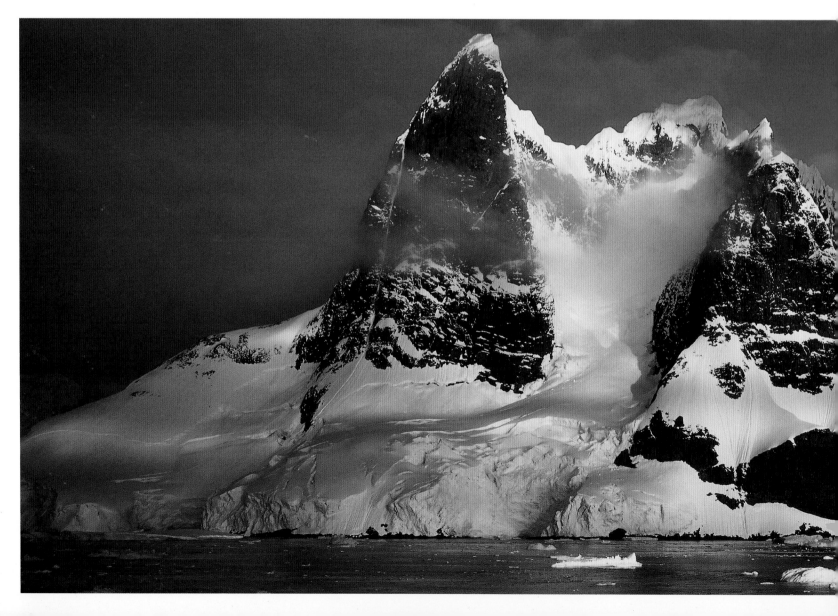

A horizon tilting left or right is another common problem in panoramic photography. For this reason, specialized cameras usually have a built-in level. The technology behind panoramic cameras also has its small disadvantages. Cameras that use a super-wide-angle lens are subject to vignetting to such a degree that most are furnished with a concentric variable-density filter to compensate for this defect. Those using a moving lens expose the film in an arc from side to side, which distorts moving subjects and may cause variations in exposure from one side of the image to the other. Some training is necessary to master panoramic cameras.

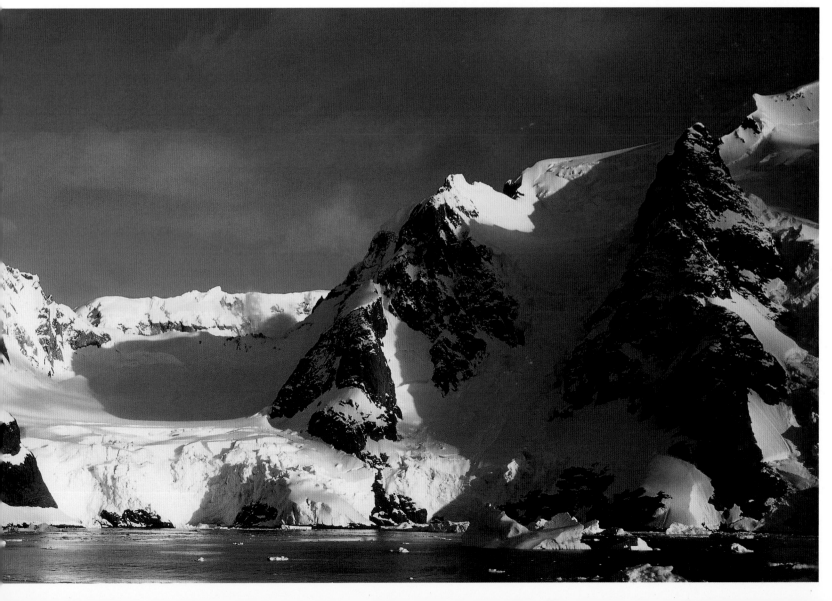

Airplanes, Ultralight Aircraft, and Helicopters

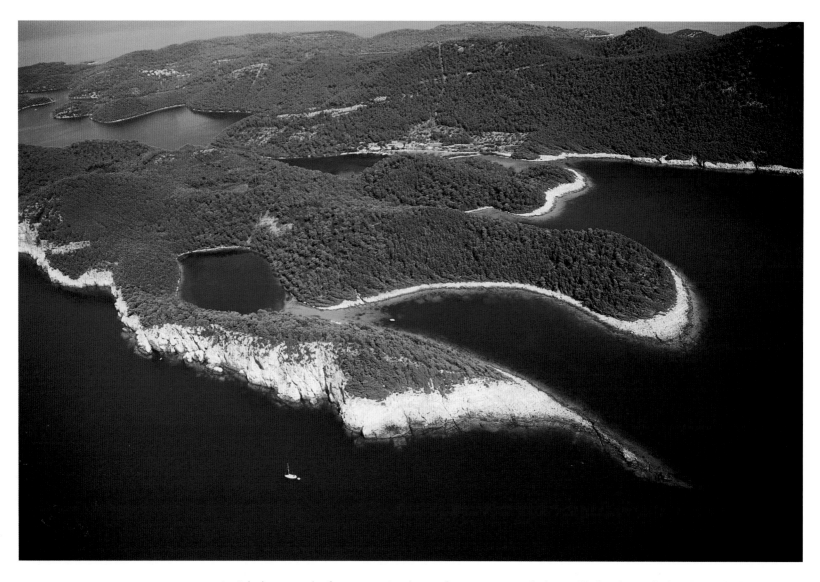

Photograph taken from a Cessna above Mljet National Park (Croatia): "Aerial photography demands perfect understanding between photographer and pilot. Here the pilot banked as he turned to give me a wider field of view for long enough to take a few photographs."

28–105mm zoom lens
1/500 sec. at f/10 - AF.

Aerial photography from motorized aircraft is a highly specialized business. It requires access to a special plane whose wings, set above the cockpit, give a wide field of view under the aircraft. Perfect communication and mutual trust between pilot and photographer are absolutely essential. It's the pilot's job to fly the plane in such a way as to facilitate photography. While the photographer should make things as easy as possible and not ask the pilot to do the impossible. Flying with the cockpit open is in and of itself risky: falling objects (film, lenses), turbulence, and distracting the pilot are all subjects for concern. Before the

flight itself, develop a flight plan with the pilot, in order to keep costs to a minimum and follow a logical path. The pilot may be aware of areas that are off-limits to aircraft. Marking strategic sites on a map generates useful geographic information that can make it easier to fly over the same flight path several times in succession since missed shots are common in aerial photography.

The airplane's high speed and vibrations require ultrahigh shutter speeds: never use speeds below 1/500 second. Specialists in aerial photography use very fast lenses, so that they can use high shutter speeds and slow film. Why

this type of film? Because a photograph taken from the airplane should be highly detailed to be appreciated. In absolute terms, aerial photography should only use medium- or large-format cameras, in order to capture as many details as possible. But as long as you stay at low altitudes, a 35mm camera equipped with high-performance lenses produces good slides. In a helicopter the risk of falling objects is still greater. Lulled by the comfort of stationary flight, it is easy to forget that the helicopter will move, bank, or turn depending on its flight path and lenses can easily roll on the cabin floor. The rotors are another

drawback for helicopter shots. When moving, they are invisible to our eyes, while they will in fact be visible in photographs taken at 1/2,000 second. Those who like to use hand-held incident light meters should be careful too because the shadow of the turning rotor will give false readings. Take an exposure reading with the camera's meter, and even use its spot metering if you don't have confidence in multi-segment metering.

Ultralight aircraft are a more inexpensive way of taking aerial photographs. They raise more or less the same technical problems as other means of aerial photography, with the additional disad-

Crabeater seal on a floating ice floe. Photograph taken in Antarctica from the crow's nest of a Russian ship (which can sometimes be used instead of a plane or helicopter to take aerial photographs).

Crabeater seal
(*Lobodon carcinophagus*)
28–105mm zoom lens
1/250 sec. at f/9.5 - AF.

Hot-air balloons are particularly well suited to aerial photography. They don't vibrate much, move slowly, and can reach high altitudes. Hot-air balloons are ideal for landscape photography.

OPPOSITE

The Masai Mara photographed from a hot-air balloon: "The zebras in the foreground seem unaware of the balloon and provide a splendid foreground for this landscape."

100–400mm zoom lens
1/350 sec. at f/5.6 - AF.

vantages caused by wearing a helmet, the difficulty of communicating with the pilot, and handling equipment when directly exposed to the wind. For example, seeing the viewfinder is more difficult because the photographer needs to wear goggles and changing film is an ordeal in itself. On the other hand, an ultralight aircraft gives you a more flexible flight path than an airplane, and the cost of an hour's flight is nothing compared to a helicopter!

Without a doubt, the hot-air balloon is the most comfortable way to take photographs from

the air. Low speed and the absence of jolts and vibrations all give more freedom in the selection of shutter speeds. Don't count on choosing where you fly, since the hot-air balloon has to follow the wind. The only way of changing course a little bit is to use a balloon pilot who is completely familiar with the local winds. Some experienced pilots are able to change direction by using the variation of wind direction at different altitudes, but don't count on it. Taking photographs in the basket is almost the same as taking them on the ground, but it requires a little more concentra-

tion. You don't want to drop a lens or a roll of film in the wild. Take most of your shots at low altitude, since the atmospheric layer becomes more of a problem as it grows thicker. The trickiest moment in a balloon ride is when you land, sometimes violently, and it is a good idea to stow your equipment in a well-padded camera bag beforehand. Landings are always a little jarring, but the pleasure of the flight and the photographs you have taken quickly supercede the memory of this discomfort.

TETHERED BALLOONS AND KITES

A camera hung from a tethered balloon or a kite lets you take aerial photographs very cheaply. Contact members of a model-airplane club in your area, who will be able to put you in touch with specialists—collaborating with experienced people is the best way to reduce the risks of breaking equipment and missing shots.

It's best to choose a lightweight, rather inexpensive camera furnished with a radio-controlled shutter release: a midrange autofocus SLR is perfect. It should hang from the balloon by a little harness, with ballast hung from the camera's tripod mount. The camera is harnessed in such a way that it points forward (the angle depends on the photographs you're trying to take), without pointing at the balloon's tether.

With a kite, the camera is hung directly from the string, a few yards or meters below the kite itself. This way the kite is still held up by the wind when the camera reaches the ground, and you can retrieve it without risking a violent drop. You should still protect your camera against rain and sand in case of a forced landing.

PHOTOGRAPHY IN ALL THE WORLD'S ECOSYSTEMS AND CLIMATIC CONDITIONS

TRAVEL TAKES PREPARATION

Proper preparation is the key to maximum efficiency during a trip. Preparation begins with research. Tourist guides, field guides, press clippings, and maps can furnish you with an impressive amount of information. They will help you determine the most likely places to look for the animals you're after, and the places where you'll be taking pictures can give you ideas for additional subjects. The time of year when you leave and the weather at your destination will in part determine your trip's success. Now that airplane tickets can be bought on the Internet in a few seconds, be sure that the great fare you find doesn't entail traveling at the worst time of the year. And remember that the seasons are reversed in the Southern Hemisphere. In the same spirit of efficiency, be as organized as possible, since being dropped by your driver right in the middle of the bush can turn out to be a real problem. Seek the advice of known and experienced travel agents to avoid irritating mishaps.

The humidity of the rain forest, the dust of the African plains, and the extreme cold of the polar regions are all hard on photograph equipment and film. Local conditions will also modify your technique: you don't measure exposure in the same way in snow and in the darkness of a virgin forest. If you know what to expect and are familiar with the local fauna and its habitat, you will save precious time, which in turn can help make your investment worthwhile.

FLYING: KEEP YOUR FILM IN YOUR CARRY-ON BAG

Security checks in airports use X-ray machines. For the last few years a new generation of scanners analyze checked bags (those that travel in the baggage compartment) thoroughly, using massive doses of X rays. No matter how reassuring they may be, these security measures are a real problem for photographers, since a single trip through such equipment is enough to immediately fog undeveloped photographic film (exposed or unexposed). There is no way to prevent this. The only solution—the one recommended by the major film manufacturers—is not to put any film in checked bags. It should go in your carry-on bags, which are exposed to much less radiation. You should still avoid putting film through the carry-on bag X-ray machines more than five times, since the effect of X rays is cumulative. You can get bags and boxes lined with lead, which are supposed to protect your films from X rays. Don't use them! When the security agent inspecting your baggage sees an opaque object in your bag, he will increase the radiation intensity. Your film may be fogged with a single exposure. It's better to put your film through the machine unprotected, if possible after you've told the agent that there is film in the bag.

Thorough preparation greatly increases your likelihood of success on any assignment. Given the cost of traveling to the other side of the world, you should never leave anything to chance.

Green Sea Turtle
(*Chelonia mydas*)
28–105mm zoom lens
1/60 sec. at f/18 - AF.

Tropical Rain Forests

Grasshopper in the Costa Rican jungle: "I brought all my macrophotography equipment along on this trip to Costa Rica to take close-ups. This portrait of a grasshopper (*Tettigoniidae*) quickly made me forget the discomfort caused by carrying the equipment."

50mm macro lens
1/60 sec. at f/11 - MF.
Two extension flashes.

Imagine a forest in which the trees are so thick that their foliage blocks eighty percent of the sunlight. Below, shadows are omnipresent in the humid heat. There is no grass on the ground: nothing but plants rooted in a thick layer of leaves devoured by microorganisms and insects. This layer of rotting leaves feeds a great variety of flowering plants. Just above, shrubs and bushes grow thickly despite the gloom. They wait for one of the forest giants to fall, struck by lightning, so they can race toward the light. On every tree trunk are vines and parasitic climbing plants. Welcome to the tropical rain forest!

The distinctive feature of this primary forest is that it is an ecosystem that operates in strata. The canopy is the highest stratum. This tangled mass of foliage and parasitic plants is home to a specialized fauna, most of whose species almost never leave the upper level.

Birds (toucans, hornbills, raptors), insects (butterflies, beetles), amphibians (frogs, tree frogs), mammals (monkeys, flying squirrels), and even crustaceans (crabs) live more than 130 feet (40 meters) above ground, where they find food, water, and shelter.

The scrub stratum is the realm of reptiles (snakes, lizards) and carnivores (panthers, jaguars). Set between the small animals of the canopy and the larger species that find their food on the ground, the scrub stratum is ideal for predators. It is the primary link between the shadowy ground and the forest canopy, bathed in light.

Tropical Rain Forests

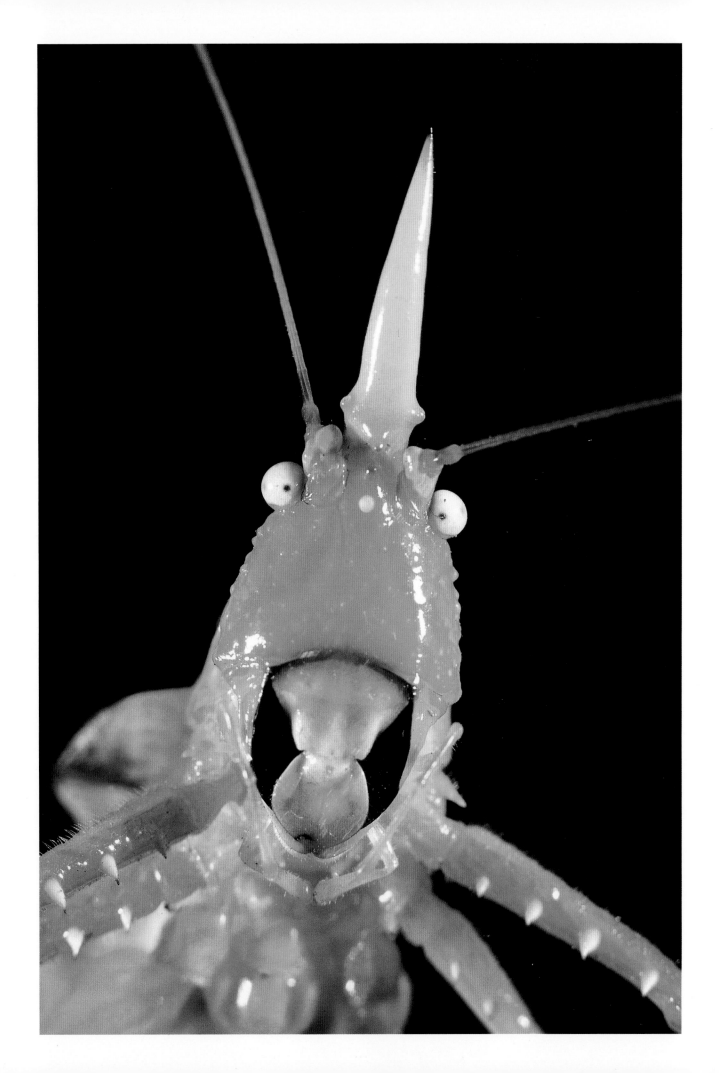

The Sand Monitor evolved in the Australian deserts. Almost impossible to catch, it disappears into the vegetation at any sudden movement.

Sand Monitor
(*Varus gouldii*)
400mm lens
1/125 sec. at f/5.6 - MF.

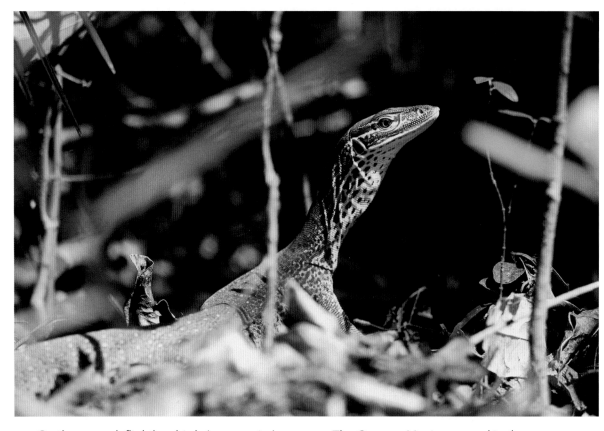

Even in the tropical forest, including a foreground makes shots more dynamic and enormously increases the perceived depth.

Cape Tribulation (Australia)
24mm lens
1/60 sec. at f/16 - MF.

On the ground, flightless birds (cassowaries) mingle with large mammals (tapirs, rhinoceroses, cervids) in search of food in the carpet of rotting leaves. The common factor between the ecosystems' three strata is the insects, omnipresent and adapted to each ecosystem.

PHOTOGRAPHY IN THE
TROPICAL RAIN FOREST

The photographer must adapt to this stratified universe. In the first place, you should never venture alone in this inhospitable environment. Travel in the tropical rain forest should be treated as a full expedition. The best thing is to team up with specialists (biologist, climbing guide, doctor), join an existing team of scientists, or travel with an organized group led by professional guides. Each forest stratum has its own techniques and practices.

○ The Canopy: Moving around in the canopy requires equipment and training similar to that used in rock climbing. You have to scale the leafy heights with mountaineering accessories (carabiners, climbing harness) and move around using ropes and spelunking ladders. For long expeditions, setting up nets will give you a certain freedom of movement, as long as you remain securely attached to a safety line: remember that you are twelve stories above the ground. Possibilities for photography in the canopy are as varied as the setting. From birds and insects to mammals, the subjects include almost all the specialties of nature photography. There is such richness that it's a good idea to establish a work plan for several days at a time, so as not to get distracted and leave something out. The animals, unaccustomed to human presence, will let you approach them and will often come close to investigate the

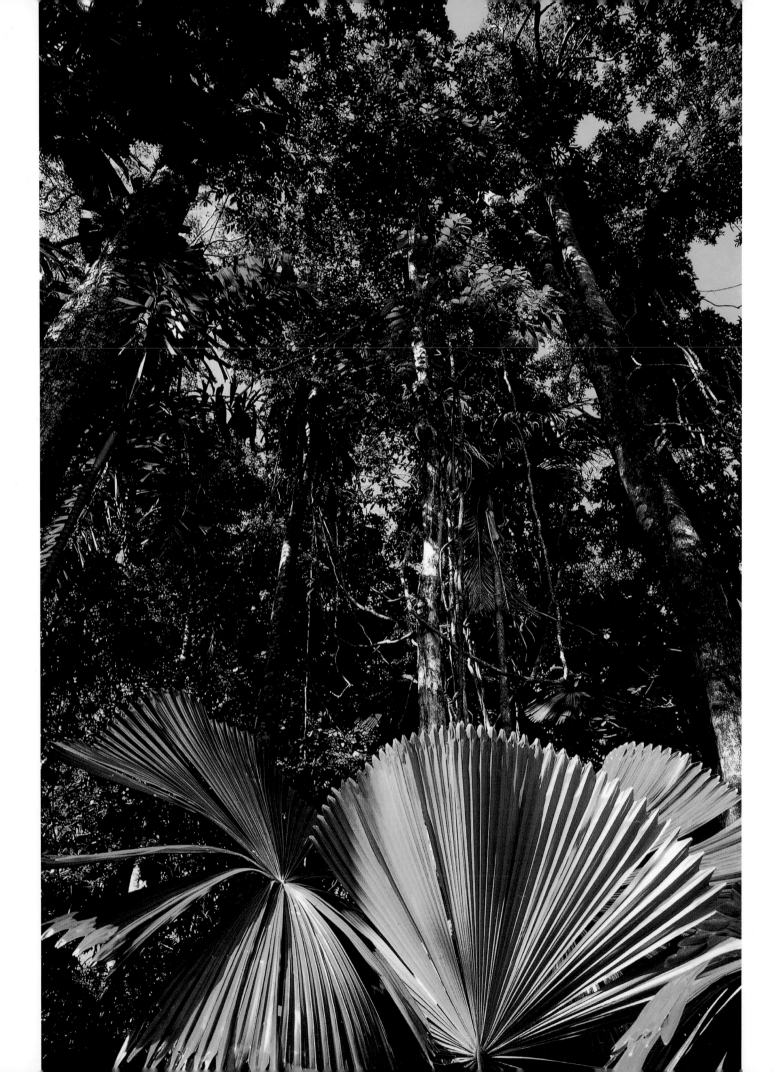

This tiny Costa Rican amphibian (½ in. or 1.5 cm long) secretes poison on its skin. Its highly visible color signals predators that it is best avoided.

Poison Dart Frog
(*Dendrobates pumilio*)
50mm macro lens
1/60 sec. at f/8 - MF.

OPPOSITE

In Costa Rica as elsewhere, the tropical rain forest is a fantastic place for macrophotography. The shadowy light makes a flash necessary. A headlamp is also very handy for lighting subjects while leaving the hands free. Photograph: Houria Arhab.

RIGHT

Detail of a butterfly's wing.
(*Ornithoptera priamus poseidon*)
50mm macro lens and bellows
1/60 sec. at f/22 - MF.
Two flip-up flashes.

This young Costa Rican sloth feeds peace-fully in preparation for a well-earned nap. An easy subject to photograph, even at low shutter speeds.

Young Two-toed Sloth
(*Choloepus hoffmanni*)
100–400mm zoom lens
1/200 sec. at f/7.1 - AF.

OPPOSITE

The bony crest of this helmeted cassowary lets it break through the vegetation if danger threatens. Its feet are lethal weapons that can disembowel a person.

Southern Cassowary (*Casuarius casuarius*)
400mm lens
1/60 sec. at f/5.6 - MF.

newcomer with the funny muzzle that makes that odd clicking sound. The canopy is also a paradise for macrophotographers, both during the day and at night. Just illuminate a piece of scrim and you'll see an incredible swarm of insects (and even some new species) alight.

○ The Scrub Statum: This intermediate zone is home to many insects, birds of prey, monkeys, and predators lying in wait for residents of the other layers to stray nearby. Here the light is weak and the risks are just as great, since moisture

makes the branches and vines extremely slippery. Take the same precautions as in the canopy (safety lines, climbing equipment) to keep from falling.

Shooting in the scrub mostly involves macrophotography (insects, spiders, caterpillars, reptiles, frogs, bats), or conventional pho-tographs of reptiles and mammals hiding in the crevices of the parasitic plants.

Large carnivores are more discreet, often nocturnal, and present a danger that you certainly should not ignore (jaguars, panthers).

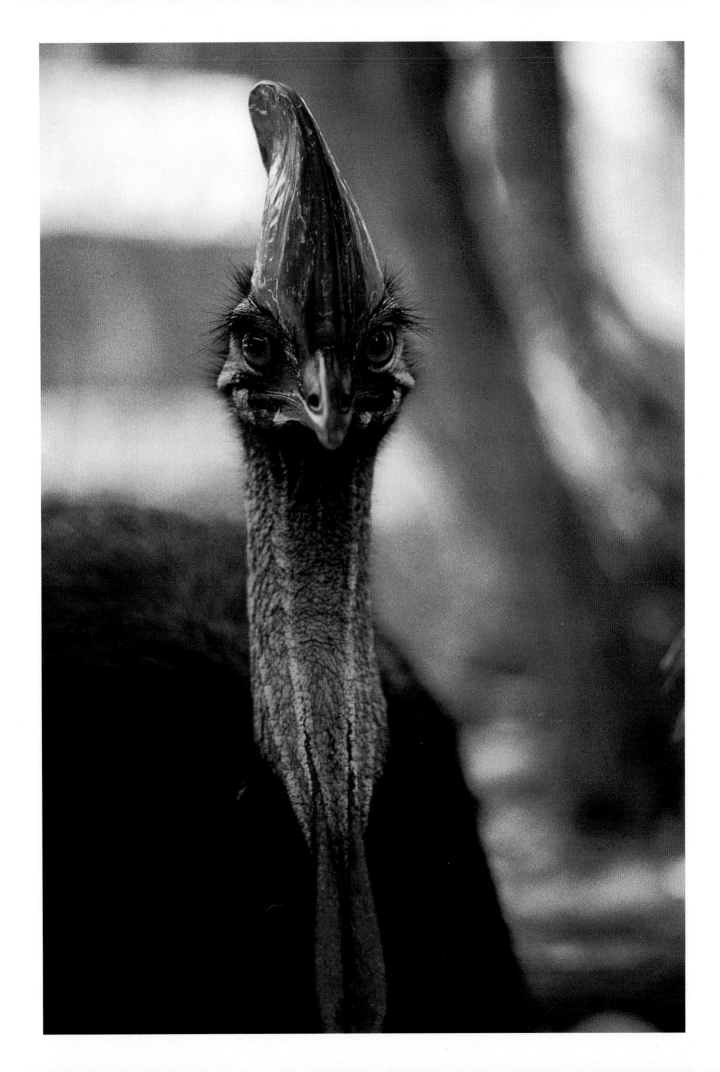

○ The Moist Forest Floor: Even if light is in short supply, taking photographs at ground level is less scary than in the treetops. Using an electronic flash is essential, unless you find a chance clearing whose light attracts rare species. Among the plants and flowers on the carpet of decomposing organic material, insects, amphibians, crabs, leeches, millipedes, snakes, and spiders join the dance of life to the delight of macrophotography enthusiasts. Some of these animals are even large enough to be photographed with a close-focus telephoto lens. The large herbivorous mammals are wary, despite the almost complete absence of human beings. In fact, their natural distrust is caused by panthers lying in wait.

HANDLING EQUIPMENT IN THE TROPICAL RAIN FOREST

Equipment used for photography in the tropical rain forest must be particularly tough. Cameras designed for professionals are most suitable, since their resistance to impact and humidity is much greater than that of consumer-grade cameras. Photographic equipment should always be protected from possible falls and humidity (around ninety percent in the tropical rain forest). The humidity's ravages are caused by microscopic fungi, which grow inside lenses, on film emulsions, and in the camera's electronics. Keep your

The Soufrière volcano (Guadaloupe) is surrounded by a tropical rain forest, especially interesting for its exuber-ant flora.

28–105mm zoom lens
1/45 sec. at f/13 - AF.

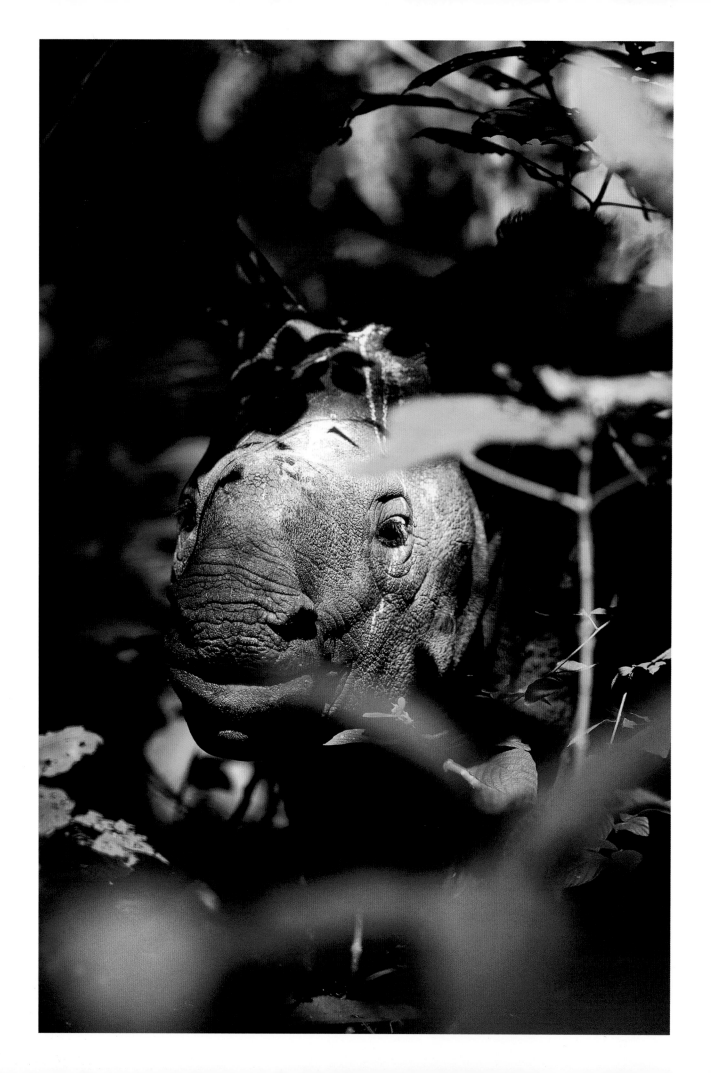

equipment as safe as possible by storing it in a dry place (e.g., in a camera bag containing moisture absorbent material like silica gel).

In permanent camps furnished with electricity, store your camera bag in a cupboard containing an electric light. A 40-watt bulb is enough to drive the moisture from modest volumes. You should also be aware that microscopic fungi grow best in the dark: take advantage of downtime in the field (e.g., at meals) to expose your lens to the sunlight for around ten minutes, enough time to destroy mildew spores. Daily cleaning of cameras and lenses is essential to remove traces of moisture and stray drops of water from the constant rain in the tropical rain forest.

Film is sensitive to heat as well as humidity, and precautions are even more important. Always keep the plastic canister in which the film is packed, in order to keep it in an atmosphere that is not too waterlogged. An insulated bag like you find in a sporting goods store is enough protection against variations in temperature. Don't keep film with the camera bag in a cupboard dried by an electric light bulb: film really doesn't like heat.

OPPOSITE

This young rhinoceros willingly shows itself in the Chitwan National Park (Nepal).

Greater Asian Rhinoceros
(*Rhinoceros unicornis*)
300mm lens
1/100 sec. at f/4 - AF.

TOP

In Guadaloupe's national park, Hercules Beetles often fight to the death.

Hercules Beetle
(*Dynastes hercules hercules*)
50mm macro lens
1/200 sec. at f/11 - MF.

BOTTOM

Tropical rain forest on Mahé (Seychelles): "I took advantage of a slight backlighting to emphasize the unusual graphic quality of these carnivorous plants."

(*Nepenthes pervillei*)
135mm lens
1/60 sec. at f/8 - MF.

Temperate Forests

Roe Deer approached by stalking in the forest. Manual focus is essential in situations like this, where the thick foliage is likely to mislead the auto-focus system.

Roe Deer
(*Capreolus capreolus*)
400mm lens
1/125 sec. at f/5.6 - MF.

Now we are on familiar ground: temperate forests are found in Europe, North America, or even Tasmania. The ecosystem of our forests is a toned-down version of the temperate forests that covered Europe in the time of the Gauls. This original forest, itself a survivor of the great glaciers, was totally transformed at the beginning of the Middle Ages, when its thickets were constantly cut down. Cutting wood for heating through the centuries has considerably reduced species variety and completely changed the forest ecosystem.

One of the typical characteristics of the present-day secondary forest is the explosion of spring flowers. The gathering of dead wood and the regular cutting of trees have led to the proliferation of flowers that were originally restricted to natural clearings. Today they have adapted their rhythm to that of the forests, and these flowers now complete their entire life cycle before the

trees grow leaves, which will block out the sun during the summer months. There are a few remnants of original temperate forests scattered around the globe: in Poland (Bialowieza National Park), extreme eastern Siberia, and Tasmania. These patches of primary forests are fiercely guarded by, and absolutely fascinating to, researchers. Mosses, ivies, and lichens bear witness to the age of these regions, which are still very rich in tree varieties and wood-eating insects. Photographing them is possible in the context of ecological studies in collaboration with researchers.

The stratification of temperate forests is reduced by the low density of trees, which gives the inhabitants of the upper branches many opportunities to reach the ground. Birds and insects are the species most commonly found in the secondary forest's foliage. Some birds share the different levels of the trees, but here there are

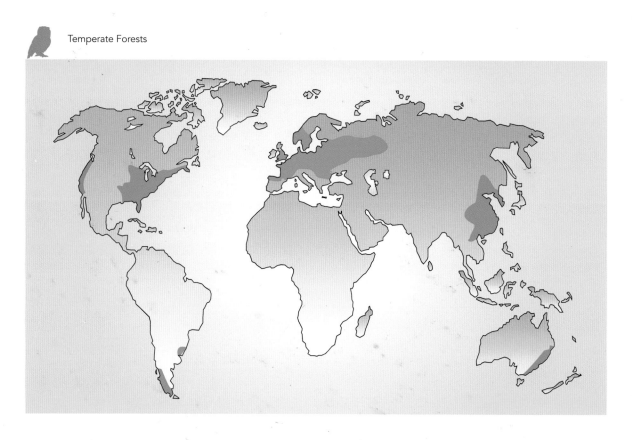

Temperate Forests

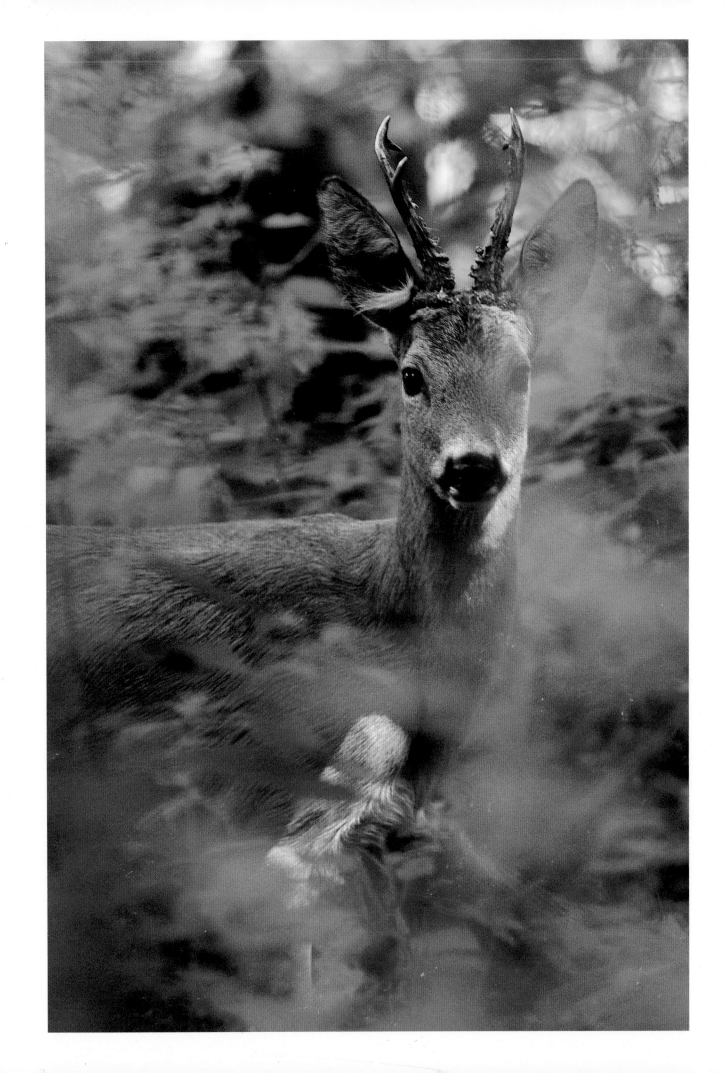

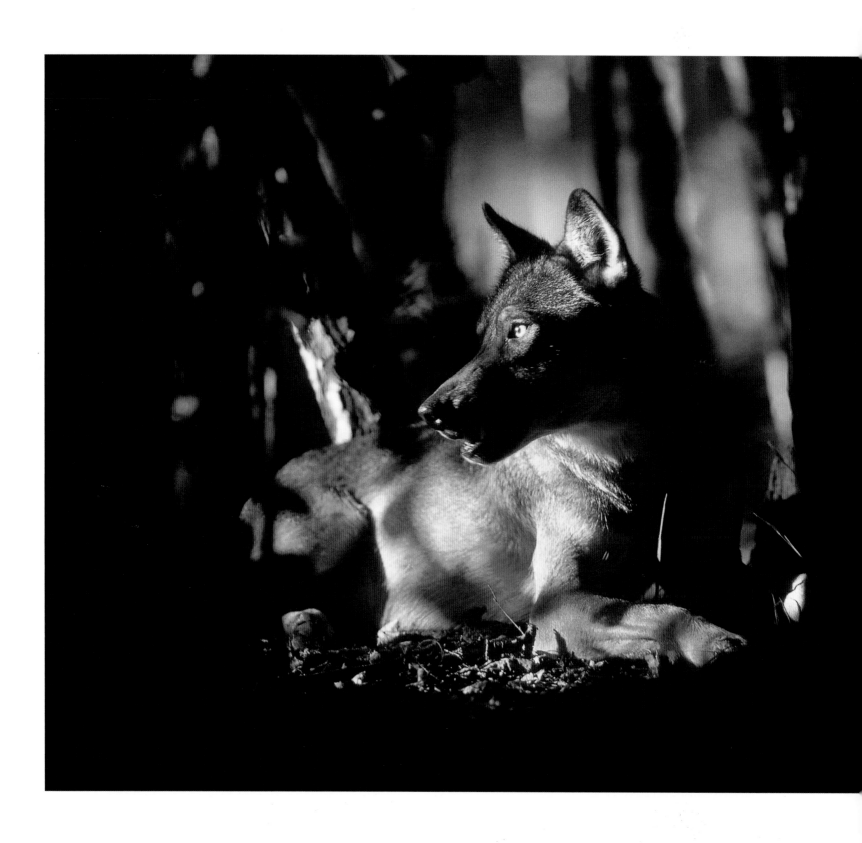

more incursions into the intermediate zones than in the tropical rain forest. The most common mammals living in the treetops are squirrels, but predators climb there often in search of prey.

The shrubs and bushes are closely linked by the abundant sunlight in winter and spring. Many birds share the thickets' shelter with forest mammals, which also hide there from human eyes. Since the top predators (bear, wolf, lynx, etc.) have almost entirely disappeared, the greatest pressure is from humans, especially due to the hunting practiced today in areas that are much too small. This pressure is so intense that some diurnal species have become nocturnal in order to avoid danger.

TAKING PHOTOGRAPHS IN THE TEMPERATE FORESTS

In temperate forests, you can take photographs almost year-round. Unlike the changeless tropical rain forest, these woods are subject to the vagaries of the seasons, which continuously change their appearance throughout the year. Each season brings its group of subjects to photograph, while changing leaf conditions modify the techniques to be used. Of course the light changes most dramatically, but the dominant color also completely changes: brown-magenta in winter, bright yellowish green in spring, deep green in summer, and orangish red in autumn.

Spring is particularly interesting because of the intense animal activity in the scrub stratum, which is still filled with light. At the height of the mating season, birds restrict their territory to the nest itself, which facilitates photography when the young are hatched—don't intrude before this, since birds will quickly abandon their eggs. The aesthetic richness of the flora is an additional benefit, which adds magnificently colored backgrounds to animal images. The flowers themselves are a good subject for bucolic scenes of the forest floor in spring.

In summer, animals are still very active but are difficult to locate because of the thick vegetation. The sunlight, which only penetrates through the leaves here and there, makes it hard to take exposure readings. You always have to decide whether you should measure the highlights or the shadows.

Since the right exposure depends on the environment and local contrast, use bracketing and take three shots to be sure (one metered on shadows, another on highlights, and the third halfway between the first two).

Typical inhabitant of the temperate forest and essential to its equilibrium, the wolf is also ceaselessly persecuted and slaughtered. The species still lives in the wild in a few areas in Europe, including France, where its survival is threatened by a small number of people.

Wolf (*Canis lupus*)
400mm lens
1/30 sec. at f/4.5 - MF.
Photographed in a Polish wildlife reserve.

At short distances using a fill-in flash solves the problem most efficiently. Blinds located on the edge of the woods or in clearings will give you the best light. Roe deer are active early in the morning and in the evening and provide many opportunities for photographs. Autumn gives the forest color and opens the foliage to the light. The mating roar of the stag and the proliferation of mushrooms give the photography enthusiast a renewed pageant, illuminated by a sun that is already lower in the sky than in summer. The brightly colored berries attract large mammals and birds eager to store vitamins and sugar in preparation for hard times and migra-

tion. Don't miss the quick frog passing unseen in the dried leaves, or the jay and the squirrel, two absentminded creatures who replant the forest by hiding acorns in the ground.

With winter the forest enters its period of sleep. The stag, exhausted by the rutting season, will approach houses and fields in search of an easy meal. Owls nap among the bare branches, and the female badger prepares her den for the joyous occasion coming at the end of the season. The sad, bare forest is still attractive to the nature photographer: the bare branches let light enter and make it easier to find animals. The early, chilly mornings are the scene of chance encounters

Incredibly quick the rest of the time, the green lizard is easiest to photograph as it awakens after hibernation. The weak April sun is here supplemented with fill-in flash.

Green Lizard
(*Lacerta viridis*)
100mm macro lens
1/60 sec. at f/8 - MF.
Flip-up flash.

Accustomed to the clearings and edges of the temperate forest, the Dark Green Fritillary is also found along forest paths lighted by the sun.

Dark Green Fritillary
(*Mesoacidalia aglaja*).

on the foggy paths. Boars and cervids, always cautious on open ground, pass hurriedly as they try to scent out the creature hiding in the odd blind that has been there for several days.

EQUIPMENT USED IN
THE TEMPERATE FORESTS

Fortunately, in the temperate forest photographic equipment is not subjected to high ambient humidity levels. Any consumer-grade SLR is suitable for working in this ecosystem, as long as you keep it protected from bad weather by covering camera and lens with adhesive tape. In case of heavy rain, put your equipment in a plastic bag or store it in a waterproof camera bag. Diligent photographers who spend a lot of time in the field will still find professional-grade equipment an advantage, since it is better suited to hard work outdoors.

Winter frost makes the metal parts of lenses unpleasant to touch, and skin can even freeze to them when it's very cold. Protect these parts with adhesive tape, or cover the lens with a wool sock. When it's cold, camera batteries lose their charge rapidly, especially when they also have to power an ultrasonic focus mechanism and an image stabilizer, both of which use a lot of energy. Whenever possible, use lithium batteries, which work much better than alkaline batteries in cold weather. They are certainly expensive, but their advantages are priceless for those who are really serious about photography. Another solution is an externally powered camera, supplied by large alkaline or, better yet, rechargeable batteries kept warm inside your clothing. An externally powered camera gives you a lot more freedom and resistance to the cold.

The temperate forest of the North American continent (here in Quebec) shelters species like the coyote that are unknown in Europe.

Coyote
(*Canis latrans*)
400mm lens
1/250 sec. at f/5.6 - MF.

The temperate forest shelters many salamanders, which seek out pools for reproduction.

Fire Salamander
(*Salamandra salamandra*)
50mm macro lens
1/60 sec. at f/8 - MF.
Flip-up flash.

As in any undergrowth, it is often dark in the temperate forest, especially in summer, when the foliage is at its thickest. Even with fast lenses, shutter speeds have an annoying tendency to flirt with low speeds (under 1/125 sec.).

Mounting the camera on a monopod or tripod greatly reduces the risk of camera shake. You can also rest your camera on your camera bag, which makes an excellent support for large telephoto lenses. Using fast color negative film (between ISO 400 and 800) can somewhat com-

pensate for low light levels. Grain and contrast in this type of film, remain excellent despite higher sensitivity. Moreover, the wide exposure latitude of color negative film is a great advantage in the often harsh forest light. With slide film, the highest useful film speed is ISO 200. Above this, films are grainy, with harsh contrasts. For this reason, supporting your camera on a tripod (or anything else at hand) is strongly recommended. Slide film also has much narrower exposure latitude than color negative film: measure light levels precisely,

and be sure to use selective or spot metering when contrast levels are high. Fortunately, the brilliance and the sharpness of slides—always more dynamic than paper prints—more than compensate for all the inconveniences of using slide film.

Several species of dragonflies take advantage of moments of rest on the forest's edge during the day.

Four-spotted Skimmer
(*Libellula quadrimaculata*)
500mm catadioptric lens
1/60 sec. at f/8 - MF.
Monopod.

Savannas

It took an eight-hour wait to catch this leopard hiding the young buffalo killed the previous night. After eviscerating it, the feline wedges its prey in the high branches of a tree, and will come back to feed many times throughout the day.

Leopard
(*Panthera pardus*)
600mm lens
1/160 sec. at f/5 - AF.

Between forest and desert, the savanna is in a state of equilibrium in which vegetation and fauna are tightly interdependent. Ecosystems close to savannas are found in Australia and South America (the Pampas), but the classical example is the African savanna, especially in East Africa, which includes Tanzania and Kenya.

Grasses more than three feet or one meter in height are scattered over the immense surface of the African plains, studded here and there with thorn trees. The grasses do most of their growing during the rainy season, sometimes within a few hours. The savanna is a particularly rich ecosystem, which generates a great deal of vegetable matter with very little biomass for fertilization. Hence the proliferation of mammals, insects, and herbivorous or granivorous birds in these regions. The dispersal of trees in the savanna is explained by the nutritious value of their shoots, very attrac-tive to herbivores, but also by the numerous fires—natural or caused by man—that burn the young trees. The grasses fertilized by the ashes grow even faster and, as a result, finish off the young trees that survived the flames.

From time to time, some shoots survive despite the heat and the crowding grasses; these become the large single trees in the middle of the immense plains.

Most herbivores eat a specific variety of grass or eat the plant at a specific developmental stage and act as a marvelous regenerating machine for the savanna. Each year, the migrating wildebeests follow the rains as they move through Kenya and Tanzania. The zebras precede them, eating the tips of high grasses; the wildebeests—the most plentiful animals—follow, eating the lower parts of the stalks. Finally, the gazelles arrive, greedy for the young shoots that grow after the wilde-beests have left.

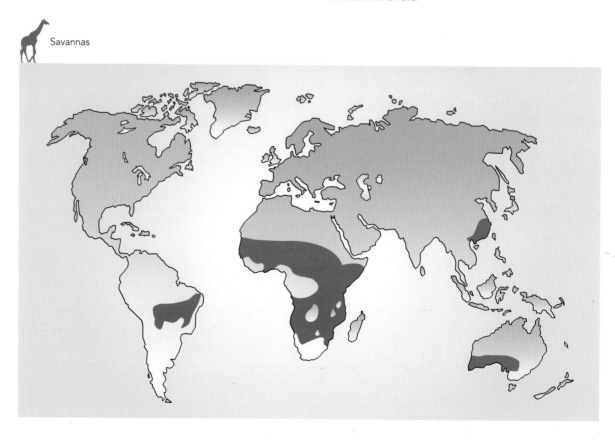

Savannas

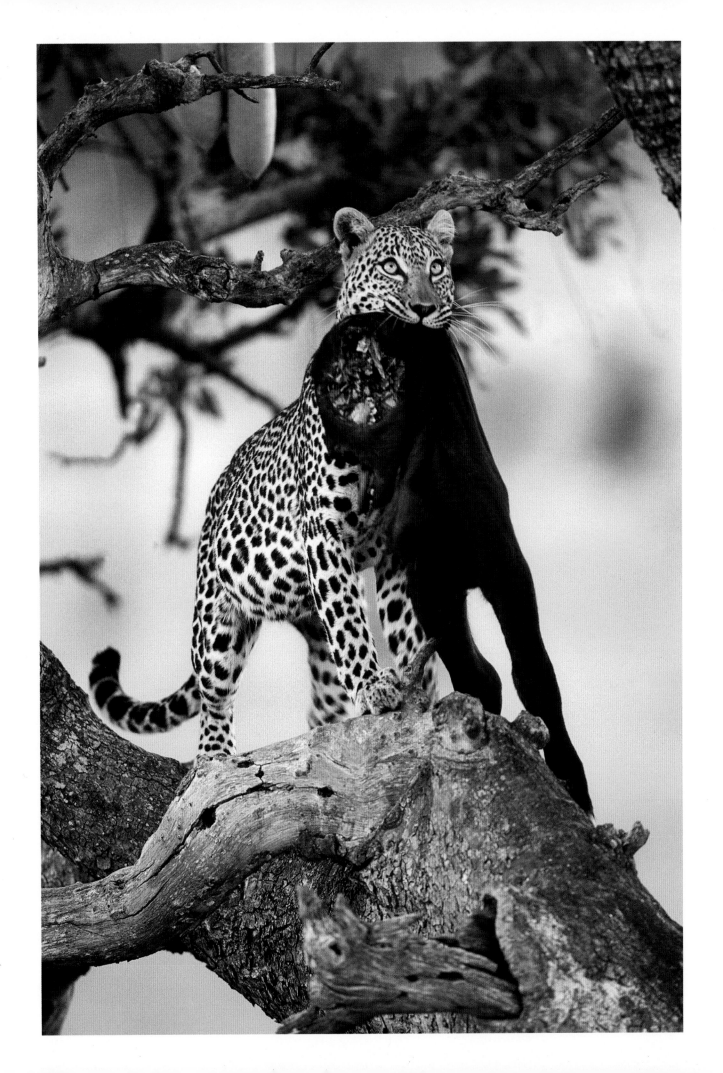

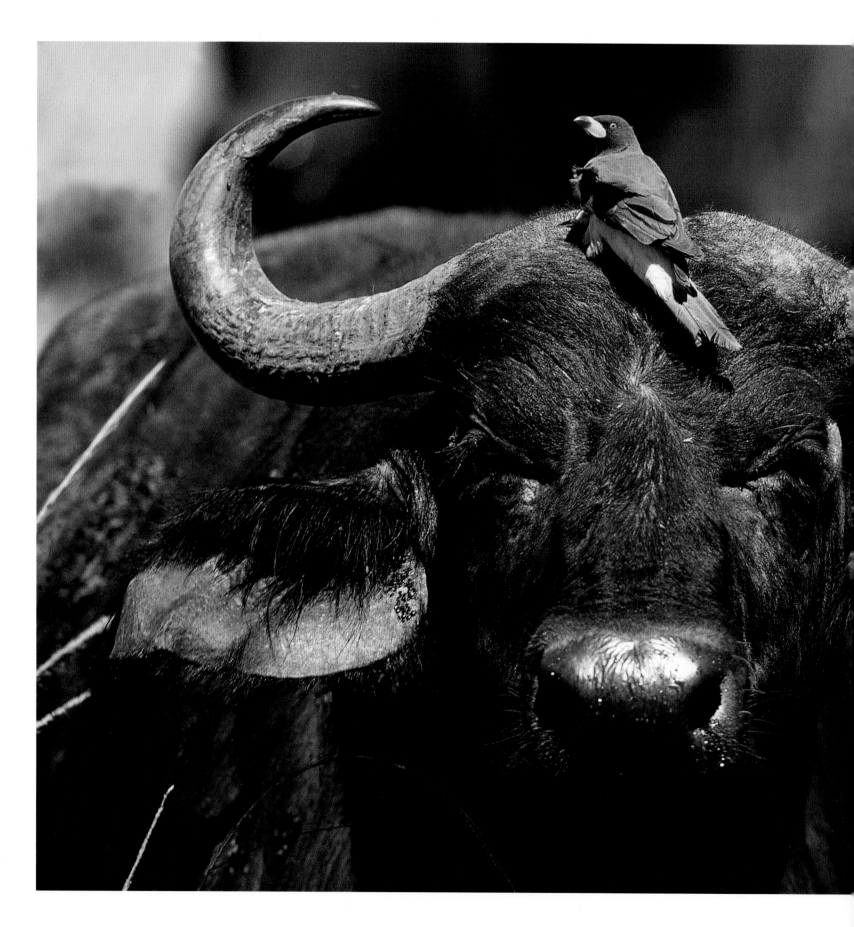

In this way, the savanna is "mowed" each year and simultaneously fertilized with the herds' droppings. Carnivores exploit this traffic, removing the weak animals and the excess young to maintain the ecological balance. Carnivores depend on the regularity of the rain, which affects the number and the distribution of herbivores in this ecosystem, in which every species (animal or plant) is interdependent.

PHOTOGRAPHY IN THE SAVANNA

The most beautiful savannas in Africa are those of the Serengeti (Tanzania) and its extension into Kenya, the Masai Mara. The immensity of the savanna (*Serengeti* means "infinite plains" in Masai) and the rutted tracks make a four-wheel-drive vehicle essential for travel. What is more, it is illegal—and dangerous—to get out of your vehicle in the parks that encompass most of these plains.

Vehicles must not leave the roads in the national parks, except in Tanzania, where this is allowed more than 10 mi. (16 km) from the lodges (bush hotels). Be sure to ask about the regulations at the park entrance.

Most animals pay no attention to vehicles. You can approach to within a few yards or meters of felines and the larger herbivores without causing them the slightest anxiety. You might think that these animals, seeing minibuses pass by all day long, have gotten used to them, but the same behavior is found in the most remote areas where few tourists go. On the other hand, the large numbers of vehicles that will surround a leopard or a family of cheetahs cause a great deal of damage to the ecosystem's plants and stress the animals. Communication by CB radio among the vehicles' drivers, who act as tour guides, cause high concentrations of vehicles

The Yellow-billed Oxpecker rids the buffalo of more than 350 ectoparasites each day! Photographers should beware of this "walking larder" since, despite his easy-going demeanor, the buffalo, along with the hippopotamus, is one of the most dangerous animals in Africa.

Cape Buffalo
(*Syncerus caffer*),
Yellow-billed Oxpecker
(*Buphagus africanus*)
600mm lens with 1.4x teleconverter
1/125 sec. at f/7.1 - AF.
Bag of rice used as camera support.

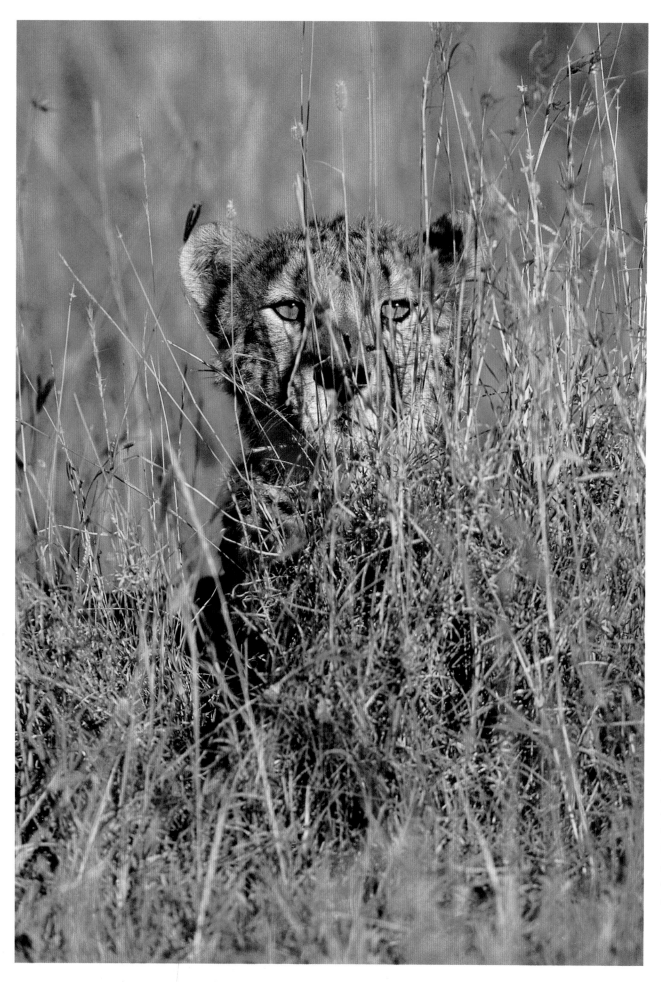

The cheetah is a predator perfectly adapted to hunting on the savanna. It is built for running through the high grasses, where its coat blends perfectly. A gifted sprinter, it may reach top speeds of almost 68 mph (110 kph), but tires easily; pursuits are rarely successful.

Cheetah
(*Acinonyx jubatus*)
600mm lens
1/250 sec. at f/4 - AF.

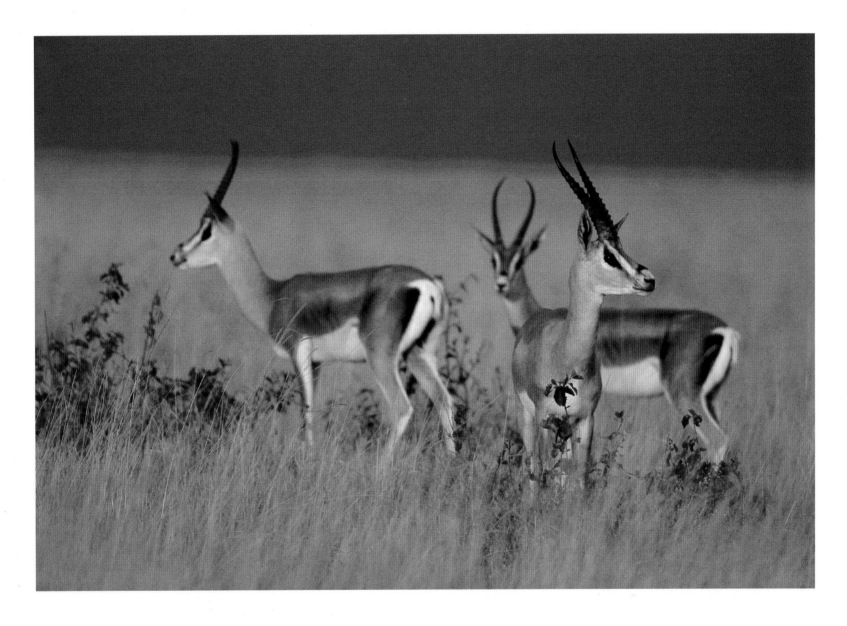

around these animals. The drivers take great risks to be the first at the scene, since their tip—much higher than their wages—depends on it.

Another problem with photo safaris is that the vehicles are often overcrowded. For the demanding photographer, the number of passengers in minibuses is negotiable when you reserve your place. You will pay a higher price when the vehicle isn't full. A minibus has eight places, but only five can take pictures because the open roof doesn't cover the whole minibus.

In a four-wheel-drive only three people can take pictures efficiently; it is up to you to determine the best relationship between quality and price. Aside from this, beware of nonspecialized tours, which aren't interested in your particular needs. A group of tourists in a hurry to see the "big five" (elephant, lion, cheetah, leopard, and rhinoceros) have only one thing in mind once they've seen the animals: going back to the lodge to party.

Thomson's Gazelle, extremely quick and rapid in its flight, is the cheetah's favorite prey. It may be distinguished from its cousin the Grant's Gazelle by the black band on its flank.

Thomson's Gazelle
(*Gazella thomsoni*)
600mm lens
1/100 sec. at f/5.6 - AF.

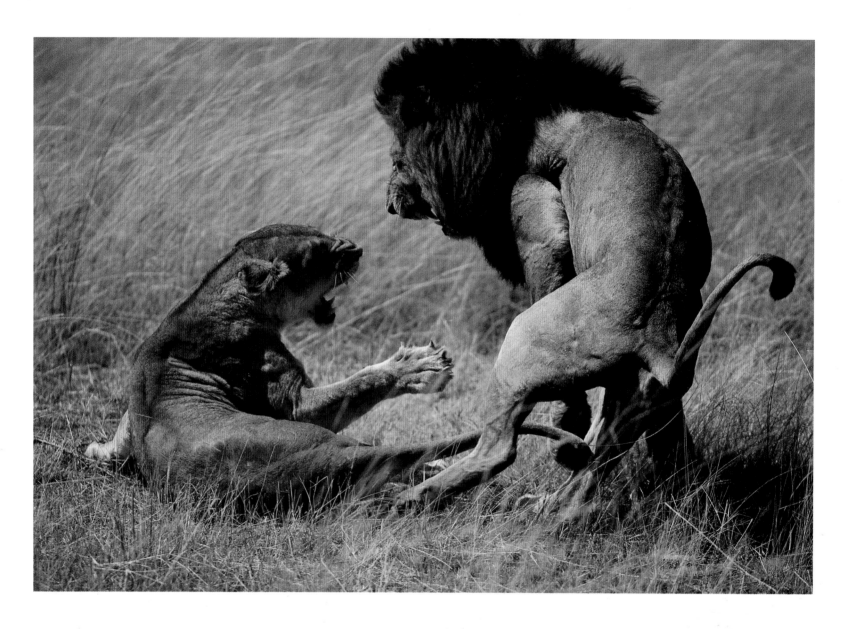

Very long lenses limit the effects of shooting down when taking photographs from a vehicle's open roof. At short distances, where the steep angle becomes an impediment, it is best to use the side windows, even if you don't have enough room to sit down.

Lion and lioness
(*Panthera leo*)
500mm lens
1/320 sec. at f/6.3 - AF.

What is more, they will rarely keep still just because you're photographing a hyena with a 600mm lens. Often the driver won't even turn off the motor when he stops. Agencies, which specialize in photo safaris, are more expensive, but their amenities better correspond to the needs of the serious photographer.

To take good photographs on the savanna you have to get up early! In an organized group, it's best to agree with the driver to leave the lodge at daybreak, before 7:00 AM This way you have 2½ hours to photograph the animals in the area

Very wary on the open savanna, the black rhinoceros—like most animals—doesn't connect the presence of a four-wheel-drive vehicle with humans. This is why such vehicles and minibuses make excellent mobile blinds.

Black Rhinoceros
(*Diceros bicornis*)
600mm lens with 1.4x teleconverter
1/250 sec. at f/6.3 - AF.

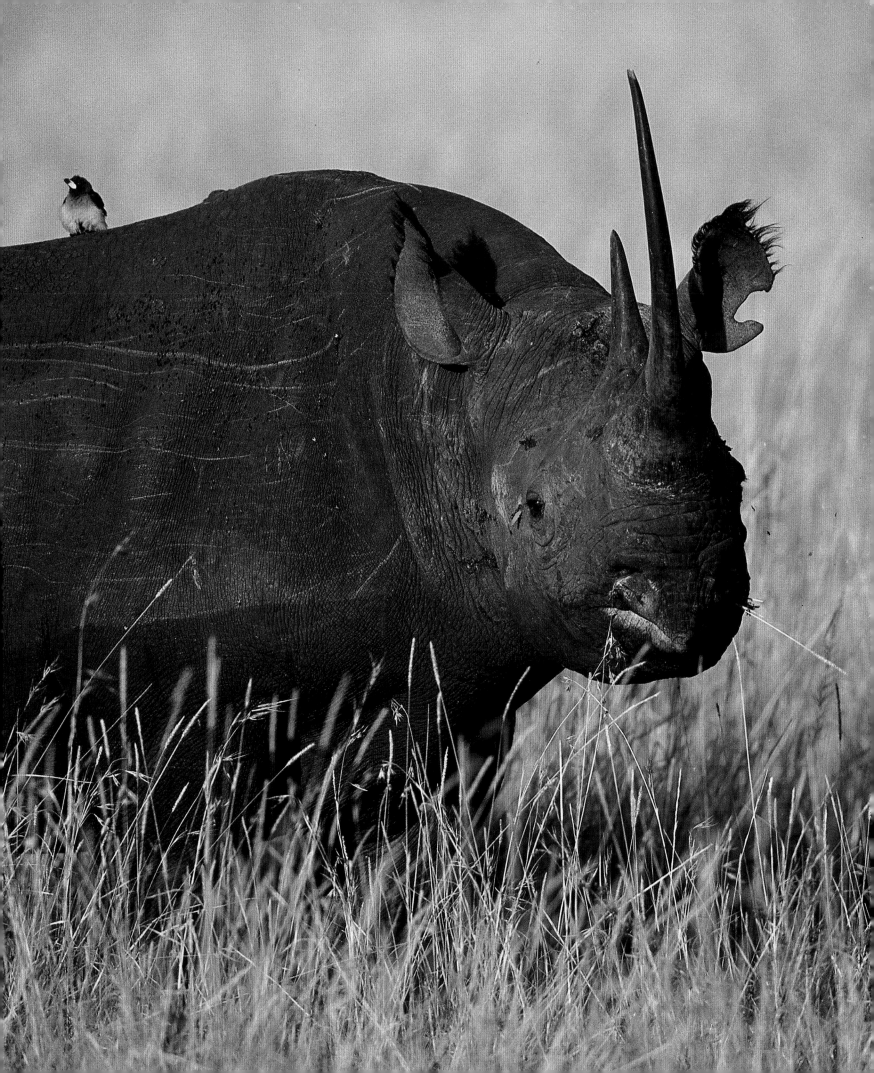

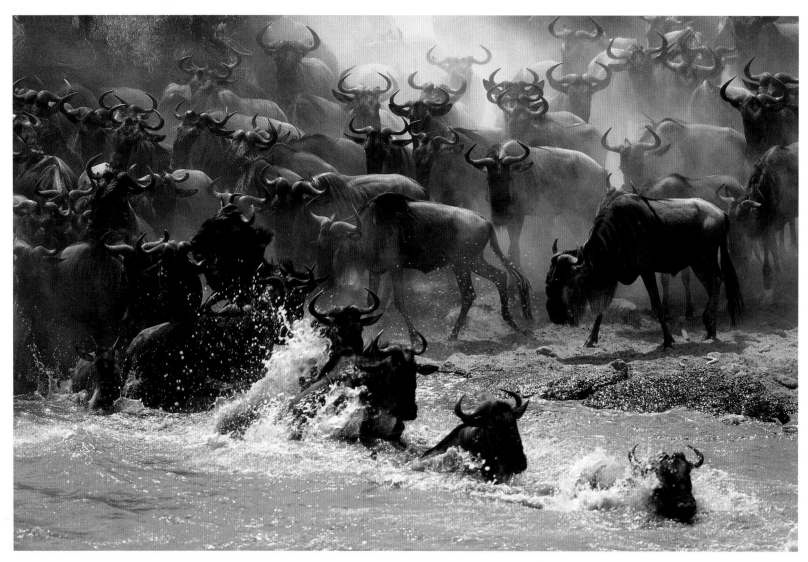

The wildebeests' great migration: more than a million individuals follow the rain's advance from Kenya to Tanzania. The most perilous stage is crossing the Mara River, where the crocodiles impatiently await this godsend.

Wildebeests
(*Connochaetes taurinus*)
600mm lens
1/250 sec. at f/8 - AF.

before returning for breakfast. The animals are most active at dawn and dusk. The magic of the early morning on the savanna is unforgettable. With modern SLRs equipped with multi-segment metering, the brightness of the savanna isn't a problem. Most light meters are set up for correct exposure in these conditions, which are similar to those found at the beach.

Nonetheless, those who use older SLRs with center-weighted metering should be careful, especially when using slide film, since the brightness can overpower the meter. Normally balanced for an average reflection of 18 percent, the meter causes massive underexposure when it encounters

a subject that reflects two or three times more light. As with snowscapes, correct the exposure by +1 EV, depending on the brightness of the dry grass. Another solution is to measure the exposure on a hand-held neutral gray card (Kodak), correcting the exposure by + 0.5 EV, or use a hand-held meter and measure incident light (with the white dome), holding the meter facing toward the camera.

On the savanna, most photographs are taken from the windows of vehicles (natural perspective) or through the special opening in the roofs of minibuses and four-wheel-drive vehicles (shooting down at close distances). The immensity of

the savanna makes very long lenses essential. A 300mm is short, a 500mm is ideal, and though 600mm and 800mm lenses are heavy, they are highly appreciated by those who prefer close-ups. You can rent these precious lenses (they're expensive) in photography stores or borrow one from a specialist.

You can also mount a teleconverter (1.4x or 2x) on your usual 300mm lens, but the sharpness of your photographs will be perceptibly diminished, and the lens' speed will be reduced by 1 to 2 EVs. Considering the cost of the trip, this type of economizing is not very smart.

In choosing your camera, you should look at high-performance models in consumer and professional grades. A low-range SLR can be used on the savanna, but dust and vibration will ruin it more quickly than a higher-quality camera. The SLR should be internally well damped when you shoot (when the mirror flips up), in order to minimize vibration with large telephoto lenses.

Even resting on the roof of the minibus with the omnipresent beanbag (cloth bag filled with rice or plastic beads), a large telephoto lens is subject to vibration from the camera. The same is true for the movements of passengers in the vehicle, with whom a good working relationship is highly desirable.

The wildebeests' migration is a fantastic source of protein for lions that follow them or raise their young nearby. This forced movement ensures the equilibrium of the savanna, both from the point of view of the vegetation and for the feeding of the carnivores along their path.

Lionesses
(*Panthera leo*)
500mm lens
1/500 sec. at f/8 - AF.

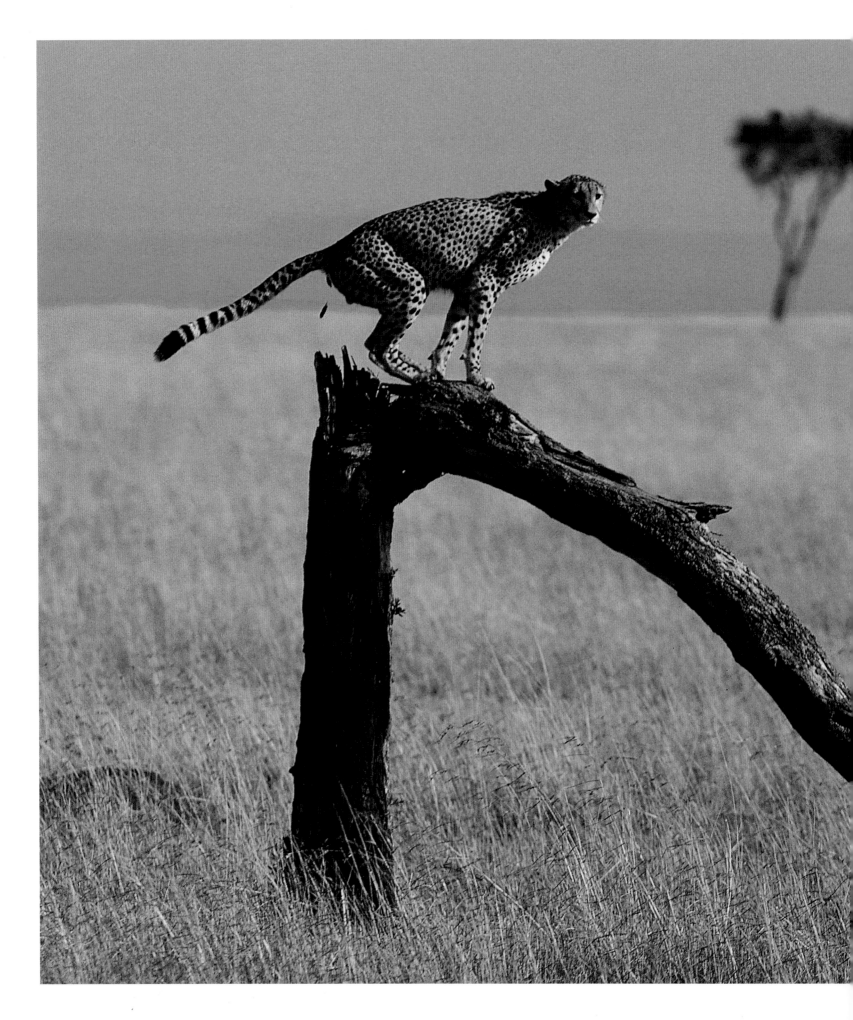

THE SAVANNA: A HARSH PLACE FOR PHOTOGRAPHIC EQUIPMENT

Photographic equipment is severely tried on photo safaris. Violent jolts, dust raised by the passage of other vehicles, and crowding in the passenger compartment all necessitate additional protection for your equipment.

A good camera bag padded with high-quality foam is ideal when the equipment is stowed away. Before going into action, cover the delicate parts with adhesive tape. While shooting, keep camera and lens under a piece of cloth to avoid dust contamination. The Saharan *chechiya* (scarf) is ideal, since it can also be used for protection from the sun and as a scarf when temperatures drop.

A cleaning kit (brush, blower, lens tissues, Q-tips) is essential for removing dust from your equipment every day. Blow off the lens before wiping it, or the glass will be permanently scratched. All the same, avoid blowing dust toward the buttons and rings of the camera and lens: any infiltration into the mechanism is catastrophic. Do the same with all your cameras, lenses, and accessories—even if you haven't used them during the day—and shake out the empty bag to get rid of any dust.

A cheetah in the Masai Mara in the midst of a very explicit session of territorial marking. Similarly, the cheetah marks his hunting territory with his waste. And woe to the intruder who crosses his borders.

Cheetah
(*Acinonyx jubatus*)
500mm lens
1/400 sec. at f/8 - AF.

No doubt killed the previous night by poachers, this elephant's carcass will be "cleaned up" in just a few days. The feast begins with the lions and ends with the hyenas, jackals, and vultures.

28–105mm zoom lens
1/200 sec. at f/11 - AF.

Paradox of poor human management of the African elephant: they disappear with terrifying rapidity under the poachers' guns, and are crowded into game parks that are too small to hold them.

African Elephant
(*Loxodonta africana*)
600mm lens
1/250 sec. at f/8 - AF.

The most useful film on the savanna is ISO 100 slide film. With its color saturation, extremely fine grain, irreproachable sharpness, and pleasant contrast, this film has what you need to take unforgettable pictures. Moreover, the processing costs are not as high as for color negative film.

Keep in mind that sixty 36-exposure rolls is a realistic amount of film to bring for ten days of shooting on a photo safari, when you'll have the good fortune to see rare sights like a cheetah hunting near your vehicle or a chance encounter with one of the few remaining packs of wild dogs.

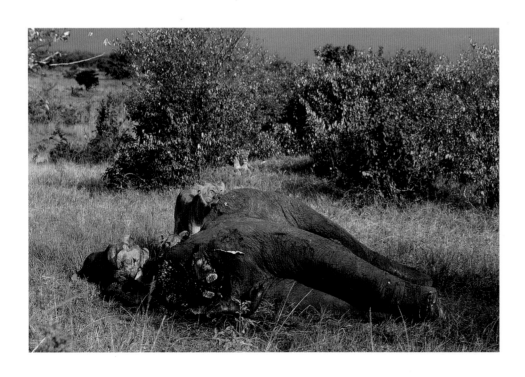

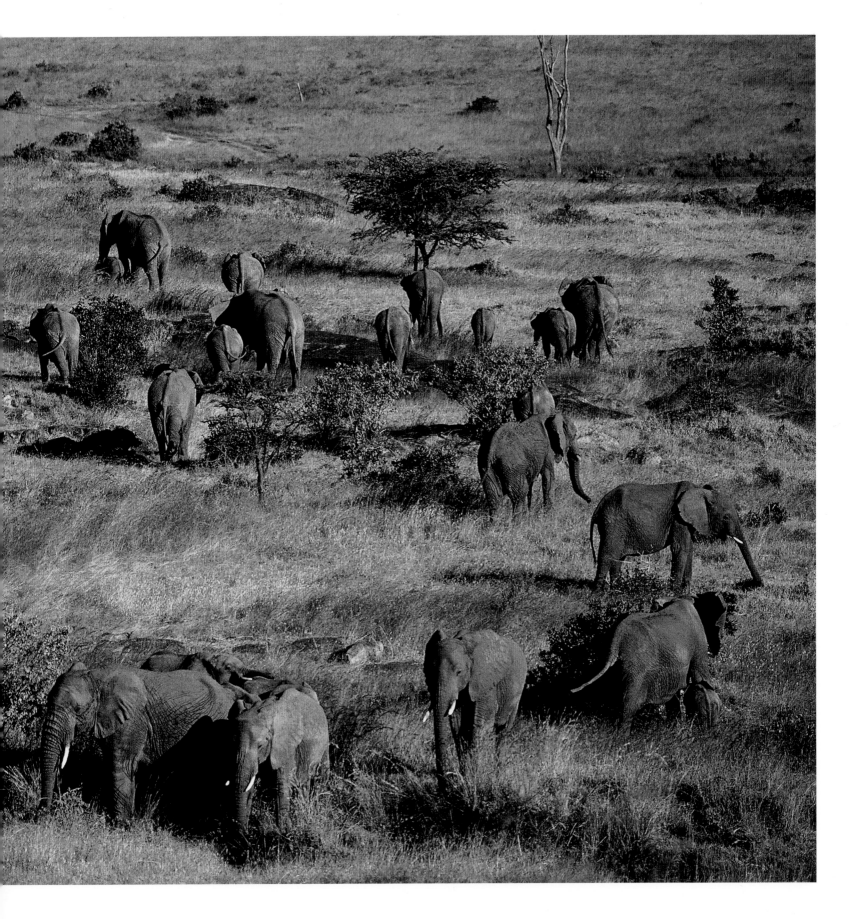

This poor cricket has just ended his life in the beak of a Lilac-breasted Roller. A golden opportunity for the photographer, but a very long lens is essential for a subject as small as this bird.

Lilac-breasted Roller
(*Coracias caudata*)
600mm lens
1/800 sec. at f/4 - AF.

OPPOSITE

Combat between Burchell's Zebra in the Masai Mara savanna. In Swahili, zebra means "striped donkey": its coat is particularly well suited for autofocus systems.

Burchell's Zebra
(*Equus burchelli*)
100–400mm zoom lens
1/200 sec. at f/6.3 - AF.

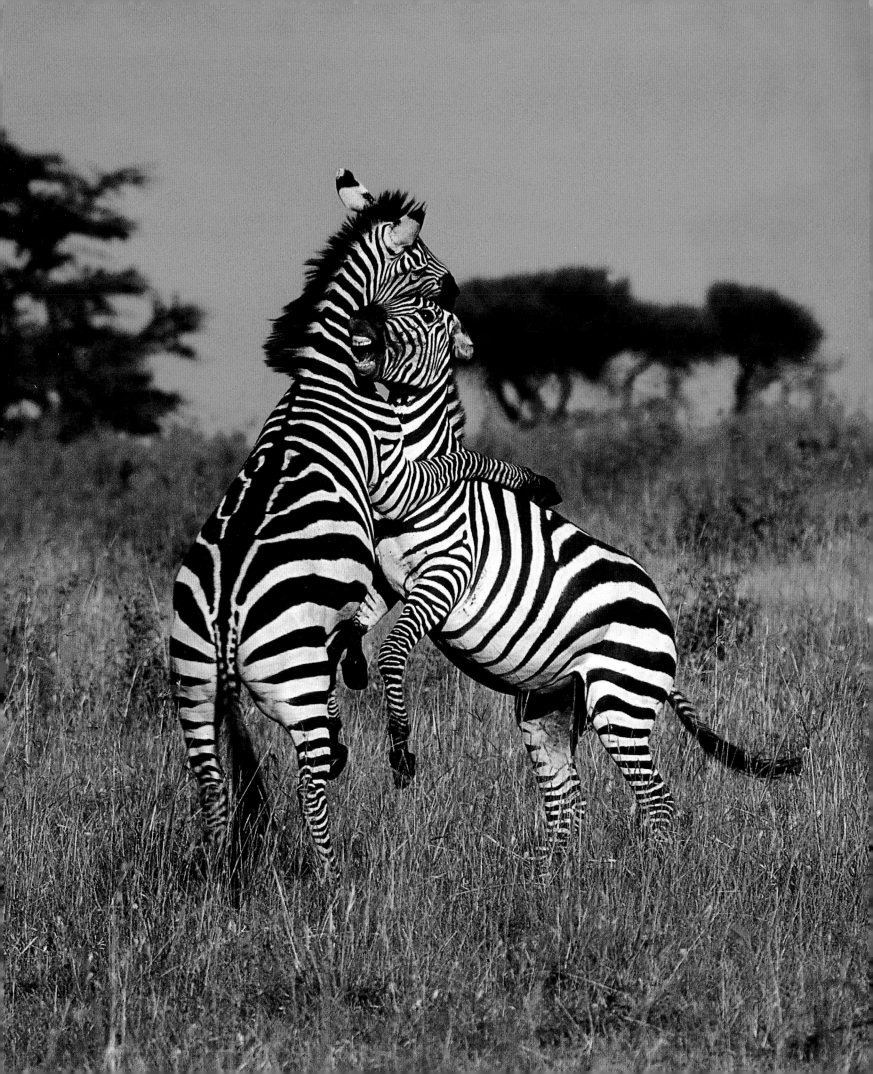

Deserts

The magnificent red dunes of Sesriem are located in the heart of the planet's oldest desert: the Namib. The vegetation gives a sense of scale to these mountains of sand. Namib-Naukluft Park (Namibia).

100–400mm zoom lens
1/100 sec. at f/7.1 - AF.

Sahara, Kalahari, Mojave, Gobi, Namib, and Atacama are immense spaces, which we call deserts, where the rate of evaporation is much greater than the rate of precipitation. In reality, the term is not really appropriate for these sun-bathed lands, since life finds its way into them in the form of woody plants, cactuses, thorn bushes, insects, spiders, mammals, and birds, all of which have developed defenses against the day's heat and the night's cold. This is quite an accomplishment, since the desert regions lying on either side of the equator have relentlessly unchanging weather: calm weather, merciless heat, and blue skies without the smallest cloud. And this goes on for months, even years, on end.

Sometimes rain reaches the ground that is hard as rock. When its quantity is insufficient, the water evaporates. But there are times when the water causes flash floods as it flows violently over the ground, which is unable to absorb it. Then the *wadis* (old riverbeds) transform instanta-neously from dried-out beds to floodwaters: they carry sand and dormant seeds and create large, shallow lakes. A few plants flower hurriedly in order to be pollinated, producing seeds that are buried in the sand. Then they go back to sleep until the next storm, perhaps in one or two years.

Animals in the desert spend the greatest part of the day underground (Fennec foxes, jerboas, kangaroo rats, spiders, insects) or under rocks (scorpions, lizards). They have only to bury them-selves a few centimeters deep to enjoy a temper-ature much lower than that of the surface sand. If insects, spiders, and lizards don't hesitate to go out in the daylight to seek their daily nourish-ment, mammals (jerboas, kangaroo rats, seed eaters) restrict themselves to going out at dawn and dusk. The Fennec fox hunts all night and goes back to its den at dawn. This little world has developed a means to deal with the lack of water. The main source of water is dietary (plants, cactuses, prey species). But many reduce their

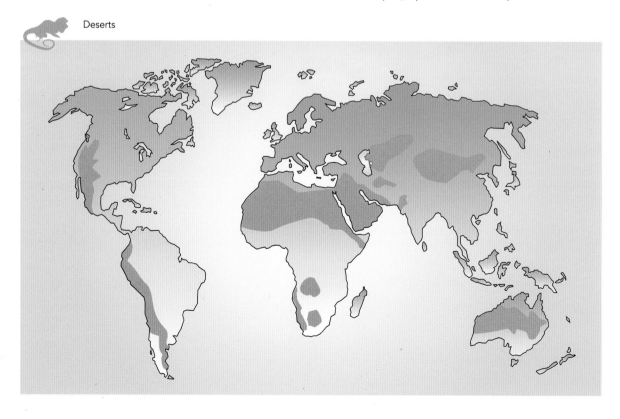

Deserts

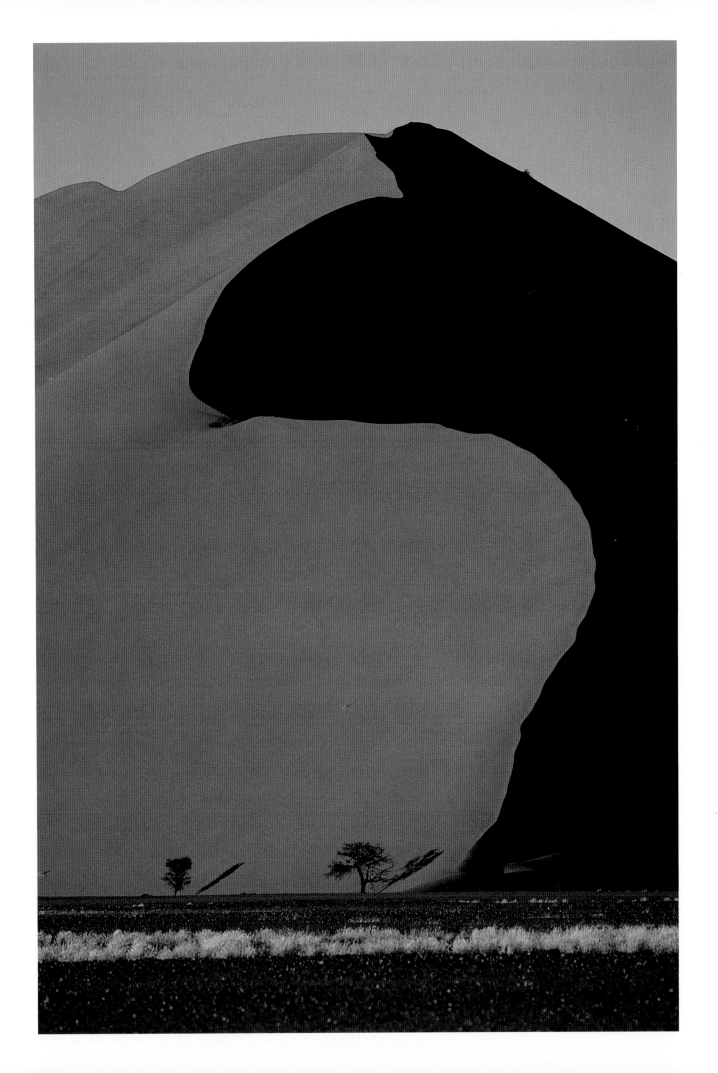

The sands of the Namib Desert are home to superb snakes, among them the Horned Adder, a magnificent viper.

Horned Adder
(*Bitis caudalis*)
100mm macro lens
1/60 sec. at f/13 - MF.

dehydration by concentrating urine, reducing perspiration, regulating body temperature, or by eating their own wastes.

The shallow roots of some plants spread over large areas to trap the least bit of moisture. Others prefer to dig straight down until they reach moisture or even water where it is accessible. There are even cactuses that swell with water when it is available and deflate as they consume it. All store nutrients in their roots in order to survive in this inhospitable world. In this way plants help fertilize the desert.

PHOTOGRAPHY IN THE DESERT

There is a host of things to be photographed in the desert. First of all the landscapes, which are composed almost entirely of rock. They offer a variety of tones, from the white of salt deposits to the black of old eroded rocks, passing through the yellow of the sand and the orange-red of iron ores. These materials are easy to emphasize when you choose the first or the last hours of the day to take your photographs. At short distances you can keep the foreground sharp during the day but be careful of long shots, where sharpness is always diminished by the waves of heat.

Daybreak is the best time to avoid this problem caused by the heating of the surface sand. Since daybreak is also the time when desert animals are most active, don't count on sleeping in.

Insects, spiders, and reptiles are easy to approach and make exceptional subjects for photography. You should proceed with caution, since desert animals are quick and fierce in their own defense. The scorpion that crawls between your legs as you kneel on the ground is particularly impressive and venomous. The same is true for snakes, among which the horned viper and the rattlesnake are the most famous in desert regions. The pretty patterns they trace in the sand as they move are often admired by photographers, but these are dangerous animals for the careless. Fortunately, all reptiles are not poisonous, as illustrated by geckos, the small lizards that crawl over any surface thanks to the electrostatic pads on their feet. Birds are easier to photograph from a vehicle, especially in the morning, as they search for insects and reptiles in rock crevices.

Harder to locate, the sand grouse has feathers that blend perfectly with the sandy soil. These plump birds can travel 50 miles (80 kilometers) to find water and bring it back to their chicks in their feathers. Mammals are more wary and, in the desert, they can see you coming a long way off.

A long lens (≥ 400mm) is necessary to photograph a kangaroo rat or immortalize a jerboa as he makes his morning rounds. The large herbivores like the oryx, the gazelle, and the antelope, are also very wary and must not be chased with a vehicle, which could cause a fatal dehydration. Incorporate them into the landscape from afar to avoid disturbing them. Since sitting in a blind becomes unbearable during the day, arriving in a vehicle before daybreak is a good way to set up a temporary blind.

BE CAREFUL OF THE DESERT'S HEAT

Heat, lack of water, sand, and dust make the desert inhospitable to photographic equipment. Camera and lenses should be kept in the shade as much as possible, inside a camera bag equipped with thick foam. During transport, the camera bag can be kept safe in a high-quality ice chest (avoid cheap ice chests, which often don't have any insulation between the plastic layers). The chest should be kept in the shade in a well-ventilated area. These two precautions will absorb vibrations, insulate equipment from the heat, and reduce the infiltration of sand.

When you take a photograph, avoid exposing your photographic equipment to the sun's direct rays. The black parts will act like magnets for heat and transmit it directly to the film. An umbrella, a piece of white cloth, shade from the vehicle, a silver reflector, or survival cloth will protect the camera from the sun's rays. Lenses are also damaged by the heat, especially those with fluorite, a crystal that is very sensitive to thermal shock. When the lens is left out in the sun the

To photograph a viper in the middle of the Namib Desert you have to be careful and something of a gambler: "I began stalking this viper with a 100–400mm zoom lens. After a half-hour, I switched to a 100mm macro, with many precautions. The snake seemed to have accepted me. A false move on my part could have been fatal." For experts only! Photograph: Houria Arhab.

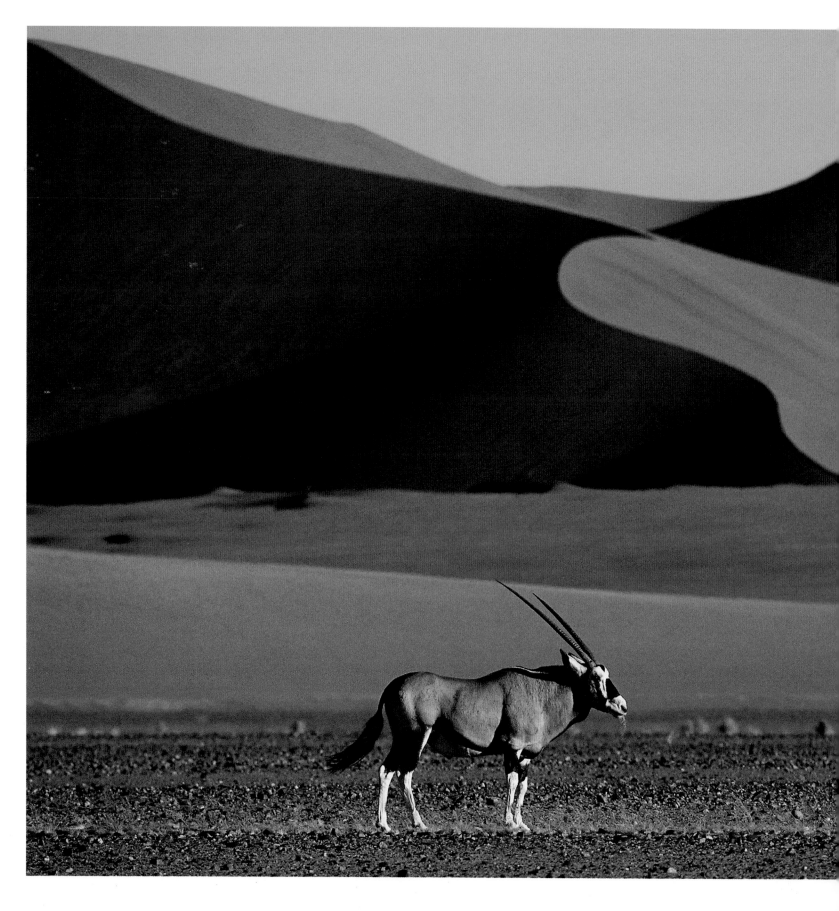

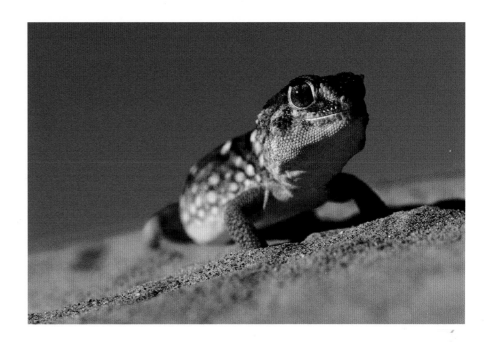

Sand Gecko
(*Chondrodactylus angulifer*)
100mm macro lens
1/250 sec. at f/8 - MF.

The chameleon hurls his tongue like a slingshot. The insect sticks to it and he pulls it back into his mouth.

Namaqua Chameleon
(*Chamaeleo namaquensis*)
100mm macro lens
1/200 sec. at f/11 - MF.

LEFT

The Oryx is one of the few ruminants capable of surviving in the blazing desert. Namib Desert.

Oryx (*Oryx gazella*)
100–400mm zoom lens
1/250 sec. at f/11 - AF.

Like most desert plants, the ruditon-sis stores as many nutrients as it can in its cells. Its roots absorb every molecule of water to ensure its survival in the blazing heat.

Sturt Stony Desert (Australia)
50mm macro lens
1/60 sec. at f/11 - MF.

cement glue that holds some lenses together will soften or even melt, putting the lens completely out of commission. The same is true of lubricants for metal parts, which melt, evaporate, and run out of the lens. Some manufacturers' repair services will relubricate lenses that are going to be used at high temperatures or in extreme cold.

Sand and floury dust (called "*fesh-fesh*" in the Sahara) should be avoided at all costs. A vehicle driving with the windows open will pick it up every time it meets another vehicle, and this dust gets everywhere, including between your teeth, which crunch when you chew. A scarf wrapped around camera and lens provides a fairly effective protection. Block all the openings to the camera and lens with tape, which should be changed every day so the adhesive won't melt. Every time you stop, be sure to blow dust and sand off your equipment with a blower, being careful not to blow it into the camera. Be especially careful when you're changing film: wait until you stop and—after getting out of the car—shake the sand off your hands, face, and clothing.

Thanks to an extension tube mounted on a 135mm lens, the necessary magnification is obtained at a distance great enough not to upset this inhabitant of the Simpson Desert: essential practice when photographing a poisonous snake!

Yellow-faced Whip Snake
(*Demansia psammophis*)
135mm lens with extension tube
1/60 sec. at f/3.5 - MF.
Flip-up flash.

Film should be kept in an ice chest and must not be removed from its plastic canister: it has been packed in a controlled atmosphere at the proper humidity level. Remove the film, close the canister, change film (be sure that the inside of the camera is kept free of sand), and put the exposed film back into its canister. Never forget to close the ice chest containing the film and put it in a shady spot. If you stop for a long time during the day, take the ice chest containing the film out of the car and bury it in a plastic bag about four inches (ten centimeters) deep in the sand near your tent: it is much cooler there than in your car. At night the ice chest can be left in your tent.

In the desert's intense light, ISO 50 and 100 color slide film are perfectly suitable. Their narrow latitude of exposure requires precise analysis of lighting conditions, especially on white sand, which can cause underexposure due to its high natural reflection. With multi-segment metering, the camera takes care of this problem automatically, as long as there is a reference subject in the frame. For shots of nothing but white sand, take a second shot exposed 1 EV more. Do the same for cameras with centrally weighted exposure meters.

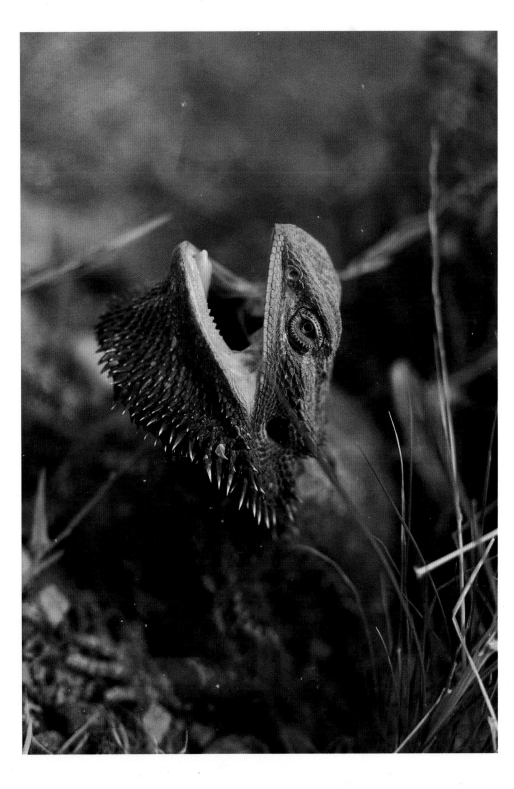

This Australian Bearded Dragon has the unusual ability to inflate its spiny collar in order to discourage its potential enemies.

Sturt Stony Desert (Australia)
Bearded Dragon
(*Amphibolurus barbatus*)
50mm macro lens
1/60 sec. at f/8 - MF.

Nambung National Park is located in the Pinnacles Desert (Australia). These surprising natural sculptures are the remains of a petrified forest eroded by rain.

24mm lens
1/125 sec. at f/11 - MF.

Islands and Coastlines

The coastline is a very varied ecosystem, which extends from the low tide line to the top of the rocky cliffs. It may be sandy, muddy, rocky, or have several of these characteristics and may change dramatically within a few hours (the coastline can sometimes change completely in a single stormy night, as pebble beaches are swept away, tongues of sand appear in the rocky zones, or sections of cliffs crumble). The coastal ecosystem functions in strata, a little bit like the tropical rain forest. There is the part that is always under water at high tide, the intertidal zone, which is covered and uncovered by the sea with the rhythm of the tides. The zone above the high tide line is constantly bathed in salt spray, and a strip of sand, mud, or cliffs marks the transition with the land. Each strip of coastline harbors its own species, as well as others that are more widely dispersed and await in a tidepool for the next tide in order to return to their usual territory.

The intertidal zone is home to a marine fauna that can stay out of the water for several hours (barnacles, mussels, oysters) or hides in the sand (worms), seaweed (crabs, see anemones), or tidepools along the rocky coast (shrimp, fish, sea anemones). The uncovered shellfish remain closed during low tide, awaiting the water's return to begin filter-feeding. They're safe in the cracks and crevices of the rocky coast, but dread prolonged exposure to the sun, and are prey to shorebirds like the oystercatcher, an expert at opening cockles and clams. The force of the waves also affects the population of the intertidal zone and varies the species, depending on how well adapted they are to the violence of the surf.

The intertidal zone is the favored habitat of shorebirds, which at low tide feed on worms, crustaceans, and other shellfish that are easily preyed upon. These birds give the photographer many opportunities to take photographs,

 Islands and Coastlines

especially since migration (in the spring and at the beginning of autumn) brings a great variety of species along the length of the coast. All these birds, together with pelagic species, nest along the coast in the spring. Wetlands, cliffs, and stretches of pebble beaches give them the security they need to raise their young, which are increasingly subject to predators (gulls, terns) in regions of human activity.

The coastal ecosystem is also found on islands, with some important differences in the tropics where coral plays a preponderant role. Coral islands and atolls, surrounded by barriers made up of madrepore coral, live in symbiosis with single-celled algae, packed on the skeletons of many preceding generations (up to more than 3,300 feet or 1,000 meters thick). These islands have an additional habitat, the lagoon created by the barrier reef. This is a band of shallow water trapped between the coral reef and the islands set in the center (there are no central islands in atolls).

The high temperature and calm of the shallow waters, protected from the surf, turn them into an ecosystem of a richness comparable to that of the tropical rain forest. Swarms of fish and invertebrates live in the coral, together with sea anemones and many other forms of aquatic life.

"The islands of the Indian Ocean have an incredible variety of natural landscapes. Here, in the Aldabra Lagoon, this rock formation has resisted erosion for 120,000 years."

20mm lens
1/100 sec. at f/20 - AF.

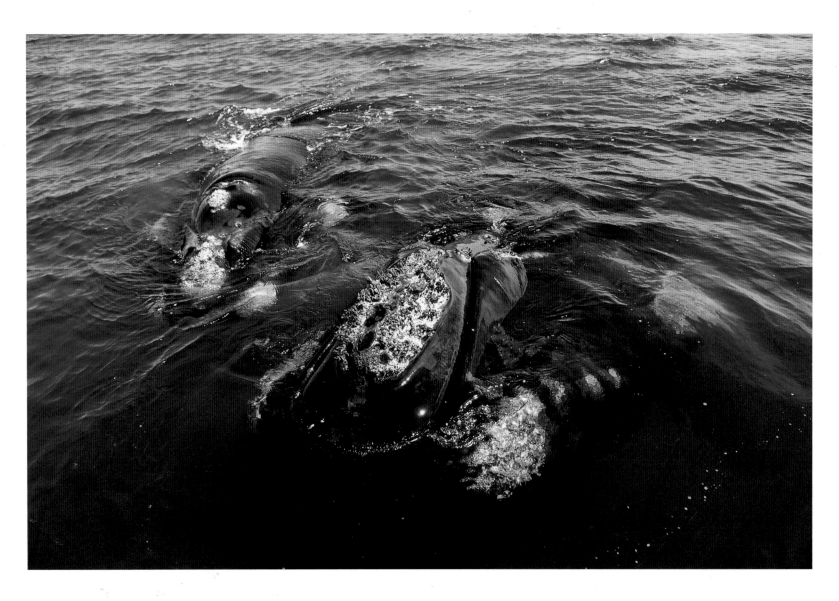

50 tons and 60 feet (18 meters) long—big enough to give you a fright when a whale approaches a small craft in Puerto Piramide (Argentina). The danger is nevertheless minimal, and will only result from clumsiness.

North Atlantic Right Whale (*Eubalaena glacialis*)
28–105mm zoom lens
1/200 sec. at f/6.3 - AF.

Northern Gannet, even during their reproductive activities, allow humans to come close to them. This is a not-to-be-missed opportunity to take an original photograph.

Northern Gannet (*Sula bassanus*)
400mm lens
1/250 sec. at f/4 - MF.

TAKING PHOTOGRAPHS ALONG THE COAST

The coastline is a magnificent landscape where everything works together to produce beautiful photographs: distant vistas, the coast's natural perspective line, graphic quality of beaches, harmony of colors, wealth of interesting foreground elements (boats, shellfish on the rocks, subjects in the sand, flowers on the cliffs, etc.), and a wide variety of lighting. Even in the midst of a storm the coastline is beautiful and majestic. A natural promontory along the cliffs is a suitable angle to reveal the richness of the uncovered intertidal zone in detail. Such a shot could be taken with a wide-angle lens, framed vertically, with the details of the foreground at the bottom of the image, and the perspective line of the coast stretching to the composition's key point, in the upper-right third of the frame. With a telephoto lens, this elevated point of view lets you compress the succession of planes formed by streams and variations in the cliffs along the shore. With backlighting, don't hesitate to underexpose by 0.5 EV to increase the subject's density when using multi-segment metering. At the foot of the cliffs, you should

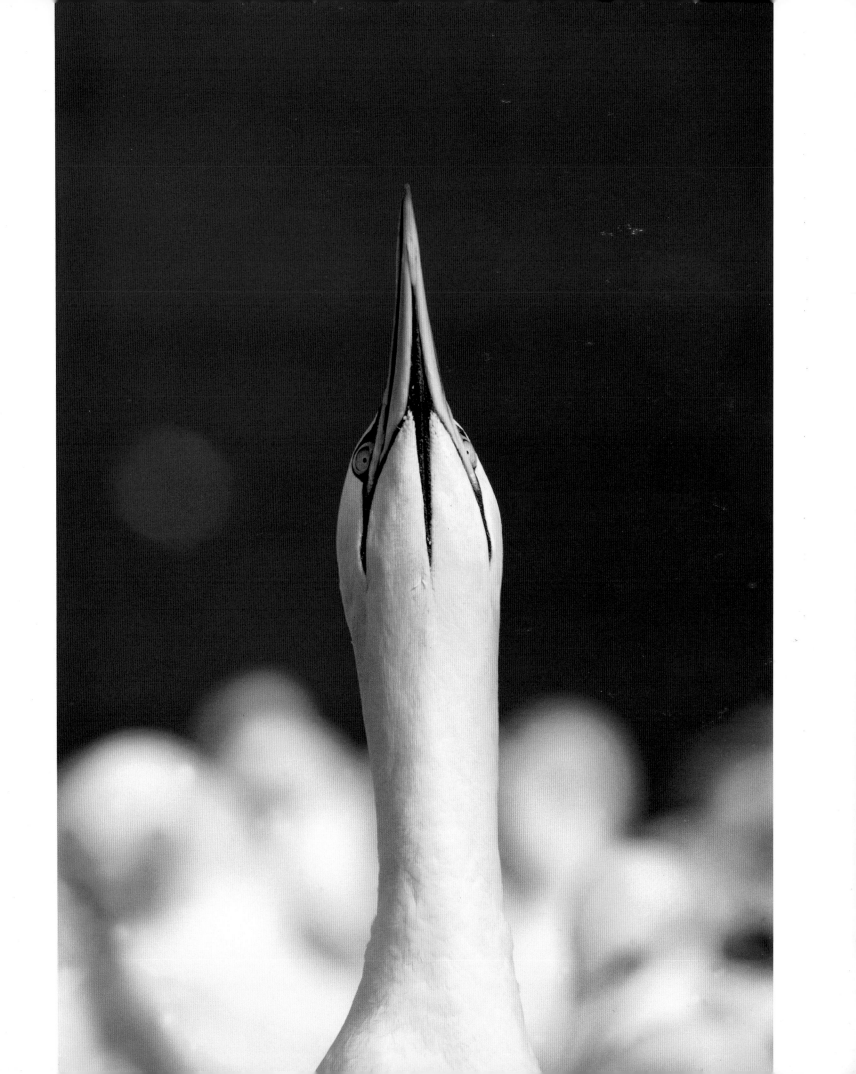

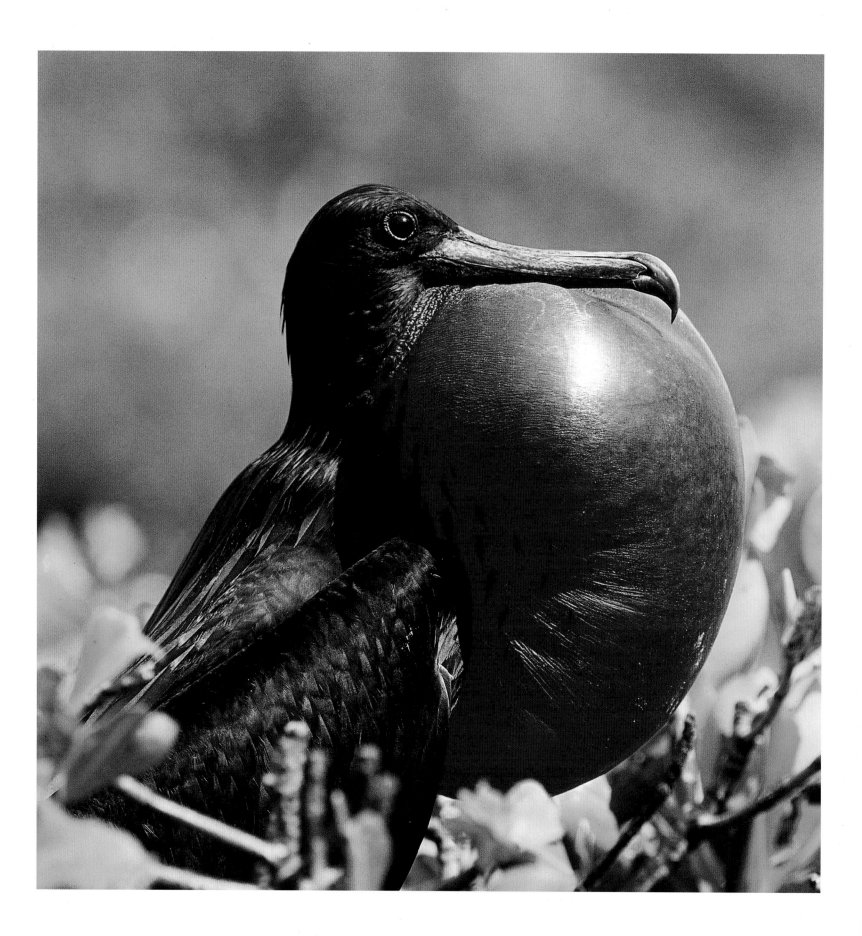

concentrate on the material there: the sea and the intertidal zone are not highly detailed when shot at low angles. If the cliffs are dark, take the exposure reading on the seaside, to avoid over-exposure caused by the cliffs. In the opposite case, it is sometimes necessary to correct exposure by + 0.5 EV in order to counter the excessive density caused by the brightness of limestone cliffs. On flat coastlines, give more relief to your photographs by including attractive foregrounds: tidepools swarming with life, the graphic quality of seaweed on the rocks, tubes of sand ejected by worms digging in the sand, or birds around the blind. The profile of a bay or the perspective of a lighthouse also bring depth to these flat landscapes. The coast is a wonderful place to photograph birds. From the shorebirds chased by the waves to boobies and terns, including murres, kittiwakes, razorbills, fulmars, and puffins (which dig their nests just above the rocks), the shoreline is where most of the coastal and seabirds meet in spring. Ducks, geese, egrets, and herons also spend time in the coastal zone, especially at low tide in search of rich and abundant food. You often have only to hide under a tarp to be surrounded by shorebirds that take off and land to the rhythm of the waves, in search of invertebrates cast up by the surf. On the cliffs, photography is even simpler, since the birds, preoccupied with their young, quickly forget the photographer who knows enough to keep a distance.

OPPOSITE

The male Lesser Frigatebird attracts females in the Aldabra Lagoon by showing them the bright red of his inflated gular pouch.

Lesser Frigatebird (*Fregata ariel*)
200mm lens
1/350 sec. at f/8 - AF.

The "robber crab" is spectacular in appearance, as well as size: some individuals may measure up to 3 feet (1 meter) between their outstretched claws.

Coconut Crab
(*Birgus latro*)
50mm lens
1/60 sec. at f/8 - AF.

PROTECTING YOUR EQUIPMENT
ON THE COAST

Photography on the coastline requires a well-stocked camera bag: wide-angle lens for landscapes, medium telephoto lens (80–200mm) and teleconverter for tidepool photography, a 300–500mm telephoto lens for photographing birds. It is imperative to equip all your lenses with neutral UV filters to protect them from the salt spray.

When the weather is good, adhesive tape wrapped around lenses (and vulnerable areas of the camera) is enough protection against corrosive salt, which infiltrates with the salt spray and becomes abrasive when it dries. In bad weather, camera and lens must be wrapped in a plastic bag taped in place and kept sheltered as much as possible.

Remove all of this protection when you've returned from your shoot, and clean your equipment scrupulously to remove grains of sand and residual salt deposits. Never wipe a lens without using the blower first: the abrasive particles may turn your cleaning cloth into a kind of sandpaper that is very destructive to the layered coatings on your lens.

On Cosmoledo Atoll, this Grey Heron doesn't seem worried by the presence of predators. Is its lack of awareness feigned or real?

Grey Heron
(*Ardea cinerea*),
Blacktip Reef Shark
(*Carcharhinus melanopterus*)
400mm lens
1/250 sec. at f/11 - MF.

LEFT

Spending long hours in the field and a little luck are necessary to catch the intimacy between these sea turtles.

Green Sea Turtle
(*Chelonia mydas*)
200mm lens
1/250 sec. at f/7.1 - AF.

As in the desert, changing film on the coast is risky, especially when the wind is blowing. Beach sand and salt spray can quickly scratch film or jam the camera's shutter. Take shelter in your automobile, behind some rocks, or under an umbrella—even in good weather—when you need to change film. Store the film in its plastic canister to minimize the effects of salt and moisture. Changing lenses poses a similar problem. It's better to use two cameras equipped with zoom lenses so you won't have to change lenses on the beach.

When the weather is sunny, use a neutral ISO 100 slide film or color negative film between ISO 100 and 200. Seaside tones are often rich and very contrasty, suitable for an already intense color saturation. More saturated slide film should be reserved for bad weather and storms, even if it means working with a tripod to compensate for the film's slow speed. With neutral slide film, intentionally underexpose the film by −0.3 to −0.5 EV to intensify colors when the weather is gray.

Two males in single combat with their habitat in the background: the perfect image?

Southern Elephant Seal
(*Mirounga australis*)
300mm lens
1/320 sec. at f/8 - AF.

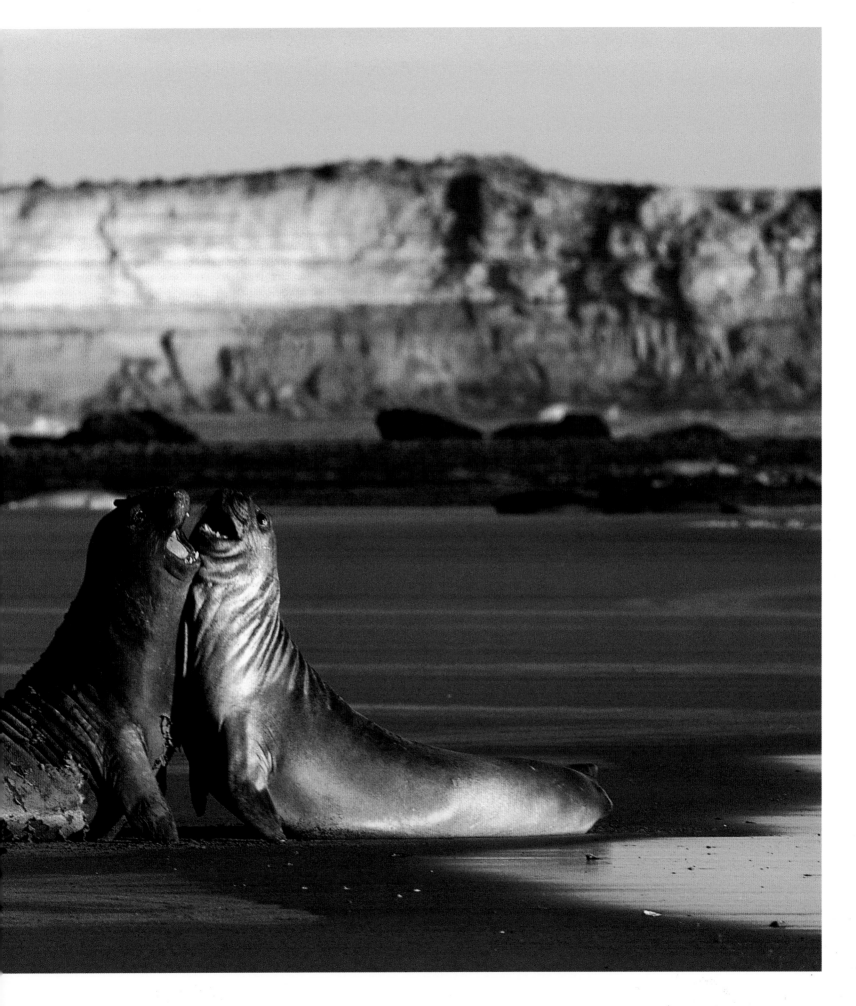

Polar Regions

Female polar bear accompanied by her two cubs near Churchill (Canada). She avoids and will sometimes fight the big males that may kill her young.

Polar Bear
(*Ursus maritimus*)
600mm lens
1/100 sec. at f/4 - MF.

At the north and south poles the sun's angle is so low in the sky and the albedo (the ground's reflection coefficient) so high that an intense dry cold reigns over the region all year long. The deeply frozen ground (permafrost), absorbs only five percent of the sun's energy, which is already minimal. The angle of the earth's axis causes endless days during the short polar summer and never-ending nights during the winter. The angle of the earth's axis also causes the reversal of the seasons between north and south. One of the hemispheres is almost facing the sun while the other receives its light at a very low angle, and vice versa six months later, when the earth has traveled half-way around the sun.

As in the hot desert, the air is extremely dry near the poles. The slightest humidity is immediately transformed into ice by the violent winds, and there is even less precipitation at the poles

than in the Sahara. Only a few animals remain there during the winter. Polar bears and seals in the north, and penguins in the south are among those that best tolerate the cold.

The ice caps at both poles melt only slightly during the summer, forcing living things to the coasts, especially on peninsulas, where the sea's influence leads to milder temperatures. The permafrost only melts for an inch or a few centimeters below the surface, transforming it into a marsh flooded with water.

As soon as the ice melts, there is a veritable explosion of plant growth, which attracts birds and mammals from afar. The extreme conditions of life in these regions require a high degree of specialization from the species that live there, both animals and plants. The plants (saxifrage, moss campion, Arctic yellow poppy, Arctic cornflower) and the dwarf trees (creeping willow,

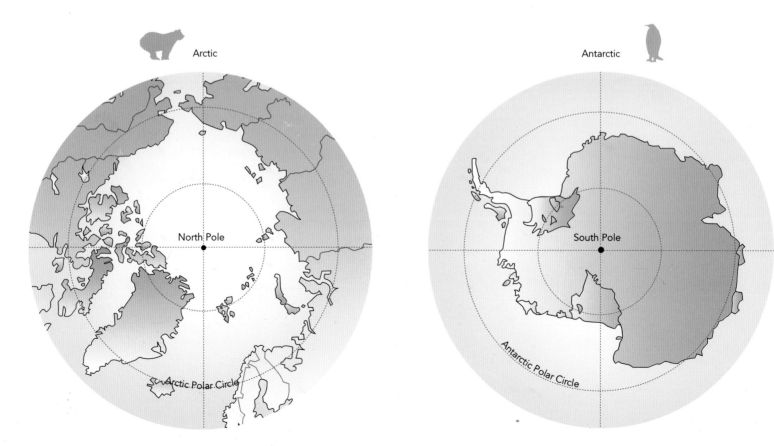

Arctic

Antarctic

North Pole

Arctic Polar Circle

South Pole

Antarctic Polar Circle

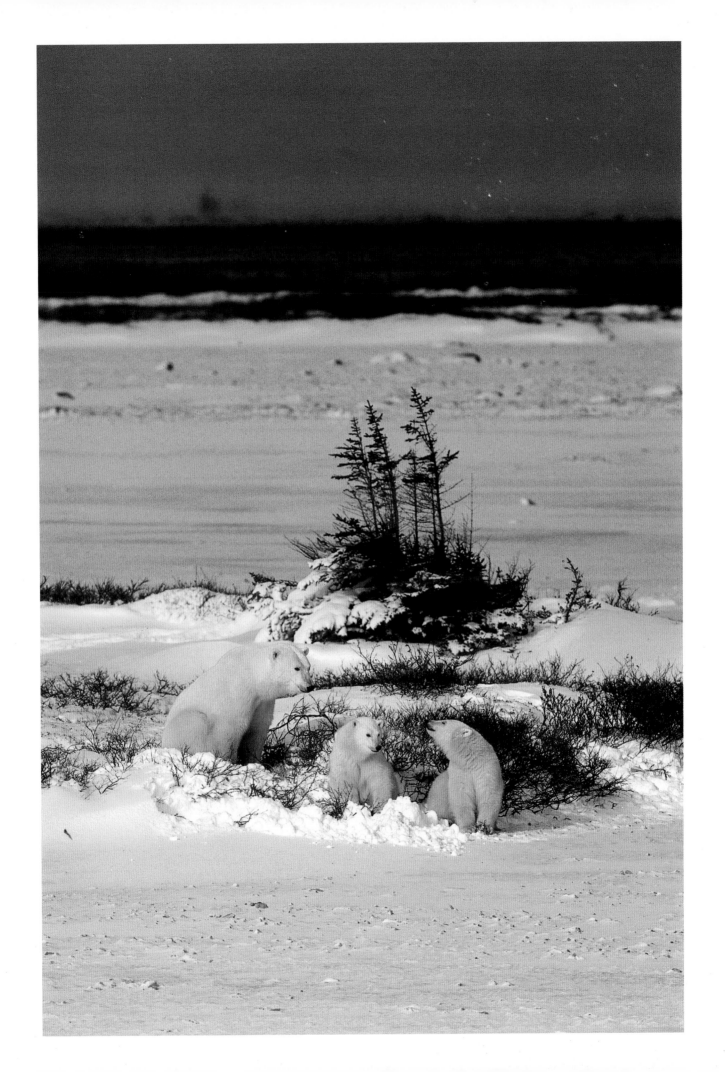

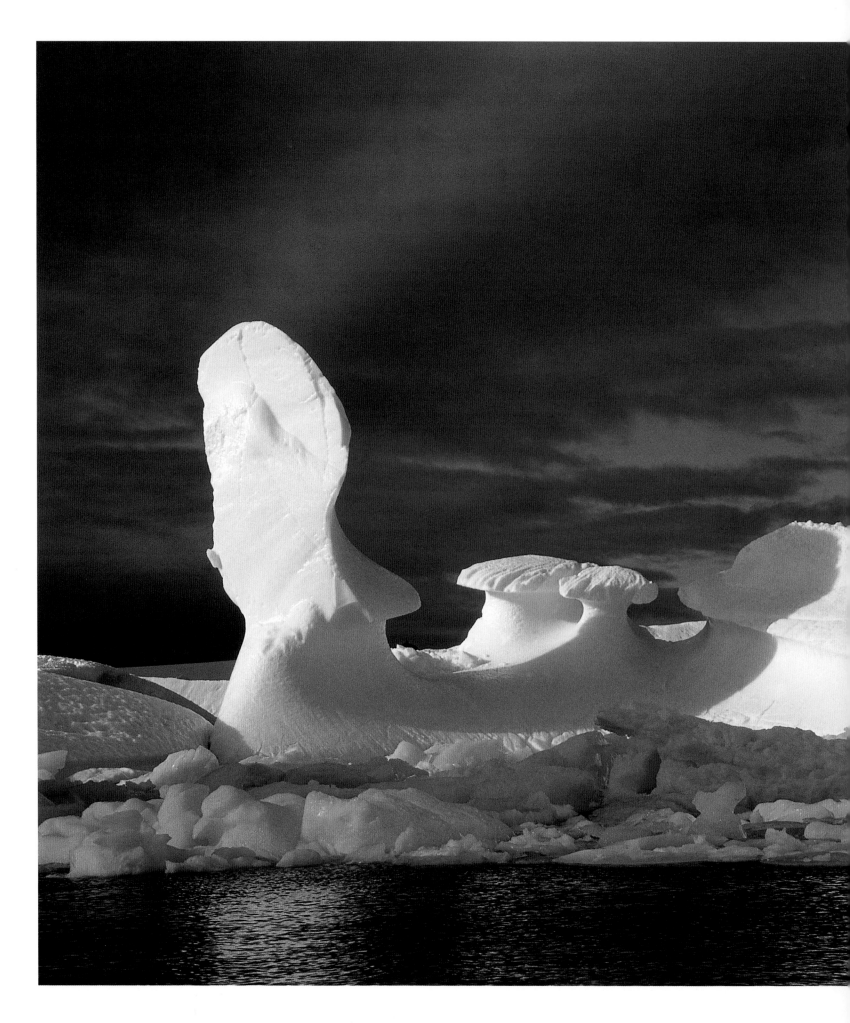

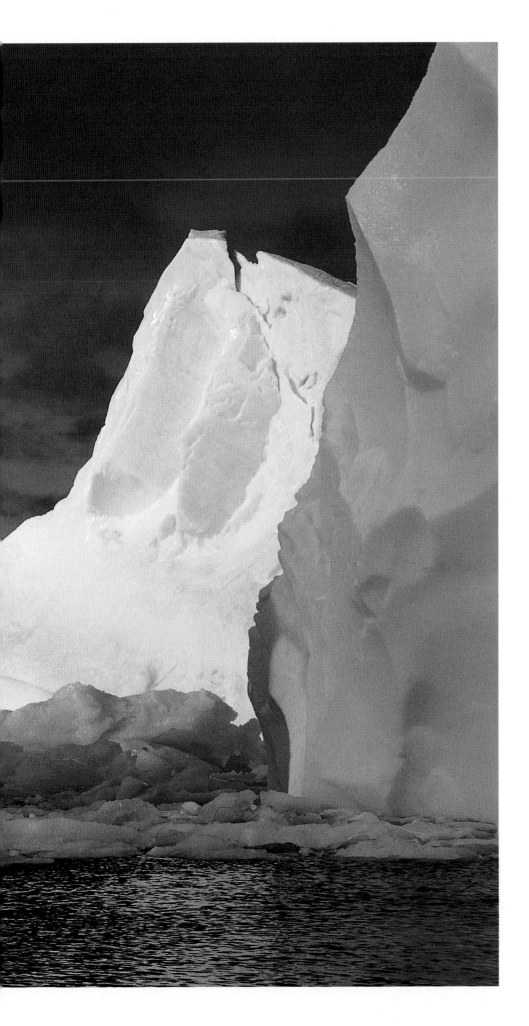

spruce, birches), which survive in the tundra, enjoy such a short summer (roughly three to four months) that they have concentrated their life cycle within it. Caribou, lemmings, Arctic hare, mice, musk ox, wolves, lynx, falcons, and Snowy Owls head north as soon as the good weather begins, some in search of vegetation, others to feed on the greedy animals invigorated by the nutritious herbaceous crop.

TAKING PHOTOGRAPHS IN POLAR REGIONS

Summer is the only season suitable for photography in polar regions. In winter it is always dark, violent dry winds blow almost without interruption, and the temperatures are unbearable. It's true that the summer is short, but the days last twenty-four hours, and the sun is always ideally low. The contrast between its reddish light and the bluish ice is fantastic, especially since the dry air is crystal-clear. These are ideal conditions for taking exceptional landscapes. Landscape photography in polar regions still demands rigor in framing and composition. It's a good idea to counterbalance the monotony of the white, flat

The southern summer in the Antarctic. Icebergs break away from the pack ice and float off to melt in warmer latitudes. The brightness of the ice causes a slight underexposure, which suits the saturated tones of the background.

28–105mm zoom lens
1/200 sec. at f/13 - AF.

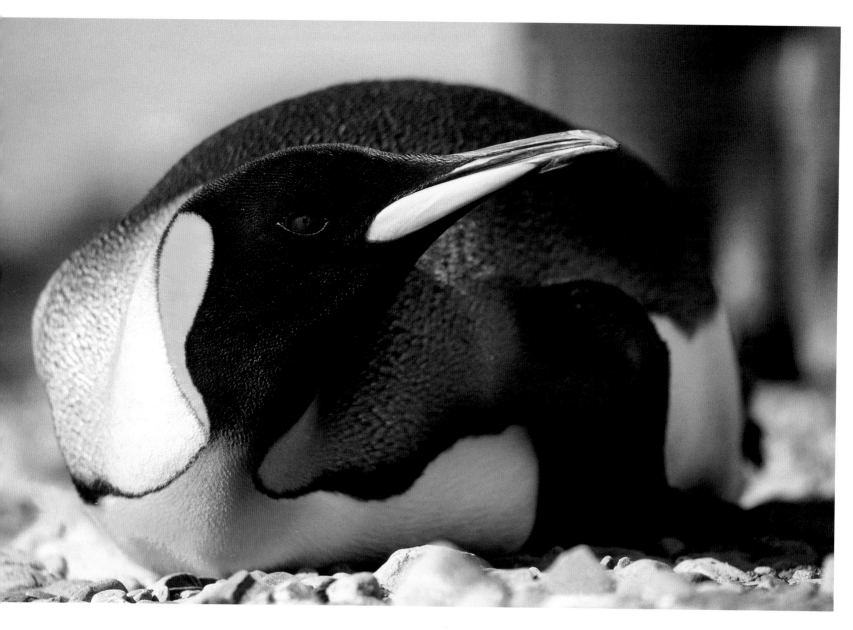

The low angle of this shot was obtained by setting the camera on the ground. When the shoot lasts a long time, put a cloth under the camera to protect it from the cold and damp.

Royal Penguins
(*Aptenodytes patagonica*)
100–400mm zoom lens
1/350 sec. at f/5.6 - AF.

horizons with well-chosen foregrounds, if possible colored by the sun's yellow-orange light. The graphic quality of ice ridges is very useful for making compositions more dynamic, which would otherwise be rather dull. With ice and snow, don't forget to pay some special attention to the problems of exposure. With multi-segment metering, the camera exposes correctly as long as it has a reference subject for making adjustments (a dark person or animal). With a uniformly

white landscape, the light meter operates like a center-weighted meter: it tries to interpret the scene using the middle gray (18 percent) for which it is calibrated. Guaranteed underexposure! In this case, set the exposure compensation at +1 to +1.5 EV, to make the ice truly white. If you are unsure about the state of the light, take a second shot with the exposure given by the multi-segment metering. It's easier to throw away a slide than to come back to retake the photograph later.

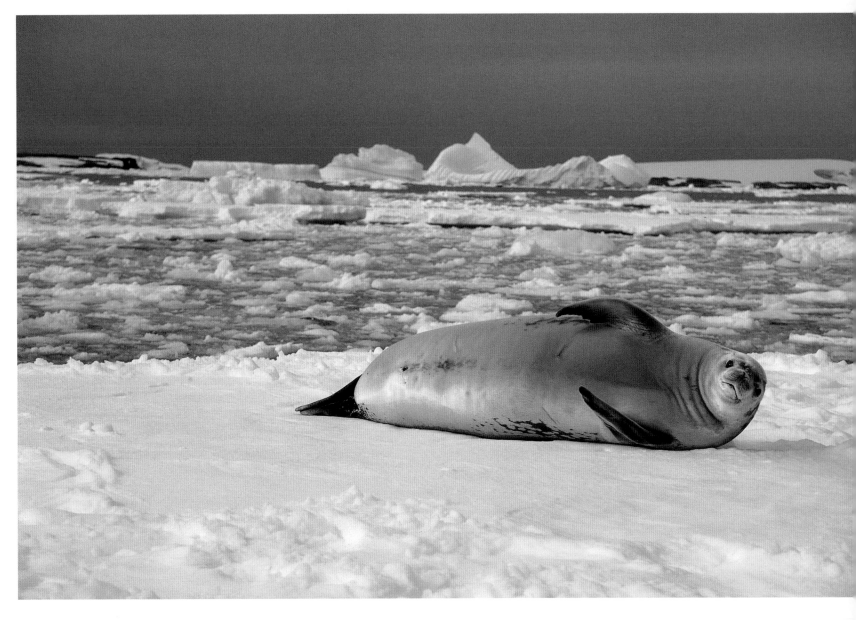

Near the coast, the rather drab carpet of vegetation is enlivened by bright little flowers. They make pretty foregrounds in front of panoramic shots of the coast and fjords. Those who enjoy macrophotography will delight in the delicacy of these plant structures, sculpted for the cold. In order to photograph animals, setting up a blind poses no particular problems beyond the moisture of the waterlogged ground and the importance of keeping a careful eye on the comings

and goings of the polar bears and other carnivores, which could be attracted by your food.

In Northern Canada, photo safaris specializing in polar bears let you take interesting photos in complete safety. You travel in large buggies especially designed for this purpose, with heating, a dining area, and even berths on the largest vehicles. For someone who isn't an expert in survival in these extreme conditions, this is probably the best way to get some very good shots.

To avoid underexposure caused by strong reflections from the ice, it was necessary to increase the exposure by +1 EV. This Antarctic seal feeds almost exclusively on krill.

Crabeater Seal
(*Lobodon carcinophaga*)
28–105mm zoom lens
1/125 sec. at f/8 - AF.

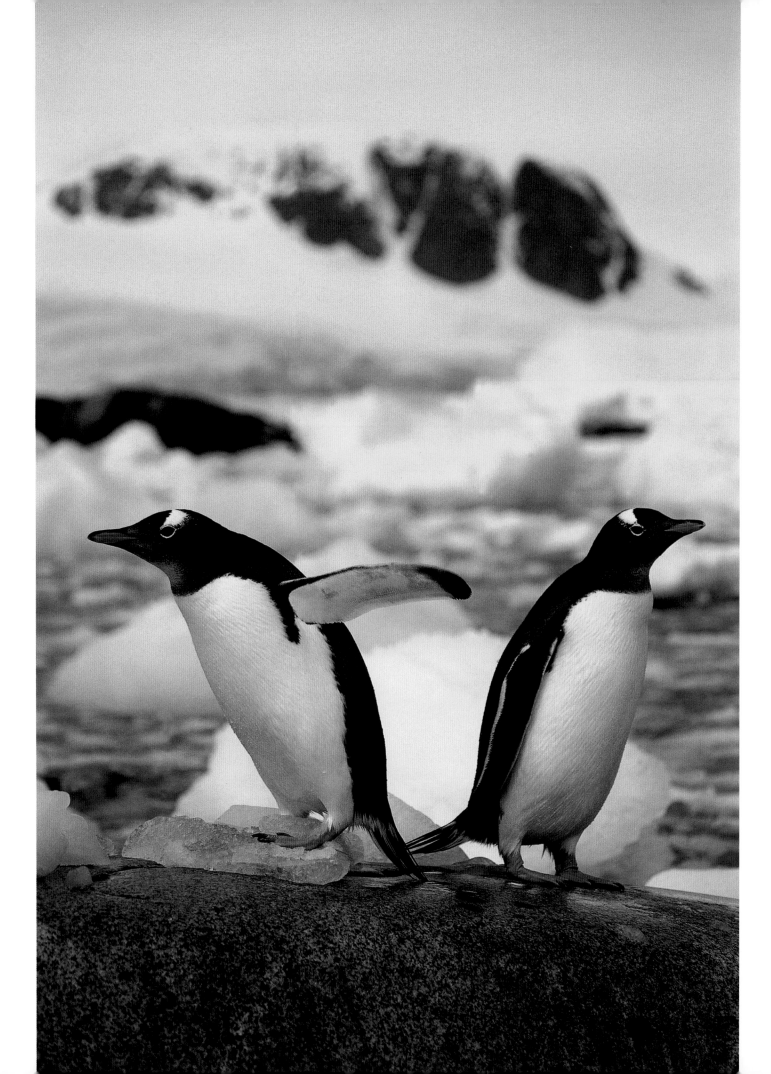

Tight shot made possible by the close focus of the 100–400mm zoom lens.

South Shetland Islands.
Chinstrap Penguin
(*Pygoscelis antarctica*)
100–400mm zoom lens
1/250 sec. at f/5.6 - AF.

OPPOSITE

The warmer waters of the Antarctic Peninsula encourage the proliferation of species. Two penguins on the island of Port Circumcision, where Jean Charcot wintered in 1909.

Gentoo Penguin
(*Pygoscelis papua*)
100–400mm zoom lens
1/60 sec. at f/7.1 - AF.

Magellanic Penguin at the entrance to the burrow where she has just laid her eggs. The low angle gives the impression of sharing her habitat in the Falkland Islands.

Magellanic Penguin
(*Spheniscus magellanicus*)
300mm lens
1/320 sec. at f/4.5 - AF.

In the cold waters of Labrador (Canada), this Humpback Whale leaps from the water in a burst of spray. The photographer has to act quickly and accurately, since there is no way to tell where the whale will surface.

Humpback Whale
(*Megaptera novaeangliae*)
135mm lens
1/250 sec. at f/8 - MF.

Hudson Bay (Canada) is the kingdom of the polar bear. Here a bear looks for food.

Polar Bear (*Ursus maritimus*)
600mm lens
1/200 sec. at f/7.1 - AF.

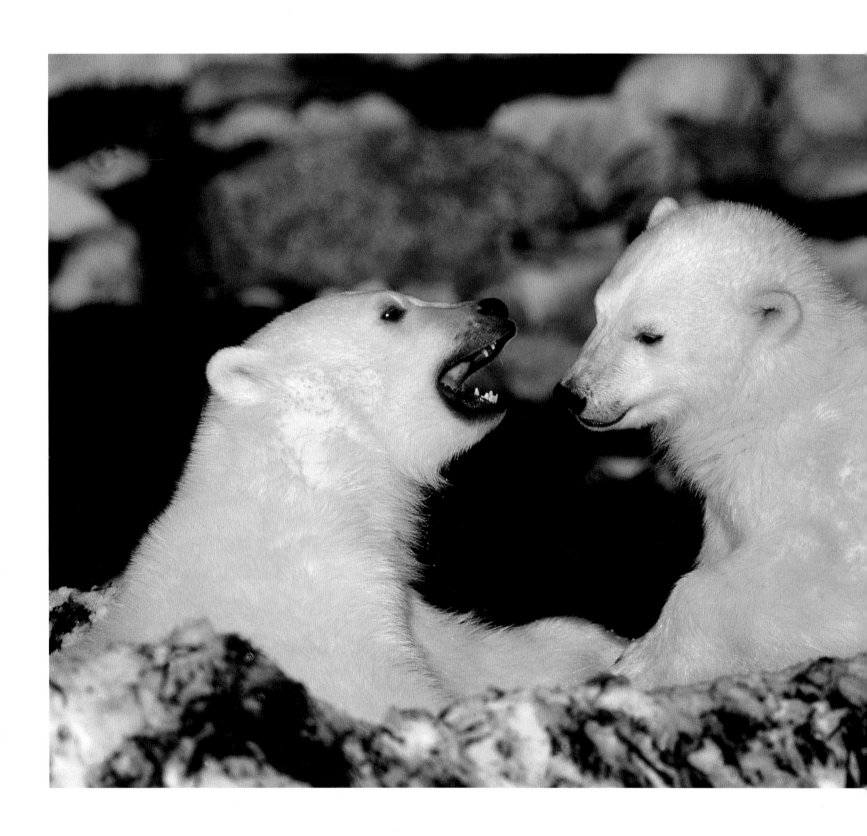

GETTING THE MOST OUT OF PHOTOGRAPHY EQUIPMENT IN POLAR REGIONS

The extreme cold of polar regions necessitates a complex management of photography equipment. Amateur cameras are not suitable, since they are too fragile to stand up to the wide variations in temperature. You must use professional equipment and, if possible, have it serviced by the manufacturer's repair department, especially regarding the lens lubricant, which will freeze in the extreme cold and make focusing risky. For this reason, zoom lenses should be avoided below −4° F (−20° C), because the relatively large amount of lubricants in the moving parts of the zoom lens will freeze more easily than the more modest amounts used in fixed focal-length lenses. This is unfortunate, since changing lenses often means you have to take off your gloves a lot, which is very unpleasant in these conditions.

High-end electronic cameras may be used in the extreme cold (down to around −13° F to −22° F or −25° C to −30° C), as long as they are powered by lithium type AA batteries (LR06). These high-power, long-lasting batteries (1.5V) resist the cold much better than other kinds of batteries. When they are temporarily overcome by the cold, you have only to warm them up in your clothes to get them working again, so bring two sets of lithium batteries and rotate them. Another solution is to power the camera by cable, with a lithium power pack or high-performance batteries kept warm in your parka. Below −22° F (−30° C), an entirely mechanical SLR completely eliminates power supply problems, but it should be handled carefully as lubricants freeze and delicate parts are more fragile when it's this cold. Be careful of the metal parts of mechanical cameras, which may freeze to your bare fingers and tear the skin. Protect your equipment with adhesive tape, and don't forget the camera back and viewfinder: an eyebrow or nose frozen to the camera is not very pleasant.

When your breath is accidentally exhaled on the camera back or viewfinder, or, purposely, on the lens for cleaning, it is instantly transformed into a totally opaque layer of frost. Once there, this layer of frost can only be removed by staying in a heated room for a sufficient period of time. It takes several hours for the camera to reach the

Young males learn through play and imitate the fights they will face as adults. These shots are especially interesting since these young bears are concentrating so intensely that they don't see the photographer.

Polar Bear
(*Ursus maritimus*)
600mm lens
1/350 sec. at f/5.6 - AF.

same temperature as the room. Also, if the camera is as cold as the outside temperature, and you come in for a short time and then go out again, a layer of frost forms immediately. For this reason, never take out your cold camera in the humidity of a tent or igloo. Open up the tent and let the interior and exterior temperatures equilibrate before getting out your equipment. Otherwise you will have another problem with frost.

Film also suffers greatly from the extreme cold and its drying effects. With professional cameras, chose slow advance and rewind speeds. Otherwise the film, hardened and dried by the cold, breaks very easily and static electric discharge may spoil the film during rewinding. Also be careful when you're changing film: the frozen film can cut like a razor blade. And since it's impossible to change film wearing gloves, care is required.

"Since I only had two hours on Gold Harbor (South Georgia Island) under cloudy skies, I had to be sure that the shots would come out so I took all of them by bracketing three images (between –0.3 EV to +0.3 EV). During these fleeting 120 minutes I took more than 1,000 photographs."

Royal Penguin
(*Aptenodytes patagonica*)
100–400mm zoom lens
1/60 sec. at f/5.6 - AF.

The Wetlands

Wetlands are a real paradise for nature photographers. Insects, amphibians, and birds are the main attractions; mammals and fish are harder to find, despite their large numbers. There are many kinds of wetlands, each with its own set of native species and visitors, which move from one place to another with equal success. Rivers, streams, pools, rapids, lakes, and river deltas are places where we see an incredibly diverse avian fauna. Little Egrets, kingfishers, mallards, Blue Herons, Little Grebes, White-throated Dippers, Great Crested Grebes, and Common Redshanks are only a few of the birds that can be observed easily with a pair of binoculars and a little patience. Add to these, Green Frogs, Southern Hawkers, mayflies, damsel-flies, Palmated Newts, water beetles, Wasp Spiders, Fire Salamanders, Common Toads, and the thousands of other inhabitants of wetlands, and you'll have a better idea of these astonishingly rich ecosystems.

○ White-Water Rapids: These areas attract the fewest birds and insects. Highly adapted species like White-throated Dippers, which swim and walk on the water with ease, or the little crayfish and larval mayflies and caddisflies, which can cling to rocks and moss to fight the current, are typical residents of rapidly flowing water.

○ Rivers and Streams: Here we find a much more extensive fauna, with spearfishers (herons, egrets), filter-feeders (dabbling ducks, spoonbills), diving birds (grebes, diving ducks, kingfishers), all the insectivorous passerines from the banks and reed beds, shorebirds searching through the ooze, Common Moorhens, and Common Coots. Among the river insects are damselflies, which like fast water, and mayflies, alderflies, fleas, and beetles. There are also mammals such as nutria, beaver, otters, Eurasian Water Shrews, muskrats, and European Water Voles.

 The Wetlands

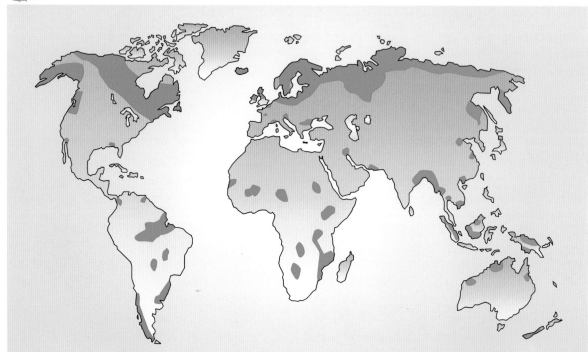

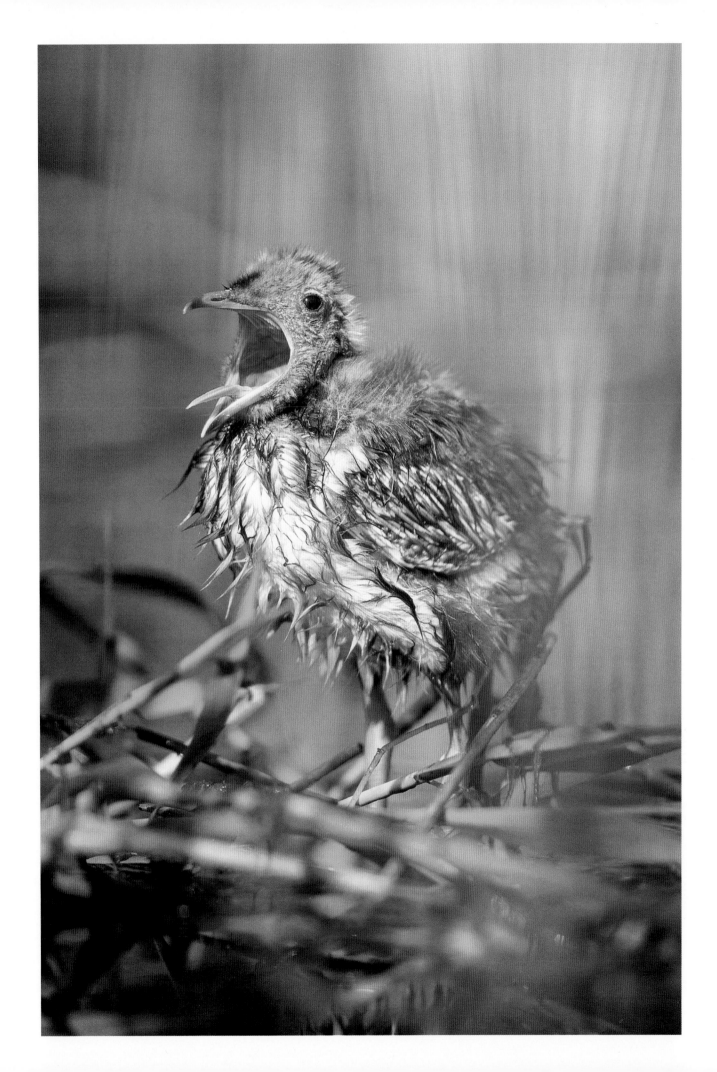

○ Lakes and Ponds: Here we find many river and stream animals, especially those living in estuaries and deltas, with a great variety of ducks, grebes, herons, and many of the species typical of the reed beds (Reed Warbler, Sedge Warbler, Cetti's Warbler, Fan-tailed Warbler). This is the favorite habitat for dragonflies of all kinds, attracted by the water's acidity. Most insects and spiders are found on the water's surface (Water-measurers, aquatic spiders), underwater (larvae, aquatic insects), and on the banks, where the flora is very rich. Reptiles and amphibians are also present in large numbers (Ringneck Snakes, toads, newts, frogs, tree frogs), with an incredible number of green frogs as soon as the weather is warm enough.

The presence of certain species in still water varies depending on the water's acidity and the elements dissolved in it, which is linked to the composition of the bottom and depth. The absence of pollution is of course the key element to the survival of wetlands, which store increasing concentrations of toxic products in resident organisms.

TAKING PHOTOGRAPHS IN THE WETLANDS

Wetlands may be photographed throughout the year, with high points related to births and migrations in the spring and fall. Summer is also a good time to take photographs. Insects become more active as they are warmed by the sun, and birds start a second clutch.

Sedentary birds and a few migratory species, which have interrupted their trip, provide photographers with subjects all winter long. This is the case with Common Cranes from Scandinavia, some of which spend the cold season on Lake Der (Marne, France), instead of continuing their

Just before mating, the male Whiskered Tern gives his female a gift: it is essential to capture this behavior in a project on this species.

Whiskered Tern
(*Chlidonias hybridus*)
300mm lens
1/200 sec. at f/5.6 - AF.

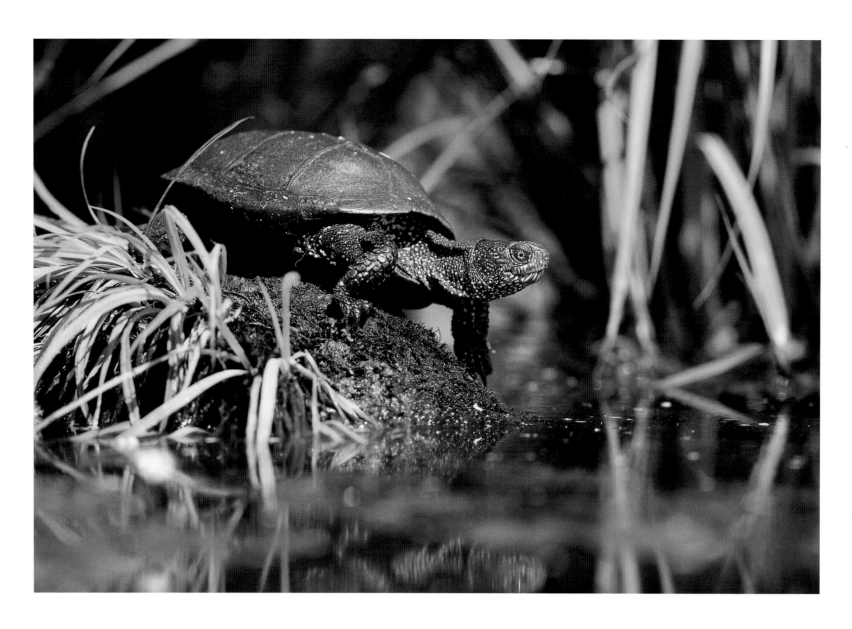

The European Pond Turtle is a splendid freshwater turtle. Unfortunately in some places it is in competition with domesticated turtles (Red-eared Sliders), released by their owners once they grow too large.

European Pond Turtle
(*Emys orbicularis*)
300mm lens
1/125 sec. at f/4.5 - AF.

migration to southern Spain or North Africa with the rest of their fellow creatures. From the banks it is easy to photograph common species with a telephoto lens. You have only to hide in the vegetation, covered with a camouflage net, and wait for the arrival of new birds that have not yet noticed you.

A pair of rubber hip waders increases your possibilities, especially in reed beds, where many passerines may provide very dynamic pictures. You can set up a blind in your favorite location

(mudflat, reed bed), so long as you are not somewhere frequently visited by the public. Hide yourself as well as you can in the vegetation, being careful not to disturb any nests.

Using a camouflaged boat or floating blind will let you approach the birds and mammals hiding in the distant corners of the reed beds. Birds are not very suspicious of such tactics and quickly return to their normal life as soon as you've been in place a little while. Use a telephoto lens with a very short minimum focus distance, or bring an

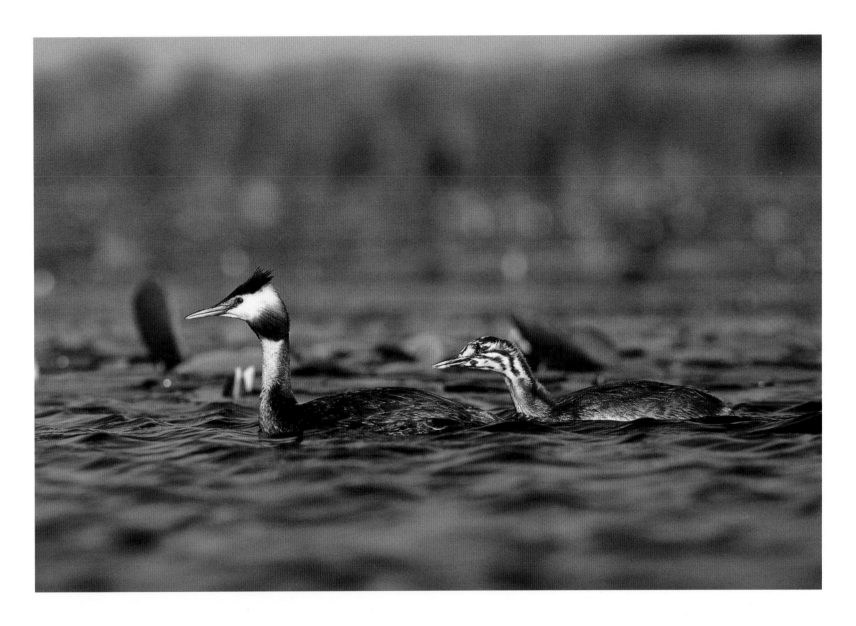

extension tube, since you can get very close to birds with a floating blind. Mammals are less easily approached since they're more sensitive to odor. Keep track of the wind's direction before you try to approach nutria or any other mammals near the water. To muffle the noise of your shutter, make a soundproof enclosure from well-insulated winter clothing (the hood from an old parka taped in place). Blimps or camera socks, marketed by photographic equipment manufacturers, are specially designed for heat and sound insulation,

but their price is fairly high, and they won't fit every camera.

A floating blind will also let you approach amphibians and insects. Though these species are easy to photograph from the banks, a floating blind opens up a much more natural perspective on their environment. You can photograph them at water level, in the forests of grass that become quite spectacular from this angle. Taking a panoramic shot with a frog on his lily pads in the foreground at water level with a super-wide-angle

Grebe followed by her chick. Precise focusing and control of depth of field allow the two birds to stand out against the blurred background.

Great Crested Grebe
(*Podiceps cristatus*)
300mm lens
1/400 sec. at f/4 - AF.

lens completely changes our perspective on wetlands.

The variety of subjects in wetlands encourages you to use many lenses: super-wide-angle (landscapes with a small subject in the foreground), wide-angle (landscapes), macro (insects, spiders), close-focus medium telephoto (dragonflies, amphibians), and long (birds, aquatic mammals). To transport all this equipment a waterproof backpack, specially designed for photography, is by far the most practical solution. You can use it as a support for shots with a telephoto lens, carry a snack and, especially, the indispensable mosquito repellent in it. A backpack can be used in a camouflaged boat, as long as you attach it with a strap to one of the benches or to the front of the prow, which is slightly elevated. Never put it directly on the boat's wet bottom.

Don't use a backpack in a floating blind: it's too heavy and can get wet if there's an accident. Use waterproof cases (plastic food containers) lined with foam to store film, lenses, and accessories that aren't being used at the moment. In case of accident, equipment and exposed film are safe as long as the covers have been sealed: be sure to squeeze out the air when you close them.

A blind integrated into a bird colony and the use of a wide-angle lens make very graphic photographs. The birds passing in the foreground give an impression of depth to the image.

Black-headed Gull
(*Larus ridibundus*)
28–105mm zoom lens
1/100 sec. at f/11 - AF.

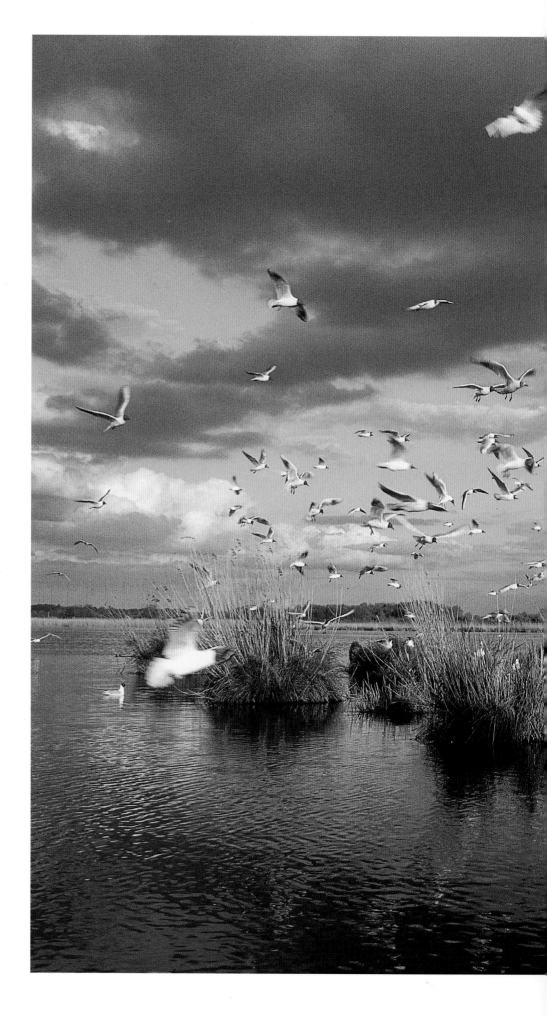

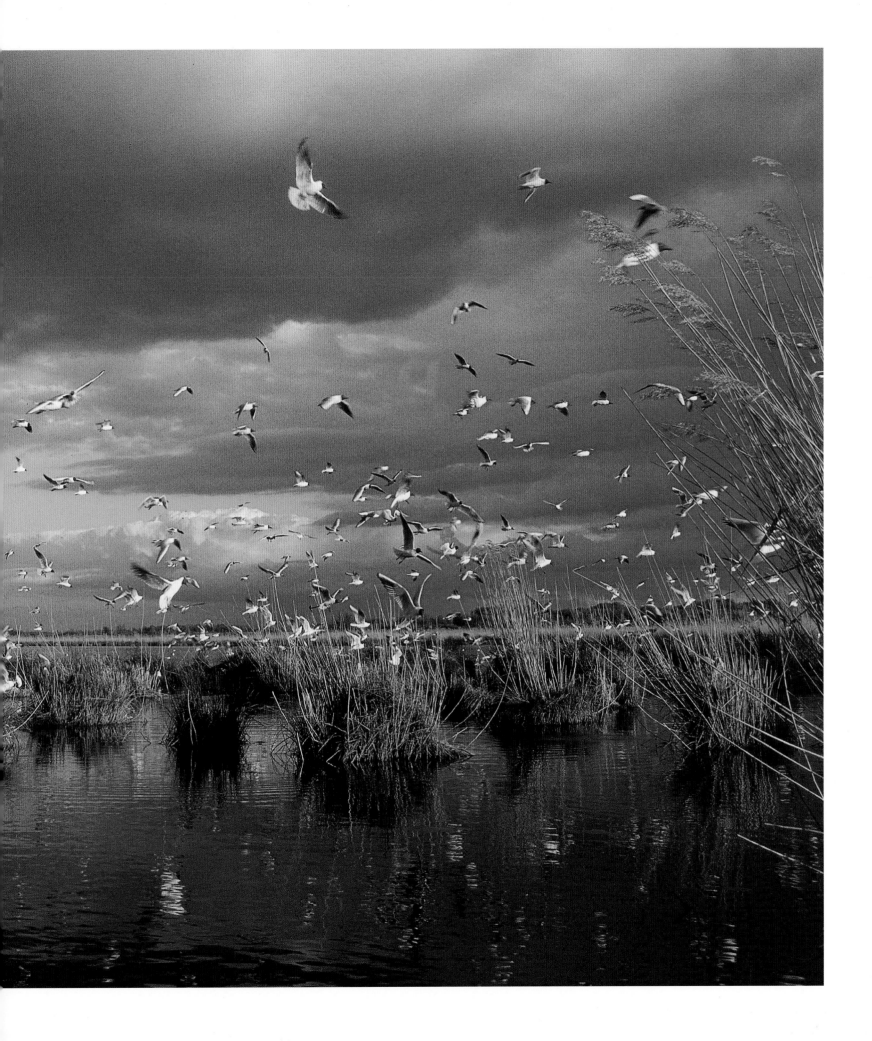

This young Common Coot, separated
from the nest that it has just left,
peeps to find its mother. On its own
the chick is easy prey for a Marsh
Harrier, which is always looking for
food.

Common Coot
(*Fulica atra*)
300mm lens
1/200 sec. at f/4 - AF.

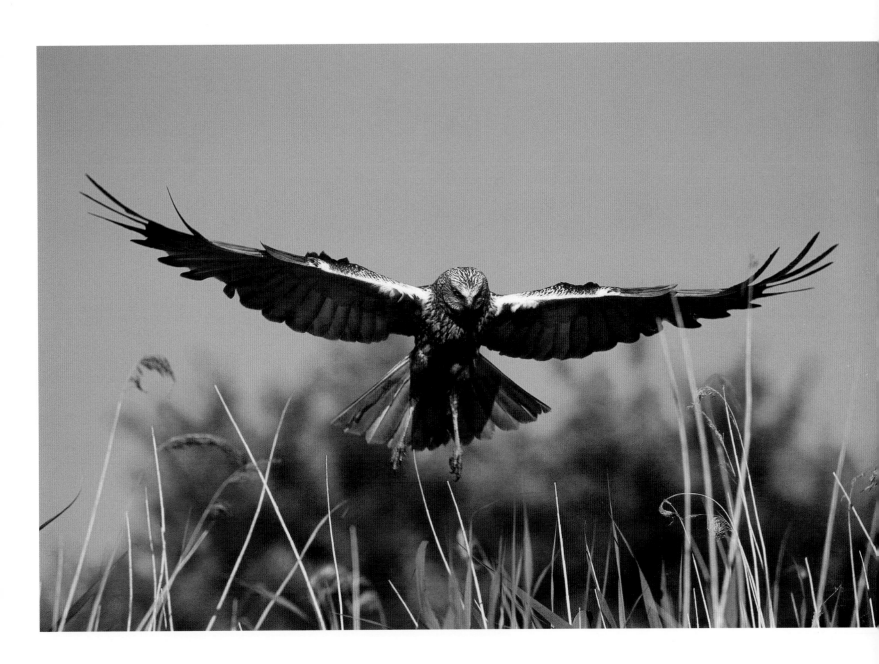

This hovering Marsh Harrier
watches for young coots that have
just left their nest, an easy meal if
their mother is not nearby.

Marsh Harrier
(*Circus aeruginosus*)
300mm lens
1/350 sec. at f/4.5 - AF.

WETLANDS:

PROTECT YOUR EQUIPMENT FROM WATER

Often exposed to water, lenses and cameras should be given special attention in wet areas. Cover joints susceptible to infiltration with plastic tape, clean off the slightest trace of water using a dry lint-free cloth, and mount a neutral UV filter on every lens.

During hikes through shallow water, wrap your camera in a plastic bag to protect it from splashes. When the risk of immersion is too great, or for taking photographs in shoulder-deep water, use a waterproof housing like those available from ewa-marine, which completely protect the camera so you can take underwater shots. This accessory is very practical for taking semiaquatic photos, e.g., the submerged body of a frog with his head sticking out of the water surrounded by water-lily pads. It is also possible to take shots like these by putting the camera into a half-submerged aquarium, but composition is mostly a matter of luck (a right-angle viewfinder is essential), and the animal may escape before you have time to stabilize the aquarium. A waterproof housing, on the other hand, has two drawbacks. Its price is fairly high, and it must be taken apart every time you change film. Safeguarding film is not a particular

The Migrant Hawker still covered with dew and numbed by the coolness of the night, is a fantastic subject for photography. It looks like a jewel set with a thousand precious stones.

Migrant Hawker
(*Aeschna mixta*)
100mm macro lens
1/125 sec. at f/8 - MF.

A pochard shakes off after its bath. Wait for the instant when the wings pause at the limit of movement before changing direction, especially when you're cutting it close on shutter speed.

Common Pochard
(*Aythya ferina*)
300mm lens
1/150 sec. at f/5.6 - AF.

problem in wet areas, so long as the rolls are kept dry and in their canisters. You should still avoid storing film in hot places, notably in the floating blind when the sun is at its peak. Use slide film from ISO 50 to 100, preferably in a "color-saturated" version, which highlights a birds' plumage and brings out the colors of reed beds. A neutral film is certainly closer to reality, but it doesn't quite capture breeding plumage and the sun-dried vegetation.

Simple portrait of a duckling stretching out one of its legs. The water lily in the background brings a touch of light and gives the image relief.

Common Pochard
(*Aythya ferina*)
300mm lens with 25mm extension tube
1/100 sec. at f/8 - AF.

 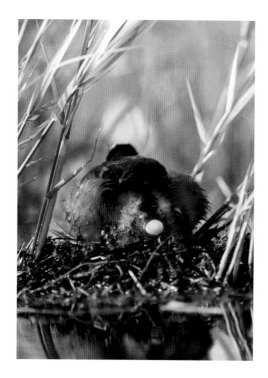 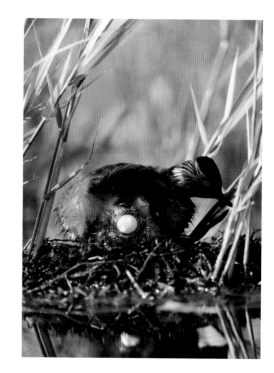

This magnificent sequence of a Black-necked Grebe laying an egg was taken in the Brenne Regional Nature Park in France: "Two meters away in my floating blind, I composed this shot perfectly with a 300mm lens. It took less than ten seconds for her to lay the egg, and the bird didn't seem disturbed by my presence. A skillful blend of long hours in the field, familiarity with the subject, proficiency at stalking and luck were necessary to capture this image."

Black-necked Grebe
(*Podiceps nigricollis*)
300mm lens
1/200 sec. at f/4 - AF.

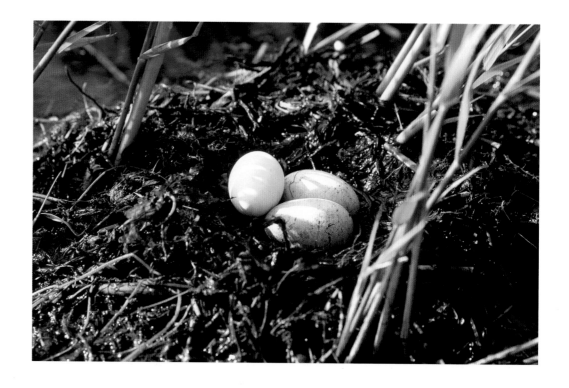

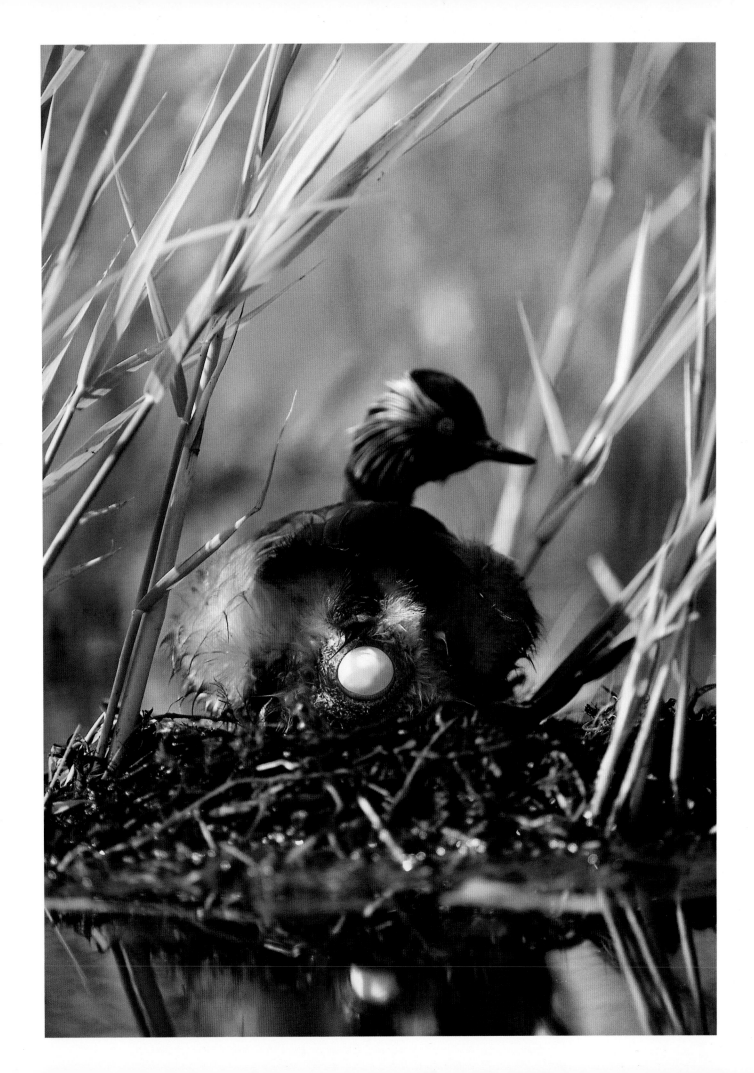

Mountains

The weathered hills of the Anti-Atlas in Morocco are subject to wide variations in temperature. The vegetation that clings to life there is particularly hardy.

Siroua Range, Anti-Atlas Mountains (Morocco).
20mm lens
1/125 sec. at f/18 - AF.

Mountainous ecosystems have more contrasts than any other. In the tropics you can go from tropical rain forest to a tundra worthy of the Arctic winter in a few hours' climb. In Europe, your hike will begin in a deciduous forest, followed by conifers, the dwarf trees of the tundra, and finish up among the last few stunted grasses, which slowly give way to rock and snow. If the vegetation in the lowlands varies from one latitude to another, the changing altitude leads inexorably to a quasi-polar climate in the highest mountains. The elevation at which the vegetation changes is the only thing that differs: the temperature drops 1° F (0.6° C) for every 330 feet or 100 meter gain in elevation. The eternal snows, for example, begin at 9,200 feet (2,800 meters) in the Alps, but only at 16,400 feet (5,000 meters) in the tropics. Even opposite slopes of a simple valley may have very different climates, with a rich vegetation on the side exposed to the sun and small, stunted plants on the opposite face. A photographer should know that the sunny side is best for flowers and colonies of marmots, while the ibex and chamois prefer to hide from hikers and the summer's heat in the shade on the opposite slopes.

Animal species also vary with altitude, even if some of them go up and down at will. In the forests at the foot of a mountain, animals from the plains (cervids, woodpeckers, boars) take advantage of the area's tranquility. You have to pass through the zone of deciduous trees and come into the midst of the conifers to find animals of a more northern origin, like the Boreal Owl, the Hazel Grouse, or the capercailie. Once you've gone past the trees, the thick grasses and rock debris shelter marmots, while along the rocky cliffs Cornish Chough and Alpine Chough enliven the mountains with their calls. At the

 Mountains

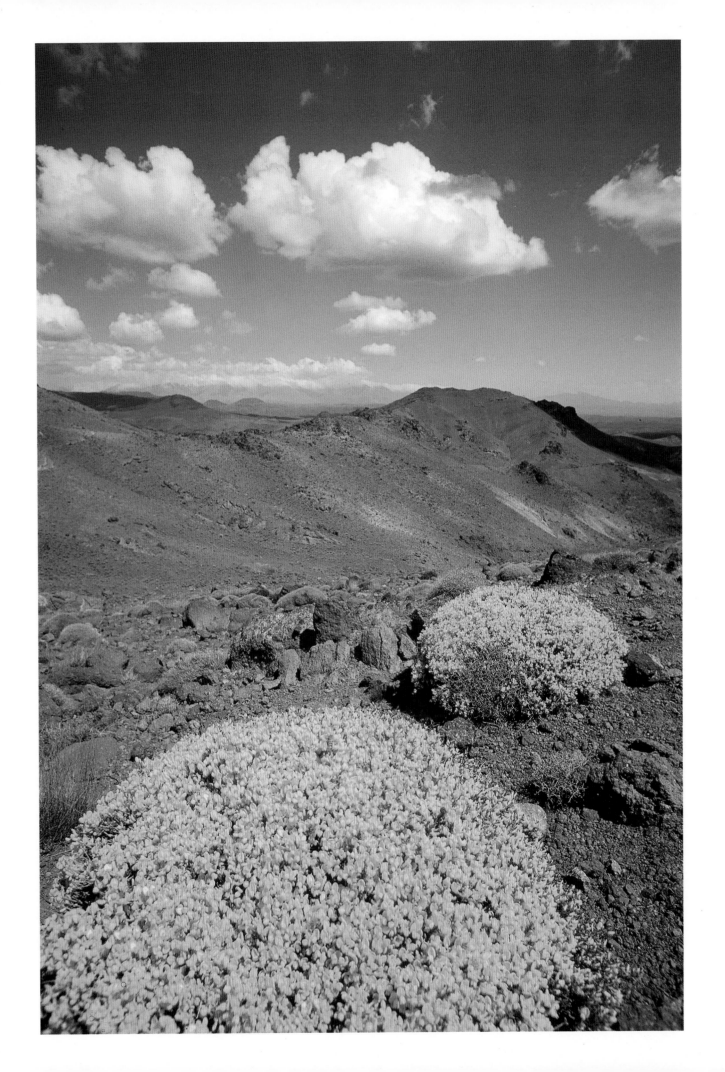

The Flinders Range (southern Australia) is home to a fairly rare plant called Sturt's Desert Pea.

24mm lens
1/125 sec. at f/16 - MF.

same height, Golden Eagles, Griffon Vultures, and Bearded Vultures ride the ascending currents, gaining altitude without the slightest movement of their wings. In the wind-swept passes, Snow Finches watch for food left by hikers, while the Rock Ptarmigan remain invisible thanks to their plumage, which blends perfectly with the rocks.

The chamois walks confidently along steep cliffs. It can climb almost 1,650 feet (500 meters) in a few minutes if it smells danger, but will soon come back down with its neighbor, the ibex of the lower level, as both find their daily nourishment in the valley in wintertime.

In the cold season, many mountain animals change colors: the Arctic Hare, ermine, and ptarmigan have an almost immaculate white coat, which helps them hide from predators. Marmots prefer to lie in a deep sleep, letting their body temperature fall (to between 39° and 44° F or 4° and 7° C), while reducing their heart rate to the minimum necessary to sustain life. Most animals go down closer to the valleys in search of food. But some animals, like the ptarmigan, brave the bad weather in holes dug into the snow and valiantly hold out at the tree line.

PHOTOGRAPHY IN THE MOUNTAINS

In good weather the nature photographer's only problem in the mountains is deciding what to shoot. Insects, birds, and mammals are abundant and very active, since they must hurry to reproduce and store enough energy before the endless winter. The altitude produces a shift in the seasons, with flowers blossoming in June and July in the high meadows where cows and sheep spend the summer. Campanula, gentian, columbine, willow-herb, centaury, saxifrage, Turkscap Lily, rhododendron, and clematis brighten the mountains with their shimmering colors. The most hardy accompany the hiker up to the glacier's edge. They need only a clump of earth between a couple of rocks to blossom. Photograph flowers at their own level, in the manner of a full-length portrait. They also make superb foregrounds in mountain landscapes as long as you close the aperture enough (f/16 to f/22) to keep everything in focus out to the horizon.

A throng of butterflies (Apollo, Black-veined White, Swallowtail, Mourning Cloak, Spanish Moon Moth) share the meadows and woods,

Sturt's Desert Pea
(*Clianthus formosus*)
50mm lens
1/200 sec. at f/8 - MF.

while the marmots whistle at hikers from their dens in the scree. If you look carefully with binoculars, you'll see the chamois on the snowbanks that persist in the hollows or in the shadow of a rock. In order to photograph them, hike up the trails in the cool of the morning, around 7:00 AM. Enthusiasts of macrophotography can pause at the tree line, while fans of marmots climb a little higher to set up a blind and surprise the greedy animals as they nibble a liquorice root. If you want to photograph chamois, you have more climbing to do: they hide under the rocky ridges and watch over everything that comes from below. So spend the night in a shepherd's hut and climb above the chamois early in the morning by an accessible pass: they won't expect you there. A 300mm f/4 gives the best compromise between weight and magnification. Sometimes as you climb down in the evening you may meet the herd at low altitudes: they too are tempted by the tender summer shoots. The most daring chamois will even visit the shepherds' salt licks. At this late hour, wide aperture is more important than magnification, so get out your 200mm f/2.8. Don't forget that you have to keep your eyes open in the mountains, or else how will you see the extremely rare Iberian Desman in the Pyrenees as it makes bubbles in the streams, notice the Bearded Vulture with its diamond-shape tail spread wide, or tell the Alpine Longhorn Beetle from an ordinary Capricorn Beetle? The mountain rewards those who take the time to contemplate it.

The mountains of the Antarctic Peninsula are among the coldest in the world. Only animals arriving from the sea occupy their slopes during the summer.

28–108mm zoom lens
1/60 sec. at f/8 - AF.

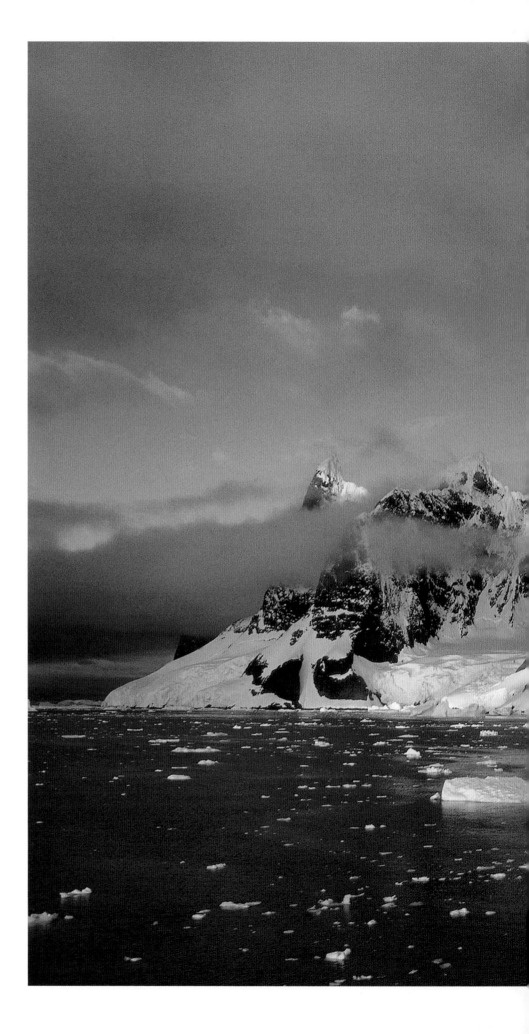

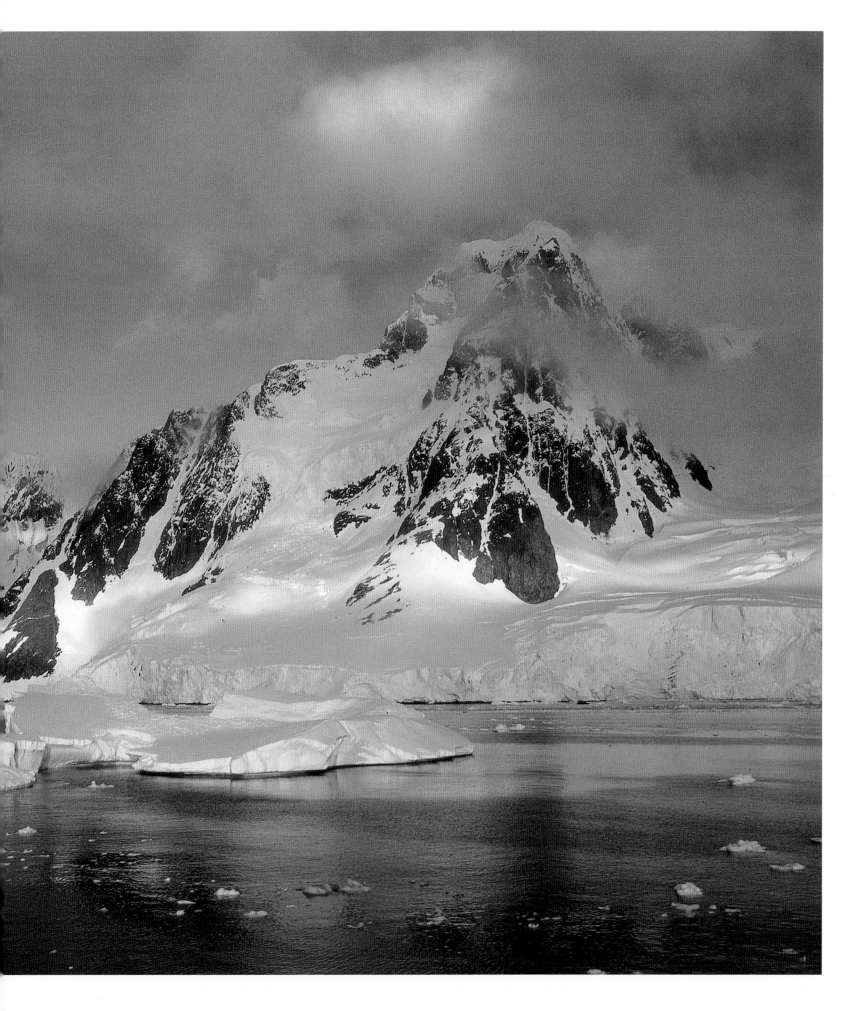

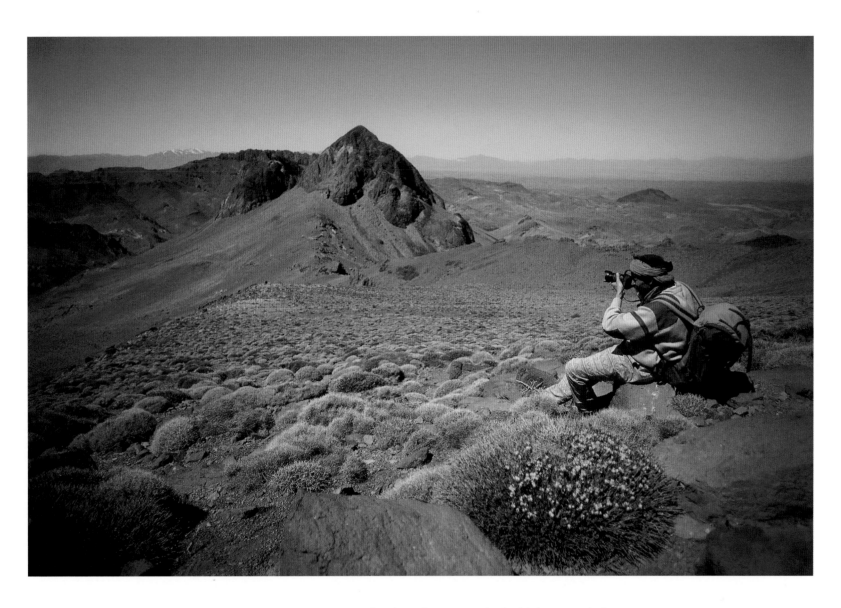

MOUNTAINS: PAY ATTENTION TO WEIGHT

The greatest enemy of the photographer in the mountains is weight. Leave your indestructible high-end camera behind and take a lightweight amateur SLR. Carry a narrow selection of lenses: 300mm f/4, 200mm f/2.8, and 24mm f/2.8 will suit most subjects. Bring a set of extension tubes for flowers, some slide film and spare batteries. Store it all in a special photography backpack, and you're set to carry your burden for a long time.

Don't forget to bring a snack, water bottle, raincoat, fleece pullover, sunglasses, hat, and trail map. In winter (or summer in the high mountains), the cold makes you take your hike seriously. Your backpack should be equipped first with survival gear even before adding your camera equipment. This should be protected and used with the same precautions as in the tundra (see page 251, "Polar Regions"): weak batteries, fragile film, exposure problems, and frosted condensation are all similar. Don't put the camera in your parka, since the effort of climbing will fill it with moisture and make it useless in the cold weather.

The rocky peaks of the Moroccan Anti-Atlas harbor an enormous number of insects and reptiles. The ecosystem of this mountain chain is very close to that of the desert.

28–105mm zoom lens
1/60 sec. at f/14 - AF.

OPPOSITE

The "Ghost Gum" is a leading attraction at the Flinders Range National Park (Australia).

200mm lens
1/60 sec. at f/8 - MF.

The marmot follows the tip of its
nose at the first sign of good weather,
and hastens to eat to build up its fat
stores.

Marmot (*Marmota marmota*)
Vanoise National Park, France
100–400mm zoom lens
1/250 sec. at f/8 - AF.

Most mountains are rich in flowers.
They make a fantastic hunting ground
for those who love macrophotography.

Mountain Houseleek
(*Sempervivum montanum*)
100mm macro lens
1/100 sec. at f/8 - MF.

A single mouse-ear surrounded by
Bird's-foot Trefoil.

Bird's-foot Trefoil
(*Lotus corniculatus*)
Vanoise National Park, France
100mm macro lens
1/160 sec. at f/4 - MF.

In France, the grizzly bear can
essentially be photographed only in
captivity. The few specimens in the
Pyrenees live in inaccessible places
and are too few to be seen, except
by assiduous professionals.

Grizzly Bear
(*Ursus arctos*)
100–400mm zoom lens
1/125 sec. at f/5.6 - AF.

Long before you think of leaving home, a project is an idea treated from a certain perspective. A piece entitled "The Bengal Tiger" has no chance for success since nature magazines reject twenty every year. If your piece is entitled "Discovering the Bengal Tiger from the Back of an Elephant," you may interest not only nature publications but also general-interest magazines in search of exotic subjects. Come up with two or three complementary pieces that can be completed at the same time ("Man-Eating Tiger: Fact or Fiction?," "Tigers and Traditional Chinese Medicine," or "Tiger: A Mainstay of Bengal's Tourist Economy") and your trip will start to show a profit.

A project begins with choosing a main theme and, through research, evolves into possible offshoots. Well-known photographers even tailor their material to suit the magazines with which they often work. When you're short of ideas, reading (general and specialized press) is a goldmine of ideas. A few words are sometimes enough to kindle an idea that will be the raw material for a subject. Be sure to write down all the phrases that attract your attention: inspiration doesn't always come right away. You will prepare

projects on your own. Unless you're on the staff, no magazine will be interested in an idea for a project, no matter how well thought out. What's more, it's a good idea not to tip your hand before a project is completed, since there are people who won't hesitate to steal the ideas of others. It's up to you to prepare your story, finance it, or find funding. Many national and regional tourist offices need articles to help attract visitors. They won't finance your story, but travel expenses and room and board (often substantial) may be paid. And don't forget the great advantage you have by being the official representative of the office of tourism. There will be no more problems with closed doors and unreturned phone calls.

Now that the project is taking shape, it's time to gather your research: maps, planning a route, shooting program, finding contacts, and requests for permission if needed. You have to draw up a complete itinerary, so that you have only to follow it once you arrive. Of course, diversions are possible, but the main thrust of the story should definitively be laid out.

The river otter is almost impossible to photograph in nature, and it is best not to disturb such a fragile species. This is why it is preferable to photograph it in captivity, especially if you want to distribute the image to promote the protection of the species.

European Otter
(*Lutra lutra*)
300mm lens
1/200 sec. at f/4 - AF.

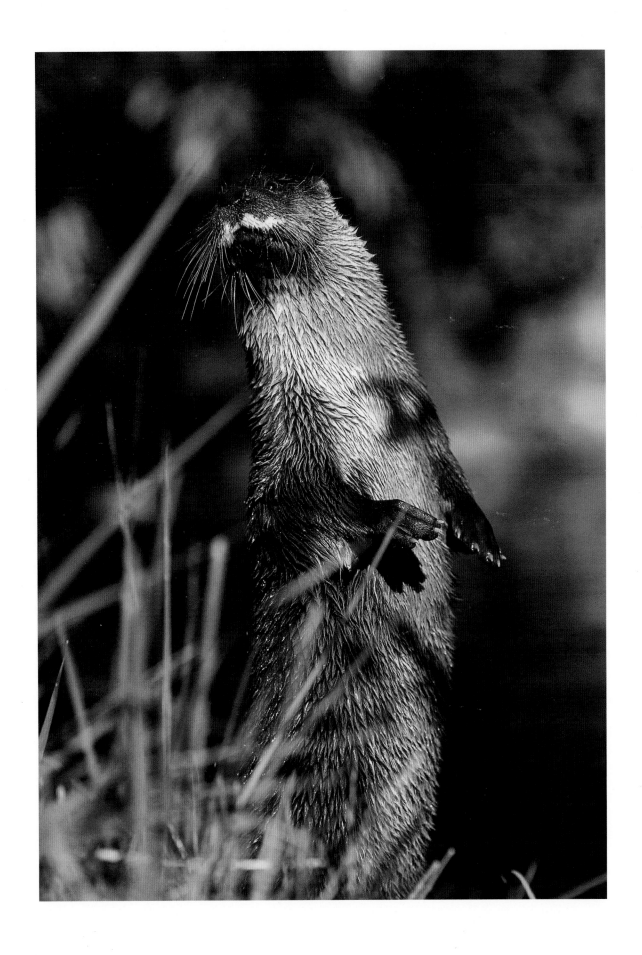

Making a Living from Your Work

Black-necked Grebes mating: "For this shot the bow of the floating blind was stabilized on a hillock of earth. The back of the blind was flooded under the weight of the photographic equipment and a camera and zoom lens were ruined! From that day on, I mounted a watertight box on the hull of the floating blind."

Black-necked Grebe
(*Podiceps nigricollis*)
300mm lens
1/60 sec. at f/4 - AF.

Earning your living from your photography is the dream of every amateur photographer. Traveling around the world, making a name for yourself, earning money while you're having fun, and using your work to make a difference in the world are among the leading motivations of those who want to cross the threshold to professional status. Since myths die hard, a lot of people think you have only to come back from your vacation with fifty rolls of animal shots taken during a photo safari to see the agents' doors open wide.

The problem is that four hundred passengers get off the airplane from Kenya each week, each with twenty or thirty rolls of the same animals immortalized in the same places.

If you figure around 10 percent on every flight are good photographers, you have at least 115,200 new photographs from East Africa every month. Even if the photographers don't all offer their work

The cormorant is an excellent diver and a skillful fisher, but his appetite is often greatly exaggerated.

Great Cormorant
(*Phalocrocorax carbo*)
300mm lens
1/100 sec. at f/4 - AF.

to agencies, it's obvious that safari photographs are not the best way to break into the profession.

The most important thing is to know how to take photographs and to have enough critical judgment to eliminate automatically any photograph unsuitable for publication. This isn't about being able to take well-focused and well-exposed photographs, but to produce images effortlessly that are engaging, original, taken in good light, and can be understood by everyone. It's no good proposing esoteric projects to an agent or magazine. Their job is to publish documents aimed at the general public. Thumb through books and magazines to get an idea of what is being published. Next, learn all the different outlets available to professional photographers to decide where you should take your chances. In every branch you will find periodicals specializing in different photographic themes: nature photography is fairly well represented. Among agencies, the level of photographers is quite high, and magazines have high standards. The best way to succeed with one of them is to produce work that is ready to be used, complete, and of high quality. Producing a complete and finalized project is the most appreciated service a professional photographer can provide.

The number of nature photographers who live solely by their work is very low. To be a part of this tightly knit group you have to do what the pros can't do. This is what Gilles Martin did when he was starting out: "Pros don't have the time to devote themselves completely to a single subject. This is why I took advantage of my amateur status to concentrate on dragonflies for almost ten years. I put together an extremely comprehensive library of images on this subject, which I have published more than 300 times in the national and international press! This is how my professional career began."

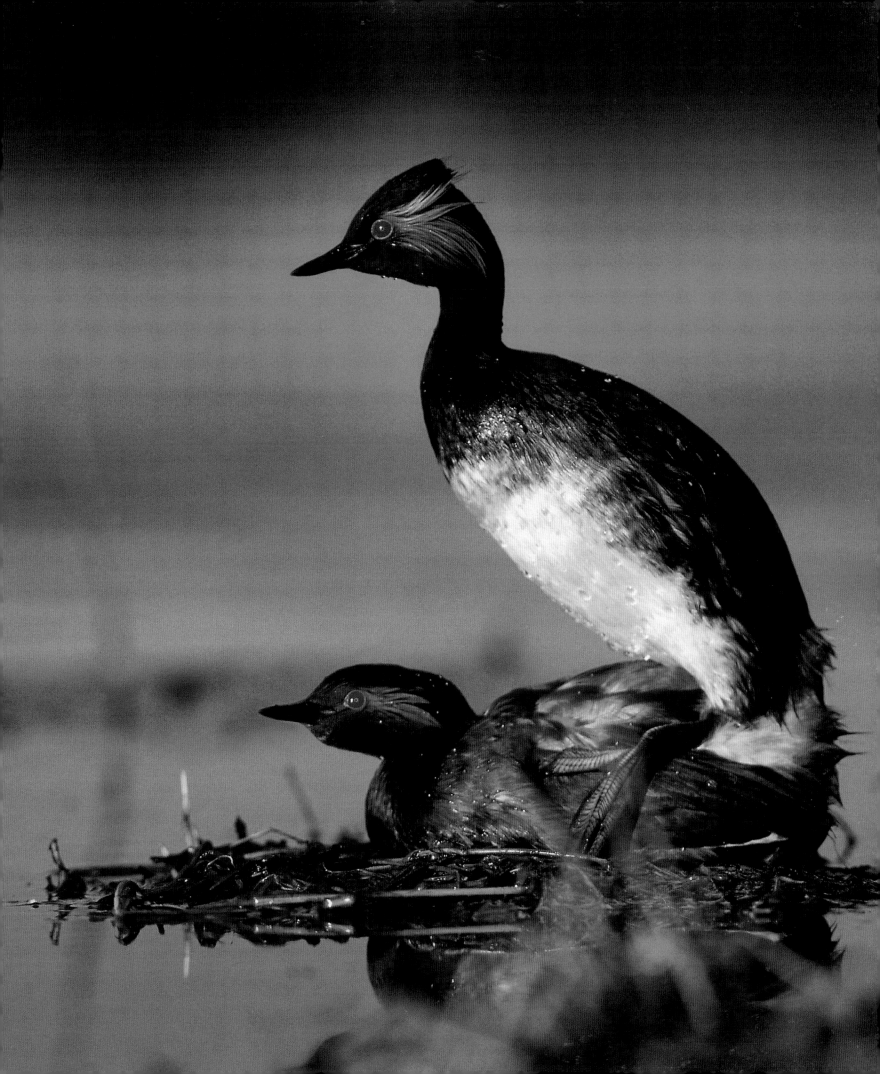

Good preparation for a project is the key to going into action once you're in the field. Following an itinerary is essential, since most nature subjects make you want to spend more time on them than you should.

South Georgia Island
Royal Penguin colony
(*Aptenodytes patagonica*).
Photograph: Alain Zaidman.

OPPOSITE

The weather is an element for success that is very unpredictable in the Arctic Circle where penguins live.

Royal Penguin
(*Aptenodytes patagonica*)
100–400mm zoom lens
1/350 sec. at f/5.6 - AF.

Completing a Project

Once you've reached your destination, everything must unfold as planned: you have to meet your local contacts, pick up your rental vehicle and baggage, start following your itinerary. It's easy to lose precious time when you're far from home. Fortunately, the first photographs you take in the field will bring back your concentration, especially photographs of animals, for which concentration is essential. This is the time to remember the technical constraints you must follow for magazine work: take both vertical and horizontal versions of important shots to facilitate layout; vary angles and distances with strong subjects; take several shots for the introductory photograph—the one that sums up and introduces the article; provide full-page illustrations (e.g., a landscape with lots of fine detail), smaller photographs (some immediately identifiable close-ups), complementary shots (details to be boxed), and—nothing ventured, nothing gained—a few slides designed for the magazine's cover (leaving space for the title). Knowing how a magazine article is organized is fundamental, and knowing how an editorial office works is just as important. A magazine that is running behind schedule (almost always the case) will give priority to projects that make their life easier. This is why it is so important to plan your photographs systematically as images to be published.

Successfully completing a project also requires learning how to handle unforeseen events. A sudden change in the weather, such as rain, snow, sandstorm, or monsoon can set in for several days. It's up to you to find the best solution to the problem. You might cover a different subject while you wait, jettison your itinerary, work in a sheltered location (underground or underwater), scout for locations, organize your notes and begin to write them up, make new contacts or, at worst, abandon this part of the project.

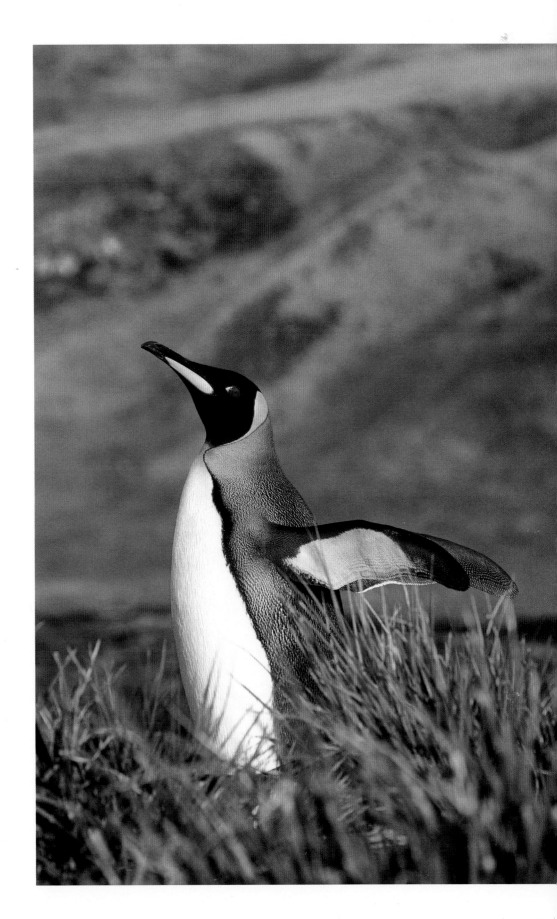

Editing Your Work

Once you return from the far corners of the globe, the rolls of film are sent out for processing by a professional laboratory. A few hours later, when all your slides are spread out on the light table, it is time to summon your critical abilities. Pros call this "editing." You should sort the slides with a 4x magnifier, with transparent sheets for organizing the good shots and a wastepaper basket for everything else.

Be ruthless: all the overexposed, underexposed, badly composed, or unappealing shots go directly into the trash. Once you've finished the first cut, look over all the slides you've put into sheets, and mark with a red dot those that you think may some day be publishable. Separate them from the others, and then put them into sheets.

Next construct your project so it will tell one or more stories.

If the project is split into different subjects, vary your approach and point of view, but don't sell the same photographs to different magazines at the same time. They're purchasing the exclusive rights.

Framing, composition, image sharpness, and exposure have to be perfect for a photograph to interest an agency or magazine.

Pied Wagtail (*Motacilla alba*)
300mm lens
1/250 sec. at f/4 - AF.

Houria Arhab, Gilles Martin's companion, during an editing session. A light table and a special slide magnifier are the most important tools for editing. The accessories are transparent storage sheets, a fine-tipped permanent marker, and a wastepaper basket.

Presentation

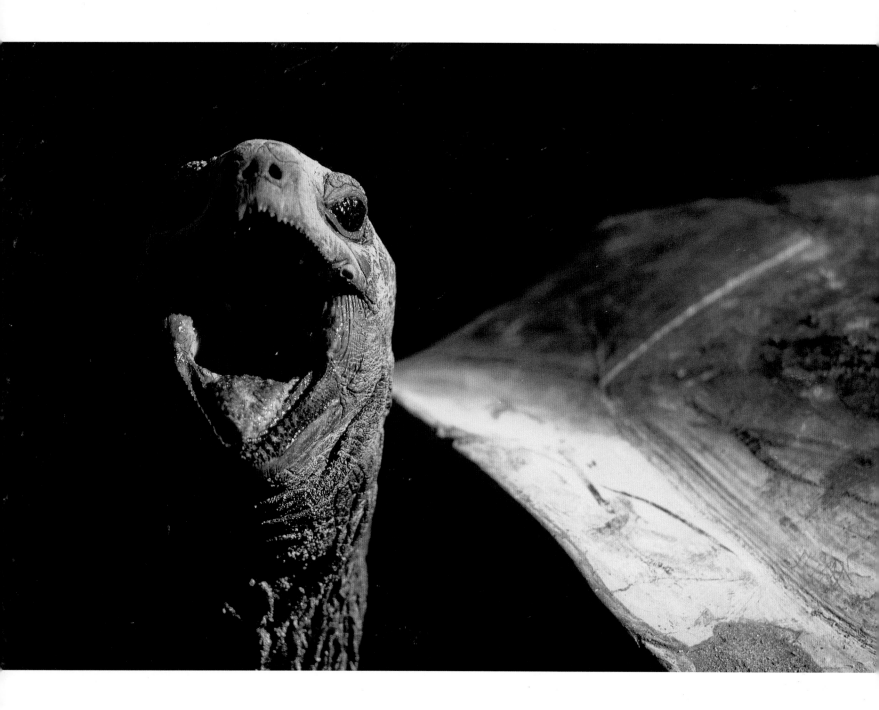

The photographer always retains ownership of published photographs. The magazine or the client pays for reproduction rights, but in no case buys the original work.

Aldabra Giant Tortoise
(*Geochelone gigantea*)
Aldabra Atoll (Indian Ocean)
Image-stabilized 300mm lens
1/125 sec. at f/5.6 - AF.
Monopod.

The sorted slides are stored in archival transparent sheets, and carefully marked: your name and telephone number at the top of the slide mount (often these are printed by the lab), and the subject or the species photographed (common and scientific name), along with the place and country given on the bottom of the mount. This information should be written directly on the plastic slide mount with a fine-point permanent marker (available at office supply stores): handling will eventually wear off labels. Never date your slides, or editors may think that they're too old. As long as the slide is in perfect shape and the subject (e.g., a landscape) still exists in that state at the time of publication, the slide may still be sold. You should still watch out for unforeseen changes, like the collapse of a section of mountains (Drus at Chamonix), or the destruction of a forest by fire.

A professional's collection should always be up-to-date to maintain his or her credibility. For an average project, you usually provide the magazine with between sixty and one hundred slides. The recipient signs a receipt, which you provide, that includes the date, number of originals, title of the magazine to which the slides are loaned, and the date by which the photographs must be returned.

Legal notices usually accompany these receipts, with the price to be paid in case of loss or damage. Their validity will have to be upheld in court, but they are a good place to start negotiations in case of accident. Fortunately, this kind of problem is usually resolved amicably, as between professionals. Nonetheless, it's a good idea to check the slides when they come back from the printer. Accidental scratches, traces of oil from the scanner drum, and fingerprints can make the original completely unusable. If this occurs, you can ask for financial compensation or have a retouched duplicate made by a professional laboratory. This is usually a 4 x 5-inch "dupe." A digitally retouched slide is also an option, with a film output of the digital image included.

It is essential to understand one thing: a photographer is always the owner of the images he or she creates. The user pays for rights of reproduction—or copyright license—for the publication of photographs, but in no case buys the original work. Photographs must always be returned to you after their use. Each subsequent publication of one or more images must be renegotiated and you must be paid. On the other hand, it is common practice to allow reproduction of covers in thumb-nail images in a summary or in pages that reproduce back issues of the magazine: you have to be diplomatic to make your way in the profession.

© Gilles MARTIN
229, av. de Grammont. 37000 TOURS

Caméléon tigre des Seychelles
Chamaleo tigris (Seychelles)

The information on a slide is not really standardized, but it should include at a minimum:
○ photographer's full name
○ complete address
○ species (common and scientific name)
○ where the slide was taken.

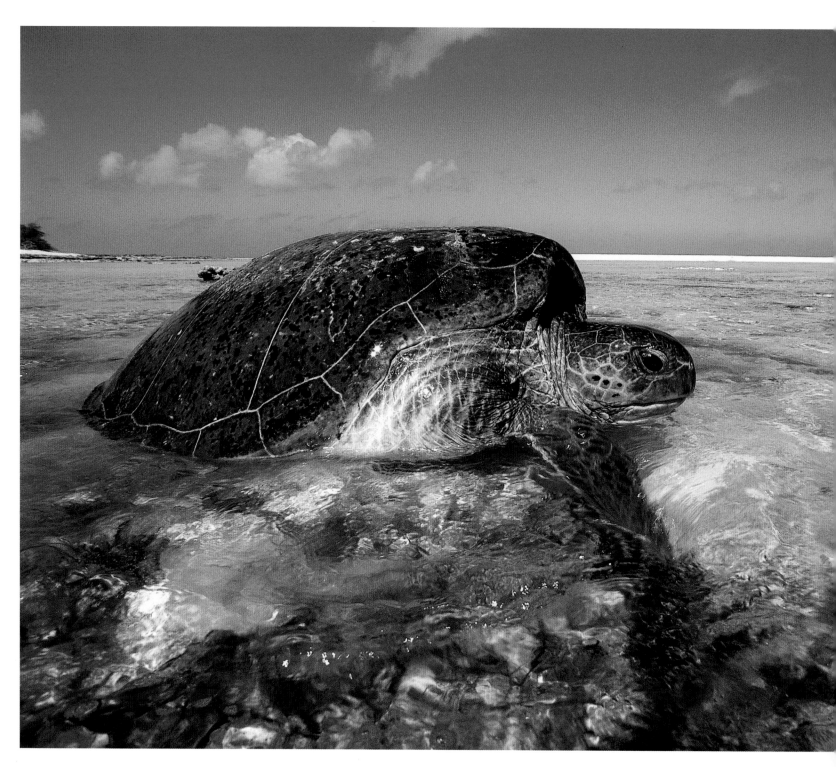

Return to the sea after laying eggs:
"I was in the water at wave level to
photograph this Green Sea Turtle.
My camera was protected in a water-
proof bag by ewa-marine, which
completely protects the camera if it is
submerged."

Green See Turtle
(*Chelonia mydas*)
20mm lens
1/80 sec. at f/18 - AF.
ewa-marine waterproof bag.

Distribution

Photographs can be distributed directly in magazines (complete projects) or through a photo library (high-quality photographs on various subjects). Each method has its advantages and disadvantages, which is often linked to the availability of the photographer.

◦ Agency (or Photo Library): These are intermediaries among magazines, publishers, publicists, and businesses and photographers who don't have the time or inclination to look for clients. Always in search of new images, most will, with an appointment, look over the work of young photographers. But to be credible you should submit at least 3,000 good slides, carefully marked and stored in plastic sheets, or digital scans on a CD. Those photographers who are accepted sign a contract with the agency, which is binding to both parties. The agency agrees to promote the photographer's work in exchange for a percentage of the fee (usually 50 percent). The photographer agrees to tie up his or her photographs for a fairly long time (five years is a usual minimum), and to produce new ones regularly. At the risk of dashing anyone's hopes, you should realize that some people make a few dollars by placing slides with an agency, but photographers who make their living from them are rare. You need to produce a great number of slides to be one of the artists promoted to the agency's clients.

◦ Magazines: With magazines, the tendency is to publish complete projects with photographs and texts. Don't bother to show up at an editor's office with an idea—even an extraordinary one—in hand: what they need it is finished projects. A piece including sixty high-quality slides on an interesting theme, treated from the magazine's particular point of view, accompanied by a synopsis that answers the five basic questions (who? where? when? how? why?) has a chance. If you have provided an opening photograph, a few full-page images, some accompanying photographs, which can be boxed, the deal is as good as done. Like most media, which are driven by deadlines, magazines appreciate professionalism and work that is ready to use. The average photographer who offers a completed project is more likely to be published than a genius who is too disorganized to finish his work.

With the development of the Internet, some young photographers put their work online in an attempt to promote it. As long as you do this for your own pleasure and in order to promote a diversity of opinions, it may be worthwhile. But in the context of professional photography, returns are close to zero: the thousands of websites devoted to young talent will completely bury your work. Even worse, putting your photographs online is the best way to have them pirated and to see your ideas in photographs published by others. The only images that should be used on the Internet for promotional purposes are photographs that are published too often to be copied, that attract interest and justify your website, whose URL should be on your business card.

The Publishing World

As with magazines, no publishing house will undertake a project by a new photographer without seeing a minimum amount of work. You need a solid foundation to convince them, including the precise subject of the book, high-quality photographs impeccably arranged, and a coherent table of contents. The ideal is to have a text, even if it is incomplete, since it will speak more convincingly than any verbal presentation.

Target the publisher according to the theme or style of the work. Some specialize in particular subjects, while others have more confidence in the intrinsic beauty of the photographs. A book made up of very beautiful images will interest publishers who target a demanding clientele, both in terms of fine printing and the quality of information. Except for those few books that gain a great deal of press, high-quality books are expensive to produce and hard to sell. Your idea should be rock-solid to be convincing.

Rather than sending in a manuscript that will be buried among all the others, make an appointment with the editor-in-chief to explain your project. Be careful—this is a professional who will be used to assessing the worth of a project in a few minutes. Even if it's hard to hear, believe what they say if they tell you to revise your project. You may also want to see other editors to see how your work is received by them. If you're rejected by all the publishers you contact, you may be the perfect client for a "vanity press."

Publication by a vanity press always begins with a flattering letter: "Sir or Madam, our editorial committee has selected your work . . . " and usually ends with "we would propose that you buy at your own expense half of the books printed, or 500 copies, while we will ensure the distribution of the 500 others and pay you the royalties resulting from their sale." Of course, the pseudo-publisher will just print the 500 copies you pay for, and will tell you that none of the 500 others sold and were destroyed after a certain date. When you realize that a real publisher pays for all the expenses of producing a book, and especially those related to distribution—always very high— you will understand that publication by a vanity press is always an excellent investment for whomever cashes your check.

To avoid paying for your book at the high prices charged by vanity presses, it is better to get a quote from a printer. You'll see that the bill is much more affordable.

In a real publishing house, the author is paid for his or her work: the publishing house bases its commercial activity on the sale of books. On the other hand, if copies of a book remain unsold after a certain date, the publisher may suggest that the author buy them, in order to sell them if he or she so desires. There are real possibilities in pursuing sales on your own, e.g., through an efficient medium like the Internet. If the author refuses, the publisher will pulp the books (resold at the price of paper and destruction).

The principles of publishing are the same for postcards. If someone wants you to pay to publish your postcards, look for another publisher or have your photographs printed directly by a printer.

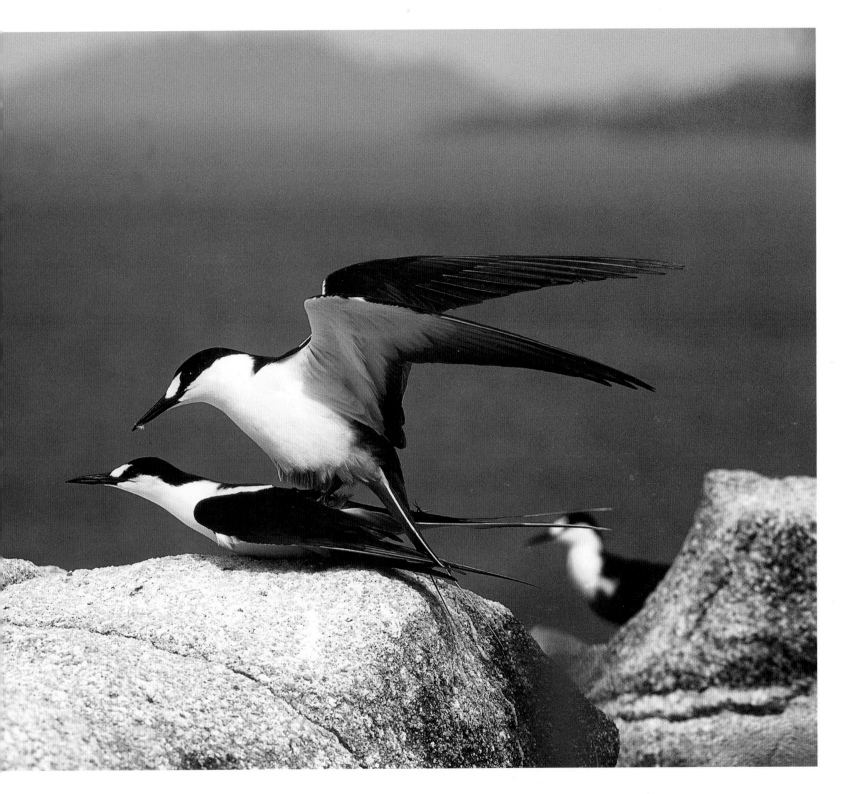

Sooty Terns mating on Aride Island (Indian Ocean): "I hid in a hole in the rocks with a piece of camouflage material over my head to photograph this scene."

Sooty Terns
(*Sterna fuscata*)
200mm lens
1/1,000 sec. at f/2.8 - MF.

Storage and Conservation of Originals

The durability of original photographs should concern the photographer. You should know that, with the exception of Kodachrome, color processes are less stable than black-and-white. You can count on an average life of twenty years for E6 slides and recent color negatives.

The life of slides depends on several factors: processing quality, frequency of projection, number of times they're printed, time exposed to light, local humidity levels, and out-gassing of solvents near the film.

In the labs of film manufacturers, processing is optimized for a conservation of slide and color negative emulsions. Pro labs also use high-quality chemicals, so they can offer the quality and flexibility of development required by the demanding professional clientele they serve. Independent public laboratories—which develop small quantities of slides compared to an enormous mass of negatives—are more risky for slides since an E6 processor must be used regularly to work well.

On the other hand, there's no problem with C-41 color negatives, which represent the bulk of the work done for the public at large. Light will cause fading in slides and negatives. The latter, usually exposed to light once or twice in the enlarger, are not much at risk. The problem is more severe with slides, which are regularly projected by the amateur and often copied or left on the light table by pros. To minimize the damage, make extra copies of your slides when they're photographed: one for archiving, the other to print or project. Professionals and amateurs who don't usually project their slides can also have them scanned and only circulate digital copies.

The location where you store your slides must be completely dry, and it must not contain furniture made of particle board—the glues they contain will out-gas solvents that are harmful to emulsions. The ideal solution is to store slides safely inside a metal cabinet with drawers, in archival transparent pages (no labels glued onto the slide mounts), hung like files in file cabinets. This is how most professionals and photo libraries store their slides.

Even in the best of conditions, slides may discolor after twenty or thirty years of storage. Until now, printing on Ilfochrome (formerly Cibachrome) or contact duplication was the only viable way to make the originals permanent. Digital tools today provide an additional solution. Don't skimp on the quality of the scanner, since it determines the resolution of the image you are preserving. If you have a lot to scan, the purchase of a slide scanner is justified, especially since the performance of these products is continuously improving. Add a CD-ROM burner and a software program for cataloguing images, and you'll be completely auto-nomous and your images safe. You just need to duplicate your digital files on a new standard when the storage medium you're using becomes obsolete.

Slides stored in archival plastic sleeves and archived in a metal file drawer will be preserved for a long time without any problem.

Barbary Macaque (*Macaca sylvanus*)
Image-stabilized 300mm lens
1/45 sec. at f/5.6 - AF.
Photograph taken at the "Valley of the Monkeys" (Romagne, France).

The Role of the Wildlife Photographer

Despite a large amount of high-quality televised coverage of the subject, nature photography maintains considerable powers of attraction for the general public. The role of the photographer is thus vital in the communication of knowledge to young people and for the popularization of ecological ideas. At a time when persistent human negligence is bringing about changing weather patterns, melting of the polar ice caps (global warming), extinction of species, erosion of arable lands, desertification, or the massive destruction of marine resources (oil spills, hole in the ozone layer), pictures are more effective as a tool for change than any slogan.

In a fraction of a second, the person who sees an oiled bird, a gorilla's hand used to make an ashtray, or a one-ton rhinoceros killed for 6½ lbs. (3 kg) of horn is necessarily touched. Even if the force of the race for profits makes any attempt at reversing the process seem illusory, the small daily efforts of enlightened people work to the good. In our times, when the "politically correct" has taken precedence over militant action, showing nature at its best is also a way to fight for its protection.

The population of Cape Farquhar gathering Sooty Tern eggs. It only takes thirty or so of the cape's inhabitants to threaten a good part of the nests (2.5 million terns). The power of images like this one is necessary to arouse public opinion.

Sooty Tern (*Sterna fuscata*)
200mm lens
1/60 sec. at f/8 - MF.

The general public, saturated with shocking images, has developed an ability to forget troubling ones very quickly. On the other hand, the need to defend nature is transmuted into a desire to appropriate the beauties of the planet.

The success of televised broadcasts and books, which inventory the most beautiful places in the world, confirms this: "This beautiful world belongs to us, we should take care of it!" seems to have become a new slogan of neo-ecologists. To encourage this ecological interest with images is a fantastic motivation for all photographers.

Sea-going poachers caught red-handed violating endangered species laws.

35mm lens
1/60 sec. at f/11.- MF.

OPPOSITE

"Population control" hunting of Australian kangaroos. A photograph that reveals human impact on the environment.

35mm lens
1/60 sec. at f/8 - MF.
Flip-up flash.

Digital Photography. . . . Yes, But How Far Is Too Far?

Today most photographs presented to the public are prepared digitally from a scanned slide or negative. All the photographs published in magazines have been digitized. The image as we know it is on the point of turning into binary arrangements of 0s and 1s, which will redefine the field of photography. Many photographers are worried about these changes, but you have to admit that in the final analysis, a pixel is very similar to a grain of silver.

Their essential difference comes from the pixel's extraordinary malleability. In the past, retouching an image required an exceptional level of skill. To remove someone from a photograph, our grandmothers cut them out with scissors and didn't care about the empty silhouette in the image. Now that the computer mouse can retouch images, you have only to outline the part to be removed, paste in another person or detail, and blend the two together. Putting a polar bear in the Sahara or dromedaries in Spitzberg only takes a few minutes when you have a little skill with the tools and the necessary raw material, i.e., individual photographs of different subjects.

This ease is worrisome to photographers, who spend a fortune to take exceptional images all over the world. Anyone familiar with computer graphics can steal bits of their photographs here and there and create new ones. Of course, copyright laws forbid using the pieces of the puzzle without the author's permission, but recognizing the components isn't always easy once they've been changed and reassembled.

There are also photographs put together by those who don't really have any talent. A polar bear inserted into its habitat is undetectable, making it possible to create more valuable photographs from badly composed images, or those taken in the wrong environment. There is nothing to stop these people from practices such as taking photographs of captive animals and then putting them back into the part of the world from which they have disappeared.

In itself not necessarily dangerous, this system does not encourage taking new photographs and may freeze the images of the world in "copyright free" CD-ROMs that completely undercut the value of professional production. Too many people already think that photographs are easy to take, but CD-ROMS filled with second-rate images give a very poor idea of the talent of our best nature photographers. Digital photography, yes, as a tool of reproduction, storage, or image acquisition. We must say no to "genetically modified" photography.

Like all the images in this book, this photograph was taken without using any computerized manipulation: "The incredible richness of nature provides enough original subjects that we may forgo digital manipulations."

Bharatpur Marsh (India)
200mm lens
1/30 sec. at f/7.1 - AF.

GLOSSARY

Achromatic: term applied to a lens partially corrected for chromatic aberration (color fringes in an image).

Aperture: relative opening of the lens diaphragm, or the ratio between focal length and diaphragm diameter.

Apochromatic: a lens that is almost completely corrected for chromatic aberration (color fringing).

Aspherical: a lens with a non-spherical surface designed to correct certain optical aberrations at full aperture.

Autofocus: a camera that focuses automatically.

Bayonet: lens mount specific to each manufacturer.

Bracketing: taking additional identical pictures while varying exposures. The number of pictures and the variation in exposure may be preset as needed.

Depth of field: zone of apparent sharpness that extends in front of and behind the focal point. Depth of field varies with aperture, magnification, and, to a lesser extent, with focal length.

Diaphragm: mechanism inside a lens for varying the quantity of light admitted to the camera using an iris with metal leaves, adjustable to different predetermined quantities. Changing the diaphragm opening (called the aperture) also effects optical performance and depth of field.

Doublet: basic cemented glass unit composed of a convex and a concave lens. There are also triplets composed of three lenses.

Emulsion: film's light-sensitive layer applied to a mechanical support.

Exposure Value (EV): grouped pairs of aperture/shutter speeds that give equivalent exposures.

Fill-in flash: a flash to brighten shaded areas when shooting backlit subjects.

Focal length: the distance between the film and the optical center of the lens when the lens is focused on infinity.

Guide Number (GN): number that provides the relative power of a flash unit, usually referenced for ISO 100 film. It is also used to determine the f-stop when flash exposure is calculated manually.

Hyperfocal distance: focusing distance that gives the maximum depth of field for a given aperture.

Image-stabilized lens: a hybrid optical and electronic lens that compensates for vibrations and movement of the camera.

Exposure latitude: ability of film to produce a correctly exposed image in differing light levels.

Lens: optical unit designed to focus an image on the film plane with the best possible quality.

Long focus: a 35mm-camera lens with a focal length greater than 60 mm. The length of this kind of lens is approximately equivalent to its focal length.

Magnification ratio: relationship between actual subject size and its image size on the film.

Light meter: photosensitive device designed to measure light intensity. May be built into the camera (TTL metering) or be an external hand-held unit.

Multi-segment metering: system that uses an array of segmented sensors to measure exposure and compares the analysis of contrasts to examples stored in the processor's memory. Also called matrix metering (Nikon) or evaluative metering (Canon).

Optical aberrations: distortion that affects image transmission through the lens or group of lenses (spherical aberration, chromatic aberration, coma, astigmatism, etc.).

Optical glass: glass with a low dispersion index, which minimizes the effects of chromatic aberration. This term refers to glass containing rare earth elements or lenses made from single crystal fluorite.

Pixel: smallest unit of information in a digital image.

Range: difference between the longest and shortest focal lengths of a zoom lens.

Retrofocus: optical assembly used to produce wide-angle lenses whose rear element doesn't enter the camera.

Selective metering: exposure metering measured in the central part of the image.

Sensor: light-sensitive electronic element composed of pixels, used especially in digital cameras, autofocus systems, and TTL metering.

Single Lens Reflex (SLR): reflex camera that allows viewing through the camera's lens using a mirror and erecting prism.

Slide (transparency) film: positive film obtained by chemical reversal during processing of the inherent negative image in the emulsion.

Spot metering: exposure metering measured in a very small area of the image.

FP synchronization (high-speed synchronization): a system for flash exposure based on the shutter travelling across the film.

X-synchronization: maximum shutter speed with which a flash is able to expose the entire image at once.

Telephoto: complex optical assembly with a focal length greater than 60 mm. Usually composed of a forward element with a power lower than the resulting focal length, and a rear group that increases the focal length of the forward group. Telephoto lenses are physically shorter than "long focus" lenses having the same marked focal length.

TTL (Through the Lens): this abbreviation means that light readings are taken through the lens in order to take account of modifications to the light beam that passes through it. Used for measuring exposure, flash control, and autofocus.

Vignetting: mechanical or optical shadowing of the edges of a lens' field of view. Causes darkening in corners of images.

Wide-angle: lens with a focal length less than 43 mm, usually retrofocus for 35mm SLRs.

Zoom: lens with a variable focal length.

INDEX

Italicized numbers refer to captions

Conditions of Photography

Gilles Martin makes the following statement regarding the conditions of photography and reproduction used: "All the animals represented in this book were photographed in their natural habitat. The only images taken in captivity are those of threatened species, which are difficult to approach and are more prudently photographed in this way to avoid disturbing wild individuals. Wolf, grizzly bear, otter, and European mink are among them, and they are all listed as captive animals in the photographs' captions."

DIGITAL TRICKERY

"As far as the aesthetic quality and the authenticity of these documents, I have made it a point of honor to eschew any digital manipulation—or other artificial technique—to 'improve' the aesthetic quality of my images. The printed documents, which you see before you, are the exact reflection of the photographs taken in the field with, I hope, the emotion of the moment transmitted in its entirety. 'Genetically modified' photographs have no place in nature photography!"

Equipment Used

35MM CANON
Bodies:
- EOS 5
- EOS 1n + Power Drive Booster El

Lenses:
- EF 20 mm f/2.8
- EF 28–105 mm f/3.5-4.5 USM
- EF 100 mm f/2.8 Macro
- EF 100–400 mm f/4–5.6 L IS USM
- EF 200 mm f/2.8 L II USM
- EF 300 mm f/4 L IS USM
- EF 500 mm f/4.5 L USM
- EF 600 mm V4 L USM
- Teleconverter EF x 1.4
- Extension Tubes EF 12 and EF 25

Flash:
- Speedlight 540 EZ

35MM OLYMPUS
Bodies:
- OM-2N
- OM 4 Ti + Motor Drive 2

Lenses:
- Zuiko 16mm f/2.8 Fish-eye
- Zuiko 50mm f/3.5 Macro
- Zuiko 135mm f/2.8
- Tamron SP 400mm f/4 LD IF (OM mount)

Flash units:
- Olympus T 32
- Olympus T 82
- Olympus T 45

24 X 65 PANORAMIC
Camera:
- Hasselblad XPAN

Lenses:
- 45mm f/4
- 90mm f/4

6 X 17 PANORAMIC
Camera:
- Fuji Panorama GX 617

Lenses:
- SWD 90mm f/5.6
- T 300mm f/8

6 X 7 MEDIUM FORMAT
Camera:
- Mamiya RB 67

Lenses:
- 65mm f/4.5
- 180mm f/3.8

Tripod:
- Gitzo

Film Used

Fujichrome Sensia II and Provia 100 F

Acknowledgments

Hocine Arhab

Laurent Arthur

Dave Augeri

Bruno Baudry

Thierry Boisgard

Stephan Bonneau

François Botté

Pascal Bourguignon

Lindsay Chong Seng

Guy Dassonville

Alexandre Delacise

Jacqueline Develay

Willy Dupin

Pascal Fournier

Bruno Hervier

Philippe Huet

Bénédicte Huriez

Daniel Ingremeau

Marcel Jacquot

Marc Jardel

Geneviève Kerberenes

Candice Labarthe

Sonia Labarthe

Emmnuel Le Grelle

Richard Lelarge

Neil Le Pérave

Guy Lionnet

Daniel Malherbe

Lucie Malherbe

Rémy Marion

Pat Mattiot

Antony Mercier

Félix Oyoua

Susan Pierce

Claude Renaud

Louis Richer

Sébastien Roué

Cyrille Royon

Marc Sauget

Gilles Martin would particularly like to thank the following companies: Fujifilm France, Canon Photo-Vidéo France, Duracell, Jama Electronique. Also Franck Fouquet, for his logistical support in Masai Mara (Kenya), Eric Male-Malherbe (and his family), who gave him access to one of the most beautiful ponds in the Brenne Regional Nature Park, Cyrille Royon for his precious assistance in creating the radio-controlled vehicle, and finally Evelyne and Denis Boyard for their professionalism.

Denis Boyard thanks his wife, Evelyne, for her wonderful drawings, his extremely patient children, Bruno Dubrac, whose rereading and enlightened advice were a great help, and, of course, Gilles Martin, whose idea it was to share in this wonderful editorial adventure.

Photograph Credit

All the images in this work are by Gilles Martin, with the exception of the photographs in which he himself appears in action. Credit for these photographs is given in the corresponding caption.

Illustrations

Evelyne Boyard

Nature Photography Training

To help you perfect your technique or discover the joys of nature photography, Gilles Martin organizes macrophotography and animal photography training in the Brenne Regional Nature Park in France. For information, write to him:

GILLES MARTIN
Résidence du Lac
229, avenue de Grammont
37000 Tours
France

Looking for the addresses of nature photography agencies, manufacturers of photographic equipment, organizations, travel agencies, or a bibliography of works on nature? Take a look at Gilles Martin's website: http://www.gilles-martin.com.

An innate behavior, the young gray cuckoo hatches first and throws the eggs of his adoptive parents (here, Reed Warblers) out of the nest. The most astonishing fact is that the young cuckoo will find the migratory route on its own, with no adult to show the way.

Common Cuckoo (*Cuculus canorus*)
50mm macro lens
1/60 sec. at f/11 - MF.
Extension flash.

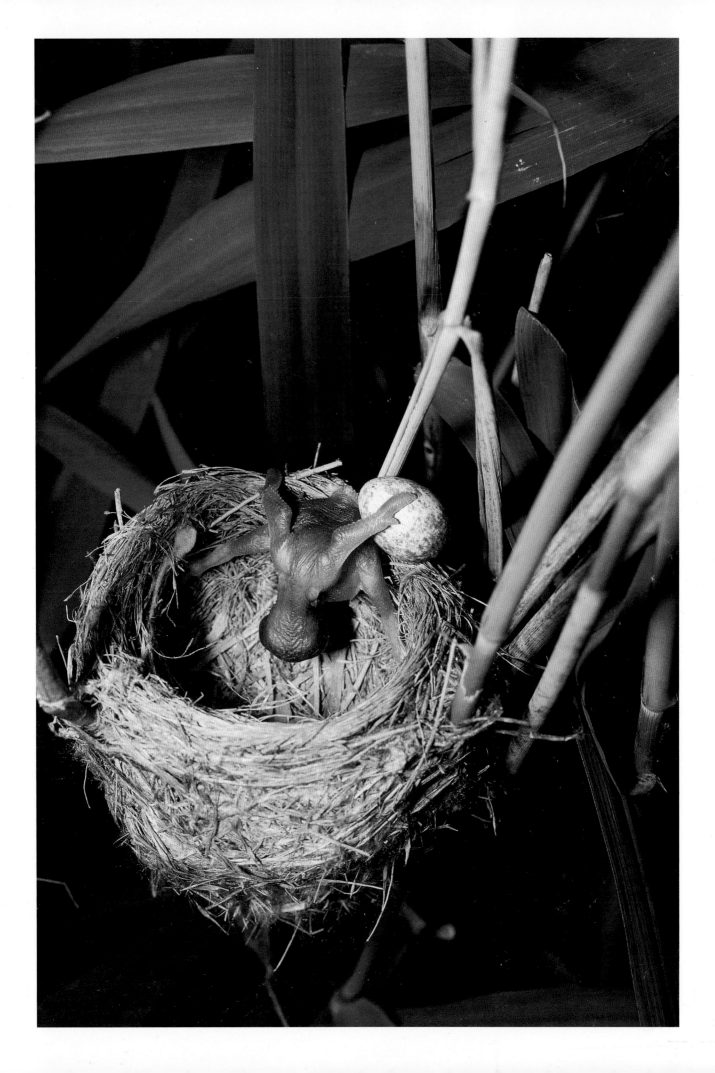

PROJECT MANAGER, ENGLISH-LANGUAGE EDITION: Susan Richmond
EDITOR, ENGLISH-LANGUAGE EDITION: Lenora Ammon
COVER DESIGN, ENGLISH-LANGUAGE EDITION: Miko McGinty and Rita Jules
DESIGN COORDINATOR, ENGLISH-LANGUAGE EDITION: Rita Jules
TECHNICAL CONSULTANT, ENGLISH-LANGUAGE EDITION: Lester Lefkowitz

LIBRARY OF CONGRESS CATALOGING-IN-PUBLICATION DATA

Martin, Gilles.
 Nature photography : learning from a master : with 300 dazzling color
photographs / photographs by Gilles Martin ; text by Denis Boyard ;
translated from the French by Jack Hawkes.
 p. cm.
 ISBN 0-8109-9116-0
 1. Nature photography. I. Boyard, Denis. II. Title.
 TR721.M38 2003
 778.9'3—dc21
 2003005347

PRINTED AND BOUND IN ITALY
10 9 8 7 6 5 4 3 2 1

Harry N. Abrams, Inc.
100 Fifth Avenue
New York, N.Y. 10011
www.abramsbooks.com

Abrams is a subsidiary of

LA MARTINIÈRE
G R O U P E